THE PUBLISHER GRATEFULLY ACKNOWLEDGES THE GENEROUS CONTRIBUTION TO THIS BOOK PROVIDED BY THE ART ENDOWMENT OF THE UNIVERSITY OF CALIFORNIA PRESS ASSOCIATES, WHICH IS SUPPORTED BY A MAJOR GIFT FROM THE AHMANSON FOUNDATION.

SINGULAR WOMEN

SINGULAR WOMEN

WRITING THE ARTIST

KRISTEN FREDERICKSON & SARAH E. WEBB, EDITORS

UNIVERSITY OF CALIFORNIA PRESS
BERKELEY · LOS ANGELES · LONDON

University of California Press
Berkeley and Los Angeles, California

University of California Press, Ltd.
London, England

© 2003 by the Regents of the University of California

Library of Congress Cataloging-in-Publication Data

Singular women : writing the artist / Kristen Frederickson
and Sarah E. Webb, editors.
p. cm.
Includes bibliographical references and index.
ISBN 0-520-23164-3 (alk. paper)—ISBN 0-520-23165-1
(pbk. : alk. paper)

1. Feminist art criticism. 2. Women artists—Biography—
History and criticism. I. Frederickson, Kristen,
1965– II. Webb, Sarah E.

N72.F45 S55 2002
701'.18'082—dc21

2002153267

12 11 10 09 08 07 06 05 04 03

10 9 8 7 6 5 4 3 2 1

The paper used in this publication meets the minimum re-
quirements of ANSI/NISO Z39.48–1992 (R 1997) (*Permanence
of Paper*). ●

To our daughters,
Avery Elisabeth Curran and
Eve Webb Bobrow,
who with their innocent question
"Can men be artists too?" remind us daily that
feminism has made progress.

CONTENTS

LIST OF ILLUSTRATIONS

ix

ACKNOWLEDGMENTS

Singular Women grew out of a panel, "The Politics of Rediscovery: The Monograph and Feminist Art History," presented at the College Art Association's 1997 national conference in New York. We thank the association for their pivotal role in the development of this book. We would like to thank those who attended and urged us to continue this discussion as a book. To all of the contributors for their hard work and patience, and to the artists whose work is reproduced, we thank you for your belief in this project. David Cast, Catherine Soussloff, and Janet Wolff offered insightful comments and encouragement, and the graduate students in the "Gender and Difference" and "Theory and Criticism" seminars at Hunter College and the Master's Program at Christie's Education gave us thoughtful reactions to the book-in-progress. Chris Morse assisted us by transcribing key documents. Our families—our husbands, John Curran and Michael Bobrow; our parents, Suzanne and Paul Frederickson and Elizabeth and Pierce Webb; and our parents-in-law, Rosemary and John Curran and Barbara and Sam Bobrow—listened tirelessly to our reports on the progress of this project from panel discussion to finished manuscript and offered us helpful analysis of the ideas themselves.

To the female artists and writers in our lives who provide us with encouragement and inspiration through their words and images we offer our respect and grateful thanks: Brenna Beirne, Kate Teale, Mary Margaret O'Brien, Lesley Dill, Amanda Guest, Kathleen Kucka, L. C.

Armstrong, Cecilia Galiena, Maggie Simonelli, Judy Natal, Colleen Buzzard, Nancy Lenker Topolski, Anne Havens, Martha O'Connor, and Rachel Hall.

Finally, to our creative and responsive editor at the University of California Press, Stephanie Fay, and to her assistants, Lynn Meinhardt and Erin Marietta, we offer our gratitude for their willingness to take on this book.

INTRODUCTION

HISTORIES, SILENCES, AND STORIES

KRISTEN FREDERICKSON

In the spring of 1996 I issued a call for papers to be presented at a panel entitled "The Politics of Rediscovery: The Monograph and Feminist Art History" at the College Art Association's annual meeting the following February. The panel was to examine some of the theoretical and practical concerns facing feminist art history and its treatment of individual women artists. Specifically, it would suggest how in the mid-1990s a theoretical climate of poststructuralist skepticism about individuality, originality, and hierarchical privileging and categorization had inspired a shift from the monographic treatment of artists (books focusing on a single artist) to thematic treatment of art historical subjects and a broad-based approach to the field increasingly known as "visual culture" rather than "art history." The panel in 1997 would explore how women artists had been inscribed into art history, focusing on the work of five art historians.

Feminist art history since 1996 has been a fraught territory, grounded in the conflicting, or at least multivalent, goals of the previous twenty-five years. Feminist art history may be said to have begun in 1971 with Linda Nochlin's essay "Why Have There Been No Great Women Artists?" Published in a special issue of *Art News,* it has been reprinted many times.[1] Nochlin wrote the article after teaching a seminar on women in art at Vassar College, in which it had become imme-

diately and abundantly clear that there was no history of women in art, no list of important women, no bibliography of the study of their work.[2] It seemed necessary to write monographs on women artists as the research of early feminist art historians made their work visible. Yet a hesitancy in the field to maintain the monograph as central to art history might reflect, as Griselda Pollock suggested in 1996, an awareness that "we could not begin to speak of the women artists we would re-excavate from dusty basements and forgotten encyclopedias using the existing languages of art history or criticism."[3]

It has become apparent in the past thirty years that the attitudes and goals of art historians committed to a feminist view will not constitute a cohesive, comprehensive "feminist art history," for feminist interventions in the history of art take many different shapes. How will feminist art historians shape the achievements of the growing list of artists who are women? Exhibitions and resulting texts (for example, Linda Nochlin and Anne Sutherland Harris's *Women Artists 1550–1950*) have identified important female artists. Should the next goal be to place these artists within the styles and time periods of canonical art history? Or should another canon be created to encompass the goals and accomplishments of women artists? Is the notion of a canon itself to be trusted and maintained, or is the category of "canonical" inherently corrupt because of its masculinist roots?

Consider the canon: artists and works familiar and familiarly beloved, "inspired and divine," as the term in its theological meaning suggests. The implication of a canon is comforting: once we know it, we know all. Once we grasp the chronological sequence from the art of ancient Greece through the art of the cubist period and beyond, once we can name the "important" figures in each period, recognize their works, identify how their styles diverge from those of the past, name the artists who succeeded each other (repeating the pattern of the vanquished father and vanquishing son that Freud defined), we know our past. Art history students learn to recognize the relation between style and representative artist: impressionism and Monet, cubism and Picasso; each one makes the other. In tracing the history of these important artists, movements, and objects as a linear progression, the authors of the histories of art (H. W. Janson, Frederick Hartt) make the history of art accessible and knowable. We know our past. But do we?

Is it really possible that in 1962, when Janson published the first edition of his familiar *History of Art*, not one single woman was impor-

tant enough to be included?[4] Had none existed? In 1962 were we collectively (as represented by Janson) unaware of such a woman? Or, as Linda Nochlin suggested, did cultural preconceptions and stereotypes mean that the canon excluded women—not by conscious definition but by systematic exclusion from important institutions, opportunities, and societal roles?

By 1971 there was enough interest in the achievements of women for Linda Nochlin to propose and teach her course. But what materials would she use? Where would they come from? The goals of feminist art history must already have been clear. The first was to show how previous tellings of art history had been blind to the achievements of women. The next was to discover institutional reasons for women's different (ostensibly lesser) achievements in the visual arts. Then would follow the excavation of the histories of women artists of remarkable achievement and the addition of their work to the canon. It was time to find the female Caravaggio, Hals, Watteau, and Degas, to conduct an archaeological dig of women artists—to turn up their works, compare them to those of contemporaneous male artists, and construct compelling life stories. To be a famous female artist (retroactively, posthumously) requires a compelling life story or an attachment as wife, lover, sister, daughter, or devoted student to a male artist with a compelling life story. It is amusing to consider the multilayered connotations of the phrase "recovered female artist." Recovery is desirable, a shift from oblivion to recognition, yet the term implies prior disease as well.

In any event, by 1971 there was an audience for, and a perceived need for, the study of individual female artists from the "dawn of history," to use Janson's phrase, to the present day. The time for the female single-artist study had come. But the matter was not that simple.

What if the whole construct of "remembered significant historical figure" was a corrupt construct of masculinist ideology? What if the whole scenario of institutional training—learning from a master, rejecting the style of that master to emerge significant in one's own right—was a masculine scenario unrelated to the experiences of women, impossible in the collective, collaborative social structures open to them? What if the linear progression from style to style in the time line was irrelevant because the artist's style was outside the dominant paradigm? What if the defining of each forgotten female artist in terms of her relation to some significant famous male artist was just

another instance of the traditional cultural practice of identifying women primarily in terms of their relation to men and therefore was undesirable to feminist art historians?

This book presents diverse voices speaking expertly about women artists and their historical treatment. There is not (nor can there be) consensus among art historians working from feminist perspectives about the form that work should take. Feminist art historical investigation takes place in a variety of formats, among them individual essays, sometimes gathered in valuable anthologies like those edited by Norma Broude and Mary Garrard and by Rosemary Betteron; surveys of women artists like those by Nancy Heller and Whitney Chadwick; and critical historical texts like those by Rozsika Parker and Griselda Pollock. There are illuminating and useful single-artist studies like Lucy Lippard's monograph on Eva Hesse, Reine-Marie Paris's catalogue raisonné on Camille Claudel, and Hayden Herrera's book on Frida Kahlo.[5] But many single-artist studies (including those I mention) are theoretically or at least linguistically complicit with sexist, masculinist structures of traditional art history in their overreliance on biographical details to explain artwork, their trivializing use of women artists' first names, or their tendency to describe art by women primarily in terms of a male artist's proposed influence.[6]

My own work on Camille Claudel and Anna Golubkina proceeds from two different theoretical and rhetorical aims: my approach to Claudel is explicitly a critical feminist one, and my treatment of Golubkina is biographical and historical.[7] During the years that I worked on Claudel and Golubkina I taught a graduate seminar at Hunter College in New York City called "Gender and Difference in Art." My students and I frequently discussed the apparent conflict between feminist theory (largely skeptical of monographic treatments) and the need many historians felt to provide women artists with the visibility and status that a monograph can confer. We debated how the art historians we studied had reconciled (or not) the conflicts we saw. During these discussions I formulated the idea of approaching established art historians to ask them about their experiences with research, writing, and curating, as well as the critical reception of the artists they had chosen to study.

Norma Broude and Mary Garrard, in the introduction to their anthology *The Expanding Discourse*, clearly describe how feminist art history and poststructuralism can come into conflict.[8] They refer to

Roland Barthes's objection, in his influential essay "The Death of the Author," to interpretations that privilege the notion of the individual author. He argues:

> The image of literature to be found in ordinary culture is tyranically centred on the author, his person, his life, his tastes, his passions, while criticism still consists for the most part in saying that Baudelaire's work is the failure of Baudelaire the man, Van Gogh's his madness, Tchaikovsky's his vice. The *explanation* of a work is always sought in the man or woman who produced it, as if it were always in the end, through that more or less transparent allegory of the fiction, the voice of a single person, the *author* "confiding" in us.[9]

Barthes then proposes that the cherished category "author" be replaced by that of "scriptor," whose function is to rearrange preexisting ideas, not to invent new themes.[10] Such a shift counters romantic notions of artistic creativity or originality as well as fundamentally dismantling the author as the source of writing. For Barthes, "The modern scriptor is born simultaneously with the text, is in no way equipped with a being preceding or exceeding the writing, is not the subject with the book as predicate."[11]

If we substitute the term *artist* for the term *author* in Barthes's text, it is easy to see why Barthes's theories might be worrisome to feminist art historians. Broude and Garrard note that "some art historians have observed that the death-of-the-author theories emerged, perhaps not fortuitously, just at the time when feminist scholars were attempting to gain a place for women artists within the historical canon."[12] Although there are problems in linking an artist's life to her work, the denial of any such linkage in Barthesian theory may be excessive and the cost to feminist art history too high. And poststructuralism has not been the only theory in which the practice of linking person and artwork is suspect and highly problematic; the same is true for psychoanalytic theory, as Griselda Pollock notes: "Of course I believe that there are producers of art works, highly intelligent and self-critical practitioners who devise their strategies and respond to their own personal, political and aesthetic promptings. But according to one major twentieth-century theory, that of psychoanalysis, we are not fully known or even knowable to ourselves."[13]

This conflict (between the understandable wish to reach, memorialize, and situate an individual and her productions and theoretical skep-

ticism about such a project) is symptomatic of the current situation of feminist art history. How do art historians negotiate it? What place is there for the single-artist study (as a feminist strategy) in the art history of postmodern times? Is there a way to reinvent the monograph and the one-person exhibition and disengage them from their masculinist predecessors, or is a desire to do so simply the manifestation of a nostalgia for less confused theoretical days in the production of art history?

The panelists and their subjects in 1997 were Katherine McIver (Lavinia Fontana), Sarah E. Webb (Gwen John), Barbara Bloemink (Florine Stettheimer), Gail Levin (Jo Nivison Hopper), and Amy Schlegel (Nancy Spero). These presenters spurred debate among audience members about artists like Artemisia Gentileschi, Camille Claudel, Frida Kahlo, Lee Krasner, Georgia O'Keeffe, and others whose careers (and lives) had been the subjects of highly acclaimed and popular single-artist studies. We asked general questions: "What other strategies are there for treating the work of women artists if we abandon single-artist studies?" "When there are so many monographs on male artists, shouldn't women artists be written about in that format too?" "Doesn't the single-artist study merely perpetuate the masculinist obsession with individual genius and originality, ignoring important feminist contributions like collaboration?" And members of the audience suggested both other women artists who would be appropriate subjects of discussion and other art historians whose work dealt with the questions we asked. The idea of this book began to take shape.

Shortly after the conference Sarah Webb and I began to discuss approaching art historians from our panel, as well as others, to contribute to a book on the role of the monograph in feminist art history. The art historians represented in this book do not offer a comprehensive examination of important female artists: Berthe Morisot, Georgia O'Keeffe, Frida Kahlo, Faith Ringgold, Barbara Kruger, and Cindy Sherman, among others, are not considered here. Further, the writers are not a cohesive group proceeding from a unified point of view. Rather, they and their subjects are an idiosyncratic and interesting group of *cases*. We made an effort to explore all media (painting, sculpture, photography, architecture, and performance); the disproportionate representation of painting and sculpture reflects art history's privileging of these media. We also wanted to cover a broad time span (from the Renaissance to the present) and to address artists of diverse cultural backgrounds.

We wanted a list of contributors who would be as important as the artists they studied. Rather than explicitly or implicitly privileging the artist subject of each essay over the writer, we formulated the book as one in which *both* the subject and the writer would be useful examples and eloquent voices in feminist art history. In some cases our system of choice privileged the author over the artist, so to speak: in other words, we approached authors whose work on feminist art history was relevant to our book's purpose. We were also concerned to explore artists whose work has a place in the ever changing and contested "canon" of art history and artists who had had monographs or significant essays written about their work and/or who had been the subjects of one-person shows. So we sought out the authors who had written the monographs or biographies of those artists.

As we discussed our project with the contributors, a second and unexpected layer of the subject emerged: behind the story of the artist involved was that of the art historian. All the authors expressed great interest (some seemed surprised at the level of their interest) in exploring how they had come to write about the artists they knew so well. We noted that all the art historians we had approached were female. Why was this? Why (the larger question) are nearly all monographs on women artists written by women? Many female art historians have written single-artist studies about male artists (among them Carol Armstrong on Degas, Linda Nochlin on Courbet, Dore Ashton on Picasso, and Lucy Lippard on Ad Reinhardt). Why is the reverse so rare, if not unheard of?[14] Does there still lurk an unspoken perception that while male artists are relevant to us all, female artists are important only to other women? Is it assumed that in writing about male artists one is writing about *art,* whereas in writing about women artists one is writing about *women*? At this point I thought of my own department chair, who, when I proposed a course entitled "Women Artists from Impressionism to the Present," strongly suggested that I offer it in the Women's Studies Department. He also doubted that there would be "enough women artists" to provide course material for an entire semester. Perhaps feminist art history had not achieved as much change as we had thought, or hoped.

In addition to all our authors' being female, all but one share the racial identity of their subjects. The exception, Melanie Herzog, who writes about the sculpture of Elizabeth Catlett, addresses the complications entailed in a white woman's writing about an artist of color. Is

there an unspoken assumption that an *identification* with one's subject is necessary for responsible art historical scholarship (an identification at the level of gender and race, at least)? Many of the contributors to this book discuss how their own lives and careers dovetailed with those of their chosen subjects, but it remains an open question whether this dovetailing is a necessary component of such writing.

While our title, *Singular Women,* clearly plays on words, in that we address many women artists, behind the title are serious methodological questions: How long can the category "exceptional woman" last? Why has it persisted for so long? Because there are (still) relatively few examples of women artists? How many more will have to be introduced as "exceptional" before the trope of singularity can give way to a more contextualizing rhetoric, grounded in acknowledging that there have been a great number of female artists and that many of them form a foundation for our work now?

The risk in describing each artist as a singular case is to make these women seem anomalies, aberrations, rather than examples, case studies of a larger phenomenon. But there is also a risk if we do not acknowledge that the circumstances of women artists differ. These artists do not necessarily share a universal set of experiences based on sex and gender roles.

This book is organized chronologically. Although chronology can rightly be criticized for implying a historical trajectory of progress, we explicitly reject this implication, instead offering chronology as an imperfect method whose principal benefit is to highlight real differences in historical moments, especially for the female condition within the art world. Simply put, the circumstances in which Artemisia Gentileschi worked and lived rightly place her early in history, and in our book. The degree to which she and her ambitions for an artistic career depended on her being the daughter of a painter, for example, distinguishes her from her nineteenth-century counterparts and even more from artists active in the twentieth century. Arguably, moreover, Gentileschi had more in common with male artists of her historical moment than with female artists of another. By contrast, the relative freedom of Florine Stettheimer, as an independently wealthy American of the 1920s, places her firmly in the twentieth century. By no means do we suggest that all women artists experienced greater freedom in the twentieth century or that all circumstances improved as centuries passed. But placing our artists in chronological order reflects our belief

that historical moment, as much as more idiosyncratic and personal circumstances, determined the experiences of each. Chronology also allows for a social history of art rather than a style-based one or one more insistently rooted in a belief that art making is independent of other social circumstances.

In addition, the relatively neutral device of chronological ordering leaves readers free to make their own connections between the essays on the basis of their needs and interests. This anthology will serve different purposes for different readers. Some will be attracted to the essays on well-known artists, like Artemisia Gentileschi, Judith Leyster, and Mary Cassatt. Others will be intrigued by less familiar figures, like Eleanor Agnes Raymond, Jo Nivison Hopper, and Clementina Hawarden. Still others will turn to specific writers whose scholarly work they know.

Despite the chronological arrangement, the essays can be fluidly grouped around several themes. Taken in total these themes represent the most frequent, and possibly most useful, ways in which the work of women artists has been described. One, represented by the work of Mary Garrard on Artemisia Gentileschi, Frima Fox Hofrichter on Judith Leyster, and Mary Sheriff on Elisabeth Vigée-Lebrun, is the puzzlingly superficial treatment of the work of some women artists, given their uncontested place in the canon of even the most conservative telling of art history. Gentileschi, Leyster, and Vigée-Lebrun have been valorized, canonized, and ultimately tokenized as "the" important female artist of their time period or their style. While Garrard, Hofrichter, and Sheriff applaud *in theory* the attention given to the artists they write about, those artists' role as "*the* significant female painter of the Italian Renaissance/the Dutch Golden Age/the French Rococo" makes it all too easy to ignore other female artists of those periods and sets apart Gentileschi, Leyster, and Vigée-Lebrun as oddities, historical anomalies, and sufficient examples of a further history that will remain unexplored. Garrard, Hofrichter, and Sheriff offer more nuanced views of these heavily mythologized artists.

Gentileschi and Leyster are nearly always described by art history texts as related integrally to particular male artists: Gentileschi to Caravaggio, Leyster to Frans Hals, and Vigée-Lebrun to Watteau and Fragonard. We need only turn to the fifth edition of *The History of Art*, by H. W. Janson and Anthony Janson (published in 2001 and completed by H. W. Janson's son Anthony Janson after the death of

his father), for representative treatments of Gentileschi, Leyster, and Vigée-Lebrun that underline dramatically the pitfalls of canonical writing. First, Gentileschi:

> The daughter of Caravaggio's follower Orazio Gentileschi (1563–1639), she was born in Rome and became one of the leading painters and personalities of her day. Her characteristic subjects are Bathsheba, the tragic object of King David's love, and Judith, who saved her people by beheading the Assyrian general Holofernes. Both subjects were popular during the Baroque era, which delighted in erotic and violent scenes. Artemisia's frequent depictions of these biblical heroines during her restless career suggest a fundamental ambivalence toward men that was rooted in her life, which was as turbulent as Caravaggio's. While Gentileschi's early paintings of Judith take her father's and Caravaggio's work as their departure, our example [*Judith and Maidservant with the Head of Holofernes*, c. 1625] is a fully mature, independent work.[15]

In their larger account of Caravaggio, Janson and Janson make no mention of Caravaggio's "turbulent" life, nor do they relate any of Caravaggio's subjects to his life. This contrast in discussions of the work of men and women artists is ubiquitous in survey texts and even, arguably, in more complex treatments. For many art historians, the details of women artists' lives provide much of the interpreted significance of their works, even when the same is not true of the male artists to whom they are compared. It is rare to find a description of the work of a female artist that does not involve a discussion of her life. Here are Janson and Janson on Judith Leyster: "Hals' virtuosity was such that it could not be imitated readily, and his followers were necessarily few. The most important among them was Judith Leyster (1609–1660). Like many women artists before modern times, her career was partially curtailed by motherhood. Leyster's enchanting *Boy Playing a Flute* (1630–1635) is her masterpiece."[16]
Leaving aside the intriguing implication that motherhood ceased to curtail one's career upon the advent of modern times, Janson and Janson's insistence on the terms *imitated* and *followers* makes clear their assessment of Leyster's independent status. They make no mention of Hals's personal life. Their brief paragraph on the work of Vigée-Lebrun maintains that her portrait *The Duchesse de Pulignac* (1783) "has the eternally youthful loveliness of Fragonard's *Bathers* ... a real-life counterpart to the poetic creatures in Watteau's *Pilgrimage to Cythera*."[17]

Clearly her work maintains its canonical status only vis-à-vis the work of male painters of the rococo. The superficiality of Janson and Janson's treatment of Vigée-Lebrun is underscored by the all too common ploy of linking the beauty of a woman artist's work to the beauty of her person:

> It is from portraits that we can gain the clearest understanding of the French Rococo, for the transformation of the human form lies at the heart of the age. In portraits of the aristocracy, men were endowed with the illusion of character as a natural attribute of their station in life, stemming from their noble birth. But the finest achievements of Rococo portraiture were reserved for depictions of women, hardly a surprising fact in a society that idolized the cult of love and feminine beauty. Indeed, one of the finest practitioners in this vein was herself a beautiful woman: Marie-Louise-Elisabeth Vigee-Lebrun.[18]

What can be the point, in a survey of the history of art, of remarking on the physical appearance of a painter? Berthe Morisot was similarly described in the late-nineteenth-century press as having a beauty that justified her painting. For example, in a 1901 article the French critic Camille Mauclair pointed out that Morisot, in addition to being an admirable artist, was "herself a creature of penetrating beauty and an elevated soul."[19] Elsewhere in the same article Mauclair implied that for the ideal woman artist, beautiful work was inextricable from personal beauty, physical and moral.[20]

A second theme arising in the essays of this book is the need to redress the injustice of the erasure (by accident or design) of women artists from the history of art. Nancy Gruskin in her work on the architect Eleanor Agnes Raymond, Gladys-Marie Fry on Harriet Powers, Gail Levin on Jo Nivison Hopper, Barbara Bloemink on Florine Stettheimer, and Kristine Stiles on Carolee Schneemann—all mean to restore these women to a visibility denied them for reasons connected with their sex. Nancy Gruskin makes clear the unlikelihood of a woman's success in the male-dominated world of early-twentieth-century architecture; given the marginalization of architecture itself in the history of art, Raymond's invisibility seems all the more inevitable. In a similar vein, Gladys-Marie Fry traces the complicated history of quilt making: the art historical distinction (once clear, now crumbling) between art and craft has relegated the work of women to another space. If, as Judy Chicago suggests in her writings about *The Dinner Party*,[21] art history has forgotten work that involves collaboration or results in a usable ob-

ject, it is not surprising that quilt makers have been set apart as irrelevant. As Gladys-Marie Fry makes clear in her work here on the quilt maker Harriet Powers, the anonymity and diffidence of many such artists ensured them oblivion, and for Powers, an African American woman, there are racial implications as well to her status as a nearly unknown artist except in the specialized realm of quilt studies or work on female artists of color.

Gail Levin discusses the by no means accidental erasure of the work of Jo Nivison Hopper, the wife of Edward Hopper, whose career eclipsed her own as he gained the historical reputation and canonical status denied her. While marriage to a prominent painter might aid some female artists building a career, Levin argues that Jo Nivison Hopper's career was damaged by her marriage.

Barbara Bloemink investigates the similar erasure and silencing of Florine Stettheimer, who almost never sold her work (by her own wishes) and whose revelatory diaries, after her death, were purged by the sister who survived her. Bloemink also discusses the preference on the part of major museums to present exhibitions in a salable, appealing way, even if that means historical inaccuracies or omissions. The result, Bloemink argues, is the slighting of female artists whose lives and works lack commercial appeal because they cannot easily be made sensational and do not conform to expected stylistic trends.

Finally, Kristine Stiles traces the complex career and reception of the performance artist, painter, and filmmaker Carolee Schneemann. Stiles argues that Schneemann's insistence on an honest, explicit portrayal of the female body denied her any chance of commercial success, even though the feminist establishment canonized her as an artist. For Schneemann, as for Jo Hopper and Florine Stettheimer, the relationship with the reputation-building museum culture has been fraught—characterized by tokenism, deaccessioning, and a reluctance to place women artists in the forefront of a collection or exhibition schedule. One wonders at the curatorial and critical power structure that produced at the Guggenheim Museum and the National Gallery of Art a total of only six solo exhibitions by women artists in the years 1970–85 (three of them by Helen Frankenthaler!).[22]

The third theme evident in the essays of this book is the continuing difficulty of writing about and describing work by women. Anne Higonnet, writing on Mary Cassatt; Amy Schlegel, on Nancy Spero;

Carol Mavor, on Clementina Hawarden; and Karen Bearor, on Irene Rice Pereira, all maintain an uneasy truce with the single-artist study. Mavor, Bearor, and Schlegel are concerned about the tendency of the monograph to privilege an appearance of coherence and a seamless historical narrative over a more honest telling in which gaps and contradictions play a role. Higonnet shows how two different approaches to Mary Cassatt and her historical importance, the single-artist study and the historical analysis, yield contradictory results. Each approach is valuable in its own way; the trouble lies only in confusing one project with another, or in hoping to gain all results from all investigations.

The themes that I have loosely outlined are, taken together, fundamental to feminist histories of art. Each of the essays exemplifies one or more of those themes as they have been played out in specific careers.

Ranging widely over approaches and concerns, these essays underscore the need for self-consciousness in choice of language and rhetorical implications by analyzing the descriptions that other scholars have given of women artists and their place in history. Some of these discussions are frankly accusatory; others implicitly admonish writers and warn readers to look carefully at language. Feminist art history's most valuable tool may well be its systematic probing of commonly accepted art historical description. For example, art historians often relate the significance of art made by women to events in those women's personal lives. Those who paint children are said to be painting their own children, painting their wished-for nonexistent children, or displaying their ambivalence about children. In contrast, male artists who paint children are said to be painting ideal love or perhaps only experimenting with a pastel crayon. Here is Janson and Janson's account of a sculpture by Camille Claudel:

> Much of her work is autobiographical. *Ripe Age* depicts a grisly
> Rodin, whose features are clearly recognizable, being led away with
> apparent reluctance by his longtime companion, Rose Beuret, whom
> Claudel sought to replace in his affections. Beuret is shown as a sinis-
> ter, shrouded figure who first appears in Claudel's work as Clotho, one
> of the three Fates, ironically caught up in the web of life she has
> woven. The nude figure on the right is a self-portrait of the pleading
> Claudel, likewise evolved from an earlier work, *Entreaty*.[23]

Here, in contrast, is Janson and Janson's account of Rodin's work:

The Kiss, an over-lifesize group in marble, also derives from *The Gates [of Hell]*. It was meant to be Dante's Paolo and Francesca, but Rodin rejected it as unsuitable. Evidently he realized that *The Kiss* shows the ill-fated pair succumbing to their illicit desire for each other here on earth, not as tortured souls in Hell. Knowing its original title helps us to understand a salient aspect of the group: passion reined in by hesitancy, for the embrace is not yet complete. Less powerful than *The Thinker*, it exploits another kind of artful unfinishedness. Rodin had been impressed by the struggle of Michelangelo's "Slaves" against the remnants of the blocks that imprison them: *The Kiss* was planned from the start to include the mass of roughhewn marble to which the lovers are attached, and which thus becomes symbolic of their earthbound passion. The contrast of textures emphasizes the veiled, sensuous softness of the bodies.[24]

Nowhere does Janson and Janson's description of Claudel's work reveal the hallmarks of serious art historical analysis. The authors make no mention of the material with which she worked or its effect on her work's psychological significance. They fail to compare her work to that of any other artist (except that of Rodin). We would be surprised, even outraged, if Janson and Janson described Rodin's *The Kiss* like this: "In this piece, sculpted when his affair with Camille Claudel was at its passionate height, Rodin presents clearly recognizable portraits of himself and his mistress. The desperation with which Rodin clings to Claudel's thigh indicates his growing insecurity about holding the interest of his young lover."

I do not mean to imply that Janson and Janson are unusual in their descriptions of women artists or make errors that other survey writers avoid. Their text exemplifies traditional art historical writing. *The History of Art*, as "the best-known and biggest-selling art survey in the English-speaking world,"[25] has unrivaled authority in shaping a large readership's perceptions of art and women's contribution to it. It points up a number of the pitfalls on women artists' path from oblivion to canonical status. What Claudine Mitchell calls the "trivializing elision of art and autobiography which so frequently operates in accounts of women's art" contrasts with the serious and more art historically grounded rhetoric used to describe male artists.[26]

The insistence on describing women artists in terms of linkages to the male artists who were their teachers or who influenced them in other ways undermines any vision of the female artist as independent. What

Linda Nochlin has referred to as the "art historical apparatus" has placed the work of women artists in a linguistically and sociologically gendered space, separate (if only implicitly so) from that occupied by their male counterparts.[27] It is this implicit separation that Rozsika Parker and Griselda Pollock refer to in their statement that "the phrase 'woman artist' does not describe an artist of the female sex, but a kind of artist that is distinct and clearly different from the great artist. The term 'woman,' superficially a label for one of the two sexes, becomes synonymous with the social and psychological structures of femininity."[28]

In an art historical system that privileges painting over all other media, followed by sculpture and, more distantly, by photography and architecture, it is no surprise that the list of canonical female artists is dominated by painters. In this way Gentileschi's, Leyster's, and Cassatt's fame exists comfortably within the familiar structures of the preferred medium. And historically there have been many more women painters than women sculptors, photographers, or architects, for the simple reason that easel and paints might easily be set up unobtrusively in a bourgeois domestic setting, to be whisked away according to the demands of social or domestic life. It would have been much more difficult to produce life-size sculptures in bronze or photographs requiring expensive and exotic technology (although, as Julia Margaret Cameron, Clementina Hawarden, Dorothea Lange, Sally Mann, and Cindy Sherman show, women have long been accepted as important photographers). It would have been most difficult of all to create buildings, given the complexity of architectural training, the exclusivity of architects' offices, the need for wide contacts, and the importance of supervising construction, which took place in a public realm that did not welcome women.

As the Broude and Garrard anthologies of 1982, 1992, and 1994 show, feminism in art history has taken many forms: excavation, recovery, theoretical skepticism, activism. We want to ask, with this anthology, where feminist art history was in 2000: What were its issues? How did feminist art historians make their decisions to write about women artists, and how did those decisions affect their careers, their visions of the field, and the status of women artists in art history today? We wonder why women art historians write about women artists. Many of our authors have written about male artists as well. How do the issues differ (if they do) in a study of an artist who is female? Important to our conversations with these authors was the question of identification with

one's subject. It has been a common feature of canonical art history that certain writers identify with (and become identified by others with) their subjects—for example, Norman Mailer with Picasso, Kobena Mercer with Robert Mapplethorpe, Leo Steinberg with Michelangelo, Albert Elsen with Rodin. But how had our writers' involvement with their subjects (as women) evolved? Was it merely coincidental that the artists they wrote about were women, or did the writers always attach some importance to the specific artist's sex and perhaps identify with the artist partly on that level?

Our book asks questions; it does not provide answers. Each of our authors has an individual motivation for her work, and we have not attempted to connect the essays or offer an umbrella theory. The voices in the book differ as much as the subjects. Some of our authors produced their first work on their subjects twenty-five years ago (Gladys-Marie Fry, Mary Garrard, and Frima Fox Hofrichter); others just now have their first treatments of their subjects forthcoming in print (Nancy Gruskin, Amy Schlegel). The subjects of the various essays have been addressed in dissertations, monographs, one-person exhibitions, articles, panel discussions, and course materials. As our gathering of writers demonstrates, feminist art historians do not always agree with one another about the shape the field should take; we believe that this multivalence gives the book its greatest strength.

This collection suggests how we are building a new canon, one that is based, not on an uncontested "quality" (whose dubious groundings Lucy Lippard has discussed in *Mixed Blessings*),[29] but rather on a matrix of relations.[30] This matrix binds together author and artist in a way that reflects the profound connection between making and viewing art so often present in a scholarly investigation. In compiling this book we express the belief that the historical personages of artist and art historian are inextricably linked. If André Breton created Salvador Dalí and Dalí, Breton, what has been the relation between Mary Garrard and Artemisia Gentileschi or between Frima Fox Hofrichter and Judith Leyster? The artists and art historians represented in our list of readings enjoy a complex relationship, living in the reflected glory of one another's accomplishments.

Sarah Webb in her epilogue to this book meditates from the artist's perspective on the ways art history will make a woman's work visible, as text and image. She explores the descriptive strategies that might inscribe work made by women artists into an organic, changing canon,

allowing their work to be seen, discussed, and contextualized for the future. Our book includes two essays by scholars who have been personally acquainted with their subjects; rarely does a writer have such a relationship with the artist she chooses to study. We can imagine in a romantic way that artists from all times have been concerned with being written into history and the means by which that might be accomplished. Even if the art historian's task is not to follow an artist's imagined agenda, the writer can consider the artist's sense of her historical place when formulating her descriptions. The work of Amy Schlegel on Nancy Spero and of Kristine Stiles on Carolee Schneemann has been significantly shaped by their knowing how these women want to be described and remembered. Despite such interventions from artists themselves, however, each writer approaches her subject from a profoundly personal standpoint: no art historian is compelled to follow the narrative an artist sets out explicitly or implicitly. But those who study, describe, and contextualize the work of an artist who has made herself and her wishes accessible to a writer become poignantly aware of their responsibility to make visible what might have remained invisible, to offer context where there might have been isolation.

Much has been made lately of the generations of feminism (both in general and specifically in art historical feminism). Whether one calls the current moment third wave or postfeminism, there is much to be learned from examining one's motives in doing work, one's experiences in exposing the work to the world at large, and one's success at increasing the attention directed to subjects long obscured. Far from only criticizing what art history has done in the past vis-à-vis discussing the women artists in this book, we hope to present a stimulating array of approaches by which feminist art history can do its work in the future.

NOTES

1. For example, in Linda Nochlin, *Women, Art, and Power and Other Essays* (New York: Harper and Row, 1988).

2. Linda Nochlin, untitled paper presented as part of a panel discussion, "Language and Desire," at Hunter College, New York, October 1997, held in conjunction with the exhibition "Text and Touch" at the Hunter College Art Galleries.

3. Griselda Pollock, preface to *Generations and Geographies in the Visual Arts: Feminist Readings* (London: Routledge, 1996), xv.

4. H. W. Janson, *The History of Art: A Survey of the Major Visual Arts from the Dawn of History to the Present Day* (Englewood Cliffs, N.J.: Prentice Hall, 1962).

5. See Norma Broude and Mary D. Garrard's *Feminism and Art History: Questioning the Litany* (New York: Harper and Row, 1982), *The Expanding Discourse: Feminism and Art History* (New York: IconEditions, 1992), and *The Power of Feminist Art: The American Movement of the 1970s, History and Impact* (New York: Harry N. Abrams, 1994); Rosemary Betteron's *Looking On: Images of Femininity in the Visual Arts and Media* (New York: Pandora, 1987); Nancy Heller's *Women Artists: An Illustrated History* (New York: Abbeville Press, 1987); Whitney Chadwick's *Women, Art, and Society*, rev. ed. (New York: Thames and Hudson, 1997); Rozsika Parker and Griselda Pollock's *Old Mistresses: Women, Art and Ideology* (New York: Pantheon, 1981); Griselda Pollock's *Vision and Difference: Feminism, Femininity and the Histories of Art* (New York: Routledge, 1988), and *Differencing the Canon: Feminist Desire and the Writing of Art's Histories* (New York: Routledge, 1999); Lucy Lippard's *Eva Hesse* (New York: New York University Press, 1976; New York: Da Capo Press, 1992); Reine-Marie Paris's *Camille Claudel* (Paris: Adam Biro, 1990); and Hayden Herrera, *Frida: A Biography of Frida Kahlo* (New York: Harper and Row, 1983).

6. In my judgment, work by Hayden Herrera on Frida Kahlo (*Frida*) and Cecily Langdale on Gwen John (*Gwen John*, New Haven, Conn.: Yale University Press, 1987) exhibits these problems.

7. Kristen Frederickson, "Gendered Expectations: The Critical Reception of the Life and Work of Camille Claudel" (Ph.D. diss., Bryn Mawr College, 1992; excerpts published in "Carving Out a Place: Gendered Critical Descriptions of Camille Claudel and Her Sculpture," *Word and Image* 12, no. 2 (1996): 161–74. To date, the published result of my monographic work is "Anna Semyonovna Golubkina: Sculptor of Russian Modernism," *Woman's Art Journal* 18, no. 1 (1997): 14–19.

8. Broude and Garrard, *The Expanding Discourse*, 4.

9. Roland Barthes, "The Death of the Author," in *Modern Criticism and Theory*, ed. David Lodge, rev. ed. (New York: Longman, 1999), 170.

10. Ibid.

11. Ibid.

12. Broude and Garrard, *The Expanding Discourse*, 4.

13. Pollock, preface to *Generations and Geographies*, xvi.

14. My own incomplete and unscientific survey has turned up only one monograph on a woman artist written by a man (men, actually, in collaboration; is this relevant, I wonder?), and that is *Sonia Delaunay: The Life of an Artist*, by Stanley Baron and Jacques Damase (New York: Harry N. Abrams, 1995). A second example would be Edward Lucie-Smith, *Judy Chicago: An American Vision* (Chicago: Watson Guptill, 2000). But that volume too is a joint effort, this time a collaboration with the artist herself, Judy Chicago.

15. H. W. Janson and Anthony Janson, *History of Art*, 5th ed. (New York: Harry N. Abrams, 2001), 552.

16. Ibid., 582.

17. Ibid., 600.

18. Ibid., 616.

19. Camille Mauclair, "L'art des femmes peintres et sculpteurs," *La Revue* 39, no. 4 (1901): 523.

20. Ibid., 514–15.

21. Judy Chicago, *Beyond the Flower: The Autobiography of a Feminist Artist* (New York: Penguin, 1996).

22. Randy Rosen, *Making Their Mark: Women Artists Move into the Mainstream 1970–1985* (New York: Abbeville Press, 1989), 212–14.

23. Janson and Janson, *History of Art,* 737.

24. Ibid., 736.

25. Cited in "Publish and Flourish: With Paul Gottlieb at the Helm, the Harry N. Abrams Imprint Is Celebrating Its 50th Anniversary," *Art News* (December 1999), 52.

26. Claudine Mitchell, "Intellectuality and Sexuality: Camille Claudel, the Fin de Siècle Sculptress," *Art History* 12 (December 1989): 419.

27. Nochlin, *Women, Art, and Power,* xiii.

28. Parker and Pollock, *Old Mistresses,* 114.

29. Lucy Lippard, *Mixed Blessings: New Art in a Multicultural America* (New York: New Press, 2000).

30. See discussion of the notion of matrix in Griselda Pollock's "Inscriptions in the Feminine," in *Inside the Visible: In, of and from the Feminine,* ed. Catherine de Zegher (Cambridge: MIT Press, 1995), 67–88, and Bracha Lichtenberg-Ettinger's "The With-In-Visible Screen," in Zegher, *Inside the Visible,* 89–116.

ARTEMISIA'S TRIAL BY CINEMA

MARY D. GARRARD

In early May 1998, the film *Artemisia* opened in theaters across America. Created by the French filmmaker Agnes Merlet and distributed by Miramax Zoë, the picture was based on the life of the Italian baroque painter Artemisia Gentileschi, specifically the period of the infamous rape trial of 1612. The relationship of the film to historical reality was problematized at the outset by a claim that originally appeared in the opening frames and in accompanying advertisements: "The true story of the first female painter in art history." Given the vast discrepancy between the facts of the trial and their interpretative rearrangement by Merlet, this assertion provoked a strong reaction from the feminist and art communities.[1] The immediate result was that Miramax removed the offending claim from the film and subsequent publicity. The film was sharply criticized on both historical and aesthetic grounds at a symposium on May 14 sponsored by the Richard L. Feigen Gallery in New York, in conjunction with the exhibition of works by Artemisia and Orazio Gentileschi and Agostino Tassi.[2] At the end of May, however, Miramax was still insisting that "a lot of research went into this film.... We stand by it 100 percent."[3]

There can be no doubt that the basic facts of the story are inverted in the film. In Merlet's narrative, Artemisia begs to study under, and

then falls in love with, the artist Agostino Tassi, is deflowered by him—an act accomplished with tender solicitude on his part and minimal resistance on hers—and is initiated by the older painter into the mysteries of love and art. When her father, Orazio Gentileschi, brings suit against Tassi for rape, Artemisia testifies repeatedly, even when tortured by *sibille* (strings tightened around the fingers), that Tassi did not rape her but gave her pleasure and that she loves him. Pained to see Artemisia suffer physical torment, Tassi magnanimously accepts the charge of rape and his own conviction, thus ending the trial as something of a hero. A vague nod to Tassi's unsavory past is given when Artemisia learns that he already has a wife, the discovery briefly complicating the course of a love affair clouded otherwise only by Orazio's paternal (and, it is hinted, jealous) intervention.

A very different account is given in the extensive testimony of the rape trial—documents that were fully published in Italian in 1981 and in English in 1989.[4] When Artemisia was tortured by the *sibille,* she insisted repeatedly that she had been sexually pressured and then raped by Agostino, an event she described in graphic detail. Judicial torture to establish veracity was a standard procedure in Rome at the time, and in this instance Artemisia voluntarily submitted to the *sibille* to prove she was telling the truth. Even so, a test designed to select between conflicting accounts by torturing the blameless party rather than the accused was a gratuitous physical insult to a girl who had already experienced rape.

Tassi himself testified that he had never even had sex with Artemisia—a claim so preposterous that the judge admonished him about bearing false witness—and he never confessed to the crime, instead accusing virtually every male in sight, including her father, of having slept with her. Tassi did not come to court as an innocent. He had previously been sued for raping and impregnating his sister-in-law (an act equated at that time with incest), and there was substantive testimony in the trial that he had arranged and paid for the murder of his own wife, whom he had also acquired by rape. This multiple sex offender couldn't even manage his own defense credibly: one of his six witnesses testified that the others had lied (prompting Orazio to file another suit). Tassi was convicted but got off lightly: he was given a choice of five years' service on galleys or a five-year exile from Rome.[5]

Why did Merlet change the story? Describing herself as a feminist who has made a feminist film, she justifies her version as an effort to

reflect Artemisia's inner struggles rather than what she seems to consider the ambiguous facts of the trial.[6] In interviews, Merlet has argued that the reality of the love affair is proved by the fact that Artemisia continued to have sex with Tassi after her violation. Yet Artemisia herself explained this: "What I was doing with him, I did only so that, as he had dishonored me, he would marry me."[7]

Here it helps to have some of that historical knowledge that Merlet considers to be constrictive to artistic freedom.[8] Artemisia's conduct was consistent with Mediterranean mores, then and later. In the seventeenth century, sexual intercourse with a virgin was considered dishonorable unless a prelude to marriage. If the man promised to marry the woman, as Tassi allegedly did, she was expected to allow further sexual favors.[9] Artemisia evidently believed Tassi's promise at first but came to doubt his intentions. Tassi's evasion of marriage defined the act retroactively as rape (that is probably why Orazio waited a year to file the suit). Had he been willing to commit himself, it might have been called a love affair. Yet Tassi neither confessed to the rape nor honorably offered marriage. Even during the trial, he was still dangling matrimony as Artemisia's sole honorable solution to the problem he had imposed upon her, on the ignoble condition that she blame someone else for her defloration. We know she resisted this pressure, for she never changed her testimony and went on to salvage her honor through an arranged marriage.[10]

As some journalists have pointed out, the real story is much more interesting than the film version. It is also more genuinely feminist. Merlet's heroine is a young girl whose courage consists of acting on her sexual impulses, whose challenge to society lies in her "giving in to love in an era of arranged marriages." The historical Artemisia broke larger rules. She was one of the first women artists to make a living from her art, producing work for some of the major patrons and collectors of the period: the scholar-antiquarian Cassiano dal Pozzo, Cardinals Antonio and Francesco Barberini, King Charles I of England, Don Antonio Ruffo of Sicily.

In a period when women were typically consigned to paint diminutive still lifes and portraits and were rarely given grand public commissions, Artemisia broke the mold, turning out large narrative compositions that feature biblical heroines but also figures of both sexes. What is more important, she challenged the gender norms of her day through her art, presenting traditional themes with altered emphases that bring

out the perspective of the female characters. It is an art that deals expressively with female experience in a masculinist world, exposing—perhaps for the first time—the realities of rape and sexual harassment that underlay romanticized themes of love, seduction, and suicide.

One might expect Merlet to have picked up on Artemisia's theme of unwanted sex, for a recurrent motif in the film is the inappropriate sexualizing of what are really artistic interests. Tassi mistakenly assumes that Artemisia's drawings of male nudes are signs of her sexual experience. Artemisia's young boyfriend's eagerness to strip for sex turns to embarrassment when he realizes she wants to draw his body. Yet the discomfort that the boy shows at being objectified is, tellingly, not allowed a group of female models who are stripped for inspection. The particular dangers of the volatile mix of art and sex for female models and artists are a worthy topic for filmmakers or scholars, but despite Merlet's flirtation with its manifestations, she doesn't really give us a feminist perspective on it. Indeed, her viewpoint is so relentlessly masculinist that many viewers have expressed surprise that a woman made the film.

For some odd reason, Merlet chose to portray Gentileschi's defiance and strength at the climactic moment by having her say nothing. As the filmmaker explains, Artemisia's silent gaze at Tassi during her torture forced him to break down and confess. She "stared adversity in the face and saved herself."[11] This does not work, even cinematically. His action speaks much louder than her silence, and one's net impression is that he confessed voluntarily. The device is particularly horrifying because through the ages women's silence has been a tool of their oppressors; it is what wife beaters count on. Furthermore, Artemisia was not silent in the trial; she was eloquent. When the *sibille* were administered, she cried out to Tassi: "This is the ring that you give me, and these are your promises!" And "It is truth that has induced me to testify against you."[12]

Perhaps worse than the film's insensitivity to feminist issues is its trivializing of Artemisia's art and falsifying of her artistic development. We have no idea from this film why her work is important. Her paintings figure only incidentally in the film, always anachronistically and always reduced in some way. Her *Portrait of a Gonfaloniere* (1622) is presented as an example of Orazio's art to which she contributed finishing details, and you would have to be a Gentileschi scholar to catch the possibly intended irony that she did not get credit even for

her own work. Her mature *Self-Portrait as the Allegory of Painting* (1630), arguably her greatest picture, figures briefly and wrongly as an example of a youthful self-portrait, in a stand-in replica that is about half the size of the original (imagine that being done to the Mona Lisa). Real paintings of the rape trial period, such as the *Susanna and the Elders* (1610) and the Pitti *Judith* (ca. 1613–14) or the slightly later majestic *Esther before Ahasuerus* (ca. 1622–23), could have been used much more effectively to represent Artemisia's creation of strong and adult female characters. But of course they would have belied and upstaged Merlet's romantic invention.

Artemisia's master composition, the *Judith Slaying Holofernes* known in two versions (Naples, ca. 1612–13; Uffizi, ca. 1620) (Figure 1), plays a more central role in the film (the Uffizi *Judith* was also central to the PBS movie *Painted Lady,* which aired on TV around the time the film opened). In Merlet's film, the execution of this picture of two capable women slaughtering a helpless man—one of the most chilling demonstrations of female power ever created—is obscenely converted into a sexual pantomime, in which Artemisia/Judith surmounts Tassi/Holofernes and slithers into coition with him. That Artemisia the rape victim must on some level have identified with Judith the tyrannicide has escaped no commentator, and though some have sought to minimize the *Judith*'s symbolic violence by calling the work a mere revenge picture, it is generally understood that the painting's expressive force was likely to have been fueled by sublimated personal emotion. Merlet has hit upon a far more effective way to deflect the picture's subversive meaning—by absorbing it into the genre of erotica.

By Merlet's own account, the key theme of the film is that Artemisia's sexual initiation by Tassi launched her artistic creativity, awakening her aesthetic and sensory perceptions through his teaching and lovemaking. It is Tassi's creative powers that are the film's focus: he shows her how to see colors, how to frame nature. In the final scene, Artemisia draws strength from the memory of his landscape lessons. This is not only nonsense but dangerous nonsense. Tassi was never her teacher at all in any significant sense; he was known for technical skill in perspective and for conventional marine landscapes.[13] Artemisia's art had nothing to do with landscape, and when she later included landscape backgrounds in her figure painting, she hired other artists to paint them.

Merlet here plays into one of the stereotypes most damaging to women. The idea that a female artist is the product of a male mentor

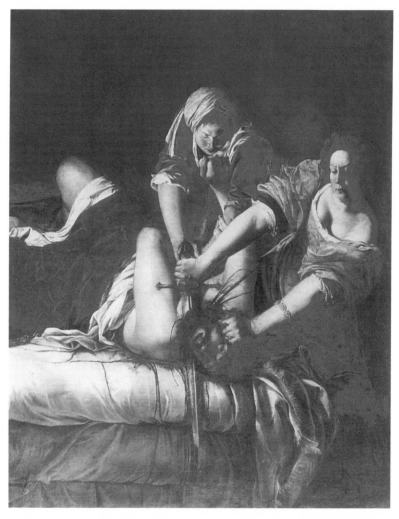

1. Artemisia Gentileschi, *Judith Slaying Holofernes,* ca. 1620, oil on canvas

has been an insistent theme since the Renaissance. In a letter to the former teacher of Sofonisba Anguissola, the sixteenth-century artist Francesco Salviati described her as "the beautiful Cremonese painter, your creation." Camille Claudel was similarly characterized as the product of Rodin, Cassatt as Degas's protégée, and Morisot as Manet's, even after these women had emerged as independent artistic personalities. The literature of art is replete with birth metaphors to describe the

masculine parturition of artistic offspring: male artists' creative energy overflows like seminal fluid into their female students; women artists, lacking the vital essence of creativity, can only receive it passively from men. Male artists generally benefit from the linkage of their sexuality and creativity. Vasari's report that Raphael died young as a result of sexual overactivity has not harmed his reputation; who even remembers it? Picasso's fabled virility only enhances his artistic identity, sustaining as it does the mythic belief that a man paints with his penis. But the stamp of sexuality is dangerous for female artists because it tends to replace rather than enhance their creative achievement.

The "Artemisia" that Merlet's film presents is merely an echo of the cultural construction that began when Tassi called her a whore in court. Our only surviving notice of Artemisia's death is a pair of mock epitaphs that lampoon her as a cuckolding shrew. In the eighteenth century, she was said to be as "famous all over Europe for her amours as for her painting."[14] The continuing preoccupation with Artemisia's sexuality, now sustained in Merlet's presentation of her as a liberated lover, has served a specific cultural function—dangerous or valuable, depending on your point of view—for if we are talking about Artemisia's sex life we are not talking about her art.

Merlet fitted her project to a time-tested formula for commercial success; sex sells, as we all know. Yet the juxtaposition of the fiction of this film with the reality of history fortuitously exposes what our culture wants to believe and what it needs to resist. We want to believe in the fantasy of woman's eternal submission to the power of love, particularly when it distracts us from the specter of a woman who was unusually free of masculine control. The Artemisia to be resisted is the artist who painted pictures that violated the social order, presenting women as powerful avengers or unwilling sexual victims. The eroticizing of Artemisia Gentileschi thus serves to contain the social threat she posed in life and art.

Merlet's *Artemisia* raises troubling questions about the responsibility of art to truth, for in the age of the docudrama and biopic, when many Americans gain their historical knowledge from TV, films, or novels, the presentation of history in fictionalized accounts plays no small cultural role. Ultimately this misrepresentation, this dishonoring, of Artemisia Gentileschi matters very much because she has been an important cultural role model for women, especially artists. Men have many role models, women very few. If someone discredits Michelan-

gelo, Caravaggio, and van Gogh (and I leave aside the fact that films about these artists heroize them as artists), you still have Leonardo, Rembrandt, and Gauguin—and hundreds more. But there was only one Artemisia Gentileschi—no other woman artist before the twentieth century has come close to being considered one of the greats. That is a status apparently worth shooting down. It is also one worth defending.

NOTES

1. Early reaction to the film came from Linda Nochlin, Judith Brodsky, and myself and from the circulation of eloquent protest letters written by Miriam Schapiro and June Wayne. A fact sheet outlining the film's outrageous liberties, written by Gloria Steinem and me, was distributed by Steinem and Brenda Feigen at the film's premiere and subsequently placed on the Internet by Sheila ffolliott and Helen Langa. This provoked widespread response, and the fact sheet was circulated at screenings in some major cities.

2. Participants in the symposium included the art and cultural historians Leonard Barkan, myself, Rona Goffen, Simon Schama, and Bette Talvacchia, along with the filmmaker Grahame Weinbren and Feigen Gallery's curator, Ann Guité. The exhibition, "Paint and Passion," was on view from April 28 to June 13.

3. As quoted in "Movies: When Hate Turns to Love," in the unsigned "Periscope" section of *Newsweek*, May 25, 1998, 8.

4. Eva Menzio, ed., *Artemisia Gentileschi/Agostino Tassi: Atti di un processo per stupro* (Rome: Edizioni delle donne, 1981); Mary D. Garrard, *Artemisia Gentileschi: The Image of the Female Hero in Italian Baroque Art* (Princeton, N.J.: Princeton University Press, 1989), Appendix B.

5. This new information comes from Alexandra Lapierre's recently published biography, *Artemisia: Un duel pour l'immortalité* (Paris: Robert Laffont, 1998), 214, 422–23. Tassi chose exile; he had previously been condemned to service on the Florentine grand duke's galleys, presumably for bad behavior.

6. See Kristine McKenna, "'Artemisia': Artistic License with an Artist," *Los Angeles Times*, May 27, 1998, F1, F10.

7. Artemisia's testimony of March 18, 1612; Garrard, *Artemisia Gentileschi*, 418.

8. "I decided that I did not have to necessarily provide the audience with a lot of historical background. . . . My analysis was more particular, more precise, similar to the one a person would have today concerning a news item. Sometimes, this approach provides more freedom." (From an announcement and description of the film, dated August 22, 1997, circulated by Miramax Zoë. Unless otherwise indicated, other citations of Merlet come from this document.)

9. See especially Sandra Cavallo and Simona Cerutti, "Female Honor and the Social Control of Reproduction in Piedmont between 1600 and 1800," trans. Mary M. Gallucci, in *Sex and Gender in Historical Perspective,* ed. Edward Muir and Guido Ruggiero (Baltimore: Johns Hopkins University Press, 1990), 73–109.

10. G. B. Stiattesi testified to overhearing Tassi's proposal when he brought Artemisia to visit Tassi in prison during the trial. Garrard, *Artemisia Gentileschi,* 467–68. Artemisia married the Florentine Pierantonio Stiattesi, whom we now know to be the brother of G. B. Stiattesi. See Lapierre, *Artemisia,* 481.

11. From another press release issued by Miramax Zoë, "Director's Note."

12. Garrard, *Artemisia Gentileschi,* 462. In the Feigen Gallery symposium, Grahame Weinbren emphasized the cinematic potential of these lines: "What filmmaker would give them up?"

13. The often repeated story that Orazio hired Tassi to teach Artemisia perspective comes only from Tassi's assertion in the trial testimony. Artemisia tells a different version of their meeting; Orazio doesn't mention this in his opening statement.

14. From an anonymous note added to the English edition of Roger de Piles's *The Art of Painting,* 3rd ed. (London: T. Payne, 1754). On the epitaphs, see Garrard, *Artemisia Gentileschi,* 137.

MARY D. GARRARD, INTERVIEWED BY KRISTEN FREDERICKSON AND SARAH E. WEBB

Following the publication of her *Art in America* article, Mary D. Garrard discussed with Kristen Frederickson and Sarah E. Webb the critical and popular reception of the film *Artemisia* in conjunction with cinematic authority.

Frederickson/Webb: How do you feel your book of 1989 stands up as an authoritative source, now that the film of 1998 has been made? Are you concerned that one will be read as a greater authority? Do you think there is any useful overlap between the audiences for the two types of treatment, or are the people with a film-based view of Artemisia not at all those who might have read your book?

Garrard: First, I doubt that Merlet's film will ever be regarded as an authoritative source on Artemisia Gentileschi. All over the country, the film closed after a short run, and not just because it was controversial. It simply didn't grab the public's attention. At the time the movie came out, there was a considerable overlap between its audience and readers of my book. Artemisia is widely familiar to a lot of people—students, academics, art fans, and women artists especially—and this large, already educated or informed group was probably the film's primary audience. Now, however, the film lives on in video stores, with an appeal mainly to uninformed viewers

looking for entertainment (though I also know a few colleagues who have shown it to generate discussion in their classes).

Fortunately, students and scholars don't normally go to video stores to do their research, and their bibliographic searches will yield more appropriate sources. At present, these include not only my book of 1989 but also R. Ward Bissell's catalogue raisonné, *Artemisia Gentileschi and the Authority of Art* (University Park: Pennsylvania University Press, 1999). New literature also includes the catalogue for the recent Gentileschi exhibition, Keith Christiansen and Judith W. Mann, eds., *Orazio and Artemisia Gentileschi* (New York: Metropolitan Museum of Art; New Haven, Conn.: Yale University Press, 2001), and my own new book, *Artemisia Gentileschi around 1622: The Shaping and Reshaping of an Artistic Identity* (Berkeley: University of California Press, 2001).

I never expected my 1989 book to stand as the authoritative source because scholarship on important artists simply doesn't work that way. It's always an ongoing project of interpretation and reinterpretation. My book broke the ice in Gentileschi studies by theorizing its subject for the first time, putting her art in the realm of ideas, and framing a discourse of gender that I and many others consider an appropriate category of analysis. But my perspective has generated both support and backlash. Not everyone wants to look at Artemisia through the lens of gender, so there has been a vigorous debate on this point, which has intensified since the publication of Bissell's book. Although I'm a partisan in this debate, I think that the growing diversity of interpretative positions is basically healthy.

Frederickson/Webb: What do you make of biographical films whose makers claim to use the person only as a jumping-off point, a melding of real and fictional characteristics to tell a story? What effect does the mixing of real and nonreal have on the "real" memory or history of a person, Artemisia Gentileschi, for example?

Garrard: This is a distinct problem of our era, not only for Artemisia, but for any historical figure whose life has been represented in film, docudramas, and other creative media that blend genres. The balance of fact and interpretation is also a problem, of course, for those—such as biographers and makers of documentary films—whose primary intent is accuracy of representation, since there is no such thing

as an "accurate" biography. Every re-creation of a life is framed by a particular point of view and shaped by subjective preferences. Still, there's a big difference between the goal of truth to historical reality and the goal of truth to artistic vision. Subjectivity is, at least in theory, a liability of the former, but it is the sine qua non of the latter.

A case in point is *Painted Lady,* another film involving Artemisia Gentileschi that was aired on PBS just at the time Merlet's *Artemisia* came out. This was a straightforward work of fiction, whose plot focused on a stolen painting that turned out to be a work by Artemisia. In spinning this fictional tale, the filmmakers drew heavily upon my book to construct a historically plausible account of the artist and her art. Their use of art historical fact to support dramatic fiction was entirely proper and lent a certain credibility to the story. (They got into some trouble, however, for not crediting their source, which shows that there are rules, even in creative projects.)

The problem with Merlet's *Artemisia* lies in the desire to combine the two strategies inappropriately: to create a work of fiction whose point of departure is an individual historical life that the maker feels free to distort or reinvent at will. Such a project is inherently unfair to its subject, using it as fictional raw material, with no respect for that person's very identity. The result is a chimera, neither fish nor fowl, and it is also historically irresponsible. Straightforward biographers might present their subject's identity with shades of difference, but the differences ultimately contribute to an aggregate view that is fuller and more rounded than that of a single text. By contrast, the deliberate mixing of fact and fiction in the representation of an historical figure plays havoc with history, and to the extent that it becomes influential it introduces into the record a mischievous confusion of identity.

The distortion of Artemisia is particularly dangerous because of the rarity of such women in recorded history; our grasp of her historical identity is too fragile to be squandered in fact/fiction confusion. Fortunately, every act of distortion tells us more about the distorter than the distorted. As I point out in the *Art in America* article, Merlet's film reveals, in its very deviations from history, what the filmmaker desperately resisted in Artemisia's story. For some reason, Merlet felt a personal need to neutralize the artist's striking originality and transgressive behavior in both art and life and to convert her story into a generic, all-purpose love story. That need was perhaps

commercially driven, yet it served a broader social mandate that one can see in many other instances: to contain women who disturb the gender peace. Such mischievous reinventions of Artemisia's story have happened before and will happen again—and that is perhaps the true measure of her historical importance. In this sense, I think it's rather a good thing that Merlet made the film, for it contributes to the ongoing cultural discourse that unwittingly exposes, under de-construction, exactly what the real issues are in Gentileschi studies.

Frederickson/Webb: What is your definition of hero, *given that you included that term in the subtitle of your monograph? Did you use it ironically, or does it have a static, unchanging definition that fits Artemisia Gentileschi and serves an art historical purpose? Do you see a difference between a hero and a heroine?*

Garrard: Unpostmodern as it will sound, I really meant *hero*, with no irony implied. A hero is, as the dictionary says, "a man of valor or performance, admired for his noble qualities," or simply the princi-pal male agent in a story. A heroine is something entirely different, though we don't see the difference in the dictionary. In the connota-tions of our culture, she is admired for her beauty or her money; she is not the performer of noble deeds but the object of the hero's ac-tion; he saves her life or she is his reward for doing something brave. Artemisia's female characters—Judith, Susanna, Lucretia—are not heroines, though the same characters as depicted by other artists fre-quently display heroinelike passivity. They act, agonize, and are thoughtful; they are noble and courageous. To characterize these women, I borrowed the term *female hero* from the title of a book of 1981, *The Female Hero in American and British Literature,* by Carol Pearson and Katherine Pope.

Yet I did intend this oxymoronic subtitle to be provocative. What does it mean when a woman acts in a way that is valorized for males but not for females? Typically, she is not applauded but disparaged; women who appropriate masculinity constitute a social threat. There was always that aggressive edge in Artemisia's art, especially the figure of Judith, whose heroic deed has, in reaction, been redefined as diabolical, castrating, autobiographically vindictive. In fact, my use of the term did provoke people. From the conservative side I was asked, "Don't you mean *heroine*?" (That is, don't you know that

only men can be heroes?) From the feminist side came the critique that in using the term *hero* I was uncritically perpetuating masculine values. The feminist criticism I take more seriously, but it is also rather silly. In Artemisia's day a "hero" was someone like Odysseus or Achilles, a male figure essentially noble but also three-dimensional, who could cry and doubt as well as fight and kill. The modern caricature of male heroism—cruel, stupid, violent, testosterone ridden—did exist at the time, but that type was ridiculed even in Renaissance culture. And such figures were definitely not the heroes of literature and art. Plainly, Artemisia did not question canonical masculine virtues; her transgression was to assign those virtues to female characters. As a historian, I felt my task was to characterize her values as expressed in her art, not to inject an anachronistic critique of the concept of heroism per se. From a modern feminist perspective, however, what's wrong with the hero is also what's wrong with the heroine. It's the power imbalance that goes along with this binary pairing that's at stake, and the whole construct that's wrong. Artemisia's creation of female heroes deeply challenges the naturalness of that construct.

Frederickson/Webb: Do you see film in general as an appropriate medium to memorialize a historical person, or are the dangers of dramatic twisting too great? I'm thinking, for example, of the recent film by Freida Lee Mock on the career of Maya Lin. I wonder if a film (on Maya Lin or Artemisia) can achieve responsible treatment of a life. Even if that film purports to be documentary rather than docudrama, is it possible to determine the reliability/accountability of the narrator?

Garrard: There's a basic distinction between Artemisia and Maya Lin in that Maya Lin is alive and fully able to protest or correct distortions. And in the film, we see her directly and hear her speak; we are not given a reinvented version of her physical presence in the form of an actress. But I think that the dangers of dramatic twisting might be somewhat greater in film than in text.

First, in written biography, by convention, factual assertions are documented through footnote references to one's sources, whereas in film, even at its most historically responsible, the crediting of all sources occurs at the end, in the "crawl" of credits (a misnomer in that it is ever accelerating and nowadays also horizontally squeezed

into illegibility). A filmmaker is thus freer to take license, knowing that criticisms will tend to be of the whole rather than of specific details. The traditionally greater emphasis on "creativity" in filmmaking (even when its goal is documentary; think of Ken Burns) than in biography further fuels the spirit of artistic license. A third factor is the genre itself. As a visual medium, film can exert a powerful emotional appeal, can make an expressive pitch that may be quite at odds with reality, and can persuade the heart even when the mind is reluctant.

A case in point is Merlet's *Artemisia*. There's a scene in which Agostino Tassi is showing Artemisia how to frame and construct a landscape painting, sketching his vision before a beautiful slice of nature. This dramatic moment, supported by music, lighting, and good cinematography, makes a strong impression: the young Artemisia drinks in her lesson avidly from the master whom she deeply loves. The trouble with this cinematically effective scene is that it glorifies what never was; Artemisia never painted landscapes, she was not Tassi's student, and the documentary evidence does not support the film's assertion that she "loved" him in a blindly romantic way. This leads us to the question, Is it possible to make good art that is not historically responsible to its sources? Or does the immorality of the careless or deliberate alteration invariably create a flawed artistic product? I wouldn't go to the mat on behalf of Merlet's film, but I would say in general that artists are neither reliable nor accountable.

We should remember that Shakespeare raided Holinshed's *Chronicles* for the lives of his English kings. Today, the historical Richard III and Henry V are completely overshadowed, if not obliterated, by the fictional characters created by Shakespeare. If pressed, most of us would probably opt to keep the fictional kings over their factual counterparts because to us they are more lifelike and complex than their long-gone models. But it depends on whose ox is being gored. I believe there exists a kind of antidefamation league for the real Richard III. The narratives of Greek myth and the Old Testament are mythic reworkings of earlier historical reality that inadvertently reflect the patriarchal struggle to stamp out female power. Many feminists would prefer the original history to the artistically (and politically) successful retelling. We humans constantly reinvent our stories to suit our own purposes and needs, and in the face of the inevitable, it's wisest to admit that we can't legislate what is permissible in art or biography. We can only look at the result and read the psyches of the perpetrators.

A LIGHT IN THE GALAXY

JUDITH LEYSTER

FRIMA FOX HOFRICHTER

For Ann Sutherland Harris

An art dealer telephoned today with a question about Judith Leyster (1609–60),[1] the Dutch genre, portrait, and still-life painter, and offered to show me a painting that might be hers. When I was a graduate student, I would have considered such a call and request an exciting adventure, perhaps yielding the discovery of another aspect of this woman to whom I had chosen to bind my professional life. Today, years after completing my doctoral dissertation, I have many strong and conflicting feelings as my whole history with this artist comes before me. The articles and lectures, the book, the exhibition at the Frans Halsmuseum and the Worcester Art Museum, the smaller exhibition at the National Museum of Women in the Arts—each has made me reexamine this artist's work and reconfigure my relationship with her. With each, I felt as I do today—an initial excitement, a closeness as I am bound to her for a true eternity—yet beyond what I thought I had bargained for. I have a connection with her across time, and sometimes its intensity and relentlessness scare me. I keep thinking that I have paid my debt to her, but maybe I have not. So I will speak to the dealer, see the painting, and write this essay.

I know male art historians whose subjects have been inextricably woven into their own lives—they have spoken to the relatives of their

© Frima Fox Hofrichter. I wish to thank my dear friend Merle Feld, whose autobiographical work *A Spiritual Life: A Jewish Feminist Journey* (Albany: State University of New York Press, 1999) helped me be more courageous in writing this essay.

subject, visited their subject's grave, and named their child after the long-dead artist. We women scholars now can have similarly intense connections to "our" artists.

The subject of one's dissertation provides a connection that is especially strong and enduring. Gail Levin, no matter how well or frequently she writes on Jo Hopper, will surely always be associated with Edward, and Barbara Bloemink, even should she investigate and publish on other twentieth-century artists, will always be "the Florine Stettheimer person."[2] Because I wrote on Leyster at the beginning of my career, senior male colleagues have asked from time to time if I was finished with this "women stuff." The quality of my work was not in question, only my decision to stay with her. I sometimes felt she had become so powerful, so overwhelming, I was not sure there was any *me* left—I was (am) "the Judith Leyster person." I wanted to move on, but when I turned down invitations to write "Leyster" articles and "Leyster" dictionary entries, I felt I had betrayed her. For me, she exists in the here and now. I do not have to visit a cemetery to feel her presence. She was buried on a farm in Heemstede, outside Haarlem, that has been built over, and her grave is not to be found. I need only take the train to Washington, D.C., and go to the National Gallery of Art. There, in her *Self-Portrait* (Figure 2), she sits at her easel, leans back with her arm hooked on the chair, and looks out at us, boldly ready to paint forever.

A slide of this *Self-Portrait* was what first intrigued me about Leyster and prompted me to investigate her. Ann Sutherland Harris, a knowledgeable and accomplished baroque scholar, showed it in a 1971 lecture on women artists at Hunter College and thereby opened this world for me.[3] Leyster's name was virtually unknown, and for many years into the writing of my dissertation in the mid-1970s I had to tell even prominent art historians who she was. But she has been discovered, revealed; her work is now included in the major art history textbooks, slides of her paintings have appeared on Advanced Placement exams in art history, and students now consider her part of the "canon." She has even been featured in novels and mysteries.[4] I am enormously satisfied by all of that.

Judith Leyster was virtually forgotten from her death in 1660 until her rediscovery in 1893 by the Dutch art historian Cornelis Hofstede de Groot. Before 1893 no museum held any works attributed to her, her name was not recorded in sales catalogues, and no prints after her

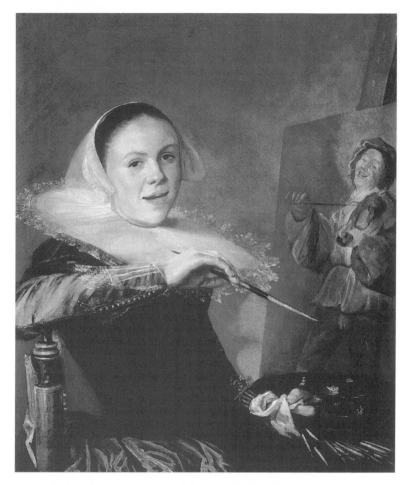

2. Judith Leyster, *Self-Portrait*, ca. 1633, oil on canvas

paintings were inscribed with her name. It was as if she had never ex-
isted. An initial catalogue of Leyster's work appeared in several articles
by Juliane Harms in *Oud-Holland* in 1927. (When I began my work,
I unsuccessfully tried to track Harms down.) The articles were the
chapters of Harms's doctoral dissertation at the University of Frank-
furt. But Leyster remained little known. I have explored that issue more
fully in "The Eclipse of a Leading Star,"[5] discussing how her work was
obscured by that of both her more prolific and frequently documented
husband, Jan Miense Molenaer (ca. 1610–1660), and her possible
mentor, Frans Hals (ca. 1585–1666). When Leyster's name was men-

tioned, she was compared unfavorably with Hals. There was even a suggestion (never made in the seventeenth century) that she had had a sexual liaison with Hals or Rembrandt! Mostly, Leyster's work was attributed to Hals—even her monogrammed pieces. Seymour Slive's publication of his immense and invaluable three-volume monograph and catalogue raisonné of Frans Hals revitalized an interest in Dutch art and coincided with the rise of feminism in the 1970s. This established a springboard for my own exploration of a woman's life and oeuvre.

My sense that Leyster was forgotten, dismissed, overlooked, absent, and invisible engendered in me both indignation and a sense of mission. So my work began as an adventure. I was exploring unknown territory—trailblazing as a historian and a feminist. That was in the 1970s, when the world was different.[6] It was not enough just to attribute paintings to her, though that was hard enough; I also had to address the question of their meaning. Where did Leyster fit in? What issues did she tackle? How did she use literature, proverbs, puns, and contemporary or religious notions of morality in her work? And how could I know this dead woman except through her cleverness and her wit and by understanding what was left of her—her paintings?

I began by exploring a painting that touched on many of these issues, with the underlying theme of the relationship between men and women—*The Proposition* (Mauritshuis, The Hague, Figure 3).[7] In 1975 I gave a talk at the College Art Association meeting in Washington, D.C., entitled "Judith Leyster's *Proposition:* Between Virtue and Vice," in one of the first sessions ever presented on women artists, chaired by the late Eleanor Tufts.[8] I suggested a "woman's point of view" for this small, intimate painting with the tantalizing subject of sex for money. I followed the talk with an article on the work for the *Feminist Art Journal* that has been reprinted many times (and is still being reprinted every year for a college freshman handbook because it deals with art, men and women, and sex—a powerful combination).[9] The experience felt like a great shared gift—I gave to Leyster by working on her and bringing her into the public eye, and she gave to me as I received early acknowledgment, praise, and even a few moments of fame. It was as if, beyond time, we were a team. My feeling of a powerful connection extended to my hosting annual birthday parties in Leyster's honor. Her birthday is not known, but she was baptized on July 28, 1609, so during the summers when I was in graduate school I gave little parties with Droste chocolate in the library; one year I

dressed in costume for a party at my apartment and served herring and beer as well.[10] Of course, we renamed the apartment Het Ley-Starre Taverne (after her father's brewery) for the occasion. I felt such joy. I loved her.

Leyster's reputation rose in the 1980s. For many artists, being the subject of a monograph confirms an established reputation and market interest. For Leyster, the publication of my monograph on her in 1989 asserted her deserving status, and articles that I published on her from 1975 onward paved the way to new thinking about her, introducing her to the public and to my colleagues and calling attention to her complex approach to such issues as iconography, gender, and social status. These were articles on *The Proposition;* her *Self-Portrait,* which I believe to be her 1633 master's piece for the Haarlem Guild of St. Luke; and *A Game of Tric-Trac*[11]—another work involving sexual innuendo. The last of these paintings, now at the Worcester Art Museum, was one that I tracked down relentlessly (I am quite proud of my detective work) before finding it in a small town in Pennsylvania. The *Self-Portrait* article was written for a festschrift celebrating Egbert Haverkamp Begemann's sixtieth birthday. Begemann—to whom I am most grateful for his accessibility, his support, and, most of all, his numerous probing questions—was both the outside reader for my dissertation and the consultant for the later Haarlem exhibition I guest curated, *Haarlem: The Seventeenth Century.*

Because I did not see Leyster in isolation—I was also curious about the community of artists in which she blossomed—she became the impetus for the Haarlem exhibition. Although the exhibition was held in 1983, planning for it began while I was completing my dissertation and my questions about the artist community were fresh and powerful. Philip Dennis Cate, director of the Rutgers University Art Gallery, was looking for a Dutch exhibition to mark the gallery's reopening as the Zimmerli Art Museum. I wanted to learn about the artists Leyster would have known and worked with and lived alongside of in Haarlem and about their connections to her and to each other—in documents, in the guild, in the proximity of their houses, in the similarity of their subjects, and even in marriage (Leyster's, for example, to Molenaer). Leyster was central to my making connections—but not the focus of the exhibition. That was, I thought, the way it should be—Leyster there with her contemporaries. It very much felt like a Haarlem reunion. I

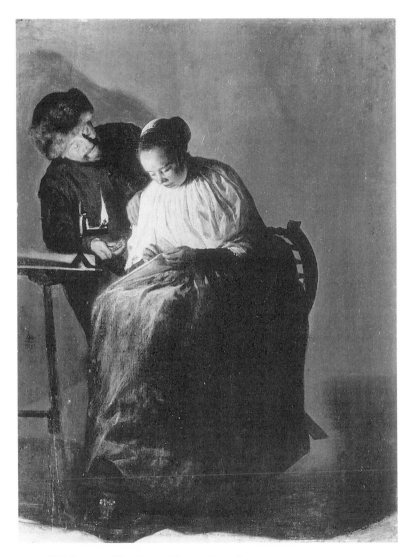

3. Judith Leyster, *The Proposition*, 1631, oil on canvas

was fascinated by the connections, which filled out her life for me. With each new piece of information, she became more alive.

Many of the artists in the exhibition, as in seventeenth-century Haarlem, had family connections: they were fathers and sons, brothers, in-laws, cousins. But Leyster, unlike her colleagues, and indeed un-

like most women artists throughout history, did not begin her life connected to the arts. Her father was a textile worker and brewery owner who also bought and sold real estate (not always successfully). She was probably sent out to work with the De Grebber family, perhaps in the family workshop with Maria de Grebber (ca. 1610–after 1658), another young girl who painted but who never became a member of the guild.[12] Leyster was sent to work, perhaps as an embroiderer, when her father lost his business to bankruptcy. Her success in making a name for herself despite her family's difficulties is an inspiring tale, one that I did not know until I was well along in my work on her. That she was "self-made"—different from her family, exceeding her family's expectations—would deepen my sense of connection with her.

I did not mean to be the sole person to write on her; I wanted her to come to the attention of others, who would add their scholarly energy to further her well-deserved recognition. But Leyster's quick rise to prominence by the end of the 1980s, both in relation to my work and independent of it, caught me off guard.[13] So I had—and still have—mixed feelings about the Leyster exhibition at the Frans Halsmuseum and the Worcester Art Museum in 1993. Organized in 1990 (not by me, although I served on the committee), it may have taken place too soon after I published my 1989 Leyster monograph. The independent scholar, even the "expert" on the exhibition subject, always plays a tenuous role amid museum professionals. In this case, I thought there was not enough time for historians to use my work judiciously, and I felt, at the same time, "ripped off" and roundly criticized when paintings in the exhibition that I had attributed to Leyster were "corrected" to "circle of Hals." Nonetheless, I was pleased with the notice and the exposure others would give Leyster after centuries of silence.

During my many years of research and investigation I felt Leyster's immediate presence keenly in the city archives of Haarlem and Amsterdam, where the births of her own family and her siblings' and children's families are recorded.[14] There the names of witnesses and family friends gave me a sense of engaging in art historical work that rebuilt her life and community. Each time I saw her name signed or inscribed on a document, I was startled at the physical evidence of her presence. I found my archival work addictive because I never knew if some new piece of the puzzle of her life would turn up on another page.

During my research on Leyster and on the larger subject of Leyster and Haarlem, I worked in the photo archives at the Frick Art Refer-

ence Library in New York, the libraries at Princeton University, the photo archives of Dutch art dealers, the library at the Mauritshuis (sometimes after hours), and, most important, the Rijksbureau voor Kunsthistorische Documentatie (RKD) in The Hague. As a "regular" at these libraries, I was always treated well but was made to feel especially welcome at the RKD and very much enjoyed working there—particularly in the old building. If I wrote ahead before arriving (I learned this was an unexpectedly polite move for an American!), the librarians would gather books or items that they thought would interest me. In those circles people knew of Judith Leyster and learned more over the years, so I did not have to explain who she was, what I was doing or why, or even who I was. It was wonderful. I have good feelings about that whole time and the people I met, especially the keeper in the old master paintings room, Gerbrand Kotting, who I hope does not mind that I mention his name here.

At various times in my life I found that I could identify with Leyster in surprising ways. Years after completing my dissertation and after I had my children, I looked to Leyster, who had five children (only two of whom survived her), and reexamined how she managed her professional life with them—the arrangements and compromises she made. For instance, her signed and dated *Tulip* drawings from 1643 coincide with the birth of her daughter Helena in March of 1643.[15] Working on small still lifes, possibly at a table with a cradle at her side, may have been one of her compromises. Indeed, the birth of children probably had a greater impact on Leyster than art historians have imagined. Often it is (still) claimed that Leyster stopped working after her marriage, but my archival work revealed that her first child, Joannes, was born in 1637, a year after she married, so I surmise it was not simply marriage but also the birth of the child that altered her career. I felt connected with Leyster not only as a mother but ultimately as a daughter. In the 1990s, many years after I began my work on her, I learned that her father, recorded as purchasing and then finally losing the brewery and his house, was actually a *smalwercker* (a "small-work weaver"), someone who made strips of cotton, wool, or silk:[16] that is, he was part of Haarlem's large textile industry. It felt so familiar. I was not surprised. My own father worked in the ladies' garment industry in New York. No, the parallel is not close enough to have some deep meaning, nor is it a real coincidence, but it is another instance of what connects and keeps connecting me to Leyster across time. There was a familiarity,

too, in walking the streets in the Netherlands—the red brick always reminded me of my native Brooklyn. It seems that I had come so far only to be attracted to the familiar.

My walking tours of both Haarlem and Amsterdam were especially powerful. I plotted on a map the streets in which Leyster lived and then tried to find those houses or approximate locations, only to discover that none of her residences from the seventeenth century are extant. But walking those streets, traveling the routes she had walked—seeing what she might have seen, following the paths to the market square and to the churches named in the baptismal notices of her children—seemed essential. I needed to find as much as I could. Although my writing would be public, the research and discovery felt intensely private; though my husband, Larry, traveled with me frequently and patiently to libraries and museums, I took those street walks alone. I can bring back the sense of them even now as I sit at my desk so many years later. They would remain evocative throughout the years as I went back to retrace them or even found myself on one of them by accident, traversing the city and suddenly recognizing where I was. My heart would race. She had walked here.

I think it is a gift to find such deep fulfillment and satisfaction in one's work. But I also found a place, and maybe even a time, where I fit. I still think this, and even now I can close my eyes and see the swans on the Hof Vijver by the RKD in The Hague or the canal boats on the Herengracht in Amsterdam, or I can walk down narrow streets with stepped-gabled roofs in Haarlem and feel that something special connects me to this place and, yes, across time, to Judith Leyster.

EPILOGUE

As I have indicated in my essay, over the years I have gone through periods of being more and sometimes less engaged in working on Judith Leyster. In the spring of 2001, while I was working at the RKD in The Hague, I decided to look her up once again.

"Looking her up" means going through boxes of photographs. I finished the formal ones and then went on to the temporary (*Voorordening*) files—those where the photos are cut up but not yet pasted onto the usual gray card stock. Photographs could be in these tempo-

rary files for years, but these files would contain her works from recent sales and so forth.

As I went through these stuffed files (10–12 folders in two boxes), I admired some of the black-and-white reproductions and occasionally flipped them over to see where they were from. They were repeatedly stamped "Tent. Leyster 93–94" (*Tent.* is the Dutch abbreviation for *tentoonstelling,* meaning "exhibition"). I did not think much of the stamping and kept going. But some of the photographs were particularly familiar, and I checked and these also said "Tent. Leyster 93–94"—the same.

I suddenly realized that all of these photos had been cut from my own Leyster book! Indeed, I knew my publisher had generously given the RKD an unbound copy of my plates to cut up for their photograph files. But all the photos read "Tent. Leyster 93–94" instead of "Hofrichter 1989." The exhibition reference is to the 1993–94 catalogue by James Welu and Pieter Biesboer. All my hard work (which was fundamental to their exhibition) was now attributed to them!

Yes. I brought the misattribution to the attention of the administrators and explained. They saw. They understood. I know it was not malicious. But I was told it would be difficult and would take a long time to repair. (Some files, I have been assured, have since been corrected.)

How could I work for years on Leyster and then see all my work, all the photographs from my book, stamped with another name? I told them, "This is how women are written out of history."

NOTES

1. *Leyster* is the last name taken by her father, Jan Willemsz. It was also the name he gave to his house and later to his brewery, and he probably took the name from the site. *Leyster* (*leidstar* or *leidster*) means "Leading Star," and she herself punned on that name in her monogram: a conjoined J, L, and star.

2. See chapters 9 and 10 in this book.

3. I wrote my master's thesis on Leyster (a general survey of her work that laid a foundation for my later work) under the direction of Harris at Hunter College, City University of New York. Harris also co-curated, with Linda Nochlin, the groundbreaking "Women Artists 1550–1950" (Los Angeles County Museum of Art, 1976).

4. Leyster appears in general survey texts: Laurie Schneider Adams, *Art across Time,* vol. 1 (Boston: McGraw-Hill College, 1999), 664, illus. 18.48 (*The Last Drop,* Philadelphia); Frederick Hartt, *Art: A History of Painting, Sculpture, Architecture,* 4th ed. (New York: Harry N. Abrams, 1993), 824–25,

illus. 28-15 (*The Proposition,* The Hague); H. W. Janson and Anthony Janson, *History of Art,* 5th rev. ed. (New York: Harry N. Abrams, 1997), 582, illus. 7-75 (*Young Flute Player,* Stockholm); Marilyn Stokstad, *Art History* (New York: Harry N. Abrams, 1995), 788–89, illus. 19-47 (*Self-Portrait,* Washington, D.C.); and David G. Wilkins, Bernard Schultz, and Katheryn M. Linduff, *Art Past, Art Present,* 3d ed. (New York: Harry N. Abrams, 1997), 355, illus. 7-8 (*Self-Portrait,* Washington, D.C.), and 361, illus. 7-13 (*The Last Drop,* Philadelphia; before cleaning). Slides of Leyster's work (of both *The Proposition* and the *Self-Portrait*) have appeared in the essay sections of Advanced Placement examinations in art history in 1994 and 1998, respectively. She appears in fiction: Amanda Cross, "The Proposition," in *The Collected Stories* (New York: Ballantine Books, 1997); and Michael Kernan, *Lost Diaries of Frans Hals* (New York: St. Martin's Press, 1994).

5. F. F. Hofrichter, "The Eclipse of a Leading Star," in *Judith Leyster: A Dutch Master and Her World,* exhib. cat. (Worcester, England: Worcester Art Museum, 1993), 115–22.

6. I would like to once again thank the Woodrow Wilson National Fellowship Foundation for their Award in Women's Studies in 1978, which helped give credibility to my dissertation work; the American Council of Learned Societies (ACLS), which provided a travel grant in 1979; and the Millard Meiss Fund of the College Art Association, for their contribution in publishing the monograph.

7. The painting was unnamed at the Royal Picture Gallery, Mauritshuis, The Hague, so in my work I named it (as I did several of her paintings), and the title *The Proposition* continues to be generally used. The notable exception to its use was by Pieter Biesboer (curator of the Frans Halsmuseum), who disagreed with the sexual implication of the title, so in the exhibition and in its catalogue *Judith Leyster: A Dutch Master and Her World,* the painting is referred to as *Man Offering Money to a Young Woman* (168–73, cat. no. 8).

8. Eleanor Tufts also included Leyster in her own book on women artists, *Our Hidden Heritage: Five Centuries of Women Artists* (New York: Paddington Press, 1974), which held a detail of Leyster's *Self-Portrait* on the cover. I dedicated my chapter "The Eclipse of a Leading Star," which discusses Leyster's reputation, to the memory of Eleanor Tufts.

9. "Judith Leyster's *Proposition*: Between Virtue and Vice," *Feminist Art Journal* 4 (1975): 22–26; reprinted in *Feminism and Art History,* ed. Norma Broude and Mary Garrard (New York: Harper & Row, 1982), 173–81 (which has given Leyster and the painting the most exposure); *Worlds of Art,* ed. Robert Bersson (Mountain View, Calif.: Mayfield, 1991), 300–303; and *Prelude and Passages: Program in Writing and Thinking,* ed. Faculty Advisory Committee (Tacoma, Wash.: University of Puget Sound), freshman orientation text, annually from 1989 to the present. My work seems to have had a distinct and varied impact: *The Proposition* is featured as the frontispiece in Christopher Brown's *Images of a Golden Past: Dutch Genre Painting of the 17th Century* (New York: Abbeville Press, 1984), was discussed and illustrated in Madlyn Millner Kahr's *Dutch Painting in the Seventeenth Century* (New York:

Harper & Row, 1978), 65–66 (with its older name, *The Rejected Offer*), and was the subject of Amanda Cross's short story of the same name (see note 4).

10. I would like to thank my fellow graduate students at Rutgers University who enthusiastically participated: Steve Arbury, Natalie Borisovets, Louise Caldi, Nancy Heller, Leslie Kessler, Betty Lipsmeyer, Barbara Listokin, Jane Rehl, John Beldon Scott, and Julie Williams.

11. For *The Proposition,* see note 9. For the *Self-Portrait,* see F. F. Hofrichter, "Judith Leyster's *Self-Portrait: Ut Pictura Poesis,*" in *Essays in Northern European Art Presented to Egbert Haverkamp Begemann on His Sixtieth Birthday* (Doornspijk, the Netherlands: Davaco, 1983), 106–9. Arthur K. Wheelock, Jr., in *Dutch Paintings of the Seventeenth Century* (Washington, D.C.: National Gallery of Art, 1995), 156–58, has argued for an earlier date of ca. 1630. I wish to thank him for his patience with my many trips to the National Gallery of Art to "visit" her—even when the portrait was in storage and later being cleaned. For *A Game of Tric-Trac,* see F. F. Hofrichter, "Games People Play: Judith Leyster's *A Game of Tric-Trac,*" *Worcester Art Museum Journal* 7 (1983–84): 19–27. The acquisition of this painting by the Worcester Art Museum became the raison d'être for its sponsorship of the Judith Leyster exhibition years later (1993).

12. F. F. Hofrichter, *Judith Leyster: A Woman Painter in Holland's Golden Age* (Doornspijk, the Netherlands: Davaco, 1989), 14.

13. I am grateful to Mary Garrard (see her entry in this book) for the several conversations we have had over the years about this issue. Ironically, once Leyster became better known, I felt more keenly that I wanted to hold on to her in a new way and bought a painting (some twenty years after I first saw it) related to her work. It is a workshop piece of *The Last Drop:* two figures smoking and drinking with a full skeleton—a death—between them. The painting served as a document in discovering the skeleton in the original work by Leyster (now in Philadelphia), where the skeleton had been painted over. It made sense in many ways to have this work—an essential piece of evidence of her complex thinking—as other scholars went on to discover her.

14. I also worked in the archives of North Holland in Haarlem and the archives in The Hague and in Utrecht. I owe special thanks to Frans Tames of the Haarlem Municipal Archives for his help over the years.

15. Hofrichter, *Golden Age,* cat. no. 46.

16. Ellen Broersen, " 'Judita Leystar': A Painter of 'Good, Keen Sense,' " in *Judith Leyster: A Dutch Master and Her World,* 15.

"SO WHAT ARE YOU WORKING ON?"

CATEGORIZING *THE EXCEPTIONAL WOMAN*

MARY D. SHERIFF

"So you're writing a biography of Elisabeth Vigée-Lebrun?" The very question made me bristle. Of course I was not writing a biography. My métier is interpreting the visual image. "So then it's a monograph?" No, not that either. I prefer to explore a few works in great detail rather than range over an artist's entire career. And to tell the truth, while writing *The Exceptional Woman: Elisabeth Vigée-Lebrun and the Cultural Politics of Art* (Chicago: University of Chicago Press, 1996), I scarcely considered the staples of either biography or the monograph. I thought little of the artist's formal development and even less about her juvenilia; I was not fascinated by the society ladies she painted, and I had no interest in exploring her intimate relationships. All in all, I found it difficult to name the genre of my writing. "I'm working on Elisabeth Vigée-Lebrun" was the most I could say.

In retrospect, it seems appropriate that I struggled to define my enterprise, since definition is a central issue in the book. Again and again, I found myself asking how Elisabeth Vigée-Lebrun imagined and presented herself as an illustrious artist in late-eighteenth-century France, when "woman artist" was a contradiction in terms. Even though many Frenchwomen practiced the arts between 1770 and 1830, the category "artist" (like that of "intellectual") excluded the sex thought weaker in reason and subject to uncontrolled fantasy. The construction of

"woman" in various overlapping discourses—including the aesthetic, the medical, the legal, the moral, and the psychological—established and enforced this exclusion. Yet there were cracks in this dominant construction, and among the more promising for women was the concept of the "exception," which became a defining feature of my book.

In titling my book *The Exceptional Woman*, I wanted the term *exceptional* to point in at least two directions: first, toward the exceptional person, that individual who achieved something considered out of the ordinary, an individual whose success historians or contemporaries valorized, and second, toward the exceptional woman, that woman whose achievement required both a dispensation from and a strengthening of the laws that regulated other women. This second definition I based on the eighteenth-century legal notion of the exception, explicated, for example, in the *Encyclopédie* under "Exception, Jurisprudence":

> *Exception* is also sometimes a dispensation from the rule in favor of some persons in certain cases. One commonly says that there is no rule without *exception* because there is no rule, however narrow it be, from which someone cannot be exempted in those particular circumstances. It is also a maxim in Law that *exceptio firmat regulam*, which is to say that exempting from the rule someone who is in the category of the exception, is tacitly to prescribe the observation of the rule for those who are not in a similar category.[1]

Given Vigée-Lebrun's status, privilege, and acclaim, she was indeed both a woman artist and an exceptional woman. Her "exceptionalness" made it particularly important that an analysis of her life and work take up the question of what it meant to be classified as a "woman" in late-eighteenth-century France. Because the exception was held to confirm or strengthen the rule for everyone else (*exceptio firmat regulam*), the fate of the exceptional woman was inextricably tied to the destiny of all women. And although by definition the "exception" was held to strengthen or confirm the rule, it also contained a subversive potential. Indeed, without that subversive potential it would not have been necessary to emphasize *exceptio firmat regulam*. Freed from some rules that governed their sex, celebrated women like Vigée-Lebrun threatened the social order and thus were in particular need of control.

In my work on Vigée-Lebrun I explored the various ways academic and government officials, as well as critics and painters, tried to man-

age, contain, and control the exceptional woman artist. I also investigated the mechanisms through which French society prevented exceptional women from becoming the rule. Here I found inspiration in the work of historian Geneviève Fraisse, who took up the concept of the exception to show the difference in women's position before and after the French Revolution.[2] Fraisse argued that the entire society under the ancien régime operated in terms of the "exception" because an established hierarchy ensured different rights and privileges for different persons. Under such circumstances, it was impossible for anyone to claim equal rights. Revolutionary and postrevolutionary notions of equality, however, allowed oppressed groups, most notably women, to claim for the majority what had been given only to a very few.

While granting the distinction between pre- and postrevolutionary France, I still wondered if and how the exceptional woman could call into question, perhaps even without knowing it, the very category that made a place for her. I wanted to know if being exceptional gave Elisabeth Vigée-Lebrun a position, albeit a contradictory one, from which to challenge prevailing constructions of woman in general and woman artist in particular. Moreover, my reading indicated that to a large extent attitudes toward women expressed in medical, philosophical, and moral treatises remained consistent before and after the Revolution. I came to believe that women in postrevolutionary France could more effectively argue for their rights—particularly the right to be cultural producers—because the work of exceptional women put pressure on prevailing norms. The shift to a logic of equality thus seemed to me only partly responsible for change. As important in opening possibilities for creative women was the continuous presence of exceptional women in pre- and postrevolutionary France.

I wondered to what extent Elisabeth Vigée-Lebrun could be seen to have aided those other creative women. To what extent might her career have provided a strategic model for others claiming to be artists? Did her work belong to a tradition of protest? In posing such questions, my goal was not to remake Vigée-Lebrun as a feminist but to recuperate her work for feminism. That recuperation seemed especially necessary on several counts. For many years mainstream art history had either ignored Vigée-Lebrun or demeaned her work. A portion of the museum-going public, however, cherished the artist as a painter of elegant ladies and beautiful mothers. Her more popular works—for example, the 1789 self-portrait (now hanging in the Grand Galerie of the

Louvre) that shows her embracing her daughter Julie—have circulated widely, reproduced on wastebaskets, paperweights, ceramics, and the like. Feminist art historians, meanwhile, could find no place for Elisabeth Vigée-Lebrun, even though she was arguably the most noted woman painter in history. Starting with Simone de Beauvoir, feminists vilified her as an artist who had sold out, who had cast herself in the most retrograde stereotypes of "woman." Beauvoir used Vigée-Lebrun as a negative example of the narcissistic woman. In *The Second Sex*, she maligned the artist: "Madame Vigée-Lebrun never wearied of putting her smiling maternity on her canvases."[3] Art historians have been even less kind: Griselda Pollock, for example, made Vigée-Lebrun the villain in two of her books, implying that the artist was merely a society lady on the wrong side of the Revolution.[4] Indeed, the association of Vigée-Lebrun with the ancien régime, and hence with conservative politics, seems to have veiled for many interpreters any association of her art and career with what might be called feminist goals. Whereas Griselda Pollock in her pioneering work valued the art of elite women such as Mary Cassatt and Berthe Morisot, she pictured that of Vigée-Lebrun, the hairdresser's daughter, as objectifying women in the most traditional way. Such ideas probably seemed entirely consonant with the artist's unwavering allegiance to the monarchy, her flattering portrayal of aristocratic patrons, and, most important, her attachment to Marie-Antoinette. They are at odds, however, with the artist's career, with her role as a celebrated artist in the public sphere, with her self-representations, and with her depictions of other exceptional women. Recent work on Marie-Antoinette, moreover, has cast that ill-fated queen in a more sympathetic light. Scholars have explored the denigration of Marie-Antoinette as symptomatic of a widespread fear of powerful women in the public sphere and have elucidated the queen's close connections to her female friends and supporters.[5] Such work casts a decidedly different light on Vigée-Lebrun's attachment to the queen and the artist's associations with other women.

In considering Vigée-Lebrun's work, moreover, I became interested in how often art historians repeated many of the stereotypes beloved by Salon critics hostile to Vigée-Lebrun, the woman artist who stepped out of her place and cast herself as a history painter. Indeed, it was the attempt to place herself in that high rank by presenting as her academic reception piece the allegory *Peace Bringing Back Abundance* (Salon of 1783; Paris, Musée du Louvre) that most angered her critics. They ar-

gued that she could not paint the "ideal," that she understood neither beauty nor the classical tradition. Her idealized portraits—well, they were mere flattery; they lacked both naturalness and truth. Detractors found her drawing weak, her color mannered, her touch soft. They called her paintings "feminine," despite the artist's masculine ambitions. Their criticism thus participated in the general cultural devaluation of the "feminine," a category in which they grouped a whole set of aesthetically undesirable properties. It struck me as particularly odd that feminists would (even inadvertently) validate any of these long-standing stereotypes, stereotypes also associated with the denigration of rococo painting in favor of neoclassical reform. That such reform was closely tied to a remasculinizing of painting, a reclaiming of art for male practitioners and masculine ideals, is a point that I am hardly alone in making.

As I thought about the feminist reception of Vigée-Lebrun, I kept coming back to one of the first books on feminist theory I had read: Toril Moi's *Sexual/Textual Politics*. That book opened with the challenge of rescuing Virginia Woolf, whose work feminist critics had received negatively, for feminist politics. "It is surely arguable," wrote Moi, "that if feminist critics cannot produce a positive political and literary assessment of Woolf's writing, then the fault may lie with their own critical and theoretical perspectives rather than with Woolf's texts."[6] I saw Vigée-Lebrun as a parallel case: she was a woman artist whose work feminist art historians had found wanting. A new, more positive analysis of Vigée-Lebrun called for new perspectives, and these new perspectives could best be framed in an old format, the monograph, which would allow an extended consideration of the artist, her art, and the cultural frame within which that art was produced and received.

It never occurred to me, however, to write a traditional monograph, treating a single artist's entire career as a more or less self-contained entity. I prefer exploring a few works in detail, and I use the narrow focus on a single work to open a broad range of cultural, social, and aesthetic issues. Moreover, I viewed my book on Vigée-Lebrun, not as a self-contained monument to a single artist, but as a chapter in a different story of art, as well as my contribution to another history—the history of how women talked back to those discourses determined to configure them as incapable of reason or cultural production.[7] In other words, I saw my monograph as part of a collective enterprise. Here I was inspired by a remark Gerda Lerner made in her sweeping history

of feminist consciousness, where she argued that for centuries "individual women had to think their way out of patriarchal gender definitions and their constraining impact," unsupported by cultural institutions and unable to pass on their knowledge effectively.[8] If Lerner is right, and I believe she is, then it seems imperative to examine how individual women artists thought their way out of restrictive definitions and to write the histories of those endeavors.

This is not to say that only women have had to think themselves out of constraining ideals and stereotypes, for surely all oppressed groups have faced similar, and sometimes far more difficult, challenges. It is to propose that art historians pay more consistent attention to the interaction between normative concepts and individual artistic production. Such a practice could illuminate differently even the work of such canonical masters as Raphael or Poussin.

Elisabeth Vigée-Lebrun's self-representations, as well as her representations of other "exceptional" women, became my central object of analysis. Did these images merely pander to the worst stereotypes, as others had argued, or did they together suggest a struggle with and against those stereotypes? Frankly, I thought it inconceivable that self-images by a painter with Vigée-Lebrun's ambition and talent, by a woman who imagined herself a great artist, would not bear the marks of such struggles. But could I glimpse through her self-representations how the artist thought herself out of patriarchal definitions? Could I interpret her self-representations as themselves subversive of patriarchal norms? These questions led me to focus on autobiography insofar as it concerned professional identity. Here the writing of French feminist philosopher Michele Le Doeuff greatly influenced my thinking.[9] In her work, Le Doeuff asked how philosophers marked themselves as philosophers, how philosophy defended its position as a master discourse accessible only to male practitioners, and, most important, how women came to philosophy. Again, I saw myself facing similar questions. My study primarily considers how the work represents the professional life, and I view Vigée-Lebrun's self-images as made by an artist in a particular historical, social, and cultural situation. Being classed as "woman" was an important part of that situation.

Although my stress on self-representation does link life to work, I do not "reduce" the works to autobiography, nor do I leave out their larger significance, two fears feminists have voiced about the monograph as a genre of art historical writing. What seems to me important

for feminist inquiry is precisely an analysis of how a painter negotiated her identity as an artist and as a woman when all the mythologies of art, all the elements of what I call the painterly imaginary, asserted the artist's masculinity. Only if I could show how in the particular case Elisabeth Vigée-Lebrun reworked these patriarchal norms could I write her art into a history of woman's resistance.

Despite my ambitions, one aspect of my book might still incline some readers to think I focused on the life at the expense of the art: my long readings of particular passages in Vigée-Lebrun's autobiography. These I took not as statements of the artist's life but as self-representations equivalent to pictorial portraits. Indeed, this eliding of the written and painted is fully justified in the French tradition, where the term *portrait* refers to both textual and visual depictions. Thus I did not read the *Souvenirs* for factual or biographical data, for their picture of life in ancien régime France, or for information about Vigée-Lebrun's sitters. Even a cursory look shows that this autobiography is no accurate record of events but a series of highly charged and often conventional image patterns. Vigée-Lebrun takes the standard tropes of the artist's biography and myths of the painter's imaginary and inserts into them the events—remembered, fantasized, or constructed—of her own life. These are combined with flattering poems and letters transcribed into the text and with reports of the libels and gossip that dogged her reputation. Vigée-Lebrun stakes her claim by publishing these self-representations as the text of her life, her biography in an approved version. Whether that life genuinely belonged to her, whether she actually lived or wrote it, mattered little to me. For my purposes, it was enough that she acknowledged that text as the representation of her life—both explicitly, in the body of the work, and implicitly by publishing it under her name during her lifetime.[10] In truth, I never believed that I was interpreting Vigée-Lebrun's life, professional or otherwise; the object of my analysis was its authorized representation. I found particularly useful those vignettes that commented on her status as both artist and woman.

To the disappointment of some readers and the pleasure of others, my book opened, not with a visual image, but with a textual self-representation whose complexity could be probed only by exploring along with it a variety of medical, moral-philosophical, and aesthetic texts on the nature of creativity. Those accounts were deeply gendered. In my opening self-portrait, Vigée-Lebrun recounts a visit to the cabinet of the famous anatomist Felice Fontana and describes her reaction to the

wax models of women's bodies displayed there. The sight of women's internal organs upsets the artist, who, after leaving the cabinet, develops a fixation on what she saw there. She returns to Fontana, seeking the anatomist's advice on coping with the affliction, which she describes as being caused by her sensitive organs. Although she specifies her organs of sight, the whole episode resounds with the current medical opinion that held women easily deranged because of their overly sensitive sense and sex organs. But rather than attribute her sensitivity to her female body, Vigée-Lebrun casts it in terms of her artistic gift. When Fontana advises her to calm her sensitivity by giving up painting, she flatly refuses. Addressing her readers, she remarks: "You will easily believe that I was not tempted to follow his advice; to paint and to live have only ever been a single and identical word for me, and I have quite often rendered thanks to Providence for having given me this excellent sight."[11] In portraying herself in Fontana's cabinet, Vigée-Lebrun challenges the problematic that deemed the "normal" female body oversensitive and inclined to mental imbalance yet that simultaneously gave to the abnormally sensitive male body the capacity to make great art.[12]

The self-representation that opens my book also sets the pattern to follow in that it shows the artist manipulating accepted paradigms to her advantage, challenging the discourses that limited women by putting pressure on their inherent contradictions. I must admit that when I came across the account of her visit to Fontana's cabinet, I was stunned. I could not believe that no one had ever noticed or commented on the section, since it so brilliantly condensed and subverted all the aspects of science that deemed woman's body and mind unfit for intellectual and artistic production. Moreover, the scene was perfectly set—taking place in an anatomical cabinet with the artist contemplating a scientific model of woman's viscera. In addressing the anatomist, Vigée-Lebrun not only turns common belief on its head but also makes him play the fool for advising her to give up painting. It is a portrait to savor, especially if one likes uppity women. But, perhaps more important to my argument, Vigée-Lebrun presents herself in this scene as both the typical woman and the exceptional one; indeed, she performs the oversensitive woman only to prove herself a great and dedicated artist. Through her performance, she undermines the distinction, often made in medical treatises and art theories, between productive male sensitivity and dangerous female obsession.

In studying the paintings of Vigée-Lebrun, I noticed that she re-
peatedly reworked traditional forms and stories, claiming the role of
Dibutades, the mythical originator of painting, or posing as the heir to
Raphael or Rubens. My work here intersected with, and was informed
by, Mary Garrard's brilliant (and now classic) analysis of Artemisia
Gentileschi's *Self-Portrait as the Allegory of Painting.*[13] Garrard's work
posed for me two fundamental questions: How does a woman pictur-
ing herself as an artist disrupt accepted ideas? and How does the
woman artist fit herself into established paradigms? What seemed no-
table about Vigée-Lebrun, however, was that she continually identified
with the constructions of others, casting her self-portrayals in preestab-
lished conventions. This process of self-construction was entirely ap-
propriate, for in her day, one became someone by becoming someone
else. One became original by imitating. Yet eighteenth-century theories
of imitation did not in themselves clarify the artistic identity forged
through imitation, nor were those theories concerned with questions
of gendered identity. The artist, they assumed, was a heterosexual Eu-
ropean male, and thoroughly masculine, subject. Current theoretical
formulations helped to elucidate imitation's effects on different sub-
jectivities. Judith Butler, for example, has shown how imitation and
identification occasion the sort of crisscrossing movement across the
sexual divide that produces a complex, layered, and (apparently) con-
tradictory subject.[14] Butler's use of citation, a notion borrowed from
Derrida, is especially helpful. Butler argues that although cultural pres-
sures urge individuals to cite (or perform) the norms that legislate iden-
tity, citation is inevitably interpretation. As such it opens gaps between
the cultural text and the individual's mimicry of it.[15] In those gaps lie
possibilities, no matter how momentary, for subverting and question-
ing the very norms and laws cited.

This understanding of imitation, citation, and mimicry helped me to
interpret several of Vigée-Lebrun's works, including the self-portrait
she exhibited in 1783 (private collection; autograph copy in London,
National Gallery of Art; Figure 4) as part of a Salon debut calculated
to present her as a history painter. The work imitated Rubens's *Le Châ-
peau de Paille* (1620–25; London, National Gallery of Art), believed
in the eighteenth century to be a portrait of his wife and often taken as
an exemplar for representing beautiful women. Vigée-Lebrun's self-
portrait intrigued me because Griselda Pollock had twice used it as a
negative example of women's art.[16] To reevaluate the work, I began

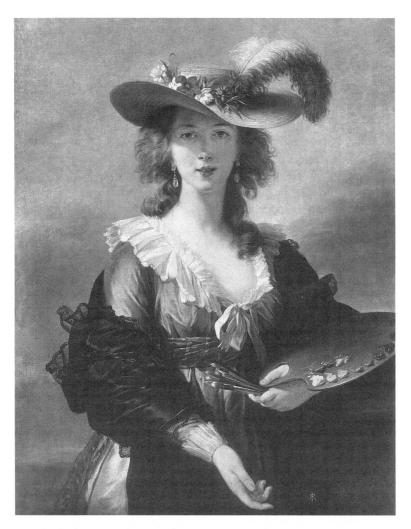

4. Elisabeth Vigée-Lebrun, *Self-Portrait,* 1783, oil on canvas

thinking about Vigée-Lebrun not only as the object of representation but also as the subject who made the representation, as both woman model and woman artist. Although such an approach might seem obvious, Pollock had argued that so strong was the image of "Woman" that it occluded any glimpse of the "artist." The comment troubled me because, as a specialist in eighteenth-century painting, I could see the artist quite clearly.

The portrait shows Vigée-Lebrun with the attributes of her art—brush and palette—and, more important, in what was by 1780 a conventional attitude for a (male) artist's self-portrait. We see her, not working at her easel, but focusing on inner vision and, at the same time, making a rhetorical gesture indicative of reason. Moreover, the apparent paradoxes of the image—for example, showing an elegantly dressed artist holding the tools of her trade—were all common in male self-portraits of the same period. Thus, certain aspects of the portrait pointed not to "woman" but to the eighteenth-century self-portrait conventions Vigée-Lebrun imitated. She was an artist at work imitating both Rubens and an accepted model of self-portraiture. A written description of the painting included in her *Souvenirs* (a self-portrayal of a self-portrait) also cast her as an artist at work and stressed the aesthetic challenge of imitating a difficult effect of light, mastered by Rubens in his *Châpeau de Paille*. Vigée-Lebrun thus depicts herself performing as Rubens, or, to use the eighteenth-century term, emulating Rubens. To emulate another artist was to try to surpass or outdo the acknowledged master, and Rubens was one of the most revered masters in eighteenth-century France. Thus the self-portrait shows Vigée-Lebrun as the emulator of Rubens even as it casts her as the one Rubens loved by borrowing elements of Rubens's depictions of his model-wife. Yet the many transformations of costume, composition, pose, gesture, dress, gaze, attributes, and so forth effectively sever any easy identification between Vigée-Lebrun and the woman Rubens depicts. Indeed, her changes also forced other associations: the costume in which she presents herself, for example, allies her to Marie-Antoinette and the queen's female friends, the so-called tribades of Trianon.[17]

Not only the work itself but its reception proved key to my analysis. Because the painting appeared in the Salon of 1783, I had a record of many contemporary responses to it, most of them written by anonymous Salon critics and pamphleteers. Those responses showed that there were many ways of reading the self-image. Far from seeing it as an unproblematic depiction of woman, as one could argue for Rubens's *Châpeau de Paille,* contemporaries understood the work as a representation of an inspired artist, one whose aspirations included history painting. Indeed, history paintings by Vigée-Lebrun (most notably her *Peace Bringing Back Abundance,* which she designated her reception piece) were on display at the same Salon and drew much comment—both positive and negative—from reviewers.

For one of the critics most closely associated with the "reform" of painting, who wrote under the name Coup de Patte, the image raised the specter of the hermaphrodite, an equivocal being of no sex. He presented his evaluation of the Salon as a conversation between a painter, a poet, and a musician. The trio pause before Vigée-Lebrun's self-portrait, and the painter is troubled because the figure's hair is a little *négligé*. The musician takes that as a sign that she has the "taste" of great artists not focused on mundane details. Addressing himself to the painter, the musician asks, "Is she a history painter?"[18] And the painter replies: "No. The arms, the head, the heart of women lack the essential qualities to follow men into the lofty region of the fine arts. If nature could produce one of them capable of this great effort, it would be a monstrosity, the more shocking because there would be an inevitable opposition between her physical and mental/moral (*morale*) existence. A woman who would have all the passions of a man is really an impossible man."[19] Thus, for our reform-minded critic, Vigée-Lebrun's self-portrait did not evoke the acceptable image of the eternal feminine. Rather, it suggested an unacceptable—even abominable—attempt to show herself a great painter, a history painter. That attempt she signaled in her distracted gaze and disheveled hair, correctly read by the musician as a sign of her affinity with masters like Rubens.

In interpreting the self-portrait, I found the traditional techniques of art historical analysis as important as the insights of contemporary theory. I compared the work with other self-portraits of the period, isolating their iconographic and stylistic features. I considered the various "sources" for the image, although I often treated them as intertextual references rather than self-conscious borrowings. Yet in the end I did not try to resolve any of these citations into a coherent picture; rather, I took seriously Butler's claim that imitation and citation produce a complex, layered, and apparently contradictory subject. Contradiction was particularly important to me, since I found the position of exceptional woman by definition contradictory. I concluded that the portrait assumed no single coherent style or posture and posited no essential identity, whether of "eternal woman" or "great artist." In her self-portrait Vigée-Lebrun identified herself all at the same time as an intimate of the queen, the painter Rubens, his beloved wife, a painted figure made by Rubens, a history painter, a hermaphrodite, an inspired artist, an intellectual making a reasoned point, a speaking subject, a beautiful woman, an immodest woman/artist pleasuring in self-display. Thus

she seems conceptually disunified, composed of discontinuous gestures or expressions, all of which are cited from other images. She is also disunified through time—presenting herself as various seventeenth- and eighteenth-century figures (Rubens, Rubens's wife, Vigée-Lebrun, Marie-Antoinette's intimate)—through position (subject, object), and through sex and gender identity. Those visual fragments and associations are framed in a coherent pictorial structure, which encourages viewers to imagine them in conformity with the dominant notion of a coherent identity, even though the image resists that reading.

Like the self-portrait in Fontana's cabinet, the image shown at the Salon of 1783 brilliantly undermines the traditions it invokes through consummate artifice. By mastering the contemporary practices of art making, Vigée-Lebrun formed her citations and imitations into a conventional pictorial structure that nonetheless challenged conventional logic. I can easily see why her work raised the sort of fear expressed by Coup de Patte, the fear that women would try to follow men into the highest realms of art. What, I wondered, could an artist with Vigée-Lebrun's talent and intelligence have achieved had she been given the freedoms and opportunities of her male colleagues? And when she performed as the emulator of Rubens, well, I imagine she was both asking that question and answering it—showing her potential as an artist. That she made many of her most compelling statements in self-portraits may be a measure less of her narcissism and more of the relative freedom the self-portrait allowed, for in that genre the artist is sometimes less constrained by the demands of sitters and markets.

If through my analysis I saw that, intentionally or not, Vigée-Lebrun's work subverted and/or remade traditional forms, I have come to envision my book as imitating that strategy. I have indeed written a monograph, insofar as a monograph is a study of an individual artist. Yet there are certain obvious differences. I assume that "artist" is a category both contested and always under construction; I organize my material thematically rather than chronologically; and I am consistently engaged with contemporary theory (in particular, feminist theory and psychoanalysis). Thus my monograph is not dedicated to the singular, original genius, and the name Elisabeth Vigée-Lebrun does not simply point to a particular artist whose will organizes and gives meaning to a unified body of work. Elisabeth Vigée-Lebrun signifies a particular historical individual, a construction of her self-representations, an imagined figure articulated through feminist discourse, and

an allegory of the exceptional woman. I used a variety of materials to make that portrait of the artist. Archival records, novels, doggerel, paintings, memoirs, pamphlets, engravings, scientific treatises, moral tracts, letters, legal codes, journals—all from the historical period—I interspersed with feminist philosophy, psychoanalytic theory, art historical analysis, literary criticism, and cultural history.

Although reviewers have consistently drawn attention to the unconventional nature of my monograph, some felt that rather than revitalizing an art historical form, it pushed art historians out of the picture: "A book that has no color illustrations, except on the cover, and a bibliography in which art historians are a distinct minority crowded out by historians, philosophers, and trendy French megathinkers is clearly not your ordinary art history monograph."[20] Yet I never meant to crowd out art historians. In fact, of the 257 secondary sources cited in my bibliography, 94 are by art historians, 57 by literary scholars, 50 by historians, and the rest by writers in other fields. Moreover, I count only 7 works by "trendy French megathinkers," and those are scattered among the many, many citations to very nontrendy French art historians, whose work of accumulating and transcribing documents, sorting through primary material, and compiling catalogues of collections and artists little known to anyone but specialists was fundamental to my own research. I do not view art historians as crowded out; rather they rub shoulders with historians, philosophers, and literary critics. I like the idea of following Michel Foucault's *Birth of the Clinic* with Joseph Raymond Fournier-Sarlovèze's 1911 monograph *Louis-Antoine Brun: Peintre de Marie-Antoinette 1758–1815.*

What I did intend to crowd out, however, were some of art history's most limiting assumptions, assumptions I am hardly alone in throwing over. They include not only myths of artistic genius and originality but also the belief that meaning is contained or fixed in a work of art and that scrupulous historical analysis can unveil the true meaning. I also wanted to jettison the interpretive strategies that hindered a feminist reclamation of Vigée-Lebrun's work. Toward that end, I imported into art history tactics I encountered in other fields of inquiry and borrowed from scholars writing about women in eighteenth-century history and literature. But most fundamental to my work were three decades of feminist art history. Clearly my work addresses the basic question Linda Nochlin posed more than twenty years ago: "Why have there been no great women artists?"[21]

If my attention to Elisabeth Vigée-Lebrun (and to other women of the eighteenth century) has strengthened my conviction that for centuries women have eroded the categories that excluded or disabled them, my work has also convinced me that it is useful to consider paintings as interpretations of other paintings comparable to, though obviously different from, analyses written by art critics and historians. Vigée-Lebrun's reworking of a portrait by Rubens, for example, is both a new work of art and an interpretation of an older one that has the power to alter how the earlier work is seen. I no longer can look at Rubens's painting without also seeing what Vigée-Lebrun made of it, and I hope that my book induces others to visualize her work even as they look at his. Such a process disrupts the singularity of any given painting, returning the work to the web of representations to which it belongs. Henceforth the two works are engaged in a dialogue whose outcome is open to interpretation. Although Vigée-Lebrun could not change the historical conditions under which Rubens's painting was made, used, or seen, she could alter its meaning for her own time and thereafter, for meaning does not inhere in the work but is continually negotiated by those who interact with it.

Since completing *The Exceptional Woman,* I have tried more consistently to take advantage of that observation and to develop a practice of subversive reading. I have used it, for example, in rereading works like Bernard d'Agesci's *Lady Reading the Letters of Heloise* (ca. 1758, Art Institute of Chicago), works whose sensual presentations of women are easily dismissed as mere fodder for the male gaze.[22] Yet in presenting a woman not only as a subject who reads but as one who reads the writing of another woman, Bernard d'Agesci's painting readily lends itself to feminist revamping. In the same way that Vigée-Lebrun re-created the body Rubens painted in his *Châpeau de Paille,* I imagine my interpretation making something different out of this seductive reader. Such a reading practice allows me to steal a few images from the canon, reinscribe them, and return them as subversive facsimiles decidedly different from the originals imagined by the artist, his patrons, or even mainstream art history. Through subversive reading, we take back the bodies of some painted women, rather than discarding them as mere signifiers of a phallocentric and phallocratic regime.

It pleases my sense of irony to root my practice in the eighteenth century and claim it as historically "accurate." Needless to say, I have negotiated earlier practices into alignment with recent feminist theo-

ries of interpretation. With Shoshona Felman, I aim to locate the "inadvertent textual [in my case, pictorial] transgression of male assumptions and prescriptions" and to amplify them by my desire and rhetorical interposition as a feminist interpreter. That interposition opens up the field of interpretation, taken as both the unique encounter with the painted image and a pragmatic act, a particular reworking of social or personal expectations.[23]

As feminist scholarship continues to urge a fundamental rethinking of the discipline, it is my hope that *The Exceptional Woman* will encourage others, especially those working on earlier centuries, to reimagine traditional forms of art historical writing and to reinvent canonical images through subversive interpretation. In pursuing such practices, we imitate the women whose lives and work we study.

NOTES

1. "*Exception,* est aussi quelquefois une dérogeance à la regle en faveur de quelques personnes dans certains cas: on dit communement qu'il n'y a point de regle sans *exception,* parce qu'il n'y a point de regle, si étroite soit elle, dont quelqu'un ne puisse être exempté dans ces circonstances particulières; c'est aussi un maxime en Droit, que *exceptio firmat regulam,* c'est-à-dire qu'en exemptant de la regle celui qui est dans le cas de l'exception, c'est tacitement prescrire l'observation de la regle pour ceux qui ne sont pas dans un cas semblable." Diderot and D'Alembert, *Encyclopédie, ou dictionnaire raisonné des sciences, des arts et des métiers, par une société de gens de lettres,* facsimile of 1751–80 edition (Stuttgart: Friedrich Frommann, 1967), 6:218.

2. Geneviève Fraisse, *La raison des femmes* (Paris: Plon, 1992), 51–54. This concept is also developed in her earlier book, *La Muse de la raison* (Aix-en-Provence: Alinéa, 1989).

3. Simone de Beauvoir, *The Second Sex,* trans. and ed. H. M. Parshley (New York: Vintage Books, 1989), 707.

4. For this assessment, see Rozsika Parker and Griselda Pollock, *Old Mistresses: Women, Art and Ideology* (New York: Pantheon Books, 1981), 96, and Griselda Pollock, *Vision and Difference: Femininity, Feminism, and the Histories of Art* (New York: Routledge, 1988), 46–48.

5. See, for example, Elizabeth Colwill, "Just Another Citoyenne? Marie-Antoinette on Trial," *History Workshop* 28 (Autumn 1989): 63–87; Lynn Hunt, "The Many Bodies of Marie-Antoinette," in *Eroticism and the Body Politic,* ed. Lynn Hunt (Baltimore: Johns Hopkins University Press, 1991); Lynn Hunt, *The Family Romance of the French Revolution* (Berkeley: University of California Press, 1992); Sarah Maza, "The Diamond Necklace Affair Revisited (1785–1786): The Case of the Missing Queen," in Hunt, *Eroticism and the Body Politic;* and Jacques Revel, "Marie-Antoinette in Her Fictions:

The Staging of Hatred," in *Fictions of the French Revolution,* ed. Bernadette Fort (Evanston, Ill: Northwestern University Press, 1991).

6. Toril Moi, *Sexual/Textual Politics. Feminist Literary Theory* (New York: Methuen, 1985), 9.

7. The problem was exacerbated because, by excluding the possibility of woman's reason, the dominant construction of woman defends itself against any assault by a "real" woman. Here, for example, is the influential physiologist Cabanis speaking about women who would claim achievement in intellectual or artistic endeavors: "For the small number of women who can obtain true successes in these categories that are completely foreign to the faculties of their minds things are perhaps worse. In youth, in maturity, in old age, what will be the place of these ambiguous beings who are, properly speaking, of no sex?" Pierre-Jean-George Cabanis, *On the Relations between the Physical and Moral Aspects of Man,* trans. Margaret Saidi, ed. George Mora, intro. Sergio Moravia and George Mora (Baltimore: Johns Hopkins University Press, 1981), 2:242.

8. Gerda Lerner, *The Creation of Feminist Consciousness from the Middle Ages to 1870* (New York: Oxford University Press, 1993), 220. Only when learned women could cluster together in informal groups, which substituted for established institutions, could an alternative vision (or feminist imaginary) begin to take root. With the recent institutionalization of women's studies, gender studies, and feminist theory in universities here and abroad, woman's resistance to patriarchy is increasingly recuperated, narrativized, and theorized.

9. Michèle Le Doeuff, *The Philosophical Imaginary,* trans. Colin Gordon (Stanford, Calif.: Stanford University Press, 1989). This English version appeared nine years after the French edition (*L'imaginaire philosophique* [Paris: Payot, 1980]) and is a careful, readable translation. See also Michèle Le Doeuff, *Hipparchia's Choice: An Essay Concerning Women, Philosophy, Etc.,* trans. Trista Selous (Cambridge, Mass.: Basil Blackwell, 1991).

10. I am suggesting that Vigée-Lebrun makes an "autobiographical pact" with the reader. For this concept, see Philippe Lejeune, *On Autobiography,* trans. Katherine Leary (Minneapolis: University of Minnesota Press, 1989), 3–30. Other works that particularly shaped my thinking include Domna Stanton, ed., *The Female Autograph* (Chicago: University of Chicago Press, 1987); Felicity Nussbaum, *The Autobiographical Subject: Gender and Ideology in Eighteenth-Century England* (Baltimore: Johns Hopkins University Press, 1989); Françoise Lionnet, *Autobiographical Voices* (Ithaca, N.Y.: Cornell University Press, 1989); and Sidonie Smith, *A Poetics of Women's Autobiography* (Bloomington: Indiana University Press, 1987).

11. "On croira sans peine que je ne fus pas tentée de suivre son conseil; peindre et vivre n'a jamais été qu'un seul et même mot pour moi, et j'ai bien souvent rendu grâces à La Providence de m'avoir donné cette vue excellent, dont je m'avisais de me plaindre comme une sotte au célèbre anatomiste." Elisabeth Vigée-Lebrun, *Souvenirs,* ed. Claudine Herrmann (Paris: Des femmes, 1986), 1:238. For a more complete interpretation of this encounter, see Mary D.

Sheriff, *The Exceptional Woman: Elisabeth Vigée-Lebrun and the Cultural Politics of Art* (Chicago: University of Chicago Press, 1996), chap. 1.

12. For an extended analysis of this problematic, see Mary D. Sheriff, *Moved by Love: Inspired Artists and Deviant Women in Eighteenth-Century France* (Chicago: University of Chicago Press, 2002), chap. 2.

13. Mary Garrard, "Artemisia Gentileschi's *Self Portrait as the Allegory of Painting*," *Art Bulletin* 62 (March 1980): 97–112. See also Garrard's essay in this book.

14. Judith Butler, *Bodies That Matter* (New York: Routledge, 1993), 104–19.

15. Ibid., 108.

16. See note 4.

17. For a fuller discussion see Sheriff, *The Exceptional Woman*, chap. 5.

18. Coup de Patte, *Le triumvirat des Arts ou Dialogue entre un Peintre, un Musicien & un Poëte sur les Tableaux exposés au Louvre, année 1783, pour servir de continuation au Coup de Patte & à la Patte de velours*, 1783, Collection Deloynes, no. 305, p. 27.

19. "Non. Les bras, la tête, le coeur des femmes sont privés des qualités essentielles pour suivre les hommes dans la haute région des beaux-arts. Si la nature en produisoit une capable de ce grand effort, ce seroit une monstruosité d'autant plus choquante, qu'il se trouveroit une opposition nécessaire entre son existence physique et son existence morale. Une femme qui auroit toutes les passions d'un homme, est réellement un homme impossible. Aussi le vaste champ de l'Histoire, qui n'est remplique d'objets vigoureusement passionnés est fermé pour quiconque n'y sauroit porter tous les caractères de vigueur." Ibid., no. 305, p. 27.

20. Ann Sutherland Harris, "Portrait of a Lady," *Women's Review of Books* 14 (January 1997): 2.

21. Linda Nochlin, "Why Have There Been No Great Women Artists?" in *Woman in Sexist Society: Studies in Power and Powerlessness*, ed. Vivian Gornick and Barbara K. Moran (New York: New American Library, 1981), 480–510.

22. This interpretation is developed in Mary D. Sheriff, "A rebours: Le problème de l'histoire dans l'interprétation féministe," in *Où en est l'interprétation de l'oeuvre d'art?* ed. Régis Michel (Paris: École Nationale Supérieure des Beaux-Arts, 2001). Another essay offers a subversive reading of Fragonard's painting *The Souvenir*: see Mary D. Sheriff, "Letters: Painted/Penned/Purloined," *Studies in Eighteenth-Century Culture* 26 (1996): 29–56.

23. Shoshona Felman, *What Does a Woman Want? Reading and Sexual Difference* (Baltimore: Johns Hopkins University Press, 1993), 6.

MOTHER LAND MISSED

THE BECOMING LANDSCAPES OF CLEMENTINA, VISCOUNTESS HAWARDEN, AND SALLY MANN

CAROL MAVOR

The landscape is teasingly slow to give up its secrets.
Sally Mann

I have just finished waiting, savoring, pushing, worrying, panting through the cycles of a book, *Becoming: The Photographs of Clementina, Viscountess Hawarden*. (I am postpartum.) Hawarden took hundreds and hundreds of sensual (I argue erotic) photographs of her adolescent daughters in the emptied parlor-turned-studio of her South Kensington home in the early 1860s. From her first encounter with photography in 1857 to her sudden death in 1864, at age forty-two, Hawarden gave birth to the last three of her eight children, while producing over eight hundred photographs. A (re)productive woman: her photographic years, like a woman's childbearing years, were fleeting. A brief life, a brief photographic career—she was almost missed altogether by history.

The first pages of *Becoming* emphasize how this Victorian photographer-mother (full of secrets) is always just missed. Hawarden and her work will always remain young, a fleeting moment marked by death and by the absence of information, mature life, images of self, and diaries. Lewis Carroll, a man who left an excess of information (letters, diaries, books, photographs) and secrets all his own, records meeting Hawarden only once (in a diary entry for June 24, 1864).[1] He mentions seeing Hawarden again one month later (in an entry for July 22, 1864), but only from a distance. Writing of that missed meeting, Carroll fore-

shadows the evanescence that now seems to characterize Hawarden: "went to call on Lord Hawarden, to get the prints I bought—& was just in time to see Lady Hawarden get into her carriage and drive off."[2] Taking many secrets with her—such as how her oeuvre would or would not develop, what she would or would not photograph after her children had grown up and left home, the significance of her focus on women and the relationships between them—Hawarden would leave this world just six months after Carroll's fleeting glimpse of her being carried off by her carriage. Leaving so much (how many other families have been so excessively documented?) and so little behind, Hawarden and her work perpetuate a state of being "just missed."

Mothers embody the state of being missed. It is a cliché to miss your mother. But it is also a cliché that you can never get all of her, that she is never fully gotten, that she is "just missed." J.M. Barrie made this Wendy's problem in *Peter Pan*. (The problem was really Barrie's problem, but that is another story.) Wendy's mother "was a lovely lady, with a romantic mind and such a sweet mocking mouth. Her romantic mind was like the tiny boxes, one within the other, that come from the puzzling East, however many you discover there is always one more; and her sweet mocking mouth had one kiss on it that Wendy could never get, though there it was, perfectly conspicuous in the right-hand corner."[3]

The British child analyst D.W. Winnicott noted how children always see their mothers as keeping something from them, as hiding secrets. In Winnicott's practical hands, the mother becomes, not an orientalized series of nesting boxes, but a mundane middle-class handbag: "Surely there is a little bit of herself that is sacrosanct, that can't be got at even by her own child? Shall she defend or surrender? The awful thing is that if the mother has something hidden away somewhere, that is exactly what the small child wants. If there is no more than a secret, then it is the secret that must be found and turned inside out. Her handbag knows all about this."[4]

I too, condemned to this state of having "just missed" Hawarden, was to learn, after staying at what had been advertised in one guidebook as Hawarden's old Irish home (in Dundrum, County Tipperary), that her "real" home was down the road. Fantasies of sleeping in the bedroom of Hawarden or her daughter Clementina, her favorite model and namesake, were snatched away. (I was at a Hawarden home, not the Hawarden estate.) And, as if that were not enough to miss, I accidentally exposed all my film of the beautiful rainy, cow-littered, ruin-

littered, snaky-rivered, pebbly trailed, green landscapes of Dundrum to light before developing. I left Dundrum with nothing more than curly gray-green-black-brown hole-notched thin translucent plastic reels of landscapes vanished, save for the few photographs taken by my traveling companion and friend Amy Ruth.

But what I intentionally missed in *Becoming* were the photographs Hawarden had taken at the family estate in Ireland. Relatively limited in number, the Dundrum photographs are seemingly unlike the supra-interiorized photographs of the girls taken at their London home, at 5 Princes Gardens. The South Kensington photographs of her adolescent daughters, posed with pretty objects from Hawarden's collection (such as an Indian traveling cabinet, a cheval glass, or a curvaceous vase) in elaborate costumes (evoking Mary, Queen of Scots, or a Spanish dancer or a concubine in Orientalized dress), picture a fetishized beauty. The details of the girls and their things emphasize the highly feminized interiority of the girls as dolls in their dollhouse home, caught by their mother's camera box. The Dundrum images are mostly of the huge ancient trees on the estate, often coupled with a daughter, who is dwarfed by the beautiful but imposing landscape, as if the grounds were an extension of her crinoline.

In one such picture, from 1858–61, Clementina, in a billowing skirt, bell sleeves, and a smart hat, is a doll to the big-tree-as-mother that guards her (Figure 5). The tree, whose leafless broken limbs anthropomorphically reach and poke, like old bones, out of the lush, lush vines that wrap *her* aging wooden skeleton, is an image of regeneration. In my eyes, Sally Mann's *Sempervirens "Stricta"* (1995) regenerates Hawarden's picture through her own particular lens: Mann features her daughter Virginia, dwarfed by the formally planted trees of Tuscany, which look to be made of dried bones, with their own dense leafy dresses (short and long) of rich spongy grassy growth (Figure 6). These mother-trees never stop drying/dying out and never stop growing. In time, Clementina will become her mother, the land that she stands on. Virginia will take her beautiful Italian bicycle down the inviting path, through the opening in the trees, spotted with a foggy light, through a Mother Land, both foreign and inviting, fecund and barren, repetitive and unpredictable, gross and delicious.

Hawarden's Irish photographs, like the London pictures, are of a circumscribed area of activity: the two bodies of work, one outside and one inside, play a stereotypically "naturalized" Ireland against a "cultured"

5. Clementina Hawarden, *Dundrum Series*, 1858–61, photograph

England. By contrast, the openness of the Irish pictures seems to intensify the confinement of the London pictures and the erotics of the passionate interiors at 5 Princes Gardens. They are two versions of motherhood: the unusual erotic (the exciting) and the usual natural (the boring).

Although I missed Hawarden's landscapes on purpose, I miss them: the trees, the river, the quarry and its rocks, the twisting paths. They are not in the book. Many of them are beautiful. More of them are boring. They are pictures of a mother land missed.

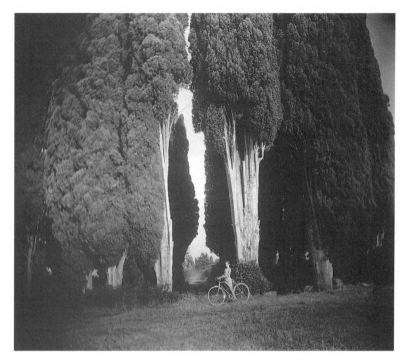

6. Sally Mann, *Sempervirens "Stricta,"* 1995, silver print

I missed them on purpose because I did not see her (or her children)
there. (Yet now, looking back, I remember how I felt Hawarden there as
I walked the paths of Dundrum, muddying the hem of my big corduroy
dress whose gathers of soft heavy fabric gave growing room to my big
round pregnant belly. I was "with child," as my artist almost always was:
"a child every year or every other year."[5] I look at another photograph
of Clementina on the Dundrum House grounds next to Amy's photo-
graph of me: I become Clementina, who is both mother and daughter:
dressed and photographed in light and dark, we touch the earth, are
touched by earth. In both pictures the mother is there, but missing.

 Perhaps I have set apart her landscapes, even landscapes in general,
in much the same way that I have set apart the boring parts of her
motherhood, and even my own. The dishes, the diapers, the endless
picking up, the folding of clothes, the sorting of toys, the wiping off of
all things sticky, making real lunches every day, eating unspicy food,
the drone of clothes dryers and dishwashers, and the anxious knock of

an overloaded washer are separate from those other parts of mother-hood that, though real, are easy to idealize. But I know I will, in that strange maternal way, miss those sticky, dirty, everyday things when the demand is no longer there. Likewise, landscapes can become an ev-eryday thing that we forget to notice. The landscape, like the mother, is there; it/she is merely (as Mary Kelly has remarked of our cultural distancing of the maternal body) "too close to see."[6]

Returning from Ireland to my home in North Carolina, I realize, with a panicked sense of loss, that the dogwoods have already bloomed. When did they come and go? How could I not have taken time to see those bright white flowers, with their pointy green leaves that make such a lovely frame for their blossomed faces of the simplest, purest, most elegant form: they are the flowers of my home. They are punctu-ated by the small, budlike, unreal dark pink of the redbuds that seem to live in honor of the dogwoods. (Redbuds are the corps de ballet that make possible the dogwood's performance as prima ballerina.) To-gether, they are dazzling. They give way to the giant magnolias of steamy summer, whose huge clean flowers boldly contrast with the rust-colored clay of our land, which resists digging as much as it anarchi-cally paints, stains, and encrusts all surfaces—our shoes, our floors. Summer turns to fall, and the last leaves turn persimmon orange, golden yellow streaked with green, fire red, crimson red, purple red, dead brown. And then all of the trees look dead. I can suddenly see houses everywhere. No longer sunk in a carpet of unnerving lusciousness, I can see where roads lead, paths go. All life seems to fade or go underground except the beauty berries—jewel-like berries, the color of the richest vi-olet velvet, that cluster on the dry sticks from which they miraculously emerge. Sometimes it snows and the beauty berries can make you cry. But although I can describe this rich scene, I have to force myself to see it. I had allowed it to become mundane.

The landscape, however, is not boring at all: it is life. If the earthly landscape gives rise to plastic roofs, power plants, chain restaurants, satellite dishes, and transmission towers masquerading as trees, it also blossoms in living plants, seeds, humus, time embodied—in sum the sensations of heaven, which I know now and feel as particularly south-ern. (Katherine Dieckmann has written, in response to Mann's com-pletely depopulated landscapes of Virginia and Georgia: "It's often said that the South is hyperbolized by those seeking a site of nostalgia and excess, a place where the sweet, humid air forever carries an aroma of

loss.... But...it's often Southerners who promote their own clichés, and every cliché contains a smidge of truth."[7] From the North, I try to be southern. I promote the clichés, in the same spirit that I promote those of motherhood.)

I work harder at learning to love the everyday aspects of the over-looked, the really boring things: landscapes, mothering, writing. I have even learned to love "that persistent but poetical Southern weed, kudzu,"[8] which smothers so many of Sally Mann's landscapes. With regard to her photograph of Georgian kudzu in Figure 7, as well as her other recent depopulated (boring) landscapes of Virginia and Georgia (so radically different from her controversial "family pictures"), Mann has commented: "They beckon me with just the right look of dispossession, the unassertiveness of the peripheral. These are the places and things most of us drive by unseeing, scenes of Southern dejection we'd contemplate only if our car broke down and left us by the verdant roadside.... Compared to the family pictures, which had the natural magnetism of portraiture, these are uncompelling."[9]

Boredom is always connected to desire, and often to the mother herself. To be bored, as a child often is, is to be without desire, in sum to be without Mother, to be on your own with nothing to do. But the child does and must learn to make desire out of nothing, without Mother's breast, without bodily attachment, through play. As Adam Phillips writes, it is critical for the adult to "hold" the experience of the child's boredom, "to recognize it...rather than to sabotage it by distraction.... The capacity to be bored can be a developmental achievement for the child."[10] Boredom, "integral to the process of taking one's time,"[11] is something to strive for: a privilege.

But I have learned from Roland Barthes that "boredom is not far from bliss: it is bliss seen from the shores of pleasure."[12] In other words, to be bored is merely to see pleasure, as one sees the shore of a utopic island from the mainland. To see pleasure is not necessarily to experience it: one must inhabit its landscape. If we understand boredom as desire for desire, then one must use the body to crack, sever, fissure boredom's shell, so as to come into the bliss that awaits us. (In Walter Benjamin's eloquent words, "Boredom is the dream bird that hatches the egg of experience."[13]) Embracing the boredom of the landscape, I am revisiting the metaphor of Mother Earth, mother nature, and our attachment to it.

Jane Blocker has written of the image of the earth as fecund eternal cycles of regeneration: "It is all womb and becoming, a rich humus for

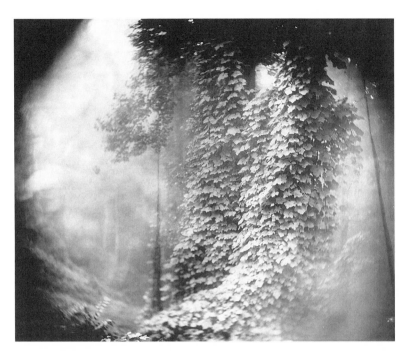

7. Sally Mann, *Untitled (Georgia Landscape)*, 1996, silver print

spontaneous and abundant growth and indiscriminate nurturing. It is also, at the same time, all tomb and decay, a crumbling and inevitable destination, the fulfillment of the process of bodily dissolution begun at the moment of separation from the mother. Earth and woman together represent both our origin and our fate. They share a sympathetic understanding of the cycles of life; indeed, they mark with their very 'bodies' the passage of time."[14]

Such cycles are linked to what Julia Kristeva has famously named "women's time." "Women's time" is apart from "father's time," apart from "history," in that it evokes "the *space* of generating and forming the human species" and is a space of repetition and eternity.[15] Father's time, a sign of alteration, destruction, finality, has its own iconographic figure: Father Time. Father Time, as Erwin Panofsky has so beautifully demonstrated in *Studies in Iconology: Humanistic Themes in the Art of the Renaissance,* has been characteristically represented since the Renaissance with a scythe or hourglass, evoking time, not as eternity and creativity (as it was evoked in classical art), but as a cooler, calculated,

clock-ticking, cultural death.[16] Recall Father Time's scary face in Bronzino's *Venus, Cupid, Folly, and Time (The Exposure of Luxury)* (ca. 1546). Eyes goggled with the pleasure of destruction, his hourglass balanced on his muscular winged shoulder, Father Time indulges in exposing Truth: love's folly. Panofsky notes, "It is characteristic of classical art that Time was only depicted as either fleeting Opportunity ('Kairos') or creative Eternity ('Aion'). And it is characteristic of Renaissance art that it produced an image of Time the Destroyer by fusing a personification of 'Temps' with the frightening figure of Saturn, and thereby endowed the type of 'Father Time' with a variety of new meanings.... Only as a principle of alteration can he reveal his truly universal power."[17]

So while alteration and finality are central to Father Time, repetition is central to "women's time"—in the "cycles, gestation, the eternal recurrence of a biological rhythm."[18] One need only think of the nursing mother, whose time is (un)structured by feedings every three hours—day and night. Likewise we imagine the earth in its seasons as a female body with its cycles. Eternity/maternity is the monumental time achieved through reproduction, in which the mother's gestating body cheats death. The belief that the body of the Virgin Mother does not die but moves from one spatiality to another, by the Assumption, mirrors this view of the maternal body as eternal. Eternity is the monumentality of the earth, always already there: Mother Earth.

The medium of Father Time is photography. Christian Metz knew this when he wrote that photography "remains closer to the pure index, stubbornly pointing to the print of what *was,* but no longer *is.*"[19] Roland Barthes knew it too when he wrote of the old wooden box cameras of the nineteenth century as "clocks for seeing."[20] Yet because photography, like the maternal body, gestates copies of itself, it is as feminized through its reproduction as it is masculinized through its scientific clockwork exactness. The famed Winter Garden Photograph that Barthes describes in his book *Camera Lucida*—a photograph of his mother at age five that moved him, wounded him, stabbed him in the heart—demonstrates this laserlike exactness by taking a tiny bit of her light (from a past moment) and delivering a magically, uncannily perfect essence of her to her grown-up son "with its own rays and not with a superadded light."[21] Poignantly, the Winter Garden Photograph is never reproduced in *Camera Lucida,* yet it reproduces itself: in Barthes's collecting of photographs; in his memories; in our own collecting of pictures; in our own memories as we conjure up the

perfect image of our own lost beloveds. It is as if, even after her death (after kissing Father Time), she (Henriette Barthes) came back home to him every time a photograph "pricked" him. In sum, Henriette was, for her son, the referent of every photograph that touched him, that gave him what he calls "punctum." And he was her photo-graph (written by the light of her eyes), her little man-boy, her copy, despite their material difference. To be "tied to the apron strings (of a mother)," says the *Oxford English Dictionary,* is to be "wholly under her influence." Barthes could not escape her hold, nor did he desire to: he was and photography is, despite Father Time, eternally "umbilically" tied to a feminized maternalized body.[22]

Mann, as that other mother-photographer who is linked to Hawarden (by my book and by history's strange, magical umbilical cord, which puts young bodies into ancestral wombs of the past), mimics this maternal eternal time of the photograph (its very condition) with an emphasis on earth. While it is easy to make such a claim about her photographs of Virginian and Georgian landscapes, shown recently in the exhibition entitled *Mother Land,* one might say that her pictures have always held the repetition and eternity of "women's time."

Perhaps Mann most urgently beckons play with "women's time" in her photographs of her daughter Virginia, for the name *Virginia* evokes Mann's mother land (her home state of Virginia), her childhood caregiver who was like a mother to her (a grand old woman named Virginia Carter), and her daughter. As Mann writes in the introductory pages of *Immediate Family,* the famed "family album" made public:

> I have lived all my life in southwestern Virginia, the foothills of the Blue Ridge Mountains. And all my life many things have been the same. When we stop by to see Virginia Carter, for whom our youngest daughter is named, we rock on her cool blue porch. The men who walk by tip their hats, the women flap their hands languidly in our direction. Or at the cabin: the rain comes to break the heat, fog obscuring the arborvitae on the cliffs across the river. Some time ago I found a glass-plate negative picturing the cliffs in the 1800s. I printed it and held it up against the present reality, and the trees and caves and stains on the rock are identical. Even the deadwood, held in place by tenacious vines, has not slipped down.
>
> Ninety-three years separate the two Virginias, my daughter and the big woman who raised me. The dark powerful arms are shrunken now, even as the tight skin of my daughter's [arms] pucker[s] with abundance. But, still, it seems that time effects slow changes here.[23]

Virginia is everywhere in *Immediate Family*. In *The Two Virginias* #1 (1988), Mann's daughter Virginia sits next to her ancient name-sake, Virginia Carter; she is wearing a too-small cotton dress with appliquéd flower, lacy trim (passed down? new?); it is the dress that girls since the 1950s have worn, still wear. In *The Two Virginias* #2 (1989), ancient Virginia wears a wrinkle-free gingham dress, a sweater with its own flowers. Her aged and aging arm prompts my memory of the aging skin of my own grandmother and that of the loving grand-mother in *Swann's Way* "which with age had acquired the purple hue of tilled fields in autumn."²⁴ Her arms, which certainly as a child must have "puckered with abundance," are very different now, no longer like the dimpled skin of little Virginia, whose right middle finger touches her namesake's old wicker chair but not her, and whose chubby left hand touches the persistently peeling fragile porch paint (old skin over brittle bone-dry wood). These old arms are like the great aunt's infusion of lime blossoms that Proust describes in *Swann's Way*: "having lost or altered their original appearance," they now re-semble "the most disparate things, the transparent wing of a fly, the blank side of a label, the petal of a rose . . . piled together, pounded or interwoven like the materials for a nest."²⁵ Two years later, in *The Two Virginias* #4 (1991), the two Virginias sleep together in one nest, as if dead: the young Virginia in the heavy sleep of a child, the elderly Virginia in the light sleep of the old. Ancient Virginia's white hair is once again the hair of her baby days, soft loose curls, "like souls, re-membering, waiting, hoping."²⁶

And even when neither little nor ancient Virginia is there, Virginia as leaves, earth, mountains, mud, stick, squash, morels, dead squirrels, field, yard eggs, dead deer, crabs, and river is there. (Virginia as mother land gives birth to Mann's son Emmett in *The Ditch*, 1987.)

Harder to look at than the family picture of *Immediate Family*, or the erotic pictures of Hawarden's daughters in fancy dress, or even the images by both photographers that feature a child dwarfed by en-croaching land and a Brobdingnagian tree are Mann's and Hawarden's landscapes with no children at all.²⁷ I place Hawarden's Irish landscape of the River Multeen (Figure 8), whose winding way is mimetically suggested by the fence, the shadows of the fence, the path, the branches of the trees, and the (unseen) roots of the trees, which drink from the river's waters, next to Mann's Virginian river and trees (Figure 9).

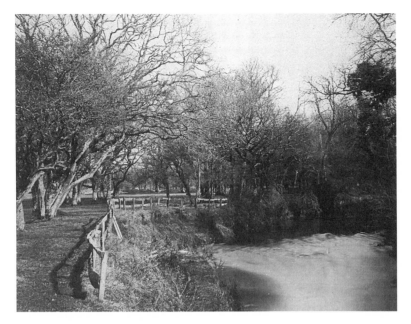

8. Clementina Hawarden, *Untitled*, 1857–64, photograph

Their waters inform each other. I seize on the universality of land-scapes, here and elsewhere, now and then. I think about the taste of water, what gloomy waters hold, what floats on water, how I want to live in Dundrum, in Virginia, in the fantasies of pure quiet, wetness, and damp earth that they induce in me. I am learning from Sally Mann to see what has perhaps been too close to see.

Printed with a view camera, with old and flawed lenses, using the wet collodion process of the masters of the nineteenth century, soak-ing prints in tea—Mann's landscapes of Mother Land are unabashedly nostalgic. The word *nostalgia* is derived from the Greek *nosos* ("return to native land") and *algos* ("suffering" or "grief"). "Nostalgia" is mother land missed. But the title of my essay also has a double mean-ing. Mann's Mother Land (and, in turn, Hawarden's) is not just a long-ing for the past; it is also a lesson forward: it teaches us not to over-look the landscape, which I had, personally, missed before.

Looking at Hawarden's landscapes through the lens of Mann's words and pictures, I begin to feel compelled. "It's not that they are easy to take or look at."[28] They are not. Their boredom is their achievement

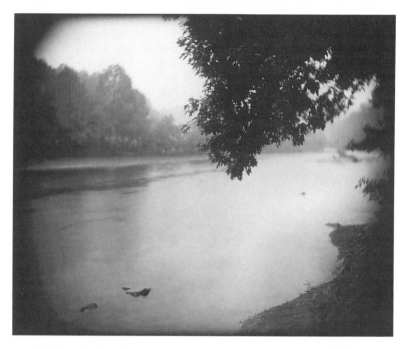

9. Sally Mann, *Untitled (Virginia Landscape)*, 1995, silver print

and mine. "The landscape is teasingly slow to give up its secrets," and I am learning to like the wait.

NOTES

1. Lewis Carroll's secrets have captivated scholars for years, prompting such questions as: Why did Carroll suddenly quit photography in 1880? Did he really ask Alice Liddell, the real little girl of *Alice in Wonderland* fame, to marry him? Was Carroll's relationship with little girls more than play and picture taking? What kind of "more"? What was at the heart of the scandal between Alice's mother and Carroll?

2. Lewis Carroll [C. L. Dodgson], "Private Journal," diary entry for July 22, 1864, British Museum, Add. 54343.

3. J. M. Barrie, *Peter Pan* (New York: Bantam Books, 1985), 1–2. The novel was first published under the title of *Peter and Wendy* in 1911. The play *Peter Pan* was written in 1904. For a critical history of the differences between the play and the novel see James Kincaid, *Child-Loving: The Erotic Child and Victorian Culture* (New York: Routledge, 1992), and Jacqueline Rose, *The*

Case of Peter Pan: Or the Impossibility of Children's Fiction (Philadelphia: University of Pennsylvania Press, 1993).

4. D. W. Winnicott, *Talking to Parents,* ed. Clare Winnicott et al. (Reading, Mass.: Addison-Wesley, 1993), 72.

5. Marina Warner, "The Shadow of Young Girls in Flower," introduction to *Lady Hawarden: Studies from Life, 1857–1864,* by Virginia Dodier (New York: Aperture, 1999), 6.

6. Mary Kelly, in an interview with Hal Foster entitled "That Obscure Subject of Desire," in *Interim* (New York: New Museum of Contemporary Art, 1990), 55; reprinted in Mary Kelly, *Imaging Desire* (Cambridge, Mass.: MIT Press, 1996), 170.

7. Katherine Dieckmann, "Landscape and the Suspension of Time," *Village Voice,* October 21, 1997, 50.

8. Ibid.

9. Sally Mann, "Correspondence with Melissa Harris," *Aperture* 138 (Winter 1995): 2.

10. Adam Phillips, "On Being Bored," in *On Kissing, Tickling and Being Bored: Psychoanalytic Essays on the Unexamined Life* (Cambridge, Mass.: Harvard University Press, 1993), 69.

11. Ibid.

12. Roland Barthes, *Pleasure of the Text,* trans. Richard Miller (New York: Hill and Wang, 1975), originally published as *Le plaisir du texte* (Paris: Éditions du Seuil, 1973).

13. Walter Benjamin, "The Storyteller," in *Illuminations: Essays and Reflections,* trans. Harry Zohn (New York: Schocken, 1968), 91.

14. Jane Blocker, *Where Is Ana Mendieta? Identity, Performativity, and Exile* (Durham, N.C.: Duke University Press, 1999), 65.

15. Julia Kristeva, "Women's Time," in *The Kristeva Reader,* ed. Toril Moi (New York: Columbia University Press, 1986), 190. First published as "Le temps de femmes" in *33/44: Cahiers de recherche de sciences des textes et documents* 5 (Winter 1979): 5–19.

16. Erwin Panofsky, "Father Time," in *Studies in Iconology: Humanistic Themes in the Art of the Renaissance* (New York: Harper and Row, 1962), 69–94.

17. Ibid., 93.

18. Kristeva, "Women's Time," 191.

19. Christian Metz, "Photography and Fetish," *October* 34 (Fall 1985): 83.

20. Roland Barthes, *Camera Lucida: Reflections on Photography,* trans. Richard Howard (New York: Farrar, Straus and Giroux, 1981), 15. Originally published as *La chambre claire* (Paris: Éditions du Seuil, 1980).

21. Barthes, *Camera Lucida,* 81.

22. Barthes uses maternal metaphors in relation to photography throughout *Camera Lucida.* He specifically uses the metaphor of the "umbilicus" twice: see 81 and 110.

23. Sally Mann, *Immediate Family* (New York: Aperture, 1992), unpaginated.

24. Marcel Proust, *Swann's Way, Remembrance of Things Past,* trans. C.K. Scott Moncrief and Terrence Kilmartin (New York: Vintage, 1989), 13. More recently, as anyone familiar with Proust will know, the title has been translated as *In Search of Lost Time.* For an understanding of the appropriateness of this translation see, among others, Julia Kristeva's *Time and Sense: Proust and the Experience of Literature,* trans. Ross Guberman (New York: Columbia University Press, 1966), first published as *Le temps sensible: Proust et l'expérience littéraire* (Paris: Éditions Gallimard, 1994), and Mieke Bal, *The Mottled Screen: Reading Proust Visually,* trans. Anna-Louis Milne (Stanford, Calif.: Stanford University Press, 1997), from the French manuscript "Images proustiennes, ou comment lire visuellement."

25. Proust, *Swann's Way,* 55.

26. Ibid., 50.

27. Brobdingnag is the place of Gulliver's second voyage, where everything is so gigantic as to make his normal size appear like that of someone from Lilliput.

28. Mann, "Correspondence with Melissa Harris," 24.

"A SERMON IN PATCHWORK"

NEW LIGHT ON HARRIET POWERS

GLADYS-MARIE FRY

Since I first began writing about the African American quilter Harriet Powers in the early 1970s, interest in her life and work has greatly increased. She has been the subject of numerous essays, a book for children, and an off-Broadway play by Grace Cavaleri entitled *Quilting in the Sun*. In addition, a good deal of information about her life has come to light as the result of a project, dedicated to her, that was undertaken jointly in 1993 by the University of Maryland and the Smithsonian Institution. That project's research has given substance to a biography hitherto short on even the simplest facts. The quilts themselves have been the subject of wide-ranging discussions. Scholars in conference and in print have explicated the meaning of Powers's work. Generally, they have seen in it evidence, on the one hand, of a highly religious Christian woman using her art to spread her faith and, on the other, of a clever artist who used Bible stories to introduce into her work African images and ideas that might otherwise have been forgotten. This discussion is likely to continue for some time as who Harriet Powers was emerges. The consensus is that Powers was an artist of considerable power and ingenuity, altogether worthy of the critical attention she has received. Seldom has a quilter been so much discussed, puzzled over, and revered.

For all this interest and activity, little written material by people who actually met Powers exists, and what there is must be considered in light of attitudes toward African Americans held by most southerners in the late nineteenth and early twentieth centuries. The most authentic material is a description of Powers and the first of her two "Bible quilts" by Jenny Smith, an art teacher who lived in Athens, Georgia, a town near Powers's home. It was Smith who first came into possession of a Powers work and who brought the quilter to the attention of the art world.

An article by Lucine Finch, "A Sermon in Patchwork," which appeared in the October 28, 1914, issue of *Outlook Magazine*, provides another, in some ways even more provocative, look at Powers.[1] It not only provides a word portrait of the artist but also comments briefly on the meaning of the Bible quilt panels. It thus represents an important extension of the Harriet Powers legacy. In this essay I would like to discuss exactly what Finch's essay has added to our knowledge of this unusual quilter and to give some background on the article's author, who is almost as elusive as Powers herself.

THE QUILT CHANGES HANDS:
THE JENNY SMITH CONNECTION

The Harriet Powers story, as the world knows it, began on one remarkable day in 1891, when Powers and her husband, Armistead, made their way by oxcart from their Clarke County, Georgia, farm to the university town of Athens. With them, carried in a crocus sack, was Powers's first quilt, which she intended to sell to Jenny Smith, a teacher at Athens's Lucy Cobb Institute, a school for girls. When after a period of increasing prosperity for the Powers family times had suddenly grown hard, Powers remembered an offer she had had from Smith to buy the quilt, which Smith had seen in 1886 at an agricultural fair. According to Jenny Smith's written record, she purchased the quilt for five dollars, though the asking price was ten—an indication of how desperate the Powerses must have been for money. That it was difficult for Powers to part with the quilt is evident, for she returned to the Smith residence on several occasions to see it. In the course of these visits she explained something of the panels' meaning to Smith, who, luckily for future art historians and folklorists, recorded those explanations.[2]

In 1895, Smith exhibited the quilt at the Cotton States and International Exposition in Atlanta, where it attracted the attention of faculty

wives at Atlanta University. Several of these women, struck by the originality and beauty of the quilt, commissioned Powers to make a second. That second work eventually came into the possession of the Museum of Fine Arts in Boston, its current owner. The one bought by Smith, now housed in the Textiles Division of the Smithsonian Institution, represents the only other surviving work from the artist's hand.

Smith was curiously negligent about the quilt she had gone to such trouble to buy. Her meticulous will made no mention of it. According to her executor, Hal Heckland, the quilt was included among the "odds and ends" of her estate. It was Heckland who eventually donated the quilt to the Smithsonian Institution, along with a sixteen-page letter by Smith describing the quilt and the *Outlook* article by Lucine Finch.

A BRIEF OVERVIEW OF HARRIET POWERS'S LIFE AND HER ARTISTIC INSPIRATION

Jenny Smith knew little about the quilter who had surrendered her masterpiece, but in its outward circumstances, as far as we know, Powers's life was not highly unusual for a woman of her race and time. Powers had been born a slave on October 29, 1837, and often talked to her patron about the days before the Civil War—a topic undoubtedly common in conversations between southern whites and blacks at the time. Like most former slaves, Powers was illiterate but generally shrewd in her business dealings, as various deeds and contracts in her name show. After 1894 she and her husband separated, and thereafter she lived independently in the country, paying her own taxes and perhaps earning her living as a seamstress.

Unfortunately, with advancing age, her income so declined that when she died at age seventy-four, in 1911, her estate was much reduced from what it had been ten years before. Like most African Americans of her era, she had worked hard all her life and had done whatever was necessary to raise her family in a society that placed little value on the lives and fortunes of African Americans. Certainly she could never have expected that her world and her artful quilts would one day be the focus of so much attention.

The Bible quilt (Figure 10) that Jenny Smith purchased was an interesting and ingenious combination of Bible stories, African motifs, and meteorological phenomena like the spectacular Leonid Star Shower of 1833 that had become part of African American folk mem-

ory. The quilt was constructed using the appliqué technique, a quilting method popular during the period, in which precut figures are sewn onto a blank background. The quilt contains eleven panels, or framed narrative scenes, in which Powers captures the stories of Bible characters like Adam and Eve, Jacob, Satan, and Jesus. Over half the panels are devoted to the story of the Garden of Eden, and the life of Jesus figures in several others.

The African element in the quilt can be seen in its design, its construction technique, and its use of narrative. The work in fact resembles the tapestries of the Fon people of West Africa, who also used the appliqué technique extensively. The Fon tapestries feature figures sewn onto a black or gold background, many of them animals that were totem representations of eleven significant kings. Perhaps because they are not portraits of real animals, these figures are pictured in unusual colors like green, blue, purple, and white and at times have an abstract quality. At the same time, the Fon tapestries illustrate well-known stories or proverbs in the Fon culture. Powers makes extensive use of uniquely realized animal figures and, like the Fon with their stories of the kings, presents in pictorial form Old Testament stories that had become part of the African American oral tradition. Finally, the astronomical bodies in her panels have, along with their connections to the folk history of African Americans, distinct African associations. The sun, which figures prominently in both her quilts, for instance, is an African symbol for the concept of circularity and the omniscience of God.

LUCINE FINCH: A SECOND EYEWITNESS

The African roots of the quilt were not known to Jenny Smith or to any other white viewer until recent years, when scholars of African art, looking at Powers's work, immediately associated it with figures and signs familiar to them from their research. Certainly those roots were not known to the Alabama writer Lucine Finch when three years after Harriet Powers's death she published her article about the Powers quilt. Lucine Finch was, however, acquainted with African American folkways. Her mother, Julia Neely Finch, was a well-known collector of "mammy songs," and she herself would write a series of vignettes featuring former slaves she had known. She and Jenny Smith, the sole eyewitnesses to the Harriet Powers story who committed their views to

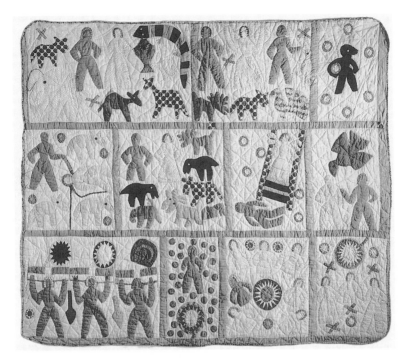

10. Harriet Powers, Appliqué quilt, ca. 1886

paper, were similar in several interesting ways. Both were well born and well bred: Jenny Smith's father had been a successful cotton buyer in Athens, and Lucine Finch came from a distinguished Birmingham family. Both were unmarried artistic ladies who supported themselves through their art. They may well have met through Smith's brother, Wales, a popular journalist on a Birmingham daily, and it is possible that Jenny introduced Lucine to Powers.

Lucine Finch was younger than Jenny Smith, and her artistic ambitions were equally high. Smith had studied art not only in distinguished schools in America but in Paris. Finch's first love was music, and she was sufficiently good at it that she gave regular concerts, including one in Carnegie Hall in February 1919. A letter to her mother stresses her excitement about not only the performances but the money she would be paid for them: "Well, tomorrow is the eventful day when I make my first $150 fee for an hour's recital!!!" she noted brightly. "The next night I have my one at Carnegie Hall, for which I hope to make $50."[3] In the same letter she speaks of a manager pressing to represent her—

an indication of how seriously she was being taken in some quarters. But while she continued giving recitals well into the 1920s, even going on regular tours, her repertoire was, by her own admission, limited, and over time her engagements dwindled.

Lucine Finch seems to have been one of those individuals who had, by any normal standard, outstanding talents in many directions, but none of sufficient quality to bring sustained recognition. As with music, so with her writing. She published poetry, short stories, and the previously mentioned series of vignettes called "Slaves Who Stayed" but only two books, which earned her no notable critical or popular success. She was also deeply interested in drama—one of her books had been a play in verse—and in addition to her concert work, she was paid to stage dramas in the wealthy suburbs of Connecticut. There, though herself far from wealthy, she spent the decade, eventually opening a shop to supplement her income. During the 1920s Finch also took responsibility for her ailing mother, from whom she refused to be parted.

THE FINCH INTERVIEW AND ITS LIMITATIONS

Finch's article on Harriet Powers in *Outlook* shows Finch to have been a southern-bred woman of her time—more than a little patronizing about the mental and emotional qualities of African Americans. The article begins with a general regret that " 'the old timey' Negro"—in other words, the former slave—was disappearing. The author takes Powers to be a good example of such a "Negro" and adopts the liberties one might expect. She does not give the circumstances of the interview, the background of the subject, or a physical description of her. Lucine Finch never identifies Powers by name, referring to her simply as an "aged Negro woman," and she sees the quilt, not as a work of art, but only as the "reverent, worshipful embodiment of an old colored woman's soul." Undoubtedly, the maker's reverence and worshipfulness *are* part of the quilt's power, but much that Finch takes for granted looks like artful camouflage on the quilter's part. What the white interviewer sees, for instance, as unintentional humor is, to the modern onlooker, a quality of whimsy consciously built into the work. Indeed, throughout the article, the reader is aware of many hesitancies and quiet evasions in Powers's words and expressions that the writer misses entirely.

HARRIET POWERS DISCUSSES HER QUILT

The article in fact reveals Powers's attitudes and personality. After the introduction it proceeds to the eleven panels of the quilt and Powers's comments on them. These comments are written in dialect—at the time practically a literary convention in transcribing the words of African Americans—but the ideas are precise. Powers presents herself as an artist working out of the deep sense of personal humility many first-rate artists feel in approaching their work, of thankfulness for the art-work as a given—as received rather than produced—and of herself as a channel through which a greater power was speaking. She says that her intention was to "preach de Gospel in patchwork, ter show my Lawd my humility." In other words, the oral tradition of the African American slave, through which all religious beliefs and legends were communicated, is transmuted into the rich African American visual tradition. Moreover, in the patchwork—pieces of fabric otherwise un-usable—the quilter finds a fitting metaphor for herself as the humble individual willing to offer herself and her talents to a great task.

Could this humility have been a pose? Possibly, considering the skill southern African Americans achieved in communicating self-efface-ment in the presence of whites. Yet the religious feeling Powers brought to her work is undoubtedly genuine, and much of it must have been ev-ident in her life—one of her sons, we know, became a minister. What-ever her intent in construing her claim and her metaphor, however, she establishes here yet another important characteristic in her makeup—a highly poetical sense of language. She discusses her work pithily and at times cryptically in the article and in her metaphors gives evidence of that abstract quality of mind that is clearly visible in her designs. But she also remarks, with more than a hint of the prophetic in her voice, that the quilt will not simply tell a story but make plain an event of uni-versal importance. Having established herself as the humble artist, she feels empowered to enter onto a great theme: "Dis heah quilt gwine show where sin originated, outen de beginnin' uv things"—the five panels of the Garden of Eden story.

Powers's references to the first panel show her keen sense of humor, some of it directed at herself, but also the care with which the quilt has been wrought. Lucine Finch praises her fine stitching but must have been surprised at the meaning invested in every figure. Even the small-

est item is significant. Powers knows exactly why a figure was portrayed in a certain way. For instance, the devil, in the form of a snake, is presented with feet—an obvious reference to God's curse on the snake in the Book of Genesis, that it would, forever after the events in the Garden, move on its belly. The reason given for the feet is humorous but not without serious implications: "ter get aroun' man, chile." Here is our first indication of how very aware Powers was of the symbolic quality of her work. The feet are not merely feet but a sign of guile, which itself points, in a later panel, to even more mysterious and terrible qualities of the devil.

In the same panel, Powers illustrates "forbidden fruit, or original sin." The figure with which she represents original sin is a dressmaker's form (drawing from the astute Miss Finch an exclamation point). Here the form signifies not only the vanity through which Eve is traditionally supposed to have been seduced by the devil but also, with deliciously comic and ironic effect, Powers's own talents as a seamstress. Asked about the intricate trimming around the neck, Powers responds that it was designed "to ketch de eye er mortal man." That is one of the aims of her quilt as well, indicating that catching the eye of mortal man was, at the least, a morally ambiguous act. The next panel continues the symbolism and the moral message. It represents Adam and Eve in the presence of a peacock, added to symbolize "dey proudness befo' de fall"—an extension of the idea of the dressmaker's form. Interestingly, the dressmaker's form and the peacock are female and male symbols respectively—a hint that Powers might not have been content with the traditional view of the Fall as the consequence of Eve's sin alone. Where there is iniquity in the story, there is also equity. Not for the first time in the quilt, Powers steps forth in feminist guise.

The third panel is one of the quilt's most striking. It represents "Satan in de Seven Stars," the seven stars being the Pleiades. Shorn of his creaturely mask in the Garden, the devil appears in his real form—a black figure with one pink eye ("sinister in its effect," Finch comments). The movement from the local event in the Garden to the dominant place of evil in the universe here goes back to Powers's intention of explaining how evil sprang from the beginning of things. She is not entirely forthcoming about this figure, however. The devil's "yuther eye is behin'" and "wusser 'n dis one," she says. Asked to explain why Satan is holding one of the stars, she replies, "Dar ain't no tellin' dat, chile; no tellin' dat." Such is the weight of meaning of all the other

figures in the panels that Powers probably could have given a direct answer had she so chosen. Perhaps she only wanted to exaggerate the mystery of the figure, perhaps she was commenting on the ultimate unknowability of the great powers of the universe, perhaps she was working out of a symbolism (rooted in African lore) that Lucine Finch would not have understood. Or perhaps she knew that to explain too much about a work of art is to risk explaining it away. One of her most powerful figures, in any case, remained her secret, and remains so to this day.

Panels 4 and 5 focus on the story of Cain. Powers establishes firmly here a major part of her color scheme: positive figures (like Abel) are portrayed in white, and negative or at least morally ambiguous ones (like Cain) in what Lucine Finch calls "drab" or black. Abel also has sheep, which are sewn in white. Along with the small doves pictured in the first two panels, we see here the visual interconnections in the panels that lead up to the appearance of Christ the Lamb, as well as the Holy Ghost. Of Cain's slaying of his brother, Abel, Powers remarks that the stream of blood from Abel's death wound is "flowin' over de whole worl'." In other words, Cain's act ushers death into the world, just as Christ's crucifixion and resurrection later bring in life, attained through the shedding of his blood. In such instances, Powers proves that she is theologian enough to know that the Creation story, in Christian belief, prefigures Christ's coming. It is no small matter, however, that the color white in much African symbolism is associated with the supernatural. Further, in panel 5 we see another possible African symbol: the lion, associated with Cain, according to Powers, "fer to prove de strength of Cain." Such use is reminiscent of the Fon tapestries, where animals are portrayed not for their own sake but as totems of kings.

Panel 6 shows Jacob's wrestling with the angel in a dream. Powers whimsically remarks about the spotted ladder: "I couldn't turn myself loose in color, honey! De animals' calico 'blige ter run over in de ladder. Dar wa'n't no yuther way." This explanation provides yet another instance of Powers's artistic eye at work. It reminds us that she makes two kinds of statements about the quilt in the article: the first is about meaning, related to the traditional Christian story, at which we are invited to experience wonder; the second is about craft. The first falls into the category of mystery; the second, of knowledge. Powers is never more sure of herself than when she explains why she adopted a certain

color or design, saying flatly that there could be no other approach to the subject. But there is yet another arresting feature of this panel: the angel with whom Jacob wrestles is female. Quite apart from the possibility that the angel is an anima figure, Powers again takes a proto-feminist stance, countering traditional illustrations of such angels as male. Panel 6 also operates as a bridge between the story of the Fall in the Old Testament (panels 1–5) and the story of Christ in the New (panels 7–11). The choice of subjects for the panel is particularly apt because it shows man at odds with God as the result of the Fall, summing up the entire human experience from Adam to Jesus in one panel—a remarkable example of Powers's narrative economy.

The five panels presenting the life of Christ, in contrast to the Old Testament story with its linear development, dispense with chronology. They are ordered as follows: Christ's baptism, the crucifixion, Judas's betrayal, the Last Supper, and a portrait of the Holy Family. Powers carefully chooses her emphases to balance the older story. For instance, the baptism, in which the dove of the first two panels reappears, symbolizes the rebirth of the spiritual in the world, severed by the events of the Fall. Powers says that "de dove is kissin' him, an' John a-leadin' him by de han' like a chile," stressing not only Christ's renascent spiritual quality but also his humility, which stands in such contrast to the pride of Adam and Eve in panels 1 and 2.

Panel 8, the crucifixion, counters the image of Cain's killing of Abel. Powers sews three suns into this panel to show the various stages in the event. Lucine Finch, quoting Powers, says, "First it [the sun] is black, the rays white, when 'darkness come over de worl' in dat minute.' Then it is white, 'when de good Lawd accepted,' and then turned to blood." Also in red is the wound in Christ's side. The phrase "when de good Lawd accepted" hearkens back to the initial dispute between Cain and Abel, which revolved around a sacrifice; God accepted Abel's sacrifice and rejected Cain's, just as here Christ's sacrifice is accepted. Powers makes one remark that seems to baffle Finch: "Wipe it out in de worl', wipe it out in de worl'." Yet these words are not so difficult to interpret: the "it" is original sin and its sign, the blood shed by Cain; Christ's blood has come to "wipe out" the stain of both sin and Cain's villainy. Powers was not, as Miss Finch assumes, being mystical.

The ninth panel shows Judas with his thirty pieces of silver: the man of sin, the human equivalent of the devil in the third panel. Referring to the silver coins, Powers says, "Missy Coomby counted 'em for me. Cos

I kin count 'em backwards same as I kin count 'em forwards, an' dat ain' no way to count!" I have been unable to identify "Missy Coomby," but the notion of counting backward is part of the folklore associated with witches and conjurers. To do anything backward is to upset the proper order of the world for evil purposes; thus counting backward is "no way to count." Further strengthening the identification of this panel with panel 3, Powers produces a disk at the bottom, representing the "whole worl' wid sin on top of it."

Lucine Finch's discussion of panel 10, the Last Supper, marks the last time we hear Powers's voice. Once again, she is concerned with the design elements of her quilt: "I giv' de Lawd a plate," she says. "I couldn't spare no plate for de 'ciples." This seems a small point indeed, but great works of art are made of many small points considered. In such comments we see the working out not only of Powers's meticulousness—also represented, for instance, by the fineness of her stitches—but also of her keen ability to see the relation of parts to the whole and to use symbols precisely. Christ alone has a plate because he is the true feast of the Last Supper from which all will feed. As always, her artistic economy is striking.

The final panel presents the Holy Family, the antitype of the family of Adam and Eve. What begins with a family ends with a family. The individuals who produce the beginning of history are replaced by individuals whose appearance heralds history's end. A certain circularity is involved, though the idea of loss and restoration is foremost.

Lucine Finch's article ends at this point, rather sentimentally, as she notes her own "wistfulness" in the presence of the quilt and her view of it as deriving from the "unbidden pathos" of the "deep heart" in all its sincerity. As I have tried to show, however, there is much more involved. Powers's comments both reveal her personality, invisible until the recovery of Lucine Finch's article except for what could be inferred from her quilts, and show how her mind worked—its basic generosity and its ability to deal with dramatic and complex events in concise form.

Since the 1970s much has come to light about Harriet Powers. The layers in which her life had been concealed have slowly been peeled away. Her life, family, and background are now, to a greater extent than ever before, accessible. But there is still much to learn and much work still to be done. For example, I have suggested that Harriet Powers may have encoded African images into her quilt. If so, for what pur-

pose? Was she engaged in Africanizing Christianity? Was the quilt really a visual means of passing on oral material about an African belief system? Did Harriet Powers fill a role in the African American community apart from her apparent roles as mother, good Christian, and quilt maker? In investigations of this kind, one hopes, the core of the Powers story will be revealed.

A SPIRITUAL CONNECTION

I would like to conclude this essay with some personal thoughts and experiences related to the Powers Bible quilts. I really do not remember the exact date—though the year was 1972—when I first saw the Smithsonian-owned quilt. What I do remember is making a routine visit to the National Museum of American History and noticing an extraordinary quilt hanging alone on the museum's second level. The inscription read simply:

Made by Harriet
An ex-slave
Athens, Georgia

Here was the quilter's entire life summarized in three lines! But I thought how sad it was that the person who had made this wonderful art was not even identified by her last name.

When I returned to my normal routine, I did not forget "the quilt" and began visiting it regularly every Saturday afternoon. Fortunately, there was a bench in front of it, so I could sit, take in a full view of the work, and meditate on it. These were truly mystical experiences. I felt drawn to the quilt. But so many questions swirled in my mind: Who was Harriet? What was her history? How much was known about her life? What was her last name? Did she make any other quilts that had survived? If so, where were they? What did this extraordinary woman look like? When did she live?

My interest in Harriet Powers became more focused that same year as I prepared to present a paper to the American Folklore Society on her and another African American quilter. The summer before my paper was due, I made a routine business trip to Boston, where, finding myself with a free afternoon, I visited the Boston Museum of Fine Arts. After viewing the museum's permanent collection and perusing the gift

shop, I asked at the information desk if the museum owned any African American quilts, and, even more boldly, whether I could see a textile curator. When the curator appeared, she responded to my question about the quilts by saying, "Yes, we have several. The most important one was made by Harriet Powers." It took a few minutes for me to connect the Harriet of the Smithsonian to the Harriet Powers of the Boston museum, but when I did, I exploded with inner excitement: "There is another quilt! I have a last name!" And then the curator said, "Would you like to see it?"

She took me to a storage facility on the museum's lower level. There I watched as she removed the quilt from a box and from its acid-free paper. I am not sure I was breathing while watching this process. But at last the quilt was spread out on a worktable and I was handed a pair of white gloves. Then the curator said, "I have to return to make an important phone call. Do you mind staying here by yourself for a few minutes?" At that she left, and, alone now, I touched the quilt, felt the raw, unprocessed cotton inside, looked closely at the various pieces of calico and other types of fabric Harriet Powers had used, and examined her quilting stitches, which I observed were fairly large to accommodate the raw cotton in the middle layer. My thoughts tumbled over each other. Harriet Powers's hands had touched this fabric, composed this square. The connection I felt with her at that moment was mystical. Then the curator returned. As I left, I remember thanking her for agreeing to see me on an unscheduled visit, but my mind was in a daze. "There are two of them! There are two of them!"

I presented my paper at the Folklore Society in Nashville, Tennessee, in the fall of that year, showing images of quilts by both Harriet Powers and Clementine Hunter (a Louisiana folk artist), as well as the animals in the Fon tapestries that resembled those of both artists. I had even visited the Benin embassy in Washington, D.C., to photograph its collection of tapestries, including one of a magnificent peacock. Once I had given the paper, I put Powers temporarily out of mind. But it seems that she was not through with me. During Christmas vacation in 1974, my telephone rang unexpectedly. I had an unlisted number, known only to family and friends, and the call came at a time of day, noon, when I was seldom home. The call was from the Georgia Council for the Arts asking me if I would be interested in coming to Athens, Georgia, for two weeks to research Harriet Powers's life—all expenses paid. The end product of this research would be an essay in a mono-

graph to be entitled *Missing Pieces: Georgia Folk Art, 1776–1976*. The call came on a Saturday; on Monday morning I was on my way to Athens, Georgia.

As a result of the research I did in Athens, the inscription on the plaque under Harriet Powers's quilt in the Smithsonian now reads:

Harriet Powers
An ex-slave
Born 1837, died 1911

Harriet Powers, at long last, had the beginnings of a personal history, and I had a new passion—nineteenth-century quilts—that eventually resulted in a book and three major exhibitions.

Having done so much work on the art and life of Harriet Powers, I now sometimes imagine her smiling down on me. In those moments I ask myself whether that smile means approval or encouragement, telling me that, though much has been done, more—much more—awaits unraveling. I like to think it is a bit of both.

NOTES

1. *Outlook Magazine* was a publication of the Congregationalist Church, edited by Lymon Abbott.

2. A reproduction of the quilt can be found on the Internet at the following site: http://www.comet.net/writersc/lyonsden/html/stars.htm

3. I would like to thank Andrea Watson of the W. E. Hoole Library at the University of Alabama for making photocopies of the Lucine Finch letters available to me.

A SERMON IN PATCHWORK

LUCINE FINCH

The quilt shown in the accompanying photograph [see Figure 10] is the work of an aged Negro woman, who put into it the reverence, the fantastic conception of sacred events, and the passion of imagination of her people. Her idea was, as she voices it, "to preach a sermon in patchwork." In other words, to express through this humble and homely medium the qualities of mind and soul that are the inborn possession of the Negro—the leveling of all events to his personal conception of them, and the free, colorful imagination of a primitive mind. The Negro's religion is instinctive, interwoven into the whole warp and woof of his being, and it finds its way out, into the realms of expression, in everything that he does. This unconscious, superstitious, symbolic relation with the Great Force behind and in all life might easily be the chief characteristic of the Negro. In order fully to comprehend the wonderful imagination wrought in mystic symbols into this old quilt one must really know something about the Negro himself, more especially about the "old timey" Negro, who is so fast and so tragically disappearing.

The religion of the Negro of the older type is a curious blend of blind superstition wrought out in imagination generally unreserved and not self-conscious, hysterical and ecstatic in its manifestation. It not only is not a mental state, but has very little of the mental attitude

Originally published in *Outlook Magazine,* October 28, 1914

in it. It is a pure emotion, in greater or less degree—absolutely sincere while it lasts, but not necessarily connected with the common activities of life. The older type of Negro reduced everything—God and the angelic hosts—to the level of his own understanding, the personal equation entering largely into his conception of such high matters. His God was the anthropomorphic God of all savage people and of all childhood—individual childhood and race childhood. A God to be feared, yet one who could be deceived, hoodwinked. A God to be reverenced, yet about whom the most absurd, incongruous, almost sacrilegious superstitions gathered.

The following lines from an old Negro "spiritual," as these songs are called, may be quoted as an example of the Negro's intimate expression of religious belief:

Fer itself, fer itself,
Fer itself, fer itself,
Every soul got ter confess
Fer itself!

De Lawd reach down
An' he says ter me
(Every soul got ter confess fer itself)
Dat he can't have no heaven
'Less he got me
(Every soul got ter confess fer itself!).

De devil reach up
An' he says ter me
(Every soul got ter confess fer itself!)
Dat he can't have no hell
'Less he got me
(Every soul got ter confess fer itself!).

And now for the explanation of the old quilt pictured herewith. It is the reverent, worshipful embodiment of an old colored woman's soul. I shall use her own words, in as far as I can quote them. So many tributes were paid to flowers and leaves by using them as decorations that she determined, she said, to "preach de Gospel in patchwork, ter show my Lawd my humility." And again, "Dis heah quilt gwine show where sin originated, outen de beginnin' uv things." The whole quilt is made of gay-colored calico, most beautifully quilted with the finest stitches. The border is rose colored, the spotted animals yellow and purple.

In [Panel] No. 1 Adam and Eve are shown in the Garden of Eden. In the upper right-hand corner is the serpent, represented with feet. When asked to explain this anatomical curiosity, she replied, elusively, "He 'blige ter have foots and han's an' all his features in *dem* days, ter git aroun' man, chile!" The coloring of the serpent is a brilliant yellow and black in eleven bold stripes. Immediately under the serpent's head is what she called "forbidden fruit, or original sin." It is in the shape of a dressmaker's form! The trimming around the neck even is most carefully worked out in its significance. "To ketch de eye, honey!" she said. "To ketch de eye er mortal man. *Yes, suh!*" To the immediate right of this strange symbol, and scarcely perceptible, is a white dove.

In No. 2 are shown Adam and Eve and Cain in the Garden, before the expulsion. The peacock, in the extreme lower right corner, is made of blue and white striped calico, and is the symbol of "dey proudness befo' de fall." The white dove is again seen, in the right upper corner, next to Cain. In the lower left corner is an elk with many branches to his horns. The animals, from an anatomical view-point, *might* be anything, but, as a matter of fact, each one represented only itself to the old creature.

In No. 3, perhaps the most purely symbolic of them all, is shown "Satan in de Seven Stars." There may be certain primitive and unconscious occultism in this strange symbol. It is sinister in its effect, positively diabolical in its feeling. The evil figure of Satan is black, with a pink eye (he is shown in profile. "De yuther eye is behin'," she said, "an' wusser 'n dis one!") The stars are black with white centers. When asked why Satan held one of the stars in his arms, she said, elusively, "Dar ain't no tellin' dat, chile; no tellin' dat."

In No. 4 is shown the murder of Abel by Cain. Abel is represented as a shepherd, and is in white. The sheep, wonderfully quilted in, are also in white. Cain is drab, the knife is red, and the stream of blood "flowin' over de whole worl'," she said, is also scarlet.

No. 5 is, perhaps, the least interesting. It shows Cain when he went into the Land of Nod to get him a wife. She designated the spotted animal as a lion, "fer to prove de strength of Cain," showing that she was working in symbols.

In No. 6 is shown Jacob's dream. The angel is descending the ladder. Jacob's prone attitude represents, as she said, "de sleepin' uv him." The angel's wings are rose-colored, like the border of the quilt. When she was asked why she made the ladder spotted, she replied whimsi-

cally, "I couldn't turn myself loose in color, honey! De animals' calico 'blige ter run over in de ladder. Dar wa'n't no yuther way." It is interesting to note, in the light of the recent controversy regarding the sex of angels, that this old creature made her angel, unreservedly, a woman thing.

No. 7 is really beautiful and certainly touching in its simplicity. It represents the baptism of the Lord Christ with the holy dove descending. Christ is in white, and "de dove is kissin' him," she said. "An' John aleadin' him by de han' like a chile." John is the right-hand figure and is in a faded gray-blue. The dove is very pale blue, almost white.

In No. 8 are pictured in epic simplicity the tragedy and the inspiration of the Crucifixion. The Lord, in the center, is in white, the two thieves in drab. The crown of thorns is rose-colored and black. The soldiers' spears (used clearly as pure symbols) are black. The three disks represent the sun in varying dramatic stages of being. First it is black, the rays white, when "darkness come over de worl' in dat minute." Then it is white, "when de good Lawd accepted," and then turned to blood. "Wipe it out in de worl'," she said, with strange mysticism, "wipe it out in de worl'." The stripe across the body of Christ is again scarlet, representing the bleeding wounds.

In No. 9 are shown Judas and his thirty pieces of silver, the price of his betrayal. "Missy Coomby counted 'em for me," the old woman said, "cos I kin count 'em backwards same as I kin count 'em forwards, an' dat ain' no way to count!" Judas is in drab. The disk at the bottom of the picture represents the "whole worl' wid sin on top of it."

In No. 10 is shown the Lord's Last Supper. The disk in the center represents the table. The Lord is in white in the lower left-handed corner. The disciples are in black-and-white speckled calico. Judas is again in drab. "I giv' de Lawd a plate," the old woman said; "I couldn't spare no plate for de 'ciples." Primitive design saw no incongruity in making the table exactly like the sun, with certain reversals of color, because they both represented symbols, containing all the elements of forms, and therefore ignoring any specific form. I am reminded of the child who drew a picture-symbol on a paper. When her mother asked what it was, she replied, tersely, "God." "But no one knows what God looks like," said her mother. And, "Well, they will when they see my picture," the child replied conclusively. It is the same thing. The Negro's mind is the child's mind; is the savage, original, spontaneous outputting of the divine.

No. 11 shows the Holy Family. The sun is white and rose-colored. The little Jesus is in white, Mary in pale blue, and Joseph in speckled calico.

There is a certain wistfulness about the old quilt that touches something fine in us. It is the unbidden pathos of any simple expression that comes from the deep heart, where sincerity bides her time in infinite patience.

TWO WAYS OF THINKING
ABOUT MARY CASSATT

ANNE HIGONNET

I have written twice about the Impressionist painter Mary Cassatt—
once in a book about Cassatt's fellow impressionist Berthe Morisot and
a second time in a book about the visual history of childhood. Al-
though my comments on Cassatt did not contradict each other at all,
they did not exactly agree either. Distance now makes it obvious that
I was asking different kinds of questions and therefore reaching differ-
ent answers. Cassatt in the context of a monograph is not the same as
Cassatt in the context of cultural history. Neither approach yields truer
or better results. Each approach yields accurate answers in its own way.
The only problem is confusing approaches. And however initially per-
turbing the disparity between Cassatt-the-singular-artist and Cassatt-
within-history might be, that disparity is among Cassatt's most valu-
able lessons.

I wrote both comments about Cassatt's pictures of mothers and chil-
dren. After about 1890, Cassatt turned away from the variety of do-
mestic feminine themes she had represented and began to concentrate
on what was already in her lifetime called the Modern Madonna. Cas-
satt produced dozens, if not hundreds, of Modern Madonnas, in the
form of oils, pastels, and prints. These pictures, previously dismissed
for their sentimentality, became in the 1990s the newest topic of the
most original Cassatt scholarship. In 1993, Harriet Chessman pub-

lished an important essay describing the mother-child pictures as erotic. The eros, Chessman argued, was the mother's: "the child offers a safe figure for the mother's more hidden erotic life."[1] The freshest part of Griselda Pollock's latest work on Cassatt is devoted to a psychoanalysis of Cassatt's late work.[2] Judith Barter, in her fundamental essay for the recent major Cassatt exhibition catalogue, has shown how the late work fits into a social and legal redefinition of child welfare, as well as of maternal rights and responsibilities.[3] Restating a decade of academic work with a masculine twist, Adam Gopnik wrote in 1999 for the *New Yorker* that Cassatt's most original contribution to the history of art was giving form to "the nearly adulterous, exhausting love with which middle-class women have come to address their babies."[4]

ONE WAY

I first considered Cassatt's mother-child pictures in a 1992 book on Berthe Morisot's images of women (which repeated what I had said in a 1988 doctoral dissertation on Morisot). The key sentence emphasized that "the difference between Cassatt's images of maternity and other modern Madonnas is that they do offer women...[a]...possibility of visual pleasure."[5] It is the key sentence not only because it deals with pleasure but also because it distinguishes Cassatt's pictures from all other representations of the same subject. I was using Cassatt to get from countless contemporary pictures of mothers and children to Morisot's unique treatment of that subject. Cassatt was a term-in-between: a transition from the many to the one. I was factoring in Cassatt's artistic singularity only in order to move from pictures not remarkable because of their style to Morisot's singularity. The subject matter of all the pictures I was discussing had already been dealt with as a subject before I got to Cassatt. My monographic purpose had pushed me to define Cassatt's mother-child pictures in terms of their style.

Cassatt's style turns a conventional subject into erotic form. Unlike any of her contemporaries, Cassatt made the experience of tiny children's bodies a visceral pleasure, both for the mothers represented within her pictures and for us, the viewers of the pictures (Figure 11). By representing touch for our sight, Cassatt engages us in the joys of infant flesh.

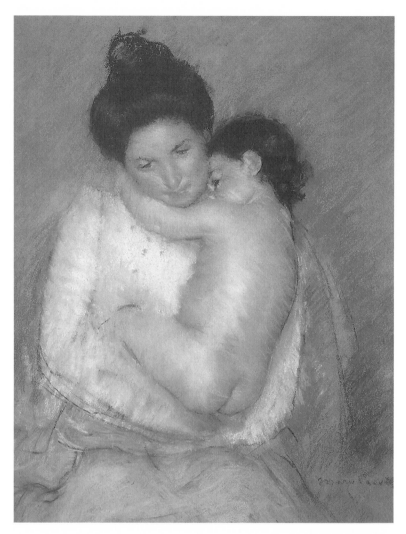

11. Mary Cassatt, *Mother and Child,* ca. 1900, pastel

More than other pictures of the same subject—by Morisot, say, or by the great illustrator Jessie Willcox Smith (Figure 12)—Cassatt's pictures join the forms of mother and child. The integrity of the individual body, which we could also call its isolation, is replaced by a formal fiction of merged bodies. In virtually all of Cassatt's pictures, neither the mother's body nor the child's has its own boundary, its own space. Instead, the figures of mother and child share a border. Mimetically, we

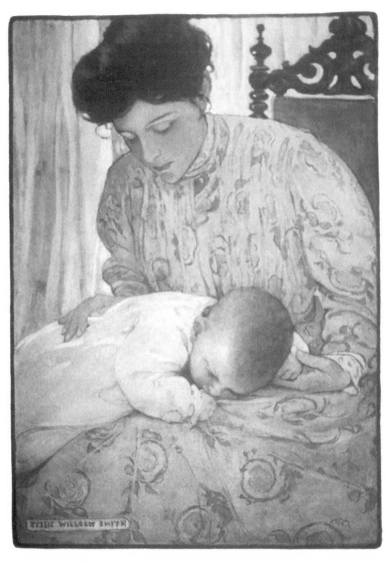

12. Jessie Willcox Smith, *First the Infant in Its Mother's Arms*, 1908, pen and ink drawing

understand that the mother clasps the baby and that the older child sits or stands pressed against his or her mother. Formally, we see how Cassatt reinforces the impression of unity by turning two figures into one shape. Often the child's figure eddies only slightly beyond the almost enclosing edges of the mother. The pretext is that the children are young, and young children are often embraced by their mothers. But is iconography cause or effect here? Perhaps Cassatt's visual concept of maternity is a physical bond, and therefore the children she represents must be not so much children as babies.

Cassatt's pictures are filled with embraces. Everything extraneous to the physical contact between mothers' and children's bodies has been eliminated. Mother and child virtually never gaze toward anyone or anything except each other, so they are engaged only in their mutual absorption. Form, too, pulls away from any outside world, swelling inward. Setting, objects, and actions are incidental, absent, subordinated, or formal versions of enclosure, echoing the containment of the child's form.[6] Replete with the substance of flesh, Cassatt's pictures are organized both two- and three-dimensionally around axes of touch. Bodies caress, kiss, fondle, hug, and stroke. Limbs and fingers, throats and cheeks, feet, hands, and lips turn toward each other, their forms gathering. Color, line, and illusions of space embrace to represent mothers and children.

We enjoy Cassatt's children because their mothers enjoy them. Of course the mothers and children are enjoying each other within the pictures. The pleasure is mutual, yet not quite reciprocal. It is always the children who wear little or no clothing, never the mothers. Even by the decorous standards of Cassatt's time, her women are covered and concealed. Had she wanted to, Cassatt could have undressed her adult female figures, licensed, like other artists, by the intimate domesticity of her subject. Moreover, the figures of the mothers are never shown beyond where they are in contact with their children. It is quite rare for the mother's entire body to be seen, and when it is, as for instance in *The Bath* (Chicago Art Institute), in which a mother bends forward to wash her child's foot, Cassatt has found some trick to reconcile adult and child body lengths. Much more often, the image ends at the mother's lap. Cassatt's choices declare whose bodies are the erotic objects: whose bodies are at once subjects and objects. If we were looking at pictures of naked adult women and clothed adult men, however interlaced, we would be quick to understand the implications of being clothed or unclothed. Nudity is being presented to us, the viewers. The

babies' pleasure in their mothers, however convincing, acts not to turn their mothers into objects of desire but rather to cue viewers. Like all the countless adult female nudes who signal their sanction of our gaze, Cassatt's babies invite our pleasure by being happy themselves.

By enjoying their children's bodies so nakedly, Cassatt's mothers urge us to do the same, vicariously and visually. Identifying with the mother offers the most rewards. We could also identify with the babies, but we would not be getting the sight of bodies from that position, and sight is what pictures provide best. It is surprising, confusing perhaps, to see infant rather than adult bodies. It should be surprising. Cassatt is the only nineteenth-century artist I have encountered who gives us such access to the pleasures a mother feels in her child's body.

Why can I say that we are identifying with a mother's pleasure rather than a woman's? An iconography of maternity inculcated by centuries of Madonna and Child images is the easy answer. Another answer, equally important, is the issue of the child's gender. In some of Cassatt's pictures, the sex of the child is identifiable. But more often, it is not. When it is, it is about as often female as it is male (breaking with Madonna and Child precedent). In Cassatt's pictures, I would argue, sex is not an issue because the child is a generic child, not a gendered boy or girl.[7] The experience conveyed is therefore not so much the pleasure of one person in the sex of another as pleasure in a child be-cause it is a child. Historically, that kind of pleasure has been ascribed to mothers—though hypothetically it could be experienced by anyone. It is a pleasure born of the intimate routine daily care that an infant body requires merely to survive, let alone to thrive—a pleasure that Cassatt cunningly winnows out from the shit, piss, vomit, screams, feedings, laundry, tedium, and other grim realities that actually go along with infant care. The pleasure taken could therefore be called erotic or sexual, but only with the caveat that sexuality must be un-derstood more broadly than usual.

Cassatt's brilliant compositions can be seen in any reproduction. When her works are actually seen, however, medium and color assert their primacy. Cassatt has always been known as the impressionist who most conservatively retained illusions of bodily integrity. While other impressionists were accused of scattering the body in calligraphic ex-cess or rotting the body with putrid color, Cassatt was praised even by cautious critics for the fresh wholesomeness of her figures. So Cassatt's use of oil or pastel in her mother-child pictures is unexpected. True, an

initial glance provides a reassuring sense of rosy roundness. But the longer one looks, the more dazzlingly abstract Cassatt's technique appears. The apparently blushing faces and limbs are in fact created out of zipping greens and meandering blues, smudges of lilac and brown hatching. The marks of Cassatt's hand are everywhere on the canvas or paper surface to be noticed and compared. And in her pastels, the effect is especially strong, as the crayon leaves its unmistakable trail, color imitating light but also leaving a velvet tactile trace. The effect of two bodies united into one is infinitely reinforced by the distribution of identical pure colors between the two ostensibly separate bodies. In many of Cassatt's mother-child pictures, color dissolves difference. What had seemed to be an edge between mother and child turns out to be a zone of shared radiance, a blue mark gliding back and forth between the two, returning flesh to the flesh from which it came.

The degree of pleasure Cassatt provides is given through the plenitude and self-sufficiency of form. Although the subject of the mother-child pictures was guaranteed by social convention to be satisfying, the coherence and the autonomy of her style make her pictures passionate rather than sentimental. Just as fantasy is an escape from reality, Cassatt's maternal pleasure is form's escape from subject matter. The passion is in what formally exceeds the subject. Call it ecstasy, call it bliss. Psychoanalysis, prodded by the subject of the pictures, would name the ecstasy a regression to the prelinguistic, the pre-Oedipal. The great French poststructuralist critic Julia Kristeva could see the effulgence of form slipping out from under language in Bellini's Renaissance Madonnas, but not in Cassatt's mother-child pictures.[8] Was Cassatt too clumsily American, too suspiciously feminist, or simply too powerful to bear? The pious would call the ecstasy grace, a state of being in which communion releases the individual from its limits. A mother might simply call it love.

ANOTHER WAY

I next considered Cassatt's mother-child pictures in the context of a book on the visualization of childhood. I was trying to understand how a currently axiomatic assumption of children's absolute innocence had been translated into images that would eventually become the most credible and ubiquitous proofs of that innocence. I did not start with any one author, or a medium, but instead with a question: How has childhood been visualized in modern times? Whatever pictures in

whatever medium by whichever artist—or nonartist—answered that question would be part of the book's argument. I did not care if the pictures were "good" or "bad," "great" or "trivial," as long as they answered the question. As far as Cassatt was concerned, the key sentence this time was: "Artists like Stephens, Cassatt, and Potter Vonnoh reinvigorated the subject formally, finding new devices to express the beauty of the innocent child body and the maternal love it inspired."[9]

Who, Cassatt, and who? My issue-driven project made me realize how little great artists could matter to visual history. At the beginning of the modern history of childhood, in the eighteenth century, painters as eminent and influential as Sir Joshua Reynolds were also the most important innovators in the visualization of childhood. But by the middle of the nineteenth century, the dominant role in shaping cultural concepts of childhood had passed to genre painting, a type of painting whose formal mediocrity has kept it outside an art historical canon based on aesthetics. By 1890, when Cassatt and Morisot both began to concentrate on the subject of mothers and children, no painting of any sort could control or alter the history of childhood. Quite simply, the social scope of the issue was much broader than the audience for modernist painting. Only image makers whose work was repeatedly reproduced on a mass scale could hope to affect an entire culture. Alice Barber Stephens (1858–1932) and Bessie Potter Vonnoh (1872–1955), along with others like Jessie Willcox Smith, made childhood innocence a cultural axiom through their commercial work for magazines, advertisements, and various forms of illustration, work consumed by millions of viewers. The commercial and amateur photographs of children that dominated the twentieth century looked back to those commercial artists, not to great painters. Nothing about Cassatt's subject matter was any more original, feminist, or modern than the pictures of mothers and children by women like Stephens, Vonnoh, and Smith, not to mention innumerable reproductions, interpretations, and adaptations of premodern religious Madonnas. Cassatt's pictures are relevant to the history of childhood inasmuch as they are ordinary. (Hence the total irrelevance of Morisot's mother-child pictures, which are much more radical than Cassatt's at the level of subject matter.)

It is of course terribly tempting to reinsert what we can now see in Cassatt's later work back into history. We would like to imagine Cassatt's formal passion radically altering the sentimental history of maternity we have inherited. Our vision of Cassatt, however, belongs to

our time. If even the most ardent admirers of Cassatt's work did not articulate the power of her mother-child pictures until the 1990s, it is because the cultural conditions of the past made such articulation impossible, perhaps even unthinkable. We also forget how the impact of Cassatt's work has benefited over time from a mass reproduction it was not intended for. If Cassatt's mother-child pictures had appeared on as many posters, refrigerator magnets, and mousepads in her lifetime as they have since then, history might have been different.

My historical project made me confront how much Cassatt's choice of subject had been determined by a factor that had nothing to do with her style or her innate genius. I wrote: "Feminine and commercial pressures on women's work were strong enough to be felt by even the most successful fine artists, as evidenced by the career of arguably America's finest late nineteenth-century woman painter, Mary Cassatt." Most of the very popular and influential images of childhood made since the late nineteenth century have been the work of women. Women were forced to produce pictures of childhood for commercial markets because of their gender. Schools tracked them, editors commissioned them, critics neglected them, patrons paid them. They spent their entire careers on childhood, as if they had never contemplated a viable alternative. The ambient power of culture could, however, overtake even someone successfully headed in another direction. Cassatt refused to become a mother biologically and roamed among various—admittedly feminine—subjects until about 1890, when, despite professional experience, critical acclaim, and financial security, she succumbed to the maternal imperative. In the end, even Cassatt obeyed a historical pattern. History swept the obdurate node of her genius along in its flow.

Cassatt's stylistic meanings may have been revolutionary, but the historical pattern within which they were embedded was politically and culturally conservative. As a subject, maternity gave women new professionally artistic possibilities (Stephens, Vonnoh, Smith, and many others were highly successful by many measures) and it also gave women new power as consumers of images. Yet it hardly needs to be said that any association of women with maternity, however new, would inevitably reinforce traditional definitions of femininity. Cassatt was able to create pleasure out of maternity, but she nevertheless linked pleasure to maternity. Form created pleasure, but subject matter harnessed pleasure. Here we can come back to Cassatt's exhilarating dis-

tillation of her subject from another point of view. Cassatt removed maternal pleasure from any distraction, loosing it from any social restraint. The relationship between mother and baby, according to Cassatt, exists in a world unto itself; it does not belong within any shared or active or collective or political or social world. Yet that freedom from the material world is itself a price to be paid. In Cassatt's vision, maternal pleasure is ours on the condition that we relinquish everything else. The mother who is absorbed in her pleasure, in her fantasy of pleasure, cannot be a part of and act in the real world.

So we are faced with a contradiction. Cassatt was revolutionary and Cassatt was conservative. Cassatt was banal and Cassatt was a genius. Cassatt is crucial to a history of art and marginal to a history of culture that includes art. The contradiction cannot be resolved. One way of looking at Cassatt cannot be reduced to the other.

And why should it be? The study of an individual artist will always be a sure way to yield intellectually sustained and emotionally inspirational formal analysis. In a modern world in which people strive to be individuals, one person's style forces attention to what makes one set of forms different from any other set. It forces precision and articulation. When organized chronologically, it becomes a kind of history, a very specific history of one mode of visual representation. If the analysis of style demands recognition of an object's condition, cultural history demands recognition of its effect. What an art object is needs to be described and judged on formal terms. How and why art objects have mattered to anyone requires analysis of more than what an object is. Cultural analysis requires its own precision, locating changes in meaning over time and from one audience to another, situating discrepancies between authorial intention and reception, between formal quality and cultural importance. The two approaches can complement each other, but they will not necessarily agree. I believe that in practice they depend on each other, but in a theoretical way they cannot be substituted for each other. They elicit different skills, different sources, and different methods—which is why the formalist fear of what is often called "visual culture" studies is absurdly defensive. What I would prefer to call more simply a historical (as opposed to the subset "art historical") approach will not render formal analysis useless. It can never replace formal analysis and the study of individual singularity. But history does bring another aspect to the study of

images that formal analysis and monographic subjects will never accurately produce.

Do we really need art to be consistent? Are we obliged to have one master method, one master narrative, one answer to all questions? The work of Mary Cassatt bids me say no.

NOTES

1. Harriet Chessman, "Mary Cassatt and the Maternal Body," in *American Iconology,* ed. David C. Miller (New Haven, Conn.: Yale University Press, 1993), 239–59.

2. Griselda Pollock, *Mary Cassatt: Painter of Modern Women* (New York: Thames and Hudson, 1998), and *Differencing the Canon: Feminist Desire and the Writing of Art's Histories* (New York: Routledge, 1999).

3. Judith Barter, *Mary Cassatt: Modern Woman* (Chicago: Art Institute of Chicago and Harry N. Abrams, 1998).

4. Adam Gopnik, "Cassatt's Children," *New Yorker,* March 22, 1999, 114–20.

5. Anne Higonnet, *Berthe Morisot's Images of Women* (Cambridge, Mass.: Harvard University Press, 1992), 218–20.

6. In one picture, for instance, in which a mother is sewing, and her daughter—who may be as old as six or seven—looks out at us, the child is still contained within her mother's pyramidal definition of space, and most of the picture's surface area is dedicated to the contact zone between child's body and mother's. Or look closely at the famous Cassatt in which a mother and child together hold a hand mirror in which both the child and we see an image of the child alone. In that hand mirror, we see nothing but the child's face, but in another mirror behind we see both mother and child, and, once again, the overwhelming share of the picture surface is devoted to contact between the child's body and its mother's—in imagined space, and even more so on the picture's surface.

7. Viewers (including myself) have often assumed, for instance, that in the famous National Gallery picture of the child holding a mirror the child is a girl. But on close examination the genitals of the child are not clear, and the child looks identical to a child in another Cassatt picture who also has shoulder-length blond hair and bangs and yet also clearly has a penis.

8. Julia Kristeva, "Motherhood According to Bellini," in *Desire in Language,* ed. Leon Roudiez (New York: Columbia University Press, 1980).

9. Anne Higonnet, *Pictures of Innocence: The History and Crisis of Ideal Childhood* (New York: Thames and Hudson, 1998), 57–60.

FLORINE STETTHEIMER

BECOMING HERSELF

BARBARA J. BLOEMINK

The world is full of strangers—
They are very strange
I am never going to know them
Which I find easy to arrange.

Florine Stettheimer, untitled poem
from *Crystal Flowers*

Recently, the Metropolitan Museum of Art publicly displayed all four of Florine Stettheimer's *Cathedral* paintings together for the first time in years.[1] It is difficult to imagine any other works that so vibrantly convey the excitement and feel of New York City's upper-crust social life during the 1930s and 1940s. Museum visitors generally traipse rapidly past paintings, giving them little more than a passing glance. By contrast, the bench in front of Stettheimer's work is inevitably crowded with viewers sitting to study the paintings. Unfortunately, the wall labels do not identify the myriad persons in the crowded compositions. As a result, little of Stettheimer's biting social commentary and intention is available to the casual audience. Nevertheless, viewers' reactions to the paintings confirm the significance of Stettheimer's work and its ability to transform paint and canvas into singular visual metaphors for the early years of American modernism.

Seeing the public's reaction to Stettheimer's work goes a long way toward confirming my commitment over more than a decade to researching the artist's work and life. I wrote about Stettheimer first as the subject of my doctoral dissertation (eventually published as a monograph) and then for the catalogue accompanying a retrospective exhibition of her work at the Whitney Museum of American Art.

Today, when I come across a painting by Stettheimer, I invariably seek out the detail containing her self-portrait. Each time I find her image, I acknowledge the strong connection I still feel to the artist and remember my decade-long battle to get her work the recognition I felt it deserved. Writing about the experience now, I acknowledge what a central role, for a while, Stettheimer played in my life.

Choosing to spend time looking at, or writing about, a body of work requires a personal affinity with it from the outset. I responded almost immediately to Stettheimer's paintings. That the artist was a woman whose work had been erroneously neglected in art history made me determined to try to remedy the situation. Stettheimer's work had been largely relegated to minor status in art history for several provocative reasons. First, it did not conform visually, theoretically, or stylistically to the accepted canons of "modernism"; second, because the artist was a woman, she was left out of most historical writings on the period; and third, Stettheimer consciously did not affiliate herself with any male artist (either a partner or a gallery owner) to support or promote her work. As a result, no cogent biography of Stettheimer existed, nor was there a serious examination of the over 150 paintings and designs that during her lifetime were recognized as bold, ironic, inventive—and among the most interesting works produced in the early decades of the twentieth century.

I came upon Stettheimer's work by accident. I had come to graduate school with a fairly comprehensive background in canonical European art history. As my interest gradually turned from the nineteenth to the twentieth century, I decided to expand my outlook by spending a year focusing on African American art topics. As a result, I began to question the Caucasian, heterosexual, male orientation of most of the art history I had been taught.[2] I also looked for a dissertation topic that would have personal relevance.[3] While conducting preliminary research in the Beinecke Library, I found a letter from Georgia O'Keeffe to someone named Florine Stettheimer in which O'Keeffe complained about men, recounting a humorous incident that derailed a trip she and Alfred Stieglitz had planned to Lake George. In trying to find out more about the letter's recipient, I learned that a number of her paintings hung in the back-office corridors of the library.

My initial reaction to Stettheimer's paintings was the same as to O'Keeffe's letter: I burst out laughing. The works exhibited none of the characteristics I had been taught to look for in modernist painting; they

were overtly feminine, crowded, narrative, and funny. From the outset, I was attracted to Stettheimer's willful refusal to fit the traditional definitions of modernism. Distrustful of labels myself, I wondered if perhaps the problem was with the narrowness of the term *modernism*—defined as a rejection of past styles and the privileging of form over content—rather than with Stettheimer's work.[4] With their style based on Persian miniatures and medieval and Renaissance painting, as well as their multiple narratives, temporalities, and crowded compositions, the paintings defy this definition. Unlike anything I had seen, Stettheimer's work engaged me to the point where I wanted to find out more. As I continued looking at her paintings, I realized that I had found a dissertation topic, but it took a while to convince my advisor that Stettheimer's work warranted being the subject of my research.

Initially I considered writing about Stettheimer's work by comparing it to that of her contemporaries, such as O'Keeffe and Demuth, and positioning her as an "alternative modernist." But factual information about her life, her philosophy, and her works proved so difficult to find that it became clear that what was first needed was to organize her work and life in the form of a monograph. I realized that I did not want to approach her work with predetermined theories that might blind me to other alternatives. Nor was I interested in configuring the artist according to the traditional, "heroic" model often used in monographs of male artists. Instead, I wanted to trace what I found compelling about her paintings and to have that guide my writing. Despite inherent flaws in the monographic approach (its being too limiting and/or tied to the idea of linear evolution), it still appeared to be the best construct for organizing information about Stettheimer's life and her work. As Nancy Miller observes, "To justify an unorthodox life by writing about it is to *reinscribe* the original violation, to reviolate masculine turf."[5] With her idiosyncratic style and feminine-oriented subject matter, Stettheimer reviolated the inherently "masculine" turf of modernism. Given the multiple complexities and paradoxes of her life and work, the challenge of framing them within a monographic format was particularly intriguing.

Virtually all of Stettheimer's paintings represent specific moments, locations, and people. All but a few are filled with image puns—words and jokes that members of her social circle would have easily recognized and understood. To "read" Stettheimer's paintings today, one must learn about each of the characters who inhabit them—many of

them recognizable portraits of her friends and acquaintances that include details of their vocations, avocations, and peculiarities. These paintings constitute cryptic visual biographies so that a monographic format gives the works context and identification. Exploring Stettheimer's maturation and aesthetic development and placing her paintings in a contemporary social, economic, and political setting seemed a straightforward and worthy goal. Instead, in virtually every environment, from academia to museums, I found that I had to constantly defend the monographic approach and argue against configuring the artist's work to suit others' theoretical agendas. This was exacerbated by the fact that, in Stettheimer's case, so little primary research had been uncovered to substantiate or disprove such theories.

In retrospect, I believe the unorthodoxy of Stettheimer's work and personal life explained many of the obstacles I encountered. It is worth considering whether Stettheimer, like so many other women artists in the past, cultivated eccentricity and obscurity in her personal life in order to control how her work would later be perceived. The absence of factual and personal information—much of it deliberately destroyed by the artist and her sister Ettie—gave her work a chance to breathe, freeing it from the encumbrance of bias against women working in a largely male profession. It also created intriguing divisions between the works, the artist's "public" face, and the mysterious private persona she cultivated for friends and the public.

Stettheimer was highly ambitious, a trait she shared with other contemporary women artists such as Georgia O'Keeffe and Frida Kahlo, who also achieved recognition for their work during their lifetime.[6] Unlike them, however, she chose not to have a prestigious partner or husband to guide her professional development. That she was nevertheless able to achieve considerable professional recognition for her work in her lifetime is one of her singular achievements. It indicates the power of her work and her strength of will, both of which were at variance with her public role as a proper social hostess.

The radical nature of her paintings, theatrical designs, poetry, and furniture caused Stettheimer's contemporaries to cite her as one of the most important historians and visual critics of the period between the world wars. However, the contradictions in Stettheimer's private life thwart all attempts to canonize her. She was a quiet and shy woman— a Jewish spinster who spent her entire life in the confines of her matriarchal family. Stettheimer was never active socially unless surrounded

by her mother and sisters. Although her social reticence gradually eased, until she was in her sixties Stettheimer was intensely private, revealing little of herself except through her work. She rarely gave interviews, and her extant correspondence and diaries cover only a short period of her life.

One can discover the most revealing aspects of Stettheimer's personality only by closely, carefully "reading" her paintings and then tying them to the spare written fragments and known events of her life. A significant breakthrough in my research came after my fifth or sixth reading of her privately published poems, when I realized that many of the poems paralleled incidents from her life and referenced specific aspects of her paintings. Although several feminist art historians had "rediscovered" Stettheimer in the 1970s and 1980s, no one had ordered her work on the basis of gathered facts or chronology.[7] As a result, although they continued to influence younger artists, the paintings remained little known or understood by the general public. To build a chronology of her work, I began hanging Xerox copies of every known Stettheimer painting or drawing on my living room walls. By seeing them together, I was able to match early studies with completed paintings and, after living with the images for a while, more accurately date several of the works according to their stylistic evolution.

Further progress in organizing and identifying Stettheimer's work came when I compared old negatives from the Peter Juley archives in Washington, D.C., with actual paintings. Although Stettheimer never allowed anyone to see her paintings until they were finished, she invited Juley to her studio to photograph them when they were completed to her satisfaction. By comparing Juley's negatives to the paintings, I located a number of missing works and discovered that the artist had significantly altered a number of them, in some cases quite radically. Stettheimer entirely painted over some compositions and changed elements of others, often with telling results. The extant version of her painting *Russian Bank,* for example, includes an image of her younger siste, Ettie, sitting under a tree, although Ettie is not present in the Juley negative of the work. Relations between the two sisters were not always amicable, and the artist probably intended to leave her younger sibling out of the composition, only adding her later as an afterthought. After Stettheimer's death, Ettie refused to bury her sister in the family plot, instead scattering her ashes in the Hudson River several years after her demise.[8]

I began tracing Stettheimer's family background, contacting relatives, and from their recollections beginning a family tree. Fortunately, one of Stettheimer's nieces, Phyllis Gordan, who had refused to talk to earlier researchers, agreed to meet with me. A woman of substantial intelligence and wit, Gordan assisted me in tracing Stettheimer's maternal ancestors back several generations. She gave me access to early family photographs and artifacts that place Stettheimer's family in the midst of one of the most influential Jewish American families living in New York in the nineteenth century.

Gordan's recollections of the Stettheimer sisters offered an interesting, unique perspective on the family's generations of radical women. Stettheimer had eight maternal aunts, most of whom married well and were financially independent. Her Aunt Josephine Walter, after studying with some of the most innovative medical teachers in Europe, became the first woman intern in the United States. Josephine, who never married, later established an active practice in New York specializing in women's ailments. There is little doubt that her highly unconventional assumption of a traditional male role had an impact on Stettheimer's own artistic development.

Socially, however, Stettheimer was far more ambivalent than her aunt. On the one hand, she lived a cloistered life within her genteel family. On the other hand, Stettheimer's diaries reveal that she complained bitterly whenever she had to accompany her mother and sisters on any moves or travels, as it prevented her from concentrating on her professional training and work. The artist's days were often filled with social obligations as a wealthy, unmarried hostess and dutiful daughter, and this greatly affected her ability to paint.

To ensure herself a proper environment in which to work, Stettheimer rented a studio away from her family's home, thereby courting their overt disapproval. Unlike most of her contemporaries, she often wore harem skirts and black velvet pants, allowing her greater freedom of movement while painting. As Ettie noted, Stettheimer "took care of her delicately made body and strengthened it into an effective tool" for the benefit of her work.[9] Her efforts to balance her disparate roles in society and in her professional life often caused her personal turmoil. Only through careful reading of Stettheimer's layered, complex paintings are her efforts to manage those mutually exclusive responsibilities revealed.

During my doctoral colloquium, a colleague who had recently completed his dissertation on a male modernist (on whom several monographs had already been written) took me to task for choosing a monographic approach to Stettheimer, claiming that it was no longer valid or significant enough for "Yale scholars." He suggested that I instead take a theory-based approach to the artist's work and that I view it in terms of the artist's sexual orientation. Prior to my research, and because of the paucity of biographical material, the issue of whether Stettheimer was or was not a lesbian often came up when her name was mentioned.

I resisted that notion, even though I believe that there are many valid theoretical approaches to Stettheimer's work and that an artist's sexual orientation can reveal information about and suggest a context for the work. However, I felt it would be misleading to postulate a theory about either an individual or a body of work unless it was rooted in primary research on the artist's life and development. In Stettheimer's case, no one had yet undertaken such research. Luckily, the department chair reassured me that the monograph was still an appropriate scholarly approach for a dissertation, even at Yale, and I continued with my work.

As most of Stettheimer's paintings were stored in museum basements across the country, if her work was to be reconsidered, it had to be seen. I therefore wrote to several museums proposing a Stettheimer retrospective like the one organized by Marcel Duchamp at the Museum of Modern Art in 1946. Thomas Armstrong, then director of the Whitney Museum of American Art, asked me to present my Stettheimer exhibition proposal to the museum committee. The Whitney staff responded enthusiastically, and I signed a contract agreeing to organize a Stettheimer retrospective for the museum with my dissertation as the accompanying catalogue. We began having the artist's work photographed, and as I knew where most of the Stettheimer works were located, I organized a checklist for the exhibition and sent it to the Whitney registrar to initiate loans.

Soon thereafter, however, the museum's administration changed, and everything was temporarily put on hold. I was invited to again present the proposed exhibition to the museum's curatorial staff, who remained supportive. I was then invited to a planning meeting, where I found myself having to again defend the monographic approach to an exhibition advisor whose overriding interest was Stettheimer's sexual orientation

rather than her work. As a result, the central question I was asked during the meeting was whether I believed Stettheimer was a lesbian. The exhibition advisor suggested that rather than deal with her life chronologically, I revise the exhibition and catalogue essays to discuss Stettheimer's interaction with homosexual life in New York between the wars.

Again I was caught off guard. My main motivation remained to rescue Stettheimer from art historical oblivion by locating and presenting as much of her life and work as I could. A great deal of my work involved exploring how cultural assumptions and conditions prevented Stettheimer's professional development. I also discussed the sexual mores of her time in some depth. Nowhere, however, in all of my years of research, had I found explicit evidence of Stettheimer's sexual inclinations. Instead, from everything I read, Stettheimer appears to have spent her life as a virgin, with heterosexual inclinations. A number of her poems and paintings, as well as several early flirtations alluded to in her diaries, strongly suggest that she was attracted to, and greatly admired, the male physiognomy:

I adore men sunkissed and golden
Like gold gods
Like Pharaoh amber-anointed.[10]

In a poem describing her early life in Berlin, Stettheimer noted that although she enjoyed seeing men in uniform who had "superforms," "they did not quite conform to my beauty norm / the Belvedere Apollo."[11] Throughout her adult life, she kept a reproduction of that statue on her bedroom mantle, facing her bed.

There is no evidence that Stettheimer was attracted to other women. She recorded that others had compared her body to that of the celebrated Australian swimmer and outspoken feminist Annette Kellerman, but otherwise she rarely mentioned other women or included women other than her sisters and mother in her work. She had no close female friends. Her father's early betrayal by leaving the artist's family when she was very young left the artist and her sisters distrustful of marriage and wifedom. By the time she was engaged with the New York avant-garde and painting her best works, Stettheimer was in her fifties and sixties. Art making was her one abiding interest, and she resisted anything that impeded it. By that time, she preferred the company of creative men, many of whom were gay, who shared her inter-

ests and did not threaten any romantic entanglements that would interfere with her independence or, more important, her work. In her paintings Stettheimer inevitably displayed herself working or holding artist's attributes such as brushes and palette. In the few exceptions to this, such as *Portrait of Myself* (Figure 13), Stettheimer portrayed herself as a large-eyed visionary who wears an artist's beret and has a slim androgynous body. Wrapped in cellophane and floating toward the sun, she is sexless and untouchable.

Convinced that Stettheimer's work deserved an in-depth, retrospective exhibition as well as a monograph—and that only afterward could her sexual inclinations and other similar issues be fully explored—I terminated my contract for the exhibition. Once it became known that the Whitney show was canceled, the director of the Katonah Museum of Art asked me to organize a Stettheimer exhibition for the museum.[12] Because the Katonah Museum has a reputation for fine exhibitions but limited space, I concentrated exclusively on Stettheimer's portraiture and the context of her interaction with her family and friends. The resulting show won recognition from the *New York Times* as one of the best exhibitions of 1993. However, a number of critics, while praising the initiative, asked when a more extensive overview of Stettheimer's work might finally materialize.

A year later, I heard that the Whitney was organizing a Stettheimer exhibition. I was alarmed, as the museum had my checklist with all the known locations of Stettheimer's work. I contacted the Whitney and, after negotiations, signed another contract, this time to serve as cocurator for the 1995 New York exhibition. The resulting Stettheimer show, although wonderful, was not a retrospective because the museum still was not interested in a monographic approach to Stettheimer, instead declaring itself to be "deeply committed to the idea of presenting multiple perspectives on historical and contemporary artists."[13] Consequently, there were compromises made to include in the exhibition only the artist's later "masterworks," painted when the artist was past her mid-forties. Nonetheless, Stettheimer's paintings glowed on the walls, and the exhibition was a great success in critical reception, visibility, attendance, and continuing influence.

The catalogue accompanying the Whitney exhibition was not my monograph but a collection of essays by different authors: the cocurator, Elizabeth Sussman; Linda Nochlin (her contribution a reprinting of a seminal 1980 article); and me. In the meantime I had

13. Florine Stettheimer, *Portrait of Myself*, 1923, oil on canvas

contracted with Yale University Press to publish my dissertation as a Stettheimer monograph. Not wanting to usurp my own upcoming publication, I decided to write on an entirely new topic for the Whitney catalogue. My essay explored Stettheimer's unusual use of time and her inclusion in a single composition of several distinct events that could not actually happen at the same time. I was not particularly pleased with the results because my writing was rather dense and because I knew readers would not have the context of the monograph as background. Additionally, the Whitney catalogue, although beautifully designed, failed to answer basic questions, such as: How did Stettheimer's style develop? What was the broader context in which she worked? Whom do the figures and objects in her paintings represent? Unfortunately, the unusually fragile condition of many paintings makes it unlikely that there will be another significant Stettheimer exhibition in the future.

These experiences, alternately frustrating and amusing, greatly lengthened my research, forcing me to consider every challenge and re-examine both my motives and the evidence from within Stettheimer's works. Today I remain convinced of the necessity of the monographic approach in order to best serve the artist. How can one explain the evolution of Stettheimer's work from an academic Art Student's League style in the 1880s to the completely idiosyncratic look of her mature work after 1916? The radical change is intelligible only when pegged to events and contexts in Stettheimer's artistic development and life. As Carolyn Heilbrun states, "We are in danger of refining the theory and scholarship at the expense of the lives of the women who need to experience the fruits of research," and she cites the need for biographers of women to "retrace in detail the history of a liberation."[14]

Even so, Stettheimer's elusiveness, in both her life and work, makes any attempt at a developmental approach difficult. First, few primary materials remain. Whether from jealousy or an overdeveloped sense of privacy, Stettheimer's sister Ettie went through all her sister's diaries and correspondence in the 1950s, cutting out everything she did not like or deemed "too personal." Repeatedly, while reading the letters and diaries, one catches traces of Stettheimer's voice, only to come to a standstill where Ettie destroyed pages. Such intimate vandalism, performed after the artist's death, makes Stettheimer all the more enigmatic. Further, while other artists (such as Jo Nivison Hopper) give us insight into their lives and perspectives in their diaries, Stettheimer's diaries only

occasionally deal with her work. After Ettie's severe editing, it is difficult to place many of the artist's comments or tie them with specific works, people, or incidents.

After Stettheimer's death, Ettie and her lawyer offered single Stettheimer paintings to museums across the country, where they were generally relegated to basement storage. In some cases, key works such as *A Day at West Point* were lost and have not resurfaced. The disappearance or deterioration of the extraordinary furniture that Stettheimer designed to correspond with her paintings as unified ensembles reflects American museums' relative lack of interest in the decorative arts. Much of that furniture was donated after her death to Columbia University's theater department, where it was used as stage furniture and gradually destroyed. Ettie and her lawyer gave Stettheimer's early gilded and plaster screens to the Museum of Modern Art, where they remain, in terrible condition, with no plans for their conservation. The artist's early work, studies, and scrapbooks went to the Columbia University library system and were accessible to the public for decades, so that they are now in very poor condition. The fragile cellophane and fabric dolls and maquettes that Stettheimer designed for two operas, *Four Saints in Three Acts* and *Pocahontas,* on which she collaborated with Virgil Thomson, were also given to the Columbia Library, where I found them wrapped in damaging newsprint and stuffed into boxes.[15]

In the course of my research I met and spoke with some of the few remaining people who had known Stettheimer. Unfortunately, the stories, facts, and dates changed depending on the occasion. Lincoln Kirsten, for example, who certainly knew Stettheimer, responded to my inquiry by saying, "I never knew Miss Stettheimer, I did not like her work, and I did not like her." Virgil Thomson and John Houseman were more forthcoming.

The significant problems Stettheimer faced as a woman artist also worked against building a strict chronology of her work and development. During the first forty years of her life, there was no clear career path for women artists. Stettheimer had to create her own art training piecemeal. She traveled, read voraciously, and used her intelligence and awareness of art theory and connoisseurship to develop a wide-ranging knowledge. To fully understand references in her paintings I had to read extensively on artists from Japanese Ukiyo-e printmakers to van Gogh, Giotto, Botticelli, Velázquez, Giorgione, Raphael, Manet, and Matisse.

Although Stettheimer loved her paintings and wanted them to receive critical recognition, she chose never to sell them. The conflict between ambition for fame and what she felt was unacceptable behavior for a woman in her social position is evident throughout her career. Stettheimer did not need the income from sales and preferred to live with her work. She hoped eventually to give it as a complete, intact collection to a major museum. Although she exhibited widely in every significant exhibition of contemporary art during her lifetime, she always priced the work so that it would not sell. By such tight control (she turned down Stieglitz's offer of a gallery exhibition several times) she courted future obscurity, provoking Georgia O'Keeffe to comment caustically, if inaccurately, "I wish you would become ordinary like the rest of us and show your paintings."[16] After her death, Stettheimer's disinclination to sell was interpreted as a bizarre eccentricity. Writers who neglected the artist's vast exhibition history have falsely claimed that she "refused to let her paintings leave her bedroom."

An observer rather than a vocal participant, Stettheimer was unobtrusive at social gatherings. Some casual acquaintances interpreted this behavior as shyness and described her as sweet, "frail," and delicate, a description that is contradicted by the often bitingly ironic cynicism and savagely aggressive wit revealed in her work. In what remains of the diaries, moreover, she emerges as a determined, driven feminist and a caustic, short-tempered snob who disliked hotels, pretension, Germans, and marriage. In one entry she noted, "A bath is still a luxury in Germany—in fact an acquired taste—oysters they are trying to master—but a bath is still a thing of the future." In another instance, on seeing abandoned crutches and a corset on a hillside near Lourdes, France, Stettheimer exclaimed, "Someone left a corset behind—I should think lots of women would do that. I shed mine long ago—but never thought of donating it to anything."[17] The poetry she wrote for her own pleasure reveals both sides of her personality:

Tame little kisses
One must give
To Uncles Nephews
And Nieces
And to friends
Who say you are charming
One does likewise
Nothing alarming.

and

Sweet little Miss Mouse
Wanted her own house
So she married Mr. Mole
And got only a hole.

In her paintings, Stettheimer sometimes made unkind references to friends and social contacts. In an early portrait of Avery Hopwood, for example, she placed him in front of a sign publicizing his most celebrated work, the bedroom farce *Fair and Warmer*. In the painting the words "Fair and" were partially obscured, so that the viewer's attention focused on "Warmer," a slightly derogatory German colloquialism for "gay man." In another work, *Soirée,* Stettheimer poked fun at Leo Stein, who was both egocentric and hard of hearing, by showing him in a one-sided conversation with Hopwood: Stein holds his hearing aid as far from his body as possible to avoid having to listen to what the playwright says.

Stettheimer's late development as a painter—she painted her mature works when she was in her late forties and continued well into her seventies—compounds the difficulties of accurately reading her work. Many acquaintances could not see beyond her superficial appearance and social demeanor as a middle-aged, unmarried woman to the sly, critical persona evident in her work. Marsden Hartley, for example, whom the Stettheimer sisters supported financially, described Stettheimer's work as "quaint" and "fanciful," terming it the "ultra-lyrical expression of an ultra-feminine spirit."[18] This characterization is distinctly at odds with the paintings and with the cynical and ironic tone of her diary and poems. Even today, our culture has trouble reconciling older women and innovation. Stettheimer clearly understood the dilemma of the creative, mature woman, as she acknowledged mordantly in her poem "Civilizers of the World":

They like a woman to have a mind
They are of greater interest they find
They are not very young
Women of that kind.

Only several years into my work on the artist was I was able to identify the painting titled *Nude* in Columbia's storage basement as a self-portrait, painted when Stettheimer was forty-four (Figure 14). It is re-

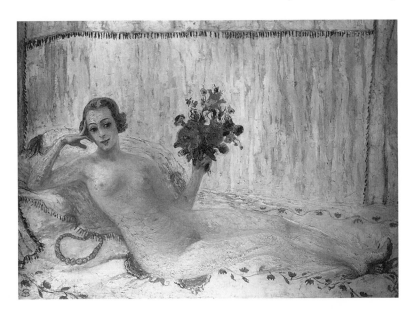

14. Florine Stettheimer, *Nude*, ca. 1915, oil on canvas

markable that in 1915 Stettheimer had the temerity to display herself thus and to make so pointed a comparison with Manet's Olympia, a prostitute offering her wares for sale. In so doing, Stettheimer aggressively took on the genre of the female nude in Western art history and its gender implications. Her own lushly displayed body in the self-portrait is less the traditional subject of a man's voyeuristic gaze than an exaltation of a woman's experience of her middle-aged body. Undoubtedly the disjunction between art historical traditional expectations and Stettheimer's candid but ironic appropriation of them blinded her contemporaries and other art historians to her true subject matter in the work.

Stettheimer was the first woman artist whose work I explored in any depth, in part because few of my academic classes ever dealt with women artists.[19] I remember a feeling of epiphany when I realized that as a woman I might have an advantage in understanding her life and work. It also worked to my advantage, I believe, that although I began my research on Stettheimer when I was in my early thirties, I completed it a decade later. Like most biographers, I found my subject alternately brilliant, infuriating, boring, silly, horrifying, and frustrating. I worked

through each of those reactions and gradually gained greater perspective and hopefully objectivity on her work and life.

While writing on Stettheimer, I was often reminded of Thomas Hardy's statement in *Far from the Madding Crowd:* "It is difficult for a woman to define her feelings in language that is chiefly made by men to express theirs."[20] Stettheimer's work stretched the patriarchal language of modernism to its limits. Her work was conceptually challenging and innovative, but she consciously camouflaged those features with a frankly feminine style. It remains difficult, if not impossible, to imagine a twentieth-century man writing the following Stettheimer poem, though it solicits an ironic smile from most women who read it:

Occasionally
A human being
Saw my light
Rushed in
Got singed
Got scared
Rushed out
Called fire
Or it happened
That he tried
To subdue it
Or it happened
He tried to extinguish it
Never did a friend
Enjoy it,
The way it was.
So I learned to
Turn it low
Turn it out
When I meet a stranger—
Out of courtesy
I turn on a soft
Pink light
Which is found modest
Even charming.
It is protection
Against wear
And tears...
And when
I am rid of
The Always to be
Stranger

I turn on my light
And become
Myself.

The largely autobiographical and contextual nature of Stettheimer's work necessitates knowledge of her life and interests, her acquaintances, and current events. Without such understanding, we risk misreading and possibly dismissing the work of a significant and influential twentieth-century artist.

NOTES

1. I take no credit for the Metropolitan Museum's decision to show the works. In the past the museum has hung an occasional Stettheimer painting in exhibitions of their permanent collection. However, since the publicity brought about by the publication of the monograph and the Whitney exhibition, the frequency and prominence with which museums across the country exhibit Stettheimer's works have dramatically increased.

2. I was fortunate that Robert Ferris Thompson and Skip Gates were teaching at Yale and I was able to sit in on lectures and seminars in the company of fellow graduate students Judith Wilson and Richard Powell. All influenced my subsequent work.

3. My work in African American art, with its implications of "otherness," initially led me to explore Charles Demuth's poster-portraits as a dissertation topic—the artist was both male and homosexual, and the work centered on the significant figures of American modernism. Concurrently I was also considering Thomas Eakins's images of women, again because I was interested in the notion of looking through another's eyes at difference. The idea of male artists capturing images of women was intriguing. When I saw Stettheimer's work, however, it quickly proved the most absorbing and irresistible topic. Her paintings were enigmatic and transgressive in terms of how American modernism had been defined in my studies to date. In addition, researching a woman artist appealed to me, particularly one who, in her caustic wit and her struggle to balance personal and professional life, reminded me of my Austrian grandmother. Once I began my Stettheimer research, however, her work and life proved so complex that I soon discarded such superficial comparisons.

4. For example, in N.E. Lahti's *Plain Talk about Art* (Brooklyn, N.Y.: York Books, 1988), 84, modernism is defined as "the theory of Modern Art rejecting past styles."

5. Nancy K. Miller, introduction to *Writing a Woman's Life*, by Caroline Heilbrun (New York: Ballantine Books, 1988), 11.

6. Stettheimer and O'Keeffe were the only women artists whose work was included in the 1938 exhibition of American art organized by the Museum of Modern Art to travel to the Jeu de Paume Museum in Paris. It was the first ex-

hibition of its kind, and Stettheimer initially refused to participate because of her dislike of the Museum of Modern Art's New York exhibition walls. She relented after Tom Mabry, the Modern's curator, wrote to her, pleading, "I write this only because I want the exhibition to represent our *best* painters. We would lose much if none was in it by you." Quoted in Barbara J. Bloemink, *The Life and Art of Florine Stettheimer* (New Haven, Conn.: Yale University Press, 1995), 213. Stettheimer's correspondence and diaries are located at the Beinecke Rare Book and Manuscript Library at Yale University.

7. Most notably Linda Nochlin in her article "Florine Stettheimer: Rococo Subversive," *Art in America* 68 (September 1980): 64–83, reprinted in *Florine Stettheimer, Manhattan Fantastica,* ed. Barbara J. Bloemink and Elizabeth Sussman (New York: Whitney Museum of American Art, 1995). In 1976 the artist Barbara Zucker wrote about Stettheimer's work in "An Autobiography of Visual Poems," *Art News* 76 (February 1977): 68–73.

8. In writing about the life of the artist, an interesting problem arose: How to avoid the trivializing use of her first name? All three Stettheimer sisters were artists in their own right, and they lived together for at least the first fifty years of their lives. How, then, to distinguish between Florine Stettheimer the painter and designer, Ettie Stettheimer the novelist, and Carrie Stettheimer the hostess and dollhouse maker, not to mention their mother, Rosetta, or their other siblings? Finally, I used the American painter Charles Peale's family as a model. Although I tried to use Stettheimer's last name as often as possible, on occasion, for clarity, I was forced to use her first name.

9. Ettie Stettheimer, introduction to *Crystal Flowers,* by Florine Stettheimer (New York: privately printed, 1949), unpaginated.

10. Stettheimer, untitled poem in *Crystal Flowers.* Handwritten versions of the poems in this book, with some revisions, are in the Stettheimer Papers at the Beinecke Rare Book and Manuscript Library, Yale University.

11. Ibid.

12. The Katonah Museum of Art is located about 50 miles north of Manhattan. George King was then director of the museum. I remain grateful to him and to Katherine Moore and Athena Kimball for their efforts on behalf of the exhibition.

13. Quotation from 1994 letter to the author from the director of the Whitney Museum of American Art. It is worth noting that later that same year the Whitney mounted a major retrospective with a monographic catalogue on Stettheimer's male contemporary Joseph Stella. In its organization, catalogue, and orientation, the Stella exhibition was very similar to monographic/retrospective exhibitions the museum had organized earlier on Charles Demuth, Marsden Hartley, and Arthur Dove—again, all male contemporaries of Stettheimer. It is also telling that the National Gallery in Washington, and not the Whitney, organized the retrospective exhibition of Stettheimer's only significant female contemporary, Georgia O'Keeffe.

14. Heilbrun, *Writing a Woman's Life,* 50.

15. With permission of the head librarian, I was able to sort through the dolls, separate them into the two different productions, and wrap them in less

destructive materials. They are no longer available for public viewing without special permission.

16. Letter from Georgia O'Keeffe to Florine Stettheimer, October 7, 1929, Stettheimer Papers, Beinecke Rare Book and Manuscript Library, Yale University.

17. Stettheimer's correspondence and edited diaries are located in the Stettheimer collections at the Beinecke Rare Book and Manuscript Library, Yale University.

18. Marsden Hartley, "The Paintings of Florine Stettheimer," *Creative Art* 9 (July 1931): 19.

19. At Stanford University in the early 1970s, none of the many art history classes that I took mentioned women artists. In the early 1980s, at Yale, the only women artists mentioned in art history courses were Berthe Morisot, Mary Cassatt, Rosa Bonheur, and Mrs. Thomas Eakins, who was an artist but who was mainly referenced as one of her husband's sitters.

20. Thomas Hardy, *Far from the Madding Crowd* (1919; reprint, New York: Alfred A. Knopf, 1991), 182.

WRITING ABOUT
FORGOTTEN WOMEN ARTISTS

THE REDISCOVERY OF JO NIVISON HOPPER

GAIL LEVIN

Why bother with the work of women artists long consigned to the rubbish heap? What can their art and lives possibly tell us about their time and ours? When a woman's history has been totally forgotten, how can we begin to recover it? When we reach beyond the canon and question the status of the great men, what hostility and obstacles block the historical enterprise? These are some of the questions that arise from the case that I know perhaps better than any other. My research, which revived discussion of a forgotten artist, provoked a tremendous reaction, illustrating with particular vividness the disadvantages and injustices that have been the peculiar and perverse destiny of so many women.[1]

Josephine Nivison Hopper (1883–1968) signed many of her paintings Jo N. Hopper, reflecting only too well what happened to her identity near the midpoint of her life, when she married Edward Hopper (1882–1967). Today perhaps the most renowned of American realist painters, he had shown little sign of rising to such eminence when he and Nivison joined forces in 1924. Roughly the same age, she forty-one and he forty-two, neither had achieved anything comparable to the prominence and acclaim of an artist like George Bellows, who had been their classmate at the New York School of Art and had quickly rivaled the fame of their beloved teacher, Robert Henri.

Yet Nivison had managed better than Hopper to establish at least a professional identity. In the New York City Directory for 1920 she listed herself as an artist, while Hopper, frustrated and bitter at his failure to find a public for his painting, still identified himself as an illustrator, the work he did to survive. In December 1922, both Nivison and Hopper exhibited in a group show of interior scenes organized by the artist Louis Bouché at the Belmaison Gallery of Decorative Arts in Wanamaker's Department Store in New York. But Hopper showed an etching, the medium in which he was beginning to find himself, while Nivison exhibited a watercolor. Her watercolors won her further attention in shows at the New Gallery on Madison Avenue in New York, directed by the artist Carl Sprinchorn for the wealthy attorney and painter James Rosenberg.

Riding this wavelet of success, Nivison was invited by the Brooklyn Museum to show six of her watercolors in an important group exhibition in the fall of 1923, a show that would prove a turning point, in different ways, for her career and that of her future husband. While they had sketched together in Gloucester the previous summer, Nivison had inspired Hopper to follow her lead in using watercolors. Generously, then, Nivison urged the Brooklyn curators to add Hopper's Gloucester watercolors to the show. As a result of her loyal initiative, the museum hung six of his next to six of hers. Both received some notice in the press, but the preponderance of critics praised Hopper's works, and the museum purchased one of them for its collection. To appreciate how important Nivison's help had been, we need only remember that this was Hopper's first and only sale of a painting since the Armory Show in 1913, and only the second painting he had ever sold.

Building on the momentum of his success in Brooklyn, Hopper found his first dealer, the Frank K. M. Rehn Gallery, where he would remain for the rest of his life. At last he could identify himself as an artist, and his career took off. He rapidly acquired a circle of interested patrons and museums who followed and sought his work. Meanwhile, with the marriage Nivison's professional identity suffered. For example, the painter James Chapin, who served on a museum jury that awarded Hopper a prize, told Nivison as late as 1938 that he recalled her work from the New Gallery show sixteen years earlier but supposed she have given up painting after marriage, as so many women did. When she declared that she was still painting, he included one of

her Cape Cod landscapes in a juried show at the Pennsylvania Academy of the Fine Arts.

Nivison's husband only aggravated the situation, disparaging her work, disapproving of her choices of subjects, expressing embarrassment that he was married to an artist, and long refusing to intercede to help her get shown. She was slow to realize the depth of his ingratitude and hostility. Eventually, she managed to place her work in occasional group shows at institutions as important as the Art Institute of Chicago, the Corcoran Gallery of Art in Washington, and the Metropolitan Museum of Art. But by then her identity had shifted: it was no longer as Jo Nivison but as Jo Hopper, Edward's wife, that she received the occasional crumb. The suspicion that her husband was the main attraction even infects the story of her finding at long last, in the spring of 1958, a gallery to represent her work. Herman Gulack of the Greenwich Gallery came to call on Edward Hopper but ended up showing nine paintings by Nivison (as Jo Hopper) in a four-person show. Gulack also included Nivison's work in his Christmas show and promised her a one-person show the following year. But as luck would have it, he fell on hard times and went out of business before fulfilling the promise.

Nivison's identity suffered even worse indignities after her death. Lacking family or close friends, she saw no choice but to entrust her own and her husband's artistic legacy to the Whitney Museum of American Art when she died in 1968. The gift had no parallel or precedent in the annals of the Whitney or any other museum of the time. The museum showed itself inadequate to the challenge. After considerable delay, it announced a plan to disperse Hopper's work, but vigilant public opinion scotched it. As for Nivison, no announcement was ever made that her bequest included her work as well as his. Instead, without fanfare, the museum set about discarding whatever works it identified as hers.

The Whitney's decision reflected that era's prejudice against women artists, even though the museum traced its own origins to a woman who had devoted her life to art, the socialite sculptor Gertrude Vanderbilt Whitney. If we wonder how art historian John I.H. Baur, the Whitney's director in 1968, with his predecessor Lloyd Goodrich, determined that Nivison's work had no significance and made the decision to discard it, we need only look at the evidence. In 1951, when Baur published his survey book *Revolution and Tradition in American*

Art, he illustrated 199 works of art, only 7 of which were by women.[2] Although Goodrich, a prolific writer on American art and an important early critical supporter of Hopper, probably shared Baur's and Hopper's contempt toward most women artists, he had included Nivison's work in several group exhibitions at the museum in the years just before her death, perhaps mindful that the couple was childless and calculating that she might outlive her husband and thus control his estate.

Despite Goodrich's gestures, Nivison expressed fears in her diary that her work would be destroyed.[3] Her intuition was uncanny. Keeping only three of her paintings for the museum's permanent collection, Goodrich and Baur trashed the rest, procuring no documentary photographs and leaving only a list. None of the three works retained was ever subsequently exhibited, and all had disappeared by the time I began work as the first curator of the Hopper collection in 1976; nor has any ever surfaced. The only things from Nivison's hand to survive at the Whitney were a few minor pieces that managed to pass as Hopper's; none of these have been published or exhibited, and none have been accessioned as her work.

Although Nivison's bequest came in 1968, a year marked by revolt against many forms of institutional authority, the Whitney's actions were challenged only when it was too late to benefit her. Her work had already been destroyed when, in 1970–71, groups of feminist activists such as Women Artists for Revolution placed eggs and Tampax on the Whitney staircase to call attention to the absence of women from a show that purported to survey the contemporary American art scene.[4]

To rescue Nivison from oblivion would require a new kind of monograph, shaped by a complex strategy. It would be necessary to assemble the sketchy visual evidence remaining and to supplement it with other forms of documentation. Available visual evidence includes the few works that survive along with the much more numerous reproductions of lost works that exist mostly in black and white. For example, Nivison published drawings in various magazines, such as the *Masses,* and newspapers. I even turned up a group of her drawings in the yearbooks and magazine of the college where she studied.[5] Professional black-and-white photographs of many of the paintings discarded by the Whitney survive in private hands, Nivison having commissioned them during her lifetime. Color reproductions could come from the few small oils and works on paper that survive at the Whit-

ney, where they were saved by being catalogued incorrectly as works by Edward Hopper, and from the small number of her paintings, watercolors, and drawings that remain in private collections. Not only recovery but interpretation of Nivison's work would require a complicated maneuver. I presented an initial view of her work in a biography of her husband. But I admit that this treatment is inadequate; women artists should not be reduced to being "significant others."[6] Nivison's struggle to maintain a professional identity would need to be placed in the context of the attitudes that thwarted and frustrated other women artists of her day. The monograph would trace the obstacles Nivison's female classmates confronted at the New York School of Art during the first decade of the twentieth century, contrasting their situations with those of the male students there, who included many men who later made names for themselves, such as Edward Hopper, George Bellows, Rockwell Kent, Eugene Speicher, Walter Pach, and Guy Pène du Bois.

It was at the New York School of Art that Nivison caught the attention of Robert Henri, the school's most popular teacher. Shortly after the death of his wife, in December 1905, he asked Nivison to pose for a portrait he titled *The Art Student,* in which he captured her determined gaze, her intensity, and her winsomeness. Although her painting smock has slipped seductively down from her shoulders, Nivison grasps her brushes with resolve, bearing witness to her relentless ambition to be an artist. Weighing a mere ninety pounds, she nonetheless looks as if she would swat anyone who tried to stand in her way. Even though she adored her teacher and he, clearly in need of a new companion, showed exceptional interest in her, no romance ensued. Posing for Henri, which must have elicited envy from her classmates, was in itself instructive, for Nivison was then studying portraiture, which would remain a lifelong interest.

The attitudes of art teachers toward their female students, at the schools where Nivison studied (the New York School of Art and, earlier, the Normal College for Women in New York) and at other contemporaneous schools, are important to understand. If women were viewed merely as dilettantes who would get married and drop out, how much did that assessment affect their self-esteem and ambition? How much did the inability of women to support themselves as artists determine the path of Nivison's career? Answering such questions will

also increase our understanding of the continuing subtle mistreatment of women artists by the male-dominated art establishment.

Nivison's landscapes resemble her husband's not so much because the two of them studied with the same favorite teacher as because it was Nivison's practice to paint a landscape to help Edward Hopper break through the painter's block from which he frequently suffered. The situation provides an unusual opportunity to consider differences in the rendering of the same subject by two intimate contemporaries and the possible sources of those differences, including gender, as a way of examining the space between experience and representation.

A monograph would have to examine Nivison's aesthetics not only in relation to those of her husband but also in relation to those of other artists, both her contemporaries and ours. A close reading of the record, including the scanty and disparate surviving examples of her work, demonstrates that she and her husband conceived of art differently. She constructed an identity for herself, insofar as the record lets us say that she did, not just as an artist but as one with a distinctive woman's perspective on experience and on what ought to be put into a painting.

To pursue such an analysis, we must define how her approach differs from his. Comparing their landscapes of the same location painted the same year, we can discern differences, but can these differences be assigned to gender? In the summer of 1927, having purchased their first car, the couple drove, with Hopper at the wheel (at his own insistence), from New York to Maine, searching for new subjects to paint. The lighthouse at Two Lights on Cape Elizabeth caught Hopper's eye. Nivison later recalled that when she remarked that she too would paint it, he snapped, "Then I won't."[7] In the end, they both did, though only one watercolor by her survives (and two canvases and several watercolors by him). The differences in their approaches may result more from personality differences than gender differences. An introverted loner, Hopper portrayed the structure in isolation, reflecting the separation of men in the Coast Guard from their families, while Nivison, gregarious and sociable, included nearby houses in her picture.

Two years later, on a springtime excursion to Charleston, South Carolina, they found different subjects to paint. Because they were staying in a centrally located boarding house, Nivison could walk to the sites she chose to paint; Hopper never let her take their car out on her own. Although several of the watercolors Hopper painted on that

trip survive, I have located only one work Nivison painted there, a watercolor of a local landmark known as the Pink House. The subject she chose dates from the mid-1690s and is constructed of pink Bermuda stone. A charming house with its original terra cotta tiled roof, it is said to be the oldest tavern building in the South. Although this quaint structure has attracted many artists, Hopper probably dismissed it as too picturesque. The subjects attracting him could be described as more ordinary and perhaps less stereotypically feminine if we consider the unusual pink color and curvilinear forms of Nivison's choice. Hopper was attracted by the more angular Ash's House, with its traditional veranda and strong contrasts between light and shadow characteristic of Charleston.

In 1930, when the Hoppers first began to summer in Truro on Cape Cod, each of them painted a canvas of the South Truro Meetinghouse Church. Nivison's version was a view from the side opposite the one that Edward subsequently painted; she worked near the cemetery, farther back from this Methodist church than he, "so as to see the sea beyond [the] row of hills," she later claimed, wanting "no close foreground at this distance."[8] In her diary she recalled in elaborate detail how her husband would drop her off with her easel and leave her in the wide empty landscape while he drove elsewhere to work on his own subject. She recorded telling a man who frightened her by approaching as she worked, "My husband...should be painting this church, more in his line than mine, but it must be painted, so I [am] trying my hand."[9] The entry confirms that she painted South Truro Church before Hopper did and suggests why she called her version *Odor of Sanctity.* Nivison, who loved the aura of churches, evidently believed that this one had protected her from violation by the intruder whose presence she found so threatening. Not only did Hopper paint his own version of the venerable building later that summer, but he also made a caricature, *Jo Painting South Truro Church in the Wind,* poking fun at her for the difficulty she had had trying to hold on to her canvas.[10]

The difference between Nivison's approach and Hopper's suggests that she refused to follow her husband's advice that she give her forms weight. (He found that a defect in her work and Cézanne's.) Nivison never accepted Hopper's criticism. In 1959, for example, when the Metropolitan Museum curator Theodore Rousseau viewed Nivison's painting *Obituary* of 1948 (Figure 15), she noted in her diary that she

15. Jo Hopper, *Obituary,* 1948, oil on canvas

had "babbled of Marie Laurencin & her triumph over specific gravity," underlining one of the qualities she had sought to achieve in her painting that Hopper viewed as a flaw.[11]

Before I discuss the implications of *Obituary,* I want to consider one more set of paintings: Nivison's and Hopper's views over Washington Square from Hopper's studio. Both focus on the Judson church and its cross-capped tower. Hers, however, *Judson Tower, Washington Square, Looking South* (Figure 16), is vertical, and his, *November, Washington*

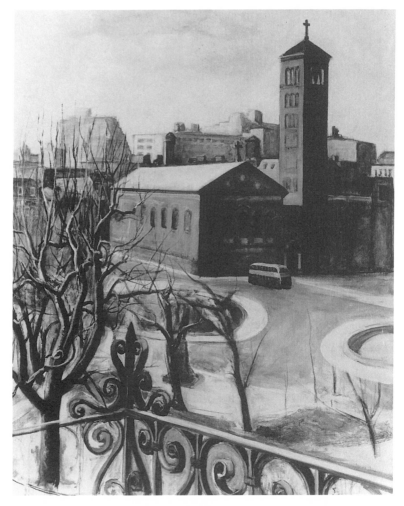

16. Jo Hopper, *Judson Tower, Washington Square, Looking South,* ca.
1950, oil on canvas

Square, is typically horizontal. Their different habits of vertical versus
horizontal framing correspond with their divergent heights: she was
barely five feet tall, whereas he was six feet five inches. Nivison added
a bus to her painting, suggesting the presence of people, whereas he
rendered the square empty. She framed her view with the ornate curves
of their wrought iron fire escape and included many branches of win-

ter trees; he, ever reductive, omitted the fire escape and all but a hint of the trees.

Nivison probably began *Judson Tower, Washington Square, Looking South* to prod Hopper out of his depression and into painting, but when she painted *Obituary*, another instinct was operating. Acutely aware of her spouse's contempt for still life and his vigorous disdain for what he called "lady flower painters," Nivison intentionally disregarded the dominant male aesthetic in both her home and her time; her subject matter seems self-consciously female. She chose as the theme of this painting her deceased women friends. In fact, she was originally planning to call it *Fleurs du Temps Jadis* (Flowers of Time Past) in homage to her favorite poem by François Villon, "Ballade des Dames du Temps Jadis," perhaps recalling how the French poet identified women with flowers. Behind a vase of dried flowers on a table by a window Nivison added her beloved cat Arthur, who had disappeared thirty-four years earlier, as well as views through the window of both the Washington Square Arch and their home on Cape Cod. Such a quirky painting has no parallel in the realist art of Edward Hopper.

But the monograph would have to pose some theoretical questions: Is there something intentionally feminine in such work? Did any of Nivison's female contemporaries share such characteristics? Do any women artists today display similar traits? The pen-and-ink drawings that she published in her college magazine and yearbook reveal a style somewhere between that of Aubrey Beardsley and that of Charles Dana Gibson, but her subject matter in those works self-consciously incorporates stereotypes of femininity, from concern with one's appearance to drinking milk for a healthy complexion. She was aiming at what she thought would please the students in a women's college at the turn of the last century. By her second year Nivison was identified as one of five "special artists" who contributed drawings. In one she depicts a young woman in cap and gown sitting on a high stool and in the other a dreamy young woman, dressed in ordinary attire, contemplating her reflection by candlelight in a mirror, where she appears in her graduation cap and gown.

Obituary and other examples of Nivison's most original and eccentric paintings, such as *Jewels for the Madonna (Homage to Illa)* of 1951, pose a further theoretical question. Such works invite reassessment in light of the postmodernist discourse that has brought attention

to women artists like Florine Stettheimer, whose sophisticated, cluttered, and intimate subject matter lay outside the dominant male aesthetic of her contemporaries. Nivison's shrinelike arrangement of baubles on her dresser top takes on a different character in light of Audrey Flack's paintings from the 1970s. The work of other contemporary women artists such as Paula Rego, Lisa Yuskavage, and Rita Ackerman employs similarly banal images that they push toward the subversive. Was Nivison also trying to subvert? She certainly questioned the validity of her successful husband's aesthetic for her own work and resented his pressure on her to stop making art. She also protested the male art establishment's disdain for work by women artists. Some of her anger she channeled into her diaries and some into weekly meetings with a group of six women friends who called themselves the Euripides Gang, reading the tragedies of Euripides together and taking comfort in his constellation of determined, if desperate, women.

The monograph would also have to reassess Nivison's role as her husband's only model. She was not a passive prop; having acted with the Washington Square Players and other troupes, she consciously acted out her husband's fantasies, collaborating with him to perform what he wanted to paint. What is the interplay between Nivison as she posed for her husband and Nivison as she represented herself—between Nivison as image maker and as made-up image? Often she posed nude for her husband's paintings, such as *Eleven A.M.* (1926), *Morning in the City* (1944), and *Woman in the Sun* (1961). But for her only extant self-portrait (Figure 17) she posed in her early seventies wearing a pink lace bra, earrings, and a necklace. Jo had purchased the bra in 1956 as a birthday present from Edward, noting in her diary that it was "the most expensive thing of the kind I've ever owned" and commenting that it was "perishable & does nothing specially for me anymore than another layer of skin."[12] In her self-portrait, Nivison was the subject of the painting but no longer the object of her husband's gaze and fantasy.

Finally, and fortunately for the prospective monograph, Nivison kept copious diaries from the early 1930s until near the end of her life. In them she recorded her efforts to preserve her identity as an artist and gain attention for her work and also documented her married life in detail: the books, articles, poems, and plays shared with Edward; her part in his work, shopping for costumes and props and serving as model; their travels in search of subjects to paint; their sojourns on

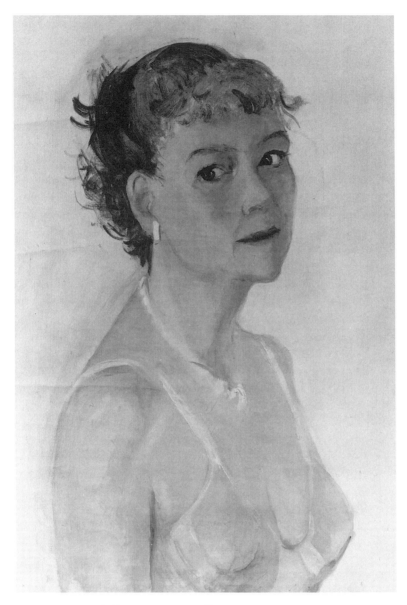

17. Jo Hopper, *Self-Portrait*, 1956, oil on canvas

Cape Cod; and their interaction with the art world, especially her husband's links with a network of galleries, museums, and male artists. Because Nivison is the sole witness for much of what she reports, her credibility must be determined. No one is likely to doubt her recitals of tea parties, books read, plays attended, trips, motels, or the progress of paintings, hers or his. And where testimony is available from other sources, it corroborates hers. But this point about her credibility has to be made, for some critics have cast doubt on what she reports about domestic and artistic tensions with her husband.

The monograph that I have been sketching should find an audience, but it will also be controversial, to judge from the response to excerpts from the diaries and to Nivison's work that I included in my recent biography of her husband. That both Nivison and my attempt to restore her to history have been attacked by antifeminists suggests that the monograph might include a preemptive strike.

Heading the pack, Hilton Kramer lost no time in labeling the biography of Hopper a "feminist soap opera."[13] The art historian Abraham Davidson felt compelled to fabricate history, claiming that I "warmed to Jo on...several meetings during the writing of the book," even though I never met Jo, who died while I was still an undergraduate.[14] Another writer labeled me "a strident feminist," arguing that I blamed Hopper for his inability to live up to what that critic imagined was my idea of the perfect man: adaptable, responsive, and constantly nourishing the creative urges of his wife.[15]

Antifeminist reactions to the biography and to Nivison also emerged where they might not have been expected. In the last years of their lives, the Hoppers began to cultivate two aspiring young critics, Brian O'Doherty and Barbara Novak. O'Doherty interviewed the Hoppers on television, and in 1965 he selected work by Nivison, along with then obscure artists such as Robert Smithson, Robert Ryman, and Jamie Wyeth, for an exhibition called "Lesser Known and Unknown Painters" that he organized for the New York World's Fair. After Nivison's death, O'Doherty also praised her in print, in 1971, as "a woman of genuine if frustrated talents, extremely well-read, and at her best a brilliant and eccentrically original conversationalist."[16]

Novak, too, praised Nivison, even featuring her ahead of Georgia O'Keeffe in a list entitled "Lady Flower Painters" for a special issue of the feminist journal *Heresies* entitled "Women's Traditional Arts: The

Politics of Aesthetics."[17] Novak knew the Hoppers too little to realize that "Lady Flower Painters" was one of the epithets Edward threw at Jo to demean her and other women artists. Ironically, Novak herself is a painter of flowers. Novak and O'Doherty were still speaking well of Nivison when I interviewed them for the biography. But its publication, with the revelations of the diaries, seems to have given them a turn, for they subsequently claimed that Jo was "slightly mad" and was "a wife whose art was all too often reminiscent of her husband's."[18] Their reversal closely fits the cultural pattern of reactions against feminism described by Susan Faludi in *Backlash: The Undeclared War against American Women*, with a trace of opportunism governing their shifts from would-be intimacy, to praise in the context of fashionable 1970s feminism, to disparagement in the context of the backlash that has allowed them to take sides retroactively in the Hoppers' tensely productive menage.[19]

Dealing with these and other polemics will be a final task for the monograph. To be sure, Nivison was not following her husband when she painted the flowers he despised or the children, still less when she initiated a subject to spur him to work. As for "mad" and "insane," those slurs are commonly employed to demean outspoken creative women. In her book *Women and Madness*, Phyllis Chesler describes madness as "an expression of female powerlessness and an unsuccessful attempt to reject and overcome this state," arguing that the tragic experiences of women like Zelda Fitzgerald or Sylvia Plath symbolize the oppression of women's power and creativity.[20] Chesler might well have been describing Nivison's situation when she wrote, "Women are impaled on the cross of self-sacrifice. Unlike men, they are categorically denied the experience of cultural supremacy, humanity, and renewal based on their sexual identity."[21] Remarkably, although Nivison was extremely angry and undoubtedly eccentric, she did not give up. Unlike many frustrated creative women, moreover, she did not escape her miserable plight through insanity. Any monograph on her work must begin by taking on her critics, not only those responsible for destroying her work but also those who would continue to dismiss her as "mad."

The failure of men to accept the efforts of creative women was not unique to the visual arts. In a letter F. Scott Fitzgerald wrote in 1934 to the physician of his wife Zelda at a clinic where she was being

treated for mental illness, he made a comment that parallels Edward Hopper's attitude toward his wife's artistic efforts:

> As to her writing: there is no longer any competitive element involved. There was a time when she was romping in what I considered "my" material, disguising her characters under such subtle names as F. Scott Fitzpatrick, when I thought she was tearing at the very roots of my profession, in other words, of our existence. She finally got the idea and desisted, but rather bitterly. At any rate all that element of competition in material which I had to turn into money, or if possible, into art, and which she was competent to turn only into essentially inefficient effort, we can now assume to be in the past.[22]

Hopper too felt threatened by his wife's efforts in his own professional arena. He experienced conflicts with his wife strikingly similar to those of Fitzgerald, yet he depended on her to model for him, keep his record books, handle much of his correspondence, and fend off those he wanted to avoid.

Nivison's fate was extremely unlucky, but she was not alone. Other artists of her generation await serious study: Hilda Belcher, Ethel Klinck Myers, Martha Rhyther Kantor, Mary Rogers, Helen Sawyer, Henrietta Shore, and many others. Articles give us a place to begin, but they are not enough, for they are often overlooked.

Some feminist art historians have suggested that the monograph as a genre should be discarded because of its traditionally masculine stamp. I would propose instead that it needs to take on a new form, tailored to the situation of artists whose lives were ignored and works neglected, when not actually lost.

NOTES

1. See Gail Levin, *Edward Hopper: An Intimate Biography* (New York: Alfred A. Knopf, 1995). For clarity in this essay, I have chosen to distinguish the work of Jo Nivison Hopper from that of her husband by referring to her by her maiden name.

2. John I. H. Baur, *Revolution and Tradition in American Art* (Cambridge, Mass.: Harvard University Press, 1951).

3. Nivison left extensive diaries, which are in a private collection. See Levin, *Edward Hopper*, xi–xiv.

4. See, for example, Judith Hole and Ellen Levine, *Rebirth of Feminism* (New York: Quadrangle Books, 1971), 366–67.

5. See Levin, *Edward Hopper,* 148–50. Nivison attended the Normal College of the City of New York, now Hunter College of the City University of New York.

6. See Whitney Chadwick and Isabelle de Courtivron, eds., *Significant Others: Creativity and Intimate Partnership* (New York: Thames and Hudson, 1993).

7. Jo Nivison Hopper diary entry for January 13, 1941.

8. Jo Nivison Hopper diary entry for June 30, 1961.

9. Ibid.

10. The *Provincetown Advocate* (March 21, 1940, 1) described the building as "a landmark famous throughout the Cape, known throughout the country, pictured by painters on hundreds of canvases" when reporting the church's destruction by fire after being hit by lightning.

11. Jo Nivison Hopper diary entry for May 4, 1959.

12. Jo Nivison Hopper diary entry for March 15, 1956.

13. Hilton Kramer, "Mr. and Mrs. Hopper: The Closet Drama of a Miserable Misalliance," *Boston Globe,* October 8, 1995. See my letter responding, November 12, 1995, B37.

14. Abraham Davidson, "Behind Every Great Man…," *Wall Street Journal,* October 4, 1995, A12. See my letter responding, captioned "Persistent Devotion to Ungrateful Husband," November 8, 1995, A21.

15. Although it has been cited in feminist circles, the first article that I wrote on Nivison, before I discovered her diaries, elicited no such antifeminist response. See Gail Levin, "Josephine Verstille Nivison Hopper," *Woman's Art Journal* 1 (Spring/Summer 1980): 28–32. See also comments on this article by Carrie Rickey, "Writing (and Righting) Wrongs: Feminist Art Publications," in Norma Broude and Mary D. Garrard, *The Power of Feminist Art: The American Movement of the 1970s, History and Impact* (New York: Harry N. Abrams, 1994).

16. Brian O'Doherty, "The Hopper Bequest at the Whitney," *Art in America* 59 (Summer 1971): 69.

17. Barbara Novak, "Ten Ways to Look at a Flower," *Heresies: A Feminist Publication on Art and Politics,* Winter 1978, 47.

18. Barbara Novak and Brian O'Doherty, letter to the editor, *New York Times Book Review,* October 29, 1995, 4, 48; see my letter responding on December 10, 1995, 4.

19. Susan Faludi, *Backlash: The Undeclared War against American Women* (New York: Crown, 1991).

20. Phyllis Chesler, *Women and Madness* (New York: Doubleday, 1972), 16.

21. Ibid., 31.

22. Quoted in Peter D. Kramer, "How Crazy Was Zelda?" *New York Times Magazine,* December 1, 1996, 108.

DESIGNING WOMAN
WRITING ABOUT ELEANOR RAYMOND

NANCY GRUSKIN

I first became aware of Eleanor Raymond in 1992 when I was a graduate student working for the Massachusetts Historical Commission. There I came across a small photograph of a Bauhaus-influenced house Raymond had designed in 1931, which I later learned had been commissioned by her sister Rachel (Figure 18). The house's crisp lines and breezy terraces were a refreshing departure from the hundreds of Capes and Victorian "Painted Ladies" I had seen that summer. A few years (and seminar papers) later, I completed a dissertation on the architect. In many ways she was an ideal subject: Raymond was hardly a household name, even in Boston, her hometown, and the only previous study of her work, a short monograph published in 1981 by the local architect Doris Cole, was written before a significant archive of Raymond's office and personal papers had become available to the public. At the time, women architects were not included in the standard surveys of modern and American architecture, and their names were rarely introduced to students, even graduate students, of architectural history. Here, it seemed, was a chance to make a contribution.

Eleanor Raymond, however, was in many ways a reluctant subject. Unlike the iconic "heroes" of modern architecture who defined their own historical contributions through treatises, manifestos, and auto-

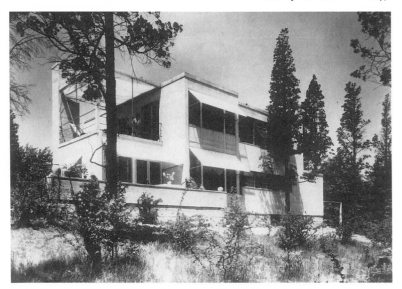

18. Eleanor Agnes Raymond, Rachel Raymond House, Belmont, Mass.,
1931

biographies (a situation that admittedly presents its own set of chal-
lenges to scholars), Raymond was relatively silent about her life, her
work, and the male-dominated profession of architecture in general.
The lack of methodological role models for dealing with the career of
a woman architect presented another challenge. Monographic treat-
ments began to be dismissed as passé just when the recovery of women
architects was in its infancy. I could sense the judgmental tone in many
colleagues' voices when they learned I was working on Raymond: "Oh,
so you're doing a *monograph.*"

The challenges and the criticisms, however frustrating, held the key
to certain insights. What I once perceived as Raymond's "silence" was
in the end quite telling—it spoke to women architects' culturally im-
posed modesty, and it suggested that artistic bravado and theoretical
polemics were often luxuries afforded only to male architects. As I
struggled to reconcile Raymond's career with the biographies of mod-
ernism's canonical architects, feminist critiques of the monograph
heightened my awareness of the implicitly male "voice" of most his-
torical narratives. In the end I settled on two goals: to reconstruct the
monograph from a feminist perspective and, in so doing, to give Ray-
mond a voice—a visible place in the history of architecture. My intent

was not to canonize Raymond—the uncritical celebration of achievement epitomized the monograph "trap"—but to provide a richer reading of the history of twentieth-century architecture by examining a figure marginalized in the field and by scrutinizing the mechanics of marginalization itself.

By the mid-1990s feminist scholarship on architecture was divided into three methodological camps. The first studies to emerge from the women's movement of the 1970s focused on women's relation to the built environment and established architecture's role in patriarchal oppression.[1] Later studies, primarily essays in anthologies, adopted a more theoretical stance, appropriating the cultural construct of gender and using it to reinterpret the history of architecture.[2] A third group of studies, in the traditional art historical form of the monograph, recovered the unfamiliar names and careers of women architects.[3]

This growing body of literature had a surprisingly limited impact on my own work, however. Expositions on gender discrimination in the *man*-made environment were too firmly rooted in contemporary feminist debates about political power and victimization to be retrofitted to the career of a woman architect practicing in the first half of the twentieth century. Theoretical explorations of gender's impact on the architectural discourse were useful in developing a critical eye, but their focus on the canonical male architects of modern architecture raised a set of issues different from those I was grappling with in my own work. In addition, it was difficult to adopt a methodology based on semiotics and literary criticism when dealing with an architect who left behind no treatises or manifestos, an architect who rarely spoke or wrote about her work at all.

The third group of studies, those that set out to examine the personal and professional lives of women architects, held more promise. Monographs on female designers are far outnumbered by those on women painters and sculptors—reflecting the greater number of women in those fields.[4] And while lavishly illustrated monographs on well-documented architects like Frank Lloyd Wright and Le Corbusier continue to appear, only Sara Holmes Boutelle's book on Julia Morgan and Peter Adam's book on Eileen Gray have been published by major presses. For many feminist scholars, however, the real problem lies not in the dearth of such treatments but in the inappropriateness

of the biographical approach altogether. The monograph, which typically glorifies singular efforts, signature styles, and larger-than-life personalities, does indeed seem inherently ill-suited for understanding the work of women architects.[5] Even the barest biographical sketch of Eleanor Raymond, for example, reveals the inadequacy of such a narrative.

A relative latecomer to the architecture profession, Raymond in childhood and adolescence did not bear out the "great artist" notion of innate genius. Her focus on domestic architecture reflected educational and professional channeling rather than her natural inclination. The centrality of Raymond's fifty-four-year partnership with Ethel Power (1881–1969), editor of *House Beautiful,* introduces issues typically neglected in architectural monographs: sexuality and the impact of personal relationships. Even the architect's work, which simultaneously exhibited both innovative and imitative forms, counters the aesthetic dogmatism of history's most celebrated architects, suggesting not only Raymond's own ambivalence toward strict modernism but also the importance of client satisfaction in a female architect's career. Exploring such anomalies might well serve to highlight the very gender biases that historians had been accused of cloaking in previous monographs. Surely the monograph was not inherently beyond reform. Surely it could accommodate a feminist approach.

Ultimately, I found methodological role models in art history, literary history, and women's studies; architectural history was still in the process of outlining the problem. Feminist biographers, also under attack, provided examples of how to contextualize female subjects by conflating biography and social history.[6] Many of the women who had been the subject of recent biographies offered remarkable parallels to Raymond in age, class, education, lifestyle, and career path. The surge of professional women who emerged during the late nineteenth and early twentieth centuries in a number of male-dominated fields provided numerous subjects for the historian or the biographer. Raymond, born into a relatively prosperous family, was a member of the first generation of women to attend college in significant numbers, graduating from Wellesley College in 1909.[7] Like many of her peers, she was active in the campaign for suffrage, volunteered as a settlement house worker, and joined a number of the women's clubs that proliferated across the country during the Progressive Era.[8] Facing discrimination

in the workplace and societal expectations of marriage and children, career women of the period often cultivated "families" of like-minded peers, bound by common interests and concerns rather than by blood relation. Raymond and four of her cohorts, including her partner, Ethel Power, shared a home on Boston's Beacon Hill that the architect renovated in 1923.[9]

The poststructuralist insistence on the death of the author/artist has shifted the focus of art history away from such biographical details. Yet given the sheer rarity of women in the early twentieth century who chose to pursue professional careers in architecture, biography seems not only a valid but an essential starting point for understanding Raymond's choices. Born at the end of the nineteenth century, she was able to take advantage of American women's newly expanding privileges and freedom—their greater access to higher education, increasing political and social equality, and ability to enter professions demanding acquired skills rather than preexisting capital or birthright. At Wellesley Raymond found a tight-knit community of female students and faculty, discovered the possibility of female support systems, and developed stereotypically "masculine" traits useful in professional life: self-confidence, creativity, and independence. But enduring Victorian notions of masculine and feminine behavior can be seen in Raymond's explanation of her choice of professions. "I was made for architecture," she claimed in 1981. "I think I'm part masculine. I think that makes the difference."[10]

Finding common threads between Raymond and other professional women of her generation gave me a more sophisticated understanding of her individual achievements. She was no longer "that exceptional one," a label that, as the architectural historian Abigail A. Van Slyck has argued, places "the onus for the lack of a female presence in architecture back on women themselves."[11] Ironically, the architects who successfully challenged gender discrimination in the profession most vehemently denied its existence. When asked if she had encountered obstacles as a woman (a question both journalists and historians frequently asked her), Raymond was often evasive, suggesting that dedication and good fortune were the only requirements for success. In the 1981 interview, she contended, "I was lucky. I never had to go out after a job. I know it was just because of my very good luck [that] that's what happened to me."[12]

I had learned from writers of women's history, however, to be skeptical of such positive accounts. In a discriminatory world, many career

women deliberately preferred to focus on professional ability and achievement, not gender.[13] The establishment of academic programs and professional guidelines after the Civil War did seem to create new opportunities for aspiring female architects, but enduring stereotypes of women and a renewed interest in architecture as a field for men with "worldly credentials" effectively limited women's professional choices. Few male architects were willing to "disrupt" the boys' club atmosphere of the drafting room, and although several universities (among them MIT, in Raymond's hometown) admitted women students to their architecture programs, admission policies based on quotas and gender segregation within the studio created an intimidating environment for the women who enrolled.[14]

Raymond found a reprieve from this system at the Cambridge School of Architecture and Landscape Architecture for Women, where she enrolled in the summer of 1916. Unofficially founded by Professor Henry Atherton Frost of Harvard in 1915, when a tenured faculty member persuaded him to provide after-hours drafting lessons for a Radcliffe alumna, the Cambridge School, as it would come to be called, gave women a unique opportunity to receive academic training in an all-female environment. Yet the school's curriculum, which focused solely on the study of domestic design, reflected prevailing gender biases and effectively confined graduates to a domestic practice for the rest of their careers. Raymond herself put a positive spin on such educational channeling, confirming that women could instinctively "do better houses than a man" because of their greater familiarity with domestic life. Yet Raymond's claims that "she never wanted a husband or to have children" and that she "wouldn't have the slightest know-how of how to take care of children" contradict her own essentialist response and again suggest an ingrained coping mechanism.[15]

The earliest graduates of the Cambridge School faced additional obstacles in the workforce. Because the program remained unaccredited until its affiliation with Smith College in 1932, students lacked the educational credentials that the American Institute of Architects and a number of state licensing boards were seeking for registered practice. Given these constraints, Cambridge School graduates fared remarkably well in the professional world, although most worked independently or as partners in small firms rather than as draftswomen and partners in the country's leading large-scale firms.[16] Raymond began her career as a draftsperson in Frost's firm while still a student at the Cambridge

School. After graduation, she was named Frost's sole partner, a position she retained until she opened her own firm in Boston in 1935. Although Frost recorded many of his experiences at the Cambridge School in a 1943 manuscript for a planned, but never published, autobiography, the forty-five-page document contains not a single reference to his former partner. Why did Frost promote Raymond over the numerous other graduates who had worked in his office? The dynamics of their partnership remain unclear to me, but it seems safe to assume that Raymond's commitment to her career (perhaps best attested to Frost by her decision to remain a single woman) assured him of a stability in the firm that was threatened by his growing responsibilities as an instructor.

Frost assumed an important role in Raymond's early career, but equally, if not ultimately more, important was a group of women Raymond met primarily as a student at the Cambridge School. Female-network building as both an extension and a repudiation of the traditional "women's sphere" has been an integral focus of women's studies and feminist art history for years, but this professional strategy has only just begun to be examined by architectural historians.[17] Raymond's circle included her younger sister Rachel, an interior decorator and 1916 graduate of Wellesley, and Cambridge School alumnae Ethel Power and Mary Cunningham. All three women shared Raymond's Beacon Hill townhouse along with Raymond's widowed mother and Cunningham's twin sister, Florence, a Vassar-educated diction and drama coach. The group not only lived together but often worked together as well. For several of Raymond's domestic commissions, Rachel was hired to coordinate the interior decoration, and Mary, a graduate of the Cambridge School's landscape architecture program, was contracted to design the surrounding gardens. Raymond's clientele also included a number of single professional women whose significant financial resources provided dozens of commissions for her. This network of colleagues and patrons, a neglected female counterpart of the homosocial connections that helped propel many male architects to fame, was a significant source of Raymond's success.[18]

At the forefront of Raymond's adult life was Ethel Power. Personal relationships are not standard subject matter in most studies of women architects. Indeed, many consider the issue irrelevant, arguing that women architects had to work too hard to maintain a life outside the office or that their private lives were of no consequence to their ca-

reer.[19] But Raymond herself, through her careful preservation of both professional and personal documents, highlights the inextricable connection between these two sides of her life. Among the blueprints and office papers given to the Harvard Graduate School of Design a few years before her death were boxes of letters, scrapbooks, and diaries that document Raymond's relationship with Power. Eleanor and Ethel met in 1915 while both women were volunteering as Massachusetts suffragettes. Raymond, who was six years younger, convinced Power to enroll at the Cambridge School of Architecture and Landscape Architecture for Women, from which they both graduated with certificates in architecture in 1920. From 1923, when work was completed on Raymond's Beacon Hill townhouse, until Power's death in 1969, the two women were nearly inseparable.

The mere longevity of Raymond and Power's partnership suggested an intense and mutually beneficial bond, but the question of a physical relationship remains more enigmatic. Both women grew up in a late-nineteenth-century world that sanctioned same-sex companionship but refrained from open discussions of sexuality, and neither Raymond nor Power ever referred to themselves, or any of the other female couples that became part of their circle, as "lesbians."[20] Their reluctance to express any romantic sentiment, whether the product of their own Yankee stoicism or broader societal pressures, was reflected even in the private diaries of Power, kept sporadically from the 1930s through the 1960s. As primary sources, such traditionally "feminine" writing forms took the place of the architectural treatises and published autobiographies that scholars working on canonical architects often rely on to shape their interpretations.[21] The result was both a blessing and a curse: private documents typically lack the self-conscious posturing found in the published writings of architects, but they also assume a level of intimate knowledge not possessed by unintended readers. Far from recounting the trials and tribulations of a professional woman and her lesbian partner, Power's diary entries focused primarily on such mundane topics as dinner menus, garden pests, and weekend visitors. More revelatory details existed, but they were far more subtle than I had hoped or expected. An entry dated October 1952, written after a recent appointment with the couple's attorney to draft wills, suggests the amount of speculation involved in interpreting even Power's most expressive passages: "[Eleanor] has left me everything but I have nothing tangible to leave her except these diaries. And even then she must

read between the lines. A will doesn't seem to be the place for senti-ment; so it must bulge here unwritten."

It seems like a cruel joke to play on someone with whom you had shared most of your adult life, not to mention future historians trying to make sense of the relationship. Power's vocation as a writer and an edi-tor made her silence only more inexplicable. But her actions revealed her powerful attachment to Raymond. When *House Beautiful* magazine was sold to Hearst Magazines and its editorial offices were moved to New York City in 1934, Power resigned from the prestigious editorial posi-tion, which she had held since the early 1920s, in order to stay in Boston with Raymond. As a fifty-three-year-old woman in an industry still hard-hit by the Depression, Power must have known the ramifications of her decision. Such sacrifices were a telling sign of a deep and abiding love.

So what, in the end, does any of this have to do with Raymond's work as an architect? A great deal, I believe. In many ways, Raymond and Power assumed traditional husband and wife roles. Because of a significant inheritance and a more stable work history, Raymond acted as the financial provider of the family, providing Power with a home and, most likely, money after Power's resignation. Power, more inter-ested in the domestic world of cooking and gardening, was on several levels "the great woman behind the great (wo)man," taking care of household responsibilities, arranging travel itineraries, and keeping up with correspondence. Power's assumption of these "wifely" duties gave Raymond the time and the energy for a full-time career in architecture. Power's tenure at *House Beautiful* facilitated the architect's career even more directly by providing Raymond with invaluable publicity: almost two major articles a year (many written by Power herself). Behind the scenes, Power fought hard to earn Raymond critical success as she championed her work during several of *House Beautiful*'s small-house competitions. From time to time, Raymond also wrote for the maga-zine, undoubtedly an economic necessity during the building recession of the late 1920s and early 1930s.

For my purposes, the magazine became an invaluable resource. Sev-eral important domestic projects from the 1920s and 1930s are curi-ously absent in the Raymond archives. *House Beautiful,* with its lavish illustrations and lengthy articles, provided not only missing plans and photographs of original furnishings but also details about the private lives of featured homeowners and anecdotes about architect-client re-

lationships—information rarely introduced in the professional journals that also occasionally published Raymond's work. During Power's reign as editor, the Boston-based publication read like a virtual "who's who" of the Cambridge School circle, featuring not only Raymond's work but also the work and writing of numerous other graduates of the program. The personal connections were never made obvious in the pages of the magazine but were clear to the informed reader.[22]

Occasionally, my interest in the relationships between these women overshadowed the work itself; more than once I had to remind myself that I was an architectural historian and not a biographer. My predilection for the social history of architecture was perhaps part of the problem, as one danger of contextualism is losing sight of aesthetic merit. But the deeper issue had to do with the varied quality of Raymond's houses themselves. I was too defensive about my decision to focus on Raymond to admit this to most colleagues, but I did not find all of her work exciting from a purely aesthetic perspective. Yet some of her domestic projects, including the 1931 house for her sister that first brought Raymond to my attention, were inspiring. Completed after a trip she and Power made to Germany in 1930, the Raymond House reflected the architect's interest in creating a regional modernism. The house's wood frame and lightly stained cladding respected local building traditions, but the unadorned rectilinear forms and open-air terraces were imported directly from Bauhaus Germany. The interior continued these themes: an L-shaped combined living room and dining room embodied the open planning principles of European modernism, while the retention of a central hall plan and the inclusion of decorative wood trim and antique Chinese hardware on the built-in cupboards disavowed the Machine Age aesthetic. This merging of American and European influences is particularly significant because the Raymond House predates by six years the house Walter Gropius designed for himself in Lincoln, Massachusetts—a work routinely credited with being the first manifestation of a regional modernism.

Several other projects by Raymond, including a modernist studio built for Boston sculptor and philanthropist Amelia Peabody on her Dover estate (1933) and a pioneering solar-heated house designed in conjunction with MIT scientist Dr. Maria Telkes with funding from Peabody (1948), pointed to a missing chapter in the traditionally male history of modernism and building technology. But Raymond's work was

not consistently modern: much of it reflected a conventional accommodation of regional building traditions and revivalist forms. The 1942 compound Raymond designed for the mining heiress Natalie Hays Hammond in Gloucester, Massachusetts, for example, harks back to the domestic architecture of seventeenth-century New England (Figure 19). Each of the four buildings (three individual houses for Hammond and two of her cohorts and a central lodge for communal dining and servants' quarters) features steeply pitched roofs, small-paned casement windows, and dark-stained clapboarding.[23] Other houses in Raymond's oeuvre combined both modernist and historical influences, creating a hybrid not entirely imitative but not exactly innovative, either. But if I left these projects out of the discussion altogether, wouldn't I be creating a canon of my own—a canon whose limited scope only confirmed suspicions that, to paraphrase Linda Nochlin, there have been no great women architects? For me, the answer seemed to be to avoid the subjective, qualitative questions that were responsible for creating a canon in the first place and to try to evaluate Raymond's work on its own terms. Why did Raymond's domestic architecture follow such a broad and varied course? If gender was an overriding factor in so many aspects of her career, did it play a role here too?

Unfortunately, women architects of Raymond's generation were not prone to architectural theorizing. Julia Morgan granted few interviews and wrote nothing for publication, insisting that she was not "a talking architect."[24] Eileen Gray, according to her biographer, "shied away from any personal revelations" and was critical of the proselytizing of her male modernist colleagues.[25] In the case of Raymond, for every suggestion of a personal aesthetic there was a disclaimer, a retraction. In a 1961 interview, Raymond professed her longtime interest in modern architecture but quickly interjected a warning about becoming a "slave" to a favorite style. "I think it is up to the architect," she argued, "to express what the client wants and not to superimpose his own ideas."[26] Such sentiments, present in almost all of Raymond's public statements, are a far cry from the uncompromising egotism of modernism's most celebrated architects and seem to suggest a lack of conviction. But as architectural historian Sarah Whiting has pointed out in an essay on Eileen Gray's work, "being anti-theory is, really, a theory in itself" and merits deeper exploration.[27]

It is tempting to attribute Raymond's responsiveness to her clients' demands to some "feminine" quality of accommodation. Previous treat-

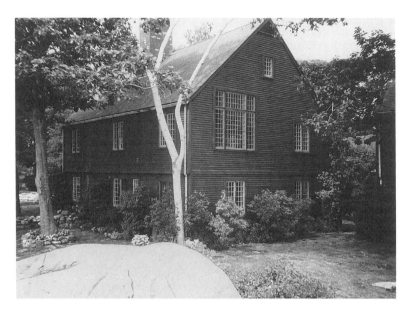

19. Eleanor Agnes Raymond, Natalie Hays Hammond House, Gloucester, Mass., 1942

ments of Raymond have tried to locate her entire career within socially acceptable parameters of feminine behavior. Doris Cole's 1981 monograph, for example, defends Raymond against the charge of unoriginality by claiming that her work possessed "a subtle simplicity without succumbing to architectural exhibitionism."[28] But the desire for client satisfaction suggests not so much feminine modesty as a practical acknowledgment of the *business,* as opposed to the art, of architecture. Working alone or often with one full-time draftswoman, Raymond profited only from commissions she herself generated, and a domestic practice was inherently less lucrative than one that included big-budget civic and commercial commissions. Few clients in conservative Boston proved amenable to the abstract forms and Machine Age philosophy of modernism, and dogmatically championing an aesthetic that clients did not want constituted professional suicide, as a number of local male architects acknowledged.[29] Surely Natalie Hammond, a member of the Medieval Academy of America and amateur historian of preindustrial England, would have sought out the assistance of another architect if Raymond had not been willing to design a "colonial village" for her and her cohorts. Gender issues only exacerbated the problem, as dealing with

suspicions about the capabilities of a woman architect increased the need to be responsive to the client. Raymond's own ambivalence about strict modernism must also be considered—even the Raymond House reflects her desire to "soften" the Machine Age aesthetic through the use of natural materials and traditional construction.

Over two hundred of Raymond's projects completed between the late 1920s and the early 1970s are documented in her office archives. Meeting the demands of her clientele may not have secured Raymond a place in the modernist canon, but it did earn her professional loyalty. Typically commissioned to design a primary residence, the architect was often hired again for additions, renovations to summer houses, or the design of various outbuildings. Raymond also designed artists' studios, churches, one factory addition, and even a luxury piggery for Amelia Peabody's Dover farm. I still have not visited all of Raymond's works; a number of minor renovation or alteration projects seem out of the scope of my research, and unknown street addresses and changes of ownership have made some domestic projects difficult to track down. But writing a catalogue raisonné, a daunting task given the longevity of Raymond's career and the sketchy documentation of her later work, has never been my intention. Her biography, coupled with my own feminist outlook, suggested a thematic approach, one that would deal with several key projects within the larger context of gender, patronage, and the modernist discourse. This strategy, which emphasizes the individual without denying the centrality of other historical agents and avoids the rigid format of a chronological treatment, may provide one way out of the monograph "trap." Admittedly, this is just one part of a feminist analysis of women and architecture. A truly comprehensive design history would also include women's relationship with architecture as users and patrons and would examine the influence of nonprofessional women on the built environment.[30] But telling the story of the lives of women architects is an essential part of this process; indeed, it is as valuable as recounting our own experiences as historians writing about women artists and architects.

NOTES

1. Pioneering investigations of women's relationship to the built environment include Matrix's *Making Space: Women and the Man-Made Environment* (London: Pluto Press, 1984); Daphne Spain's *Gendered Spaces* (Chapel

Hill: University of North Carolina Press, 1992); and Leslie Kanes Weisman's *Discrimination by Design: A Feminist Critique of the Man-Made Environment* (Urbana: University of Illinois Press, 1992).

2. Recent anthologies focusing on the role of gender and sex in architectural discourse include *Sexuality and Space*, ed. Beatriz Colomina (New York: Princeton Architectural Press, 1992); *Architecture and Feminism*, ed. Debra Coleman, Elizabeth Danze, and Carol Henderson (New York: Princeton Architectural Press, 1996); and *The Sex of Architecture*, ed. Diana Agrest, Patricia Conway, and Leslie Kanes Weisman (New York: Harry N. Abrams, 1996). In response to these anthologies' focus on architecture's role in the formation of female identities, Joel Sanders has recently edited an anthology of essays dealing with architecture and the construction of the male identity. See *Stud: Architectures of Masculinity* (New York: Princeton Architectural Press, 1996).

3. The most notable monographs include Judith Paine, *Theodate Pope Riddle: Her Life and Work* (Washington, D.C.: National Park Service, 1979); Virginia L. Grattan, *Mary Colter: Builder upon the Red Earth* (Flagstaff, Ariz.: Northland Press, 1980); Doris Cole, *Eleanor Raymond, Architect* (Philadelphia: Art Alliance Press, 1981); Sara Holmes Boutelle, *Julia Morgan, Architect* (New York: Abbeville Press, 1988); Doris Cole and Karen Cord Taylor, *The Lady Architects: Howe, Manning and Almy* (New York: Midmarch Arts Press, 1990); David Gebhard, *Lutah Maria Riggs: A Woman in Architecture, 1921–1980* (Santa Barbara, Calif.: Capra Press, 1992); and Peter Adam, *Eileen Gray: Architect/Designer* (New York: Harry N. Abrams, 1987).

4. According to data collected by the U.S. Bureau of the Census, less than 2 percent of all American architects practicing in the first three decades of the twentieth century were women (cited in Sophonisba Breckinridge, *Women in the Twentieth Century: A Study of Their Political, Social and Economic Activities* [New York: McGraw-Hill, 1933], 188). Today, according to the July 1999 issue of *Architecture* magazine, women constitute nearly 40 percent of architecture students in America but still own fewer than 9 percent of the nation's architecture firms. Educational obstacles, professional discrimination, and enduring stereotypes about women's unsuitability for architecture are just some of the factors that help account for such discouraging figures.

5. In her book review of published monographs on Theodate Pope Riddle, Mary Colter, Eleanor Raymond, and Julia Morgan, architectural historian Abigail Van Slyck argues that "the growing sophistication of feminist theory requires a serious reassessment of the usefulness of the architect's biography as a tool for reintroducing women in architectural history." See Abigail A. Van Slyck, "Women in Architecture and the Problems of Biography," *Design Book Review* 25 (Summer 1992): 19.

6. For an introduction to the issues raised by feminist biography, see Sara Alpern et al., ed., *The Challenge of Feminist Biography: Writing the Lives of Modern American Women* (Urbana: University of Illinois Press, 1992).

7. For the period 1890–1910, the number of female students at women's colleges increased by 348.4 percent, while the number of women at coeducational institutions increased by 438 percent. See Joyce Antler, *The Educated*

Woman and Professionalization: The Struggle for a New Feminine Identity, 1890–1920 (New York: Garland, 1987), 48–49. Raymond was the first of three daughters to attend Wellesley. Her sister Rachel graduated in 1916; her sister Dorothy left Wellesley after three years to get married in 1912.

8. Like many female college graduates of her generation, Raymond found the transition to postcollegiate life somewhat difficult in that her years at Wellesley had provided ample opportunity for personal growth but few practical or marketable skills. Volunteer activities and political causes like the suffrage campaign were common outlets for this generation's energy. For a more detailed discussion of these issues, see Rosalind Rosenberg, *Divided Lives: American Women in the Twentieth Century* (New York: Hill and Wang, 1992).

9. Raymond was able to purchase the Beacon Hill house because of a substantial inheritance left to the architect upon the death of her father. Such financial considerations and the larger implications of class should not be overlooked in the study of women architects and artists of the period, many of whom share upper-middle-class backgrounds.

10. This 1981 interview, perhaps the most extensive record of Raymond's personal views, was conducted by Doris Cole in conjunction with an exhibition of Raymond's work at the Institute of Contemporary Art in Boston. See *Eleanor Raymond: Architectural Projects, 1919–1973* (Boston: Institute of Contemporary Art, 1981), unpaginated.

11. Van Slyck, "Women in Architecture," 19.

12. Quoted in *Eleanor Raymond: Architectural Projects*.

13. See Nancy F. Cott, *The Grounding of Modern Feminism* (New Haven, Conn.: Yale University Press, 1987), 226–28.

14. For a discussion of the impact of professionalization on women architects, see Elizabeth G. Grossman and Lisa B. Reitzes, "Caught in the Crossfire: Women and Architectural Education, 1880–1910," in *Architecture: A Place for Women*, ed. Ellen Perry Berkeley (Washington, D.C.: Smithsonian Institution Press, 1989), 27–39. In the 1981 interview cited above, Raymond reflected on her own decision not to apply to MIT's program: "I knew that MIT was accepting women, but they were not making them very welcome."

15. Raymond's comments are published in *Eleanor Raymond: Architectural Projects*.

16. An alumnae survey conducted in the early 1930s revealed that 83 percent of all Cambridge School graduates were active in the profession. Of those working, 34 percent either had entered into independent practice or were serving as partners in small firms. Slightly more graduates, 39 percent, were employed as draftswomen in private firms, and 10 percent of alumnae were working in related fields such as teaching or editorial work. The results of this survey were published in the March 1932 brochure of the school, a copy of which is included in the Cambridge School Archives at Smith College. For a general history of the school, see Dorothy May Anderson, *Women, Design and the Cambridge School* (West Lafayette, Ind.: PDA Publishers, 1980).

17. To date, the most detailed examination of female-network building appears in the scholarship on women and the American political system. In par-

ticular, see Blanche Weisen Cook, "Female Support Networks and Political Activism: Lillian Wald, Crystal Eastman, Emma Goldman," *Chrysalis* 3 (1977): 43–61, and Estelle Freedman, "Separatism as Strategy: Female Institution Building and American Feminism, 1870–1930," *Feminist Studies* 5 (Fall 1979): 512–29. For the importance of female client networks in architecture, see Boutelle, *Julia Morgan, Architect*. Deborah Cherry's *Painting Women: Victorian Women Artists* (New York: Routledge, 1993) suggests the importance of female colleagues and patrons in the nineteenth-century art world, while Bridget Elliott and Jo-Ann Wallace's *Women Artists and Writers: Modernist (Im)positionings* (New York: Routledge, 1994) raises similar issues for twentieth-century artists.

18. In *American Architects and the Mechanics of Fame* (Austin: University of Texas Press, 1991), Roxanne Kuter Williamson investigates the common reasons for fame in the architecture profession, including proper networks and social connections, well-known mentors, and prestigious degrees. Not surprisingly, not a single woman is included in Williamson's 236-person "Index of Fame."

19. In her monograph on Julia Morgan, Boutelle dismissed Morgan's sexuality in the introduction without further exploration, claiming that "devoted to her career, [Morgan] seems never even to have considered marriage." See Boutelle, *Julia Morgan, Architect, 7.* Despite Peter Adam's repeated emphasis on Eileen Gray's professional relationships with several men and women throughout the main body of his book, his introduction discloses his choice to refrain "from probing too deeply into the private lives of those who were at times her most intimate friends," as this constituted an area of Gray's life that had "little bearing on [her] work." See Adam, *Eileen Gray, 2.*

20. Two general surveys of lesbian and independent American women of the twentieth century were particularly helpful in contextualizing Raymond and Power's relationship: Lillian Faderman's *Odd Girls and Twilight Lovers: A History of Lesbian Life in Twentieth-Century America* (New York: Penguin Books, 1991) and Trisha Franzen's *Spinsters and Lesbians: Independent Womanhood in the United States* (New York: New York University Press, 1996).

21. As cultural historian Irit Rogoff has argued in an essay on the role of "gossip" in art historical writing, the legitimization of "distinctly feminized" modes of communication is an important step in countering the conventional male narratives of modernism. See Irit Rogoff, "Gossip as Testimony: A Postmodern Signature," in *Generations and Geographies in the Visual Arts,* ed. Griselda Pollock (New York: Routledge, 1996), 58–65.

22. Unfortunately, no one has yet undertaken a scholarly examination of this important publication. The years of Power's tenure are particularly difficult to document, as *House Beautiful* did not transfer their records from the Boston office when they relocated to New York in 1934.

23. This is not to say that the Hammond Compound is unworthy of close examination. The nontraditional lifestyle of Natalie Hammond provides a compelling case study of architectural patronage. Like Raymond, Hammond was a single woman who chose to live her life surrounded by other professional

women. An accomplished painter, costume designer, and inventor, she settled in Gloucester during World War II to run the Massachusetts Women's Defense Corps—a volunteer paramilitary organization that trained women in civilian defense. Alice Laughlin and Phyllis Connard, Hammond's fellow residents, were also founding members of the corps. In addition to their wartime activities, Laughlin was an Arts Student League–trained artist and Connard was an actress and painter. Each house included a large studio or office for independent work and a compact galley kitchen, as most meals were prepared by servants and eaten in the separate dining hall.

24. Boutelle, *Julia Morgan, Architect,* 110.

25. Adam, *Eileen Gray,* 8.

26. Quoted in Nan Trent, "Award Winner Designs Houses Inside Out," *Christian Science Monitor,* October 31, 1961, 6.

27. See Sarah Whiting, "Voices between the Lines: Talking in the Gray Zone," in *Eileen Gray: An Architect for All Senses,* ed. Caroline Constant and Wilfried Wang (Tubingen: Ernst J. Wasmuth, 1996), 72. Whiting's essay examines Gray's writings, composed primarily in the form of dialogues, and suggests how the architect's approach to discourse deliberately differed from the style adopted by her male colleagues.

28. Cole, *Eleanor Raymond,* 10. The author also maintains that Raymond's work reflected "the needs of people and the concerns of the feminine world" (10).

29. Royal Barry Wills, a New England architect noted for his Colonial Revival houses, also flirted with a more modernist vocabulary but concluded that he was not "rabid enough to wage an unholy war against the inherent desires" of his clients. See Royal Barry Wills, "Confessions of a Cape Codder," *Architectural Record* 105 (April 1949): 134.

30. An excellent analysis of the role of women as patrons of modern architecture is contained in Alice Friedman's *Women and the Making of the Modern House: A Social and Architectural History* (New York: Harry N. Abrams, 1998). Dolores Hayden's groundbreaking history of feminist designs for American homes and cities, *The Grand Domestic Revolution* (Cambridge: MIT Press, 1981), is an exemplary model for future investigations of the contributions of nonarchitects.

ELIZABETH CATLETT

MELANIE ANNE HERZOG

Elizabeth Catlett (b. 1915) is the most renowned African American woman artist of her generation. For over half a century she has produced eloquent and impassioned visual statements against race, class, and gender oppression, against imperialism and other forms of injustice, and "for liberation and for life."[1] With supreme command of form, sensitivity to materials, and powerful imagery, her art proclaims the fierce determination, staunch resistance, and absolute integrity of her subjects.

Born in Washington, D.C., Catlett was educated at Howard University and the University of Iowa, where she received the first M.F.A. earned in sculpture. She taught at Dillard University in New Orleans and worked for several years at the George Washington Carver People's School in Harlem. Then, in 1946, with funds from a Rosenwald Fellowship, she went to Mexico to complete her *Negro Woman* series of linoleum cuts, paintings, and sculpture. In 1947, after ending her marriage to the artist Charles White, with whom she had traveled to Mexico, she decided to stay on and make her home there. She became a member of Mexico's internationally recognized Taller de Gráfica Popular (TGP; Popular Graphic Arts Workshop), and she and her second husband, the Mexican painter and printmaker Francisco Mora (1922–2002), remained members until 1966. She was the first woman

© Melanie Anne Herzog. Part of this essay was previously published in my book *Elizabeth Catlett: An American Artist in Mexico* (Seattle: University of Washington Press, 2000).

professor of sculpture at the Escuela Nacional de Artes Plásticas at the Universidad Nacional Autónoma de México, where she taught for sixteen years (1959–75). Though she continues to live in Mexico, since the 1970s she has exhibited her prints and sculpture in the United States—in community centers, libraries, schools, galleries, and, more recently, major museums.

My study of Elizabeth Catlett was inspired simultaneously by her art, her powerful representation of a multiplicity of women's experiences, and my own growing curiosity about the choices she had made in her life. I wondered why I had not heard about her reasons for making her home in Mexico or how, in the political context in which she was operating, she was able to maintain a political stance in her art.

To study an artist like Catlett inevitably involves considering art historiography—who is written into the history and who is written out. Catlett has been included, at least by mention, in all the major histories of African American art, from Alain Locke's *The Negro in Art* (1940) and James Porter's *Modern Negro Art* (1943) to recent histories of women artists.[2] Still, like most black artists, she continues to be excluded from books on American art and general survey texts.

How, then, are students to learn about Catlett and other artists who are recognized by those knowledgeable about African American art but who have been accorded little or no space in the larger discourse of American art history? Richard J. Powell's *Black Art and Culture in the Twentieth Century* (1997), in Thames and Hudson's World of Art series, and Sharon F. Patton's *African-American Art* (1998), in the Oxford History of Art series, are more widely available than are the earlier surveys by Samella Lewis, David Driskell, and others. Historians of African American art have written informative exhibition catalogue essays, but there are still too few book-length studies of well-known African American artists of the twentieth century or earlier. When I became aware of Elizabeth Catlett's work, Samella Lewis's book *The Art of Elizabeth Catlett* was the most substantive treatment available of any black woman artist.[3] Seeing so much of Catlett's work in one place inspired me to focus my own research on her. If Lewis had not written that homage to her colleague, friend, and former teacher, I probably would not have imagined that I could find enough information on Catlett to pursue my dissertation and my book.[4]

Although these artists are marginally recognized in survey texts, substantive information on them is most accessible in monographs—

yet too few have been written to date. And now, as African American artists, other U.S. artists of color, and indeed artists of other colonized peoples are beginning to be addressed in monographic studies and in art historical discourse, some critical theorists are challenging the validity of the single-artist study. Nancy Hartsock asks, "Why is it, exactly at the moment when so many of us who have been silenced begin to demand the right to name ourselves, to act as subjects rather than objects of history, that just then the concept of subjecthood becomes 'problematic'?"[5]

As bell hooks asserts, "Representation is a crucial location of struggle for any exploited and oppressed people asserting subjectivity and decolonization of the mind."[6] Writing about artistic expression as "essential to any practice of freedom," hooks argues that "without a doubt, if all black children were daily growing up in environments where they learned the importance of art and saw artists that were black, our collective black experience of art would be transformed."[7] Access to information about individual artists' work and lives is key to such transformative awareness.

I am not arguing for uncritically inserting marginalized artists into the canon (a practice that would validate the canon as potentially "inclusive" and thus serve to mask its structural and ideological exclusivity), or for reading their work transparently as illustrative of their life circumstances, or for valorizing them as "exceptional"—all potential traps for scholars of marginalized artists. Linda Nochlin notes that "each concrete art historical issue, problem, or situation demands a different set of strategies."[8] I envision monographs that examine the lives and work of these individual artists in relation—to other individuals, to their communities of origin, to their audiences—and that interrogate how, as members of particular communities, these artists are socially constructed and choose to position themselves in response to that social construction, including how they deal with racism, sexism, and other forms of oppression and how they engage with questions of visual representation. Such counterhegemonic studies, which draw upon what Lucy Lippard calls "relational, unfixed feminist models of art"[9] without presuming that such an individual can "stand for" an entire community, would have implications for how the work of other artists might be understood as well.

Certainly, many young (mostly European American) women art students during the 1970s were transformed by encounters with the work

of (European and European American) women artists. When I entered an art history graduate program after completing my M.F.A. in the mid-1980s, my department offered only one course on women artists and barely included them in other art history courses. Thus the university's women's studies program was crucial to my graduate education, for I wanted to learn and be able to teach my young women art students about women artists who had preceded them. As I developed greater consciousness about race and class issues, I began to understand how my vision of art and awareness of women artists had been severely constrained by my art training and my own social position—as European American, Jewish, middle class, and highly educated. As an undergraduate I had been shocked to discover that women artists who had been well known in their own times were excluded from the discourse of art history. Now, as I began to investigate artists that I and most of my teachers had relegated to the margins of our art historical vision due to their race or class as well as gender—even though they might have been well known in their own communities—I felt a similar sense of shock and betrayal.

To venture into women's studies and ethnic studies programs felt risky because my own department regarded the material I began to study as marginal and my chosen approach as suspect. Still, I felt drawn to learn about artists whose politics made sense to me, who grappled with questions of identity and representation, and who thought about audience, accessibility, and meaning. These were things I too thought about as an artist. I learned that many of the scholars and critics of African American, Native American, and Latin American art whose work I read were also artists. The model of the socially engaged artist/scholar was enticing, for I had been told that one could not be both.

Newly energized by these discoveries, I felt the courage to investigate art, literature, and discursive traditions with which I was unfamiliar. I also began to examine my own internalized racism, a process that is necessarily ongoing and often painful. By *internalized racism* I mean the unconscious acceptance of the white privilege that informs my experience of the world (even though my Jewishness renders this privilege potentially tenuous) and the unguarded responses, whether verbalized or not, that emerge at unexpected moments in situations where, to quote Cornel West, "race matters."[10] I hold the view that one cannot grow up in a racist society without internalizing racism and that I have a re-

sponsibility to examine, interrogate, and work to change unintentional reactions that come out of my deepest unconscious training.

I learned about Elizabeth Catlett in an African American studies seminar on contemporary African American artists. In this class, the privileging of whiteness that shapes the dissemination of knowledge within the European-dominated discourse of art history became clear to me, as I encountered the work of artists I had never heard of through books and journals published with much less financial and institutional support than the materials on European and European American artists with which I was more familiar. This course was taught by Freida High W. Tesfagiorgis, who broke new theoretical ground with her concept of Afrofemcentrism (a term she first used in 1984 in writing about Faith Ringgold) as a basis for understanding the artistic affirmation of identity by African American women artists such as Catlett.[11] She writes, "Conceptually, Afrofemcentrism gives primacy to Black-female consciousness-assertiveness by centralizing and enlarging intrinsic values, inadvertently liberating 'Black feminism' from the blackenized periphery of feminism." At the same time, she adds, Afrofemcentrism, while taking an activist stance that is centered in the experiences, consciousness, and worldview of black women, shares aspects of Afrocentric ideology and assumes a fundamental basis in African American experience, cultural values, and traditions.[12] What I learned in this class from artist/scholar Freida High (as she now identifies herself) became the foundation of my further study of Catlett's life and work.

When I began to learn about Elizabeth Catlett, I was curious about how half a century in Mexico had shaped her life, art, and sense of self. I wanted to know more about how her artistic practice has been rooted in community, her involvement with communities of socially engaged artists, first in the United States and then in Mexico, and how these communities had sustained her as an artist, teacher, activist, wife, and mother. I also wanted to explore the subtle and complex ways in which Catlett draws upon African, pre-Hispanic, Mexican, and modernist art traditions to convey, with such command of sculptural and graphic media, the strength, dignity, beauty, and humanity of her subjects—for here I see not only the figural representation to which she has committed herself but also representation of her sense of identity as syncretic and multivalent.

Catlett's sense of "identity" is certainly not fixed and stable, yet historical exigency—the social, historical, and cultural marginalization

and erasure of black women—demands that she name and position herself as a black woman artist. Her changing self-construction at various historical moments, in various geographic, political, and social spaces, and the manifestation of her sense of identity in her art for various audiences fascinate me. They continually impel me to see her art in new ways, not simply as illustrating her emotional states or her life circumstances but as representing her location—how she has positioned herself geographically and politically and how this positioning informs her artistic choices. Her art manifests the border crossings that have been defining forces in her life; it is a visual narrative of identity, transnational movement, and cross-cultural exchange that, in Judith McWillie's words, "explores the frontiers of tradition without relinquishing ancestral fidelities."[13]

But how could I, who at first glance have little in common with Elizabeth Catlett, do this work with any sort of integrity? Without commonality of race- and class-based experiences, I was relying on my admiration for her work and accomplishments as an artist, activist, and teacher, my respect for her politics and their infusion into her art, and my intellectual and personal curiosity. I had studied in Mexico, and I relished the thought of returning there to engage in research. I began by reading everything I could find about Catlett—and about African American and Mexican art, art history and criticism, and black feminism, about which I, a white Jewish feminist, knew virtually nothing. Cultural studies–based critical and theoretical writings on transnational movement and what Lucy Lippard calls "the cross-cultural process" informed my own crossing of borders within and outside of art history as I sought to make sense of Catlett's life and art.[14] bell hooks admonishes "progressive white critics working from critical standpoints that include race and gender [who] appropriate the discussion in ways that deny the critical contribution of those rare individual black critics who are writing on art."[15] Taking this to heart, I acknowledge my debt to those writers, and other scholars of color, whose work informs mine. This is not a burden of guilt, as some may read hooks's statement, but a responsibility that enriches my writing because it demands that I be conscious of my own position in relation to my subject and to the discourses in which I participate. I privilege the voice of Catlett herself in my writing, for art historical discourse too often denies the artist's voice, questioning its veracity, and black women are seldom acknowledged as speaking subjects in historical narratives.[16]

Though Catlett herself has been gracious in accepting my presence in her life, some who doubt that a white woman can write from an insider's perspective about a black woman artist have questioned my motives and capability. Indeed, I cannot bring to this work a black woman's "knowledge from within," as Patricia Hill Collins characterizes this insider's perspective.[17] Accordingly, I try to approach this work from a position of learning *from* rather than *about*.

My position as a scholar in this enterprise is a curious one. To study a living artist while maintaining a relationship with her in which we are both aware of our commonalities and our differences casts me simultaneously as authority, student, and collaborator. Archival research, consultation of previously published texts, and extensive study of Catlett's art give me the sense of authority I bring to my writing and to interactions with Catlett in which, on occasion, I remind her of documented occurrences in her past that she has forgotten and that even challenge the narrative of her life as she chooses to tell it. As this research leads me to intuit spaces or slippages in the narratives that have been previously constructed about Elizabeth Catlett's life, I explore these with her. This means examining my role as narrative maker—authoritative? collaborative?—for there are parts of her life that she does not wish to have told.

In such a relationship, how does one write an artist's life? To be able to question the subject of my research has been intimidating, as my lack of knowledge is revealed; exhilarating, as a conversation leads to new understanding; and affirming, as I reflect upon the depth of our human connection. Yet my position as a scholar is also complicated by this relationship. If I leave something out, honoring Catlett's wishes, whose story am I telling? What if someone else has already told that part of the story? To learn from a living artist means relinquishing the (fictive) assurance of scholarly objectivity and comfort of absolute authority, for a living artist can challenge even the most carefully supported research and insist on her version of the story. At the same time, as I acknowledge our multiple perspectives on her story and hold these in tension in my writing, and as I interweave the various strands of my research, from the archival to the conversational, I position myself as authority *and* as transmitter of what she tells me. Indeed, it is the profound connection I feel with Elizabeth Catlett, along with my continuing intellectual curiosity about questions of transnational identity, representation, positionality, and community, that has motivated my work.

As I interrogate my position as outsider/authority, I begin to understand ways in which my outsider status has afforded me a particular vantage point for exploring Catlett's multivalent and complicated sense of identity and location—as an African American woman living in Mexico, a U.S. expatriate barred from this country by the U.S. State Department as an "undesirable alien" during the 1960s but exhibiting here primarily since the 1970s, and a Mexican citizen (since 1962) producing work about and for black people in the United States. As an outsider to both her worlds, I bring curiosity about the connections between her experiences and social engagement in the United States and Mexico as they inform her art.

Throughout her life, Catlett's social concerns have informed, impelled, and perhaps limited her artistic and life choices. She has chosen to take a stand for justice in her art, to participate in activities (beginning with a protest against lynching in front of the Supreme Court while she was a high school student in Washington, D.C.) that made it impossible for her to remain in the United States after 1947 without facing political intimidation and harassment. Following World War II, the U.S. government launched increasingly vicious attacks on progressive artists, intellectuals, and activists. Catlett soon realized that suspicion of her apparent political sympathies would inevitably result in government harassment and questioning by the House Committee on Un-American Activities if she remained in the United States. Her continued insistence that her art be visually accessible to "ordinary people" has at times positioned her as marginal, or invisible, in mainstream art discourse in both the United States and Mexico—though as a black woman she was, a priori, outside U.S. art discourse no matter what her art looked like. Still, she would argue that she had no choice—that as a black woman who came of age in the early twentieth century, hearing her grandmothers' stories of slavery, and who had the opportunity and privilege to become highly educated, she was obligated to serve through her art those who had been systematically denied such opportunity.

Catlett's political convictions, relocation to Mexico, and chosen forms of artistic practice reinforced her marginalization as an art historical subject. Along with the disavowal of so-called Red art and artists, the ravages of the Cold War also affected art historians and critics of this period. One result has been that much of the writing of the

1950s and 1960s about the art of the preceding decades minimizes or ignores the achievements of the socially conscious artists of the 1930s and 1940s and the links between U.S. and Mexican artists during this period. Lack of attention to this vibrant history has led to disparagement and disappearance of these artists' work and what it stood for—the conviction that art could lead to real social change. The art historical invisibility of Catlett's artistic milieu in the years preceding her relocation to Mexico has thus compounded her marginalization—as a socially engaged African American woman artist—from mainstream art history. This returns us to the question of the monograph: What knowledge is necessarily resurrected when the stories of artists written out of this history are told as politically and socially located and relational?

In Mexico, Catlett asserts, she found relief from the racism that she had experienced daily in the United States. She chose to immerse herself in Mexican life and culture (not an inevitable choice among expatriates), marry fellow TGP member Francisco Mora, and raise their sons in Mexico. She embraced the collective process of the TGP, taking its audience, which encompassed "ordinary" Mexican people as well as people working for social justice in other parts of the world, as her own. The politics and social realist style of the TGP were regarded as politically suspect in the United States; the U.S. government labeled the TGP a "Communist Front organization" and prohibited its members from entering the United States.[18] Catlett's affiliation with the workshop thus reinforced political suspicion of her in this country. Still, the TGP provided a physical and social space where it was possible, indeed desirable, to produce socially engaged, overtly political prints that could not have been produced or exhibited in the Cold War United States. And the TGP's collective approach reinforced Catlett's conviction that a "people's art" must be accessible in its style and imagery without sacrificing aesthetics and mastery of technique. In Mexico, Catlett could affiliate herself with a community of like-minded artists and teach at the university level when such opportunities were rare for black women in the United States.

Still, her relocation bore adverse consequences. With three small children and little money, Catlett was able to travel to the United States only once in the 1950s. When she became a Mexican citizen in 1962, she was declared an "undesirable alien" and denied entry to the United

States until the 1970s, even when her mother was ill and facing major surgery. Her 1961 visit to the United States, when she delivered the keynote address to the Third Annual Meeting of the National Conference of Negro Artists in Washington, D.C., was her last until 1971, when she was granted a visa to attend the opening of her solo exhibition at the Studio Museum in Harlem.[19] Catlett's invitation to speak to the major organization of African American artists was evidence that she had not been forgotten in the United States despite her absence.[20] Yet with only a few exceptions, the artists with whom she had worked in New York during the 1940s maintained a careful distance from her during her visits to New York (in 1954) and Washington (in 1961). Though she understood that this response was based in the fear brought on by the U.S. government's anticommunist crusade, she was hurt when only a few of her former acquaintances had the courage to publicly associate with her.[21] This marginalization within the black artistic community, based on her political choices and compounded by her relocation to Mexico, severely limited her exposure as an artist in the United States.

Nonetheless, Catlett's achievements as a teacher, sculptor, and member of the TGP were recognized in Mexico. Her work was acquired for important collections; her students became highly regarded sculptors. Mexican art critics repeatedly noted her artistic contributions to Mexican national culture.

In the 1960s, Catlett turned her attention to the Civil Rights and Black Power struggles in her country of origin, repositioning herself as a black nationalist in Mexico. And as the U.S. political climate changed, she became one of the primary female voices in the Black Arts Movement, the visual manifestation of Black Power ideology in the United States. Though prohibited from traveling to the United States, Catlett focused her art with passion and clarity on the hopes and struggles of her sisters and brothers, demanding witness for women's role in Black Liberation and responding with fury against the racist repression and brutal attacks aimed at African Americans mobilizing for justice.[22] Though her work became less militant in the decades that followed, she has maintained her stance as an artist committed to social justice for African Americans and other oppressed peoples.

Catlett's art is marked not only by her politics but also by her sense of identity as informed by her social, artistic, and geographic location and relocation. Richard J. Powell writes of her prints: "When one is

face to face with Elizabeth Catlett's graphic work, after celebrating her technical accomplishments and eye for eloquence, one must acknowledge, then marvel at, the inclusive, international dimensions of her subjects' blackness, femaleness, and *mejicanismo*."²³ In Mexico, Catlett came to understand the meaning of *mestizaje,* the blending of indigenous, Spanish, and African ancestries shared by many in Mexico. She loved to draw the faces of Mexican people, which she rendered with a sculptural roundness reminiscent of pre-Hispanic stone sculpture, as she loved to draw African American faces, nuanced by her attraction to African sculptural traditions, which also reveal a mix of ancestries. Her meticulously textured, starkly black and white linocuts and subtly modeled lithographic drawings of powerfully massive figures depict Mexican subjects: urban workers and *campesinos,* children working and caring for smaller children, homeless children in the city, indigenous children in the country; and African American mothers, workers, ordinary people, and historical heroines.

When Catlett's children were young, she made prints at the TGP in the evenings and always tried to attend the workshop's Friday night collective meetings. But her sculpture had to wait, she says, until the day she took her youngest son to kindergarten. She put her work as a sculptor on hold for about eight years. Still, she insists, motherhood has been profoundly important for her as an artist, giving her work "immeasurably more depth.... Raising children is the most creative thing I can think of."²⁴ She suggests that maternity can benefit one's work rather than detracting from or limiting it, a view of the relationship of motherhood to (other) work that was immeasurably important to me when I became a mother during my research. The theme of maternity, though not new to her, became prominent in her sculpture after she became a mother and took on new meaning for her. Her images of maternity—a theme that always risks critical disparagement as "sentimental"—reflect the creative process of sculpture and of mothering; she represents mothers as playful, sorrowful, exhausted, joyous, fiercely protective (Figure 20).

As Michael Brenson notes, critical and scholarly attention to Catlett's work has most often focused on her politics. "However," he argues, "while her artistic vision cannot be understood apart from her political beliefs, it cannot be fully appreciated within the language of ideology alone."²⁵ Noting its evident relationship to "modernist organic abstraction," Brenson explores Catlett's sculptural aesthetics as grounded

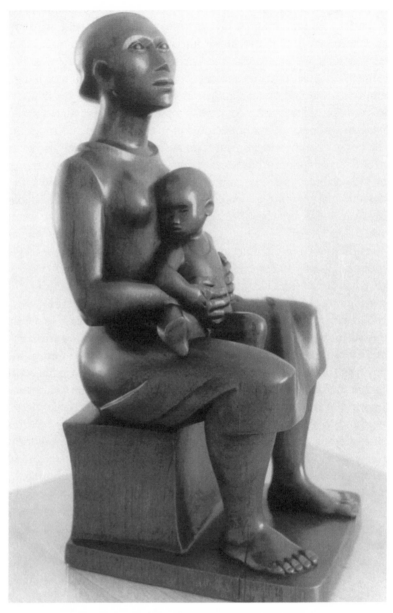

20. Elizabeth Catlett, *Mother and Child,* 1959, mahogany

in a fusion of African, pre-Hispanic, and modernist sources.[26] The women Catlett sculpts in wood, stone, marble, or clay and sometimes casts in bronze are solidly grounded representations of mothers, workers, survivors—proud, angry, determined, celebratory women, women stepping out. In many, suggestions of ethnicity are subtly fluid. Eyes, mouths, and facial structure suggest indigenous ancestry. Catlett's sculptures represent the realities of mixed ancestry for Mexicans, African Americans, and her own children. Some of these figures have faces that look different when viewed from different angles, suggesting simultaneously multiple ethnicities. I read these as sculptural representations of identity as fluid, in motion, subject to the play of location and relocation, in a modernist idiom that acknowledges its sources in the lineages of African and Mexican art and in the European modernism through which Catlett was introduced to African art, even though her art has remained for the most part representational.

In her eighties Catlett has continued sculpting, assisted by her youngest son, David. She also experiments with various printmaking processes. Finally gaining long-deserved critical attention, Catlett has received major commissions and several honorary degrees, and her work is now included in the collections of the most important museums in the United States. So that her art will be accessible to "ordinary people," she continues to exhibit in community centers, public libraries, and historically black colleges and universities as well as major museums and galleries.[27] She maintains her belief that art by itself cannot change society but can raise consciousness, be a source of pride, and make people aware of the possibility for change:

> Art can't be the exclusive domain of the elect. It has to belong to everyone. Otherwise it will continue to divide the privileged from the underprivileged, Blacks from Chicanos, and both from the rural, ghetto, and middle-class whites. Artists should work to the end that love, peace, justice, and equal opportunity prevail all over the world; to the end that all people take joy in full participation in the rich material, intellectual, and spiritual resources of this world's lands, peoples, and goods.[28]

As a woman artist/scholar—and teacher, activist, and mother—writing about this particular woman artist has mattered immensely to me, personally and intellectually. Her race, gender, and chosen locations— political, social, artistic, geographic—have been key to her marginal

treatment, until recently, by American art historical discourse. As well, the way she has chosen to work—collaboratively, in community, in service to the people's struggles in which she so fervently believes—has had no place in the dominant narrative of modernism that celebrates the individual rather than the relational.

The series of positionings through which she has defined and redefined herself, even as she has continued to designate herself primarily as a "black woman artist," and the choices and risks such positionings have entailed disallow a transparent, essentializing reading of her work and life story. Instead, they suggest avenues of exploration for those who continue to "write the artist."

NOTES

1. Elizabeth Catlett, quoted in *Forever Free: Art by African-American Women, 1862–1980*, ed. Arna Alexander Bontemps and Jacqueline Fonvielle-Bontemps (Normal: Center for the Visual Arts Gallery, Illinois State University, 1980), 68.

2. Alain Locke, *The Negro in Art: A Pictorial Record of the Negro Artist and of the Negro Theme in Art* (Washington, D.C.: Associates in Negro Folk Education, 1940); James A. Porter, *Modern Negro Art* (New York: Dryden Press, 1943).

3. Samella Lewis, *The Art of Elizabeth Catlett* (Claremont, Calif.: Hancraft Studios, 1984).

4. Melanie Herzog, "'My Art Speaks for Both My Peoples': Elizabeth Catlett in Mexico" (Ph.D. diss., University of Wisconsin–Madison, 1995); Melanie Anne Herzog, *Elizabeth Catlett: An American Artist in Mexico* (Seattle: University of Washington Press, 2000). That monograph offers a fuller treatment of Catlett's life and work than is possible in the present essay.

5. Nancy Hartsock, "Rethinking Modernism: Minority vs. Majority Theories," from *The Nature and Context of Minority Discourse*, ed. Abdul R. JanMohamed and David Lloyd (New York: Oxford University Press, 1990), 26.

6. bell hooks, *Art on My Mind: Visual Politics* (New York: New Press, 1995), 3.

7. Ibid.

8. Linda Nochlin, *Representing Women* (New York: Thames and Hudson, 1999), 10.

9. Lucy Lippard, *Mixed Blessings: New Art in a Multicultural America* (New York: Pantheon, 1990), 4.

10. Cornel West, *Race Matters* (Boston: Beacon, 1993).

11. Freida High Tesfagiorgis, "Afrofemcentrism and Its Fruition in the Art of Elizabeth Catlett and Faith Ringgold: A View of Women by Women," in *Sage* 4, no. 1 (1987): 25–32; reprinted in *The Expanding Discourse: Feminism*

and Art History, ed. Norma Broude and Mary D. Garrard (New York: IconEditions, 1992), 475–85.

12. Tesfagiorgis, "Afrofemcentrism," 26. See Freida High Wasikhongo, "Afrofemcentric: Twenty Years of Faith Ringgold," in *Faith Ringgold: Twenty Years of Painting, Sculpture and Performance (1963–1983),* ed. Michele Wallace (New York: Studio Museum in Harlem, 1984), 17–18.

13. Judith McWillie, *The Migrations of Meaning* (New York: INTAR Gallery, 1992), 8.

14. Lippard, *Mixed Blessings,* 3.

15. hooks, *Art on My Mind,* xiii.

16. On the importance of the writings of women artists for understanding their visual art, see Mara R. Witzling, introduction to *Voicing Our Visions: Writings by Women Artists,* ed. Mara R. Witzling (New York: Universe Books, 1991).

17. See Patricia Hill Collins, *Black Feminist Thought: Knowledge, Consciousness, and the Politics of Empowerment* (New York: Routledge, 1991); also Patricia Hill Collins, "The Social Construction of Black Feminist Thought," *Signs: Journal of Women in Culture and Society* 14 (1989): 745–73.

18. Elizabeth Catlett, interview with Clifton Johnson, January 7, 1984, audiotape recording in Elizabeth Catlett Papers, Amistad Research Center, Tulane University, New Orleans, Louisiana. Also see Karl M. Schmitt, *Communism in Mexico: An Exercise in Political Frustration* (Austin: University of Texas Press, 1965), 140–42; and Helga Prignitz, *El Taller de Gráfica Popular en México 1937–1977,* trans. Elizabeth Siefer (Mexico City: Instituto Nacional de Bellas Artes, 1992), 142. Prignitz cites conversations with various Taller artists who were denied entry to the United States during the 1950s and 1960s.

19. Published in the first issue of *Freedomways* magazine in 1961, Catlett's talk at the National Conference of Negro Artists is reminiscent of her earlier writing on art and democracy. See Elizabeth Catlett, "The Negro People and American Art," *Freedomways* 1, no. 1 (1961): 74–80, reprinted in part in Lewis, *Art of Elizabeth Catlett.* On her exhibition at the Studio Museum in Harlem, see *Elizabeth Catlett: Prints and Sculpture,* exhib. cat., foreword by Elton Fax, commentary by Jeff Donaldson (New York: Studio Museum in Harlem, 1971).

20. In 1964, Catlett was first among the "Four Rebels in Art" discussed by Elton Fax in an essay in *Freedomways.* Fax discussed her early exposure to the oppression suffered by African Americans and its ongoing impact on her work. He also noted her residence in Mexico. He reiterated and expanded upon these themes in *Seventeen Black Artists* (New York: Dodd, Mead, 1971), where he also described her experiences with racism and political conservatism in the United States. Elton C. Fax, "Four Rebels in Art," *Freedomways* 4 (1964): 215–25. The other artists were Jacob Lawrence, Charles White, and John Biggers.

21. See Fax, *Seventeen Black Artists,* 24, 29.

22. In 1970 Catlett was honored as an Elder of Distinction by CONFABA 70, the Conference on the Functional Aspects of Black Art held at Northwestern University in Evanston, Illinois. Denied a visa by the U.S. embassy to attend, she made a statement to the conference by phone from Mexico. From her Mexican vantage point, she offered her experience in Mexico as a model for black artists in the United States. Typed manuscript in Elizabeth Catlett Papers, Amistad Research Center, Tulane University, New Orleans, Louisiana; quoted in part in Herzog, *Elizabeth Catlett,* 147–49.

23. Richard J. Powell, "Face to Face: Elizabeth Catlett's Graphic Work," in *Elizabeth Catlett: Works on Paper, 1944–1992,* ed. Jeanne Zeidler (Hampton, Va.: Hampton University Museum, 1993), 53.

24. Quoted in Marc Crawford, "My Art Speaks for Both My Peoples," *Ebony* 25 (January 1970): 101.

25. Michael Brenson, "Elizabeth Catlett's Sculptural Aesthetics," in *Elizabeth Catlett Sculpture: A Fifty-Year Retrospective,* exhib. cat. (Purchase: Neuberger Museum of Art, Purchase College, State University of New York, 1998), 27.

26. Ibid., 36.

27. A major retrospective of Catlett's prints and drawings, "Elizabeth Catlett: Works on Paper, 1944–1992," has traveled to museums, university art galleries, and community art centers throughout the United States since 1993. "Elizabeth Catlett Sculpture: A Fifty-Year Retrospective" opened at the Neuberger Museum in Purchase, New York, in 1998 and traveled to several additional venues.

28. Quoted in Lewis, *Art of Elizabeth Catlett,* 26; also in Herzog, *Elizabeth Catlett,* 173.

SUBJECTIVITY, (AUTO)BIOGRAPHY, AND THE "ARTIST NAMED PEREIRA"

KAREN A. BEAROR

In recent years, scholars in literature and anthropology have debated how "postmodern" biography, challenging the realist conventions and authorial objectivity of traditional biography, and "postmodern" autobiography, questioning the unified self of the autobiographical narrative, might be written. In the past decade, a growing number of art historians have similarly been attentive to issues of identity and subjectivity, especially as feminist, ethnographic, and psychoanalytic discourses have framed those issues.[1] But during the same time, shorter or more thematic researches have largely displaced full-length artist biographies. "Postmodern" alternatives to this genre remain virtually unexplored. In fact, to write biography at all is to invite speculation that one is ignorant of the past thirty years' worth of intellectual history.

In 1988, J. R. R. Christie and Fred Orton offered one possible explanation for this state of affairs. They observed that the "biographical narrative," which does not foreclose the possibility of a pluralized subject or endless possible story patterns derived from both nonfictional and fictional literary genres, has frequently and incorrectly been regarded as synonymous with the familiar "monographical narrative," which tends to offer an overly individualized account of a unified subject, a "genius," whose life follows a predictable trajectory from birth through creative development to career peak and decline to death.[2] Fur-

thermore, as Griselda Pollock pointed out years earlier in her classic indictment of the default assumptions of art history, the excessive focus on the art object itself requires the production of an artist-subject for and from the work, one who becomes the source of originary meaning. Through solipsistic circularity, the object then becomes the conduit to knowledge of that subject's supposedly transcendent self. Such circularity is central to conventional narrative practice, "which produces coherent, linear, causal sequences through which an artistic subject is realised" as "the effect of his works, the hero of the story, the character whose 'truth' is to be sought and visualised, reconstructed and made plain."[3]

Despite these challenges, the structure of the full-length traditional artist's biography (the monographical narrative) remains fundamentally unchanged in mainstream art history, its service to "objective" scholarship largely unquestioned. Plurality is reduced to sameness. Competing and potentially incompatible elements of the subject's life are harmoniously resolved, while the biographer's conceptual arbitrations regarding conflicting evidence are effectively concealed. I hoped to resist these conventions when I wrote the manuscript published as *Irene Rice Pereira: Her Paintings and Philosophy* (1993).[4]

The form of the artist biography is foregrounded when its subject is someone like Irene Rice Pereira (1902–71). Best remembered as a painter, she wrestled with the design and content of an *auto*biographical manuscript. "Eastward Journey" was written in 1953, the year of her retrospective at the Whitney Museum of American Art, an exhibition noteworthy in the history of women's art in the United States.[5] Never published despite her dogged pursuit of a publisher,[6] it was to have been the artist's authoritative statement regarding her life and work, wresting from others the power to define either and ensuring that her reputation would last.

An artistic reputation is critically dependent upon what is written about an individual and its degree of concordance with popular but historically variable patterns regarding the model artist's life. Pereira evidently wrote "Eastward Journey" with that idea foremost in her mind. The text follows the form of a secularized spiritual autobiography or conversion narrative in that it is characterized by an introspective and retrospective view of personal experience and a consistent hermeneutic system by which meaning is assigned to that experience. Interpretation supersedes description, for the text's purpose is to edify:

the subject's exemplary life is meant to illuminate the way for others. Historically colored in the United States by the Puritan practice of publicly reciting one's spiritual history to prove worthiness for congregational membership, this narrative form connotes the desire of its subject to be counted among the elect. Eighteenth-century spiritual autobiographies were based upon biblical hermeneutics; "Eastward Journey" ultimately relies upon romantic discourses surrounding artistic creation for its principles and strategies of interpretation. Thus the manuscript's primary significance lies in its construction of its author-narrator, the "I" of the narrative, as the paradigm of the artist-hero-seer, simultaneously reinforcing and defying convention in usurping for herself all the power and privilege associated with this figure. To clarify, the "I" here is not the "real" Pereira, the historical figure who is herself the product of multiple subject positions and whose life exceeds text-based archival and explicative materials. (As Jacqueline Rose observed in her superb book challenging the "authorized" interpretations of the poet Sylvia Plath's life and work, all such texts are representations only, standing in effigy for the deceased and speaking in her name.) Rather, this narrating subject, a persona one might call the "Artist named Pereira," is produced by the text. The narrator's developing "self," a separate persona *becoming* the Artist named Pereira, emerges as a painter who is not merely rhetorically but demonstrably the effect of her art. The reader thus "journeys," with the narrator as guide, toward *Mecca,* a 1953 painting, as the narrator enumerates and interprets the artworks and events marking the path to her own enlightenment, manifested by her now-congealed philosophical beliefs. According to the text, the developing self is a mere spectator to the visual drama unfolding before her. She is "converted" in stages, her canvases revealing the transcendent artist-self to herself. By the end, her story told, her worthiness demonstrated, the Artist named Pereira is prepared to take her place with the congregation of celebrated artists.[7]

Such metaphoric peregrinations certainly had precedents in autobiographical literature of the time. One notable example is the multivolume novelized autobiography *Pilgrimage* by the English author and film critic Dorothy Richardson (1872–1957), who, like Pereira, fashioned herself as a "seer."[8] But the "real" Pereira's inability to secure a publisher, though it probably had several causes, pinpoints a difficulty besetting women artists during this era: the form of the artist biography, which tended to fuse with that of the fictional *Künstlerroman*[9] to

proclaim the advent of the male artist-hero, was inherently exclusionary and inadequate to their needs. Not only did women bear little ontological resemblance to the protagonists of these stories, but the interpretative systems by which their narratives derived meaning, although secularized, had roots in biblical hermeneutics, territory historically forbidden to women because of assumptions about inferior female intellect. Linda Peterson notes in her studies of Victorian autobiography that women like Charlotte Brontë and George Eliot chose fiction to critique the conventions and implications of the prohibition against female self-interpretation, thus safeguarding their private selves from the penalties of violating social taboos. In a later era generally suspicious of "eggheads" and amused at women too eager to be seen as such, Pereira was less circumspect. Her self-interpretative autobiography was unremittingly transgressive. In usurping the masculine position of enunciation, as Sally Robinson reminds us, a woman changes the politics of the enunciation.[10]

What remains compelling about "Eastward Journey" is Pereira's location of a site of potential resistance and strategic attempt to resituate herself in contemporary discourses on the identity of "the Artist" so as to open them to the possibility of a woman's being *emblematic* of that exalted, "universal" role. Even so, one could not call her a feminist. Indeed, she endeavored to transcend the issue of difference rather than embrace it. She probed neither the deficiencies of her model nor alternatives based on women's experiences. Her purpose was to exploit existing discourses and to render herself visible where women had lacked visibility before.

Pereira's paintings, poetry, philosophical writings, and self-conscious shaping of the archive to survive her were all in some measure intent upon constructing an Artist named Pereira. These self-promotional "autobiographical acts"[11] were central to my book (and, a year later, to an exhibition catalogue, *Irene Rice Pereira's Early Work: Embarking on an Eastward Journey*). While writing, I was aware that I, too, was constructing a "Pereira" in accordance with my own needs. In many respects I desired to contribute to feminist recuperative practices, to accord forgotten women their rightful and active places in history. Still, I was unwilling to ignore questions of subjectivity raised by poststructuralism, despite my considerable skepticism regarding the phantom existence to which "the author" had been relegated in poststructuralist discourse.[12] Not seeing these positions as necessarily in

opposition, despite their stark polarization within much contemporary feminist criticism, I wanted to write a biography that, while resuscitative and dependent upon archival research, was also resistant to realist conventions. Nevertheless, an examination of the form itself was not my goal. Further, I was under the publisher's mandate to write for a "general audience" and omit any difficult jargon. Thus I tried to signal my critique of the traditional monographical narrative through the organization of the book, its publication as part of an American Studies series, and its considerable focus on Pereira's maneuvers to gain visibility and patronage and to secure the longevity of her reputation. Interpretations of paintings or iconography, where offered, were subservient to this agenda. They demonstrated the artist's conscious choices to participate in certain discourses of the day while disdaining others. Other critical concessions I made, however, muted the impact I wanted my book to have.

Consequently, I would like to explore here some of the tensions between Pereira's "autobiographical acts," my own mediating "biographical acts," and the sometimes conflicting needs of publishers—particularly as they assess their market—so as to open wider a space within art history for the practice and evaluation of critically informed accounts of artists' lives. Ideally, these biographical narratives would consider their subjects as positioned within multiple discourses without foreclosing their ontological existence, would resist simplistic cause-and-effect relationships between isolated events and individual works of art (or vice versa), and would avoid notions of god-given "genius" or linear narratives of artistic "development."

My position regarding the subject is clearly antihumanist and antiessentialist, and I am heavily indebted to, although not uncritical of, poststructuralist discourse theories. The notion of the coherent, rational individual is itself a consequence of discourse.[13] Being the subject of a discourse, though, is not the same as being passively subject to it. Like other feminists, I believe that some measure of agency must be theorized for resistance or change and that there must be some accounting of embodied existence, even if the body itself is situated discursively at the intersection of multiple axes of meaning. I find much with which I agree in Wendy Hollway's "Gender Difference and the Production of Subjectivity." According to Hollway, discourses make available positions for subjects to take up. Because traditional discourses concerning sexuality are gender differentiated, men and women are not equally able to take

up subject or object positions. Although these positions are specified for "man" or "woman," particular men and women fill them, and their practices and experiences are rendered meaningful according to gender-differentiated discourses; practices and their meanings have histories, developed through the lives of people concerned. These behaviors are the products of multiple discourses, although the hegemony of any one discourse may make meanings more or less homogeneous. Because discourses do not exist independently of their reproduction through the practices and meanings of particular women and men, we must account for changes in the dominance of certain discourses, and the development of new ones, by taking account of men's and women's subjectivities. For example, we might question why men or women "choose" to position themselves within certain gender-differentiated discourses or whether practices signify differently for women and men because they are read through different discourses. Finally, by showing that subjects are invested in certain discourses, and that these investments are socially constituted and constitutive of subjectivity, one can avoid the determinism characteristic of some discursive theories and thus allow for resistance and change.[14] A consequence of being invested in subject positions is expecting some sort of satisfaction or reward, such as relative power over or solidarity with others. This need not be rational or consciously determined, and one subject position need not exist harmoniously with others. To complicate matters, new discourses often coexist with rather than displace the old. Subjectivity, then, is the product, not the sum, of often contradictory positions within discourses. Each position, each relation, becomes as much a site of potential change as one for the reproduction of practices and meanings, so some measure of agency, of intention, can be theorized.[15] One can examine the strategies, maneuvers, or practices of historic figures within discursive frameworks without pretending that one can know or represent the "real" person and without resorting to humanist individualism or to traditional psychoanalytic theories of desire.

One might say that our sense of our "self," however fragmentary or illusory, is dependent upon the stories we tell ourselves and that these are largely determined by how others narrate us, by language, and by the genres of storytelling we inherit from our cultural traditions. Anthony Paul Kerby, in his 1991 study of self-narration, argued that "much of our self-narrating is a matter of becoming conscious of the narratives that we already live with and in.... Such external narratives

will understandably set up expectations and constraints on our personal self-descriptions, and they significantly contribute to the material from which our own narratives are derived.... [E]ven fictions can provide us with characters and plots that we may identify with and which disclose ourselves; our experience of literature and film should readily prove this point." More simply, we interpret our lives through readings of other life stories, factual or fictional.[16]

Irene Rice Pereira clearly read her own life story through those of others. Among the few details she ever recounted publicly about her youth was her passion for literature, including works by Louisa May Alcott and Jane Austen, and "any biography of a great woman she could lay her hands on."[17] She also made early attempts at writing a biography of Joan of Arc. She related these memories late in 1952 to John I. H. Baur, author of the catalogue to her Whitney retrospective, when she was writing, or preparing to write, "Eastward Journey." Her choice to foreground these particular details of her childhood suggests a preoccupation with biography itself. It also signals to readers her precocity as a girl and provides an intellectual foundation for her subsequent achievements as an artist and philosopher. Pereira thus gave shape to her life through calculated answers in this and other interviews. (One should not discount Baur's role, however, in editing responses and giving final form to the catalogue narrative.) Her accounts construct an "origin" for her interest in writing, nurtured with night courses in literature when she was in her twenties and marked by the increasingly frequent appearance, in the 1950s, of published essays, poetry, and philosophical tracts. Perhaps they also reveal her contemplation about the strategies by which successful women become "famous women" with enduring reputations, the subjects of autobiographies and biographies.[18]

Most scholars of autobiography are quick to indicate the elusive boundary between fact and fiction in the genre. Such writing is inherently interpretive. Isolated yet significant incidents are extracted from the past, from memory, and given continuity and meaning within a narrative framework. Clinton Machann has argued that the author makes an "autobiographical pact" with the reader that, if the author's name refers to a person whose existence is confirmable, the text will be essentially accurate. Verifiably inaccurate statements will thus be adjudged flaws. On the other hand, Timothy Dow Adams maintains that autobiography is essentially a means by which one attempts to reconcile past events with one's current sense of self. The narrative is to be

taken as metaphorically authentic, its significance lying in what the writer hopes to achieve by deliberately straying from fact.[19] My sympathies lie with Adams's assessment. The perceived "authenticity" of an autobiographer's story is measured by its proximity to the "truth" of the metaphors employed and by the meaningfulness of the author-confessor's standpoint. Pereira's manuscript may have failed this test on both counts for contemporary publishers, who lacked the evidence necessary to evaluate its factual merit. In "Eastward Journey," she imparts to her developing self the identity of a pilgrim following a lonely, dangerous pathway through the darkness of the early 1940s, marked by a sister's death and her own battle with a "severe illness" (breast cancer), toward the light of 1953. This trek also inscribes "step by step or depth by depth" her movement from figurative art to abstraction, from the imaginary to the symbolic, and her simultaneous intellectual transformation from apprehension of mere physical space to apprehension of a metaphysical, multidimensional space. The text is filled with dualisms: the familiar distractions of the temporal world countered by an aesthetic, spiritual, or inner life that "swings on a pendulum of stars"; the existential world of three-dimensional space versus infinity; being "split in two" as an instructor at the Design Laboratory, a WPA-sponsored and Bauhaus-inspired school of industrial design in New York, teaching students rote technical skills while simultaneously trying to instill aesthetic appreciation; and Pereira's favorite opposition, "thinking and feeling." All dualisms are ultimately resolved by resort to "the symbol," the "structural essence of experience," which, as the narrator makes clear in prefatory remarks, is her guide and the reader's.[20]

Significantly, the dichotomy between masculine and feminine is also resolved in the symbol: "I," the transcendent essence, the romantic artist-seer. Pereira's autobiography, like her paintings, is signed by the sexually ambiguous "I. Rice Pereira," and at no point in the text is there an indication of the artist-narrator's gender. Readers gain a fleeting glimpse of her body in the reference to her unidentified illness; otherwise all concerns are noncorporeal. The single gendered term used throughout the text is *man*, employed only in the so-called neutral or universal sense customary at the time for referring to humankind.

In its focus upon its character's development, "Eastward Journey," although autobiographical, echoes the closely related fictional genre of the *Bildungsroman*, the German romantic novel of individual self-

realization. Having its own origins in confession narratives, the *Bildungsroman* is sometimes called an apprenticeship novel, based upon filiation with Goethe's *Wilhelm Meisters Lehrjarhre* (1795–96). Usually associated with the enculturation of its youthful protagonist, the genre has been described by Martin Swales as "essentially an epic of inwardness, one that celebrates the imagination of the hero as the faculty which allows *him* to transcend the limitations of everyday practicality [italics added]" to become "whole" and integrated, by symbolic stages of transformation or initiation, into the community. Ultimately, it is the implied reader, the middle-class European male, who is initiated into the wholeness of the *Bildung*, following the exemplary model of the hero. In its civilizing, social function, the *Bildungsroman* seeks to impose order, resolving differences through the seduction of the "universal." If the story does not always detail the protagonist's (and hence the reader's) reconciliation with the social, that reconciliation is intimated, as Swales suggests, "through the writer's collusion with *his* artistic community of notional readers [italics in original]."[21]

However, in its focus upon an artist's development, Pereira's text more aptly resembles the near twin of the *Bildungsroman*, the *Künstlerroman*. Gerald Goldberg's survey of this genre in 1961 noted that through the nineteenth century the artist-hero of the *Künstlerroman* retained a social function, a stage of reconciliation with the community, like that just described for the *Bildungsroman*. However, by the era of the abstract expressionists, the famed inheritors of the mantle of "artist-hero" in much critical literature, this figure had assumed "his" estrangement from society from the outset and realized himself in a state of alienation without assuming any responsibility to the social. By virtue of the continued currency of romantic aesthetic discourse, this shift in discourse did not displace but coexisted with the view of the artist as a universal symbol of humanity. In that view, propounded by Schiller in his *Aesthetic Education of Man,* the path taken by the artist was the path all humanity must take. Therefore, the narrative of subject-formation in the *Künstlerroman* implicitly was more than the life story of a mere artist: it was a universal history.[22] For those midcentury artists fearing not only that they had been displaced by the critical acceptance of abstract expressionism but also that art's relevance to society was at stake, a crucial issue left unresolved by this confluence of personas was this: Was the fate of the postwar world to be alienation and chaos, with humanity following the path of the abstract ex-

pressionist artist-hero? Or might harmony and order yet be reclaimed by following an alternative course?

If Goldberg's observations regarding the history of the artist-hero are even superficially accurate, one can locate a tension between the shifting discourses concerning this persona that Pereira could conceivably exploit to secure legitimacy for her own claims to that identity. She persistently stationed herself against the abstract expressionists, who, she argued, having lost their psychological balance, were unable to find integration in the social. They were alienated, caught in the "Void"—a viewpoint in some agreement with Goldberg's. Consequently, in embracing the earlier romantic function of the artist-hero as the reconciler of opposing social forces, Pereira could position herself in a tradition by which she could lay claim to exemplary status. She could also posit a more socially responsible future for the artist, one more consistent with Depression-era ideas with which she retained much sympathy and with the caregiver role usually accorded to women. Pereira clearly believed that women were on the brink of a new age of public visibility and social responsibility. Indeed, according to a passage she marked with emphasis in her copy of Carl Jung's *Contributions to Analytical Psychology* (1928), "the modern woman longs for greater consciousness, for meaning, and *the power of naming her goal in order to escape from the blind dynamism of nature....* The modern woman stands before a great cultural task which means, perhaps, the beginning of a new era" [italics added].[23]

The romantic function of the artist-hero was updated in psychoanalytic discourse in the twentieth century. In the *Aesthetic Education of Man*, Schiller had called for a resolution of the intellect/senses ("thinking and feeling") dichotomy through beauty, the means by which humanity became civilized. Jung, who acknowledged his debt to Schiller in several of his volumes, viewed this reconciliation as a metaphor for the integration of conscious and unconscious levels of the psyche in the process of individuation. Jung, who apparently did not reciprocate the esteem voiced by some of the abstract expressionists for his work, was a major source for Pereira's concept of the "hero," particularly as this figure was popularized in the writings of Joseph Campbell, himself indebted to Jungian thought. As I have argued elsewhere, the psychoanalyst's books were also a primary resource for ideas framing Pereira's own statements regarding the multiplanar glass paintings for which she garnered critical acclaim.[24]

Her concern with and investment in the role of the artist-hero in society was manifested in her art before she began using glass, however. In 1937, Pereira painted *The Artist,* also titled *Struggling* (Lowe Art Museum, University of Miami), which visually encapsulates the romantic concept of the artist, weighed down by worldly concerns yet seeking transcendence. Ironically, the shackled bodies she painted to depict writers and painters, emblematic of her own dual interests, were male. Working within mainstream discourses and using a figurative style, she opted for social acceptability and denied her own subjectivity as either a painter or a writer in her own painting. When she began to work with geometric forms, hardly gendered neutral in art discourses, she could at least comfort herself that, as symbols, they were open theoretically to any number of interpretations, just as alphabetic characters can take on different values as variables in algebraic equations. Her abstract paintings show a constant balancing of forms coded as "masculine" and "feminine." For example, the rectilinear shapes (masculine) appearing in her glass paintings float illusionistically in a "fluid" matrix (feminine) caused by the visual integration of superimposed transparent planes fixed in a box frame. Since in the Jungian psychology that Pereira expounded in her written works, the concepts of the conscious and unconscious mind are also gendered, the whole suggests a metaphorical representation of the individuated Jungian psyche.[25]

Such reconciliation of opposites is symbolized in Jung's writing by the androgyne, which has a long history in mystical and philosophical traditions as the symbol of the ideal psychic state and which plays a prominent role in both romantic and surrealist bodies of thought. Diane Long Hoeveler has observed that the androgyne, as the poetic representation of the "whole" transcendent mind, is the antithesis of the hermaphrodite, a bodily representation. Jung, however, represents the androgyne by the hermaphroditic figure of Mercurius and uses the terms more or less interchangeably. Transcendence in romantic literature is a masculine project, the male redeeming himself through the "completion" of his own psyche. On the other hand, Mercurius often appears in female form in Jung's books, as in his *Psychology and Alchemy* (1953). Thus the androgyne, like Virginia Woolf's "woman-manly" and "man-womanly" androgynous mind, has dual imagistic possibilities in that it can be exalted as essential for both male *and* female creativity.[26]

Pereira began to identify with the hermaphroditic Mercurius soon after her body had been surgically disfigured. This, considered with her

bisexuality, her successful painting career, and her belief that, through Jungian analysis, she had achieved full integration of her "masculine" and "feminine" aspects, led her almost inevitably to her ultimate conclusion.[27] The "I" of her autobiography is the union of opposites, the androgynous ideal, the Artist named Pereira, the artist-hero of the traditional *Künstlerroman*. The path taken by the *woman* artist becomes that along which humanity must pass. *Her* narrative of subject-formation becomes that of universal history.

The idea sounds preposterous, even megalomaniacal, only because Pereira was a woman. Similar romantic claims continue to be made without evident embarrassment in much of the literature concerning male artists. Although Pereira had inserted personal events into a recognizable literary framework, her narrative lacked "authenticity" because of its distance from metaphoric "truth" and the relative lack of meaning society accorded to her subject position. While her autobiographical writing must have felt liberating, the power of self-interpretation she claimed came as a result of the suppression of that undermining signifier, her femaleness. Nevertheless, she was unable to fulfill Jung's prophecy for the modern woman by rising above the blind dynamism of nature to claim her right to name her own goals. Contemporary critics, promoting the affective art of abstract expressionism, ridiculed her for providing a philosophical rationale for her "cold" paintings, and even friends advised her to downplay her metaphysical interests. Lacking access to viable alternative discourses and practices, she was overdetermined as "female" despite her efforts to locate herself in the "ideal" middle ground between discursively polarized gender positions. Like the *Bildungsroman,* "Eastward Journey" remained open-ended, its protagonist's welcome integration into the community implied. But the integration did not happen. Her autobiographical tract was never published, and Pereira was unable to "collude" with *her* notional readers, the canon of celebrated male artists in whose congregation she coveted membership.

Unlike Pereira, I found a publisher. Nonetheless, I decided to examine her participation in modernist discourses with the awareness that there would initially be a small audience for my book. Her name was unfamiliar to most art historians outside New York, where the gallery owner Andre Zarre has kept her work visible. Although she had apparently taken great pains in later years to shape her archive and ensure that it survived her in public institutions, there was no serious

scholarship on her, and her paintings had little value. In addition to satisfying professional desires, my recuperative project was partly recompense for the emotional support of a paternal great-grandmother, who had introduced me to the lives of celebrated women, and of her daughter, my grandmother, who had introduced me to art. Self-supporting and schooled in the Southwest, with almost no preuniversity access to museums despite my having painted since childhood, I was not destined for a "conventional" career in art history. Thus, my interest in the discipline was little shaped by the aura of the object, and I was determined not to characterize Pereira as being defined by the paintings she produced, particularly since she was so multifaceted in her professional output.

I never intended to write about Pereira's entire life. Although I had been introduced to her work in a graduate seminar on mysticism in modernist art, I was at first highly resistant to her esotericism, predisposed as I am toward more material and political matters. I was more attracted to her social realist paintings of the 1930s, but the brevity of her interest in that genre rendered the topic unsuitable for a sustained study. The discovery of "Eastward Journey" on microfilm, and the realization that it was among the first batch of papers she had lent to the Archives of American Art for shooting, caused me to reconsider my approach. I assumed that she had planned this manuscript to be a hermeneutic key to the rest of her work, and, while I did not expect to use it in that fashion, I became aware of the breadth of her interests, from theories of the space-time continuum to light mysticism to experimentation with unconventional painting materials to mediumship and crystal lore to literature. There were many Pereiras here—the painter, the philosopher, the poet, the mystic, the lab technician, the teacher—and I knew her work would be engaged with the conflicting discourses surrounding those identities as well as other identities that I suspected were not represented in the autobiography. I resolved to write an "intellectual biography," for want of a better phrase, with thematic divisions of the chapters. My book contained no linear "development" of the artist's life and no hagiography; the chapters, which explored her sometimes competing strategies and interests, overlapped one another in time. Some paintings I situated within multiple discursive frames to render it evident that both the contextual structure and my interpretation were contingent, with other avenues remaining open for investigation. I tried to make clear that I was dealing with materi-

als that had largely been edited by the artist and that the "real" Pereira, most of whose life was undocumented, exceeded this archival material.

In fact, key to my understanding of how much editing Pereira had done was my serendipitous discovery of uncatalogued correspondence in the archive of her third husband, George Reavey, a professor and translator of Russian symbolist poetry at the University of Manchester. Pereira wanted these love letters, filled with esoteric symbolism, destroyed following their divorce, but Reavey clearly had not complied. In short, whereas Pereira had tried to benefit from inserting herself into mainstream constructs of who the artist was, I was invested in nontraditional, more socially oriented issues overlaid with feminist sensitivities. I hoped the tensions between the two agendas, colored by the knowledge that neither of us would have the last word, would provoke interest on the part of future readers.

My book was to be an utterance, in the Bakhtinian sense of the word, with an expectation of response from other scholars. With a newly acquired tenure-track job at a reputable institution, I expected full entry into "the dialogue." Naïvely, I had not expected my "utterance" to be so mediated by the machinery of publication. Having written on a relatively obscure woman artist and having found a press interested in my topic and interdisciplinary approach, I made several concessions, fearful of relinquishing my grip on a publication opportunity as the tenure clock ticked down. These altered the form of what I had hoped would be the final product. I had discovered the tensions intrinsic to the publishing process as interested parties' investments in different discourses collide and must somehow be resolved. I am certainly not the first to address such difficulties, even within art history.[28] Yet here my own subjectivity as the "author" of the text was at stake, located as it was in the gap between how I wanted to be seen and how, by virtue of the final product, I might be seen. These discursive tensions, of course, extended to perceptions of Pereira as the subject(s) of my biography.

As mentioned above, my press wanted my book to address a "general audience" and explicitly requested that any arcane or difficult (read "poststructuralist") jargon be omitted. This request, in and of itself, was not a problem, for I, too, object to impenetrable writing. Besides, I was not interested in writing theory; I was intent on putting it into practice. I was also aware that many presses, in an effort to expand their sales, were exacting similar commitments from their au-

thors. However, I worried that scholars or colleagues might dismiss the book out of hand because it would lack sufficient textual markers—the recognizable "buzzwords" and ritual namedropping—to signal the "proper" (academic) audience, despite its active engagement with issues raised by feminist scholars.

A more critical concession, however, was based on an outside reader's request to have more information about Pereira's "personal life." Reluctantly, I added more information about her childhood, her marriages, and so forth. While not opposed to providing such information, I felt that by integrating it into the narrative, as opposed to leaving it in the appended chronology, I was rendering the form of the book too traditional. My text took on a likeness to the standard artist biography, the very structure I wanted to resist. Since I was unable to alter the book's title, proposed by the press to enhance the book's marketability by strengthening connections with conventional genres, reviewers, who have been most generous in their praise, have had a tendency to approach the book as a traditional monograph—the subject Pereira becoming, despite my efforts to "decenter" her, essentially a humanist subject after all.

From my perspective, the traditional artist biography, the monographical narrative, has outlived its usefulness. Numerous feminists from diverse ethnic and cultural backgrounds have exposed its limitations. The romantic concept of the artist as the symbol of the condition of humankind or as the demigod who lights the way for others is seductive but exclusionary by design. Still, the whole enterprise of biographic writing should not be abandoned because the conventional model is flawed. There is a need in art history for critically informed biographical narratives (perhaps analogous to Toril Moi's exceptional portrait of Simone de Beauvoir in literature)[29] and for presses to support them. As a rule, publishers with established reputations for promoting theoretical texts avoid biographies, and those interested in publishing biographies avoid theory. The two need not be, and should not be made to appear, mutually exclusive. As things stand, the average student or enthusiast of art history is never asked to question the discursive frameworks—whether conventional or "postmodern"—by which information about artists and art objects is delivered. Looking at the ways each of us is differently situated within and differently invested in our disciplinary discourses may open space for more complex and interesting narratives than those currently patterned after old models.

NOTES

1. Subjectivity, generally, is the condition of being a subject; the subject is understood to be multiple, always positioned in relation to and regulated by particular discourses and practices and produced by these. (See the development of this concept in the text to follow.) Discourses are those ensembles of beliefs, concepts, and specialized terms through which disciplines, media, institutions, and ideologies organize, understand, and produce their objects of study.

2. See J. R. R. Christie and Fred Orton, "Writing on a Text of the Life," *Art History* 11 (December 1988): 558–60.

3. Griselda Pollock, "Artists, Mythologies and Media Genius, Madness and Art History," *Screen* 21, no. 3 (1980): 58–59, 95. In 1989, in revising her position somewhat to reflect the intervening debate regarding the issue of subjectivity and agency, Pollock acknowledged Christie and Orton's theoretical distinction between biographical narrative and monographical narrative, a distinction she had not made in 1980. See Griselda Pollock, "Agency and the Avant-Garde: Studies in Authorship and History by Way of Van Gogh," *Block* 15 (1989): 4–15. The Christie/Orton article and the Pollock *Block* article are reprinted in Fred Orton and Griselda Pollock, *Avant-Gardes and Partisans Reviewed* (New York: Manchester University Press, 1996), 295–314 and 315–42, respectively.

4. Karen A. Bearor, *Irene Rice Pereira: Her Paintings and Philosophy* (Austin: University of Texas Press, 1993).

5. In this joint exhibition, Pereira and Loren MacIver shared the distinction of being the first living women artists honored with a retrospective at the Whitney Museum of American Art. For a detailed chronology of Pereira's life and a record of her most significant exhibitions, see the appendices in Bearor, *Irene Rice Pereira.*

6. "Eastward Journey," Irene Rice Pereira Papers, microfilm roll D223, Archives of American Art, Smithsonian Institution, Washington, D.C. Most of Pereira's philosophical writings were self-published. The Corcoran Gallery of Art, Washington, D.C., reprinted two, *The Nature of Space, a Metaphysical and Aesthetic Inquiry* (1956) and *The Lapis* (1957), in 1968 and 1970, respectively. (For a list of her published and unpublished manuscripts, see Bearor, *Irene Rice Pereira,* 302–3.) Surviving correspondence suggests that the desired number of costly reproductions for "Eastward Journey" formed a major obstacle to securing a press, although there also appears to have been little editorial interest in negotiating the matter.

7. On spiritual autobiography, see Linda H. Peterson, *Victorian Autobiography: The Tradition of Self-Interpretation* (New Haven, Conn.: Yale University Press, 1986), 125, and Peter A. Dorsey, *Sacred Estrangement: The Rhetoric of Conversion in Modern American Autobiography* (University Park: Pennsylvania State University Press, 1993), 9. On Puritanism, see Kathleen M. Swaim, "'Come and Hear': Women's Puritan Evidences," in *American Women's Autobiography: Fea(s)ts of Memory,* ed. Margo Culley (Madison:

University of Wisconsin Press, 1992), 32–56 ; and Jacqueline Rose, *The Haunting of Sylvia Plath* (Cambridge, Mass.: Harvard University Press, 1992), 2. On the artist as spectator, see "Eastward Journey," frame 52. Many scholars have commented upon the rhetorical connections between travel writing and conversion narratives. See, for example, Dorsey, *Sacred Estrangement,* 30; and Casey Blanton, *Travel Writing: The Self and the World* (New York: Twayne, 1997), 3. There has been relatively little scholarship devoted to reputation-building strategies by artists or their estates. See, however, Rose, *Haunting of Sylvia Plath;* Gladys Engel Lang and Kurt Lang, *Etched in Memory: The Building and Survival of Artistic Reputation* (Chapel Hill: University of North Carolina Press, 1990); and Carol M. Zemel, *The Formation of a Legend: Van Gogh Criticism, 1890–1920* (Ann Arbor, Mich.: UMI Research Press, 1980). For additional information on women in the United States, see Gladys Engel Lang and Kurt Lang, "Etched in Memory: An Essay on Rescuing Reputations," in *Etched in Memory: Women Printmakers from the Gladys Engel Lang and Kurt Lang Collection,* ed. Gladys Engel Lang and Kurt Lang (Seattle: Frye Art Museum, 2001), 1–11.

8. Horace Gregory, *Dorothy Richardson: An Adventure in Self-Discovery* (New York: Holt, Rinehart and Winston, 1967), viii. *Pilgrimage* was published in eleven chapter-volumes between 1915 and 1935. These were collected and published with an additional chapter in 1938, and a thirteenth chapter was added posthumously to the four-volume 1967 edition. Dorothy Richardson, *Pilgrimage,* 4 vols. (New York: J. M. Dent and Sons, 1938; New York: Alfred A. Knopf, 1967).

9. The *Künstlerroman* is typically defined as the novel of the artist's aesthetic education, although this is generally understood to include the development of the entire personality. The form often overlaps with the *Bildungsroman,* the so-called apprenticeship novel, although the *Künstlerroman* does not necessarily concern itself with youthful protagonists. Both these forms have affinities with the more generalized "development novel," the *Entwincklungsroman,* and the more narrowly focused *Erziehungsroman,* which generally concerns the impact of schools or teachers on the central character. Like the autobiography itself, these fictional forms emerged in the eighteenth century from confession narratives. Although literary critics have devoted much ink to defining these elusive and much abused terms in more concrete ways, as a literary nonspecialist I am not invested in that debate and depend only upon common usage.

The early-twentieth-century form of the artist biography is heavily dependent upon the overall development of modern biography in Victorian England, particularly as it fell under the spell of Thomas Carlyle's so-called Great Man theory of history. Carlyle (1795–1881) popularized German romanticism in England, particularly through his translations of Goethe's *Faust* and *Wilhelm Meister,* his *Life of Schiller* (1825), and his *On Heroes, Hero-Worship, and the Heroic in History* (1841). Hence the artist biography, understood here as the monographical narrative, was already heavily informed by German romanticism before Jungianism and Otto Rank's *Art and Artist: Creative Urge and Per-*

sonality Development (New York: Alfred A. Knopf, 1932) helped incorporate the aspects of inner development central to the *Künstlerroman* into the genre and provided the critical basis for the "heroic" phase of abstract expressionism.

Although Pereira was associated with leftist causes during the 1930s, her use of the conversion narrative is unrelated in purpose to the so-called proletarian *Bildungsroman,* whereby non–class-conscious workers develop into fighters for the proletariat. However, these examples do indicate the continued vitality of the genre, broadly conceived. See Barbara Foley, "Generic and Doctrinal Politics in the Proletarian Bildungsroman," in *Understanding Narrative,* ed. James Phelan and Peter J. Rabinowitz (Columbus: Ohio State University Press, 1994), 43–64.

10. Peterson, *Victorian Autobiography,* 130–32; Linda H. Peterson, "Gender and Autobiographical Form: The Case of the Spiritual Autobiography," in *Studies in Autobiography,* ed. James Olney (New York: Oxford University Press, 1988), 211–22; Sally Robinson, *Engendering the Subject: Gender and Self-Representation in Contemporary Women's Fiction* (Albany: State University of New York Press, 1991), 191.

11. This term originated with Elizabeth Bruss in her *Autobiographical Acts: The Changing Situation of a Literary Genre* (Baltimore: Johns Hopkins University Press, 1976). It is now widely used to refer to any of a number of autobiographical practices manifested in diverse forms, including not only the traditional literary form but also poetry, photography, essays, performance art, dreams, visions, and so forth. See Sidonie Smith, "Autobiography," in *Oxford Companion to Women's Writing in the United States,* ed. Cathy N. Davidson and Linda Wagner-Martin (New York: Oxford University Press, 1995), 85–90.

12. I refer here, of course, to the position left to the "author" by Roland Barthes's "The Death of the Author" and the countless writings it inspired. See Roland Barthes, "The Death of the Author," in *Image Music Text,* trans. Stephen Heath (New York: Hill and Wang, 1977), 142–48.

13. As Felicity Nussbaum wrote, "One consequence of the subject's entering into the culture's language and symbol system is a subjectivity placed in contradiction among dominant ideologies while those ideologies simultaneously work to produce and hold in place a unified subject. In order to preserve the existing subject positions, individual subjects are discouraged from attending to the ways in which the discourses are incongruent. We *believe* that the different positions make an autonomous whole, but the *feeling* that we are constant and consistent occurs because of ideological pressures for subjects to make order and coherence. Though we have confidence that the conflicting positions will add up to a whole, it is partially that we attend to the particular memories that match the available codes and make us believe in a fundamental unity. If human subjects give heed instead to inconsistencies, the reformulated 'self,' an intersection of competing discourses, may seem less obviously continuous and explicable." Felicity A. Nussbaum, *The Autobiographical Subject: Gender and Ideology in Eighteenth-Century England* (Baltimore: Johns Hopkins University Press, 1989), 33.

14. Wendy Hollway, "Gender Difference and the Production of Subjectivity," in *Changing the Subject: Psychology, Social Regulation and Subjectivity,* ed. Julian Henriques et al. (New York: Methuen, 1984), 236–37. Hollway chooses the term *investments,* despite reservations, to theorize forces for people's actions that cannot be reduced to biology or the social, without resorting to the model of the humanist rational subject or to terminology overloaded with meaning from psychoanalytic theory (238). There is extensive literature on the body as a site of meaning. For an examination of the discursive relationship between the female body and autobiography, see Sidonie Smith, "Identity's Body," in *Autobiography and Postmodernism,* ed. Kathleen Ashley, Leigh Gilmore, and Gerald Peters (Amherst: University of Massachusetts Press, 1994), 266–92.

15. Hollway, "Gender Difference," 238, 228, 260. Griselda Pollock came to similar conclusions regarding agency in part by following Raymond Williams's idea of art as practice. See Pollock, "Agency and the Avant-Garde," 14–15.

16. Anthony Paul Kerby, *Narrative and the Self* (Bloomington: Indiana University Press, 1991), 6. See also Smith, "Autobiography," 85, and Christi and Orton, "Writing on a Text," 559.

17. John I. H. Baur, *Loren MacIver; I. Rice Pereira* (New York: Macmillan and the Whitney Museum of American Art, 1953), 40–41.

18. For an excellent study of the difficulties associated with being an intellectual woman during this era, and a model of what a "postmodern" biography might be, see Toril Moi's *Simone de Beauvoir: The Making of an Intellectual Woman* (Cambridge, Mass.: Blackwell, 1994).

19. Clinton Machann, *The Genre of Autobiography in Victorian Literature* (Ann Arbor: University of Michigan Press, 1994), 6; Timothy Dow Adams, *Telling Lies in Modern American Autobiography* (Chapel Hill: University of North Carolina Press, 1990), ix, 3. For interesting developments in the ways our notions of our selves are changing with new technologies, see Debra Grodin and Thomas R. Lindlof, eds., *Constructing the Self in a Mediated World* (Thousand Oaks, Calif.: Sage, 1996). I have addressed some of these new developments, and how they intersect with feminist pedagogies, in a paper entitled "Situated Knowledges: Bodies, Politics, and Technology in the Feminist Art History Classroom," presented at the annual meeting of the College Art Association, Chicago, March 2001.

20. Pereira, "Eastward Journey," n.p. Pereira's attempt to teach students technical skills as well as aesthetic appreciation was a key aspect of Design Laboratory pedagogy in that the school endeavored to bring "good design" to the industrial arts. However, this raises broader issues concerning how the "artist" and the "craftsperson" are distinguished. For a discussion of the role of professional and liberal arts schools, including the Bauhaus under Walter Gropius, in making these distinctions clear, see Howard Singerman, *Art Subjects: Making Artists in the American University* (Los Angeles: University of California Press, 1999). For more on the construction of the identity of the professional artist, see Caroline A. Jones, *Machine in the Studio: Constructing the*

Postwar American Artist (Chicago: University of Chicago Press, 1996); and Kirsten Swinth, *Painting Professionals: Women Artists and the Development of Modern Art, 1870–1930* (Chapel Hill: University of North Carolina Press, 2001).

21. Martin Swales, *The German Bildungsroman from Wieland to Hesse* (Princeton, N.J.: Princeton University Press, 1978), 29, 32; Franco Moretti, "The Comfort of Civilization," *Representations* 12 (Fall 1985): 139, n. 31. There has been much recent writing on women and the *Bildungsroman*. See in particular Esther Kleinbord Labovitz, *The Myth of the Heroine: The Female* Bildungsroman *in the Twentieth Century* (New York: P. Lang, 1986); Bonnie Braendlin, "*Bildung* and the Role of Women in the Edwardian *Bildungsroman:* Maugham, Bennett, and Wells" (Ph.D. diss., Florida State University, 1978), and "New Directions in the Contemporary *Bildungsroman:* Lisa Alther's *Kinflicks,*" *Women and Literature* n.s. 1 (1980): 160–71; Laura Sue Fuderer, *The Female Bildungsroman in English: An Annotated Bibliography of Criticism* (New York: Modern Language Association of America, 1990); and Annis Pratt, "Bildungsroman and Künstlerroman," in Davidson and Wagner-Martin, *Oxford Companion to Women's Writing*, 104–6. The subject of autobiography is a rich one, with many scholars making it their life's work. Apart from sources already cited, those most useful to me have included Estelle C. Jelinek, *The Tradition of Women's Autobiography: From Antiquity to the Present* (Boston: Twayne, 1986); Paul John Eakin, *Fictions in Autobiography: Studies in the Art of Self-Invention* (Princeton, N.J.: Princeton University Press, 1985); Sidonie Smith, *Subjectivity, Identity, and the Body: Women's Autobiographical Practices in the Twentieth Century* (Bloomington: Indiana University Press, 1993); Sidonie Smith and Julia Watson, eds., *Women, Autobiography, Theory: A Reader* (Madison: University of Wisconsin Press, 1998); Françoise Lionnet, *Autobiographical Voices: Race, Gender, Self-Portraiture* (Ithaca, N.Y.: Cornell University Press, 1989); Deborah E. Reed-Danahay, ed., *Auto/Ethnography: Rewriting the Self and the Social* (New York: Berg, 1997); and James Clifford and George E. Marcus, eds., *Writing Culture: The Poetics and Politics of Ethnography* (Berkeley: University of California Press, 1986).

22. Gerald Jay Goldberg, "The Artist-Novel in Transition," *English Fiction in Transition* 4, no. 3 (1961): 25; Marc Redfield, *Phantom Formations: Aesthetic Ideology and the* Bildungsroman (Ithaca, N.Y.: Cornell University Press, 1996), 21–22.

23. See Bearor, *Irene Rice Pereira*, 298, nn. 12, 14; Carl G. Jung, *Contributions to Analytical Psychology*, trans. H. G. Baynes and Cary F. Baynes (New York: Harcourt, Brace, 1928), 187–88.

24. See Friedrich Schiller, *On the Aesthetic Education of Man, in a Series of Letters*, trans. Reginald Snell (New Haven, Conn.: Yale University Press, 1954). See also Bearor, *Irene Rice Pereira*, 298, n. 13, and 138–77, and Karen A. Bearor, *Irene Rice Pereira's Early Work: Embarking on an Eastward Journey* (Coral Gables, Fla.: Lowe Art Museum, University of Miami, 1994), 12–17.

25. In "Eastward Journey," in the only statement of which I am aware that Pereira explicitly tied the physicality of her triplanar glass pieces to her philosophical concerns, she wrote that these paintings had taught her that there are "three systems in operation; one positive, one negative, the other neuter. The neuter system unites the opposites making multiplicity a unity" ("Eastward Journey," frame 76).

26. Diane Long Hoeveler, *Romantic Androgyny: The Woman Within* (University Park: Pennsylvania State University Press, 1990), 7; Carl G. Jung, *Psychology and Alchemy*, vol. 12, *The Collected Works of C. G. Jung*, trans. R. F. C. Hull (New York: Bollingen Foundation, 1953), originally published as *Psychologie und Alchemie* (Zurich: Rascher, 1944); Virginia Woolf, *A Room of One's Own* (1929; New York: Harcourt Brace Jovanovich, 1957), 108. See the excellent discussions of the problems inherent in woman's seeking transcendence using romantic models in Rose, *Haunting of Sylvia Plath*, 148–64, and Judith Butler, "Sex and Gender in Simone de Beauvoir's *Second Sex*," in *Simone de Beauvoir: A Critical Reader*, ed. Elizabeth Fallaize (New York: Routledge, 1998), 29–42. See also the discussion of the mind-body split in Enlightenment discourses and its impact upon women's autobiographical writing in Sidonie Smith, "Resisting the Gaze of Embodiment: Women's Autobiography in the Nineteenth Century," in Culley, *American Women's Autobiography*, 75–85.

27. Regarding Pereira's sexual orientation, there is documentary evidence of relationships with a number of men within her archive at the Arthur and Elizabeth Schlesinger Library on the History of Women in America, Radcliffe College, Cambridge, Massachusetts, and elsewhere. So far, I am aware only of anecdotal evidence of her lesbian relationships, although this evidence is sufficiently extensive and corroborative to have convinced many people, including myself, of her bisexuality.

28. Orton and Pollock, *Avant-Gardes and Partisans*, iii–iv.

29. See note 18. Excerpts from this biography appear under the title " 'Independent Women' and 'Narratives of Liberation,' " in Fallaize, ed., *Simone de Beauvoir*, 72–92.

CODEX SPERO

RETHINKING THE MONOGRAPH AS A FEMINIST

AMY INGRID SCHLEGEL

Feminist art historians are by now well aware that the revisionist notions of rediscovery and recontextualization imply an insertion of women artists into the existing canon and not a reconceptualization of its rules. Many, I suspect, have eschewed this "mix-and-stir" recipe, since evidently few have pursued the monograph as a viable approach to writing art history from a feminist vantage point, especially about the work of women artists (Mary Garrard's monograph on Artemisia Gentileschi is an obvious exception). What follows is a meditation on how to rethink the discursive form of the monograph and what is entailed in this rethinking as a feminist.

I contend that the monograph is a masculinized form of writing that needs to be recast. In this essay I examine the underlying assumptions of the monographic model (and, to a lesser extent, the thematic case study) and the stakes involved in either pursuing or eschewing it. Can the monograph be recast without unwittingly replicating or mimicking its codified form, and the values inherent in that form, or is an entirely different approach required? Is it desirable, moreover, for a feminist to write, let alone possible to publish, a monograph on an obscure, nonmainstream woman artist—living *or* dead? Can the "masculinized monograph," one that tends toward hagiography, be reworked productively from a feminist perspective if its biographical model and

chronological structure are kept more or less intact? Or is an alternative, such as the currently fashionable thematic case study, more appropriate for a feminist critique, especially of a woman subject? By posing these questions we can begin to understand the investments we make as feminist art historians in *how* we write and *what* we choose to write about.

Such questions are, I believe, at the root of the current major dilemmas faced by feminist art historians, especially the challenge of getting explicitly feminist material published in a supposedly "postfeminist" age. They are also the ones that most perplexed me while formulating and writing *Codex Spero,* a project methodologically located in between an unconventional monograph and a thematic case study.

The monograph and the thematic case study are often perceived as sharply contrasting approaches. It is argued that the monograph generally functions as an uncritical celebration of a single artist's work and life, whereas the thematic case study takes a more critical, skeptical, and theoretical stance. One of the crucial differences between the two approaches is the conception of the artist as subject. The monograph, catalogue raisonné, and biography (which I am lumping together here for the sake of argument, though I acknowledge they are discrete endeavors) treat the artist as a centered, rational subject, ever-conscious of his or her intentions and the meanings of the work. The primary goal is to celebrate the "genius" and significance of the artist by relying on the time-honored assumption that art and life explain each other, quite apart from any broader context or deeper historical and cultural elucidation. The thematic case study, by contrast, considers the artist as a historical figure who is part of a given society, not an exceptional individual separate from it. In the thematic case study, more emphasis is placed on the work, the process, the practice, and the signifier than on the artist, the content, or the signified. The conception of the artist in the thematic case study corresponds, therefore, to poststructuralist notions of authorship such as the Barthesian "text" (which Barthes called "a tissue of quotations").[1] (Some feminist art historians have begun to identify the masculinist bias of poststructuralist theories of authorship, particularly the implications of the death of Barthes's author and the identity of his reader.) But despite these contrasts, the monograph and the thematic case study are not always antithetical approaches. Some of their goals obviously overlap when both are focused on a single artist, whether his or her achievement is a mat-

ter of historical consensus, as is often the case in the monograph, or the project's polemical assertion, as is often the case in a thematic study. Writing any type of study, whether monographic or thematic, on a critically underrecognized living (woman) artist poses particular problems. How does one go about making a case for the importance of an artist of the post–World War II period without engaging (what I consider to be) the generally stultifying conventions of the masculinized monograph? Hopefully, one writes about an artist whose career is rich and complex enough to make claims for the work as an important, representative example, or, in my case, an important counterexample, of a specific cultural and historical moment. I chose to write about the art of the veteran American painter and printmaker Nancy Spero (b. 1926).

Initially I formulated *Codex Spero* with what Lisa Tickner calls a "feminist problematic" in mind. In 1988, Tickner asserted that "there is no such thing as a 'feminist art history.' Feminism is a politics, not a methodology."[2] In place of the category "feminist art history," Tickner suggested "a feminist *problematic*" that would "carr[y] the analyses and goals of political feminism into the realm of cultural inquiry."[3] These words resonated as I began to think of how to craft a manageable study. There was never any doubt in my mind about *how* to write—I would write as a feminist—but I knew that my decision to write on a living woman artist was an example of what Tickner has called "motivated scholarship." The decision was based in part on the dearth of scholarly literature available at the time (the early 1990s), which consisted of only two small but respectable retrospective exhibition catalogues with short essays by prominent art historians. In the intervening years, Spero's critical fortune has changed dramatically, most notably with the publication in 1996 of an unconventional, multiauthored monograph in the Phaidon Press Contemporary Artists Series.[4] Spero is no longer an "overlooked" or "underrecognized" artist, but neither is she quite canonical or a sure bet for art book publishers.

Spero received no rigorous historical and theoretical consideration before the late 1980s, primarily because she was a woman and a self-described feminist, as well as the wife of a (then) better-known artist. Her work also escaped critical attention because it did not comfortably fit the proposed categories or tropes of feminist artistic practice, such as identity (personal vs. professional and "the personal is political"), (female) victimization, the body, and the gaze. But this situation has

changed since 1987, the year in which two traveling retrospectives of Spero's work were mounted in the United Kingdom and the United States. After nearly forty years of neglect, her work began to garner serious, if seriously delayed, critical reception and curatorial response. During the 1990s, she has been invited to show her work internationally at prestigious museums and in coveted exhibitions (such as "Documenta" and the Whitney Biennial) and to install temporary and permanent public commissions in libraries, galleries, museums; on a wall in occupied Derry, Northern Ireland; and even in a New York City subway station. All of this activity does not quite qualify Spero for canonization, which is perhaps a mixed blessing. It also apparently does not necessarily make her a viable subject for an academic press monograph (in contrast to a trade art book), even an unconventional one. This may just be "a sad reality" of the art book market, as one university press editor phrased it. The lesson from Spero's example is that being prototypical is not good enough. Western culture is enamored of singular individuals—celebrities, leaders, athletes, and those who "think differently." The publishing industry looks most favorably upon books about such individuals, even if, like Duchamp, they are then treated in a thematic case study fashion. This proclivity explains the steady stream of studies on Picasso and Matisse being published year after year. A "singular" artist, we realize, is one with a canonical, household name recognizable by the educated layperson. Apart from a handful of women artists throughout Western history, *singular* essentially means "male." This anthology offers a good deal of evidence challenging that definition.

In *Codex Spero,* I intend to convey why Spero should be regarded as one of the most important American artists of the postwar period, but I want to debunk the masculinist notion of greatness by avoiding heroicizing statements and sweeping explanations that are neither historical nor theoretical. Writing reflexively about these issues and reassessing methodological premises brings me a step closer to resolving the paradox at the heart of the project: As much as I want to characterize Spero and her body of feminist work (i.e., works produced since the late 1960s) as prototypical and representative, rather than as singular and unique, I also want to show how her work *is* exceptional for its formal innovations and conceptual challenges. This paradox maintains the ultimate rationale of a monograph (the importance and "quality" of the

work and the significance, if not the greatness, of the artist) yet presents the material in a different way, without employing a biographically motivated, decontextualized, and transhistorical model.[5]

At the beginning of the project, I decided that I wanted to write about an artist whom I respected as a person without extolling her in terms of the by now mythical constructs of modernism and masculinity—genius, originality, autonomy, and greatness. I do not want to examine Spero's work in terms of the ideological analysis posited by Linda Nochlin in her landmark 1971 essay, "Why Have There Been No Great Women Artists?"[6] The concept of greatness was subsequently debunked by feminist art historians as a code word for a subjective, male-identified, and economically privileged position. While my project is indebted to Nochlin's radical questioning of disciplinary assumptions, I do not locate Spero's enterprise in terms of an alternative canon of great women artists, as one might have been tempted to do on the heels of Nochlin and Ann Sutherland-Harris's monumental late-1970s revisionist exhibition and catalogue, *Women Artists, 1550–1950.*[7] These exemplary efforts of "first-wave" feminist art history took the first, necessary steps toward the goal of completely overhauling the discipline of art history. Like much Anglo-American feminist art history, my project builds on but does not try to emulate those achievements.

In addition to the criteria of greatness, I resisted another masculinist attribute of the monograph: the impulse to construct the study like a submarine—streamlined, airtight, a microcosm unto itself. I felt I had to take more risks in my attempt to write an unconventional monograph whose content and structure were not blueprinted before the writing process began but rather grew organically over time as I wrestled with the dilemma of how to write critically, while also in celebration, as a feminist about a feminist artist and feminist art practices. The more I researched and developed *Codex Spero,* the more I realized that a monograph could be whatever I wanted it to be, including thematically driven and issue oriented. I had the liberating sense that I was inventing something from scratch rather than responding to an existing body of literature. The challenge, though, lay in how to set limits and decide what issues to write about.

I decided not to comprehensively examine Spero's art and activism. Rather, I would focus on her career only once she began identifying herself as a feminist—that is, from the late 1960s onward (though she

has been active as an artist since the late 1940s). As I proceeded with my research, I was guided not so much by a preexisting theoretical model or the writings of one theorist as by the image of a wheel, with the sign "Spero" (her work, her feminist activism, and her writings) as its hub and the issues addressed by her, as well as specific, related works by other artists, all emanating from its hub like spokes. I thought this format would allow me to selectively examine specific works that seemed to be lightning rods for feminist debate and to posit new strategies, at times in comparison with those of other contemporary artists, both female and male.

In *Codex Spero* I consciously avoided applying an overriding method that would make the chapters read as a seamless argument. From chapter to chapter, I explored different methods but consistently viewed Spero's art and activist practices from the dual perspectives of second-wave American feminism as a political and social movement and of feminist theory as an increasingly complex and polyphonic network of gender-based discourses. I knew I did not want my project to be a case study of a theoretical method or a model, since I am opposed to using an artist's work and stated intentions as mere illustrations of theoretical discourse. Rather, I use different theoretical approaches suggested by the art itself, ones that are appropriate both historically and contextually to the milieu in which Spero was working, to other contemporaneous artistic practices, and to second-wave American feminism itself. The most surprising revelation I had was that, no matter how hard I tried, if I was honest with myself, I could not identify with any one particular feminist theoretical model. Perhaps this is so because I do not see the wisdom in inserting an artist or her work into a model, theoretical or methodological, in order to show how the model works. The fact that I feel "in between" feminist theoretical models is only one indication that the intellectual terrain between art historical scholarship and feminist theorization, especially as it applies to living women artists, is wide open.

Codex Spero, then, is a neologism conveying three ideas that encapsulate my attempt to rethink the monograph as a feminist. The study's main subject and primary point of departure is the work, rather than the life, of Nancy Spero. Her work, writing, and activism are treated as indices through which critical dialogues constituting a feminist and/or an activist art practice at specific historical moments are explored. One of three points of departure is the dictionary definition

of the word *codex,* meaning "a manuscript book, especially one of Scripture, the classics, or ancient annals," but also referring to an artist's sketchbooks or notebooks, as in Leonardo da Vinci's *Codex Leicester,* in which the text-image relation is unconventional and almost illegible. The codex is invoked conceptually as both a historical and a transhistorical type of instrumentalizing, or codifying, writing. It also characterizes the idiosyncratic and immensely innovative nature of Spero's collage works on paper, or what the critic Lawrence Alloway termed their "interpenetrating" text-image relation.[8] In fact, the codex form itself is an apt, prescriptive model for inventing an unconventional, "demasculinized" monograph. The codex does not replicate existing conventions of writing but rather establishes a new set of rules of interpretation that become instrumental once codified.

A second point of departure is Spero's idiosyncratic approach to collage, inaugurated around 1970 in two series based on the writings of Antonin Artaud (1896–1948), the early-twentieth-century French poet, essayist, and theoretician of the theater. These two series, the *Artaud Paintings* and *Codex Artaud,* were inspired by and appropriated extensively from Artaud's writings. Because the *Codex Artaud* (the more formally and intellectually complex of the two series) is Spero's most enigmatic and pivotal work as well as the linchpin of her oeuvre (I hesitate to use the term *masterpiece*), it warranted extensive examination and became the subject of two of five chapters. *Codex Artaud* (Figure 21) both summarizes the major concerns of the first twenty years of Spero's career (from the late 1940s to the late 1960s) and radically shifts gears in its introduction of compositional issues and strategies of appropriation that continue to preoccupy her. A final point of departure in the study is the term *Codex Spero,* a more cryptic reference to the task of explaining the dense references and interconnections between Spero's most significant serialized collage and hand-printed works on paper and her most important feminist activities in their critical, art historical, and theoretical contexts.

The structure of *Codex Spero* was determined ultimately by the shifts in Spero's artistic practice since the late 1960s, not by important events in her life, such as a geographical move or the birth of a child (although Spero's artistic production is marked profoundly by the conditions of her domestic life, marriage, motherhood, and, for the first thirty years of her career, the overlap of her living space and her studio space). The important shifts occur around issues concerning materials,

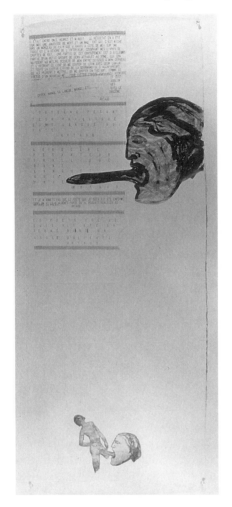

21. Nancy Spero, *Codex Artaud XVII*
(detail), 1972, typewriter and painting
collage

compositional format, and imagery. Each chapter seeks to account for
at least one significant change in Spero's practice as understood within
its art historical, historical, or cultural context (the emphasis depends
on the subject matter of the work). The goal of each chapter is to ex-
plain why the change in practice occurred when it did and how it con-
tributes to a countertradition or represents an ideological rupture in
mainstream postwar American art. Only after several years of research

and thinking, and only once the writing began, did it become clear that the overall approach to the project itself could, and should, be an experiment in how to rethink the art historical monograph as a feminist. It also became clear that the project offered me an opportunity to write about contemporary American feminist art practices without ghettoizing, and thereby marginalizing, them yet again.

Whether one pursues a monograph (conventional or not) or a thematic case study of several artists, it is impossible to avoid completely the question of how to use biographical information and archival documents (transcribed or recorded interviews, diaries, journals, correspondence, and personal effects, for instance). As the backbone of any monograph, such documents are typically used to systematically reconstruct the artist's life and artistic development. They can still be used in a thematic case study but with a different purpose. Such information becomes especially useful when one is reconstructing chronological sequences and exhibition history on women artists, particularly living artists, since information on them is often sparse and/or uncatalogued in museum archives and libraries. As Laura Cottingham has noted, the self-censorship and erasure of lesbian artists in the historical record is an even greater obstacle, at least in terms of researching closeted historical figures.[9] If possible, it can be crucial to work "in dialogue" with the artist, to gain access to her personal archives and slide collection. That metaphorical dialogue depends on the artist's willingness, generosity, and understanding of the stakes of writing history from a feminist perspective. Interviews (both current and dated) still play a very useful role in conducting research, though one need not agree with the artist's interpretation of her own work or the intention behind making it. Similarly, personal archives should not be treated as *the* singular, privileged source of information in a thematic case study, but they can be an indispensable point of departure. It is all a matter of how those documents are treated and what kind of information is emphasized. What types of historical documents are selected and deployed as "evidence"—that is, as authoritative of a certain experience—closely reflects discursive and critical norms, which are manifestations of dominant ideology. In contrast, my research in the Museum of Modern Art and Whitney Museum archives turned up many obscure documents and "unauthoritative" voices that collectively narrate the first chapter, on the early years of the New York women's movement in the arts, from 1969 to 1973.

We are now in the midst of a third wave of feminist art historical analysis, which builds on the earlier theoretical insights of Nochlin, Harris, Griselda Pollock, Rozsika Parker, Lucy Lippard, Whitney Chadwick, and Lisa Tickner, among many others. This third wave, ever conscious of its predecessors, offers a widening range of analyses that combine a gender-based approach to representation with Marxist, materialist, psychoanalytical, or social art historical methodologies.

I prefer an approach that combines the polemical import of Tickner's feminist problematic as a politics in the realm of cultural inquiry (which is more than a method simply to be chosen or discarded) with an intertwined social and feminist-theoretical approach to art historical analysis. I aim to write a feminist art history that functions as *both* a politics and a method, one not burdened by the clichéd, unidirectional axis of influence from the famous husband to the obscure, long-suffering wife "who happens also to be an artist."

One issue I had to address was that of influence. Spero's husband of over fifty years, the painter Leon Golub, does not appear as often in my discussions as one might expect, since I do not believe he has unduly influenced her work or thinking any more than she has influenced his. The marginal presence of Golub in my study has struck some people as audacious, inadequate, or just plain wrong-headed. But no one has undertaken an extended examination of how Golub's work has been influenced by Spero's; why should it be the other way around? My position was that there were several monographs about Golub, his painting, and his writings in print, not to mention many exhibition catalogues, and that that was sufficient. Besides, Spero is a marginal presence in the books on Golub. There were no books about Spero before 1996 and only two decent yet modest retrospective exhibition catalogues in print. It does seem, in hindsight, unfair and inaccurate to marginalize Golub as I did. Perhaps my treatment of "the husband" was a semiconscious manifestation of feminist rage and retribution toward all the people who over the years had belittled, downplayed, or ignored Spero's presence in Golub's life, work, and their shared studio and home. In any event, Golub never once complained about being marginalized in *Codex Spero;* he knows better.

Perhaps Spero's work has been responding to Golub's work, and the aspects of patriarchy, militarism, masculinism, and phallocentrism that it represents, all along. Golub himself remarked in a 1983 exhibition catalogue statement for "Art Couples" at P.S. 1: "I sometimes wonder, 'Is

she trying to embarrass me?' All those little figures, many minute, some half an inch tall! Like termites! To make [my] giants topple?"[10] Conversely, Golub's work of the 1990s shows unmistakable signs of Spero's signature: the incorporation of textual fragments and quotations, and the gradual breakdown of a legible, narrative pictorial space in favor of a more chaotic, collagelike one; and at least one tiny female figure.

No one has written yet on the psychologically fraught topic of the correspondences, the reciprocity, and the "interpictorial dialogue" (to use Jonathan Katz's phrase)[11] between Spero's and Golub's oeuvres. At one point I entertained the idea of switching my topic to the relationship between Spero's and Golub's work, but I did not pursue it. I believed that Spero's work deserved sustained visual, theoretical, and historical analysis on its own terms and in the immediate context of second-wave U.S. feminism before it was interpreted primarily in relation to her husband's work.

In conclusion, let me pose a broader question related to the one with which I began: What *are* the dilemmas and stakes of writing feminist art history now? Always, the choice of a critical approach is not only a question of *how* to write but also, as the Vietnamese-born postcolonial theorist and filmmaker Trinh T. Minh-ha reminds us, a "question of priorities" in terms of how an author conceives of her own identity. Trinh writes about the "bind" of writing as a practice in which a conflicted subjectivity, both gendered and racialized, takes form. For Trinh, the "triple bind" of writing is the conflict she feels in having to choose from among her competing identities as a woman, as a writer, and as an Asian. "Today," she writes, "the growing ethnic-feminist consciousness has made it increasingly difficult for her [that is, Trinh herself, but also all women writers] to turn a blind eye not only to the specification of the writer as historical subject (who writes? and in what context?), but also to writing itself as a practice located at the intersection of subject and history."[12] I am attracted to Trinh's ideas because I know she is writing to me and for me and women like me. Reading Trinh makes me self-conscious about my own position as a Western, white, middle-class, heterosexual, Ivy League–educated, self-identified feminist engaged with the challenge of writing history and a critical questioning of disciplinary conventions. I partially identify with Trinh's conflicted sense of authorial identity.

But I am also aware that Trinh's triple bind of how to write is not my own. I am faced with another bind of competing identities: whether

to write first as a feminist or as an art historian. But the bind is more complicated than that. To answer Trinh's question of priorities, I write as a white, middle-class, heterosexual, North American liberal feminist first, then as a social art historian; moreover, I have written primarily about the work of straight, white, middle-class, liberal American feminist visual artists. I must admit that in important respects (in terms of gender, class, sexual orientation, and political views), Nancy Spero and I have a good deal in common, though she is older and of a different religious background. In part, my decision to write on an artist who in many important respects is similar to myself was also at least partially a response to the then-current climate of political correctness, in which the only critics/voices deemed authoritative were the ones who looked and sounded very similar to the subjects they wrote about.

We—feminists, art historians, scholars—must acknowledge, without seeming apologetic, that the subjects we choose to research and write about often have many points of overlap with the circumstances of our own lives, both personal and professional. We cannot escape the fact that most art historians write about artists, as opposed to art markets or art institutions: that is, about embodied, desiring, and political subjects, subjects marked by gender, class, ethnicity, sexuality, and other inflections. Our often subliminal identification with our subjects is, however, never a precise mirror-image and should not be the basis for choosing what to write on and how to write. Writing self-consciously about one's own position as a historian and interpreter is crucial to establishing a metaphorical dialogue with one's subject and provides an engaging point of entry for the reader into one's work.

My dual identity is at once both personal and professional, as it is for most feminists. I experience the world and try to live my daily life according to feminist principles of equality, tolerance, and justice, yet I am trained as a historian of art. The trick is to hold the two identities in some acceptable form of balance, though it is not always a perfect balance. The issue of how to bridge one's personal and professional identities begs the question of who a feminist is and what feminism means at this moment. The terms *feminist* and *feminism* have become so overdetermined that, as I see it, they can barely contain their multitudes, complexities, and contradictions. Even more worrisome and dispiriting is the current tendency of those who once called themselves feminists to regard the term as suspect and a turn-off to young women and college-aged students. The dilemma of writing feminist art history

and of writing a monograph is, for me, the dilemma of how to write "as a feminist" in order to continue challenging the masculinist biases of the discipline (the monograph, the canon, the masterpiece, the genius) and how to keep our scholarship motivated by our feminist commitments while also continuing to use the "f" word.

NOTES

1. Roland Barthes, "The Death of the Author," in *Image-Music-Text,* trans. Stephen Heath (New York: Hill and Wang, 1977), 146.

2. Lisa Tickner, "Feminism, Art History, and Sexual Difference," *Genders* no. 3 (Fall 1988): 93.

3. Ibid.

4. Jon Bird, Jo Anna Isaak, and Sylvère Lotringer, *Nancy Spero* (London: Phaidon, 1996).

5. I was not able to resolve this paradox to my satisfaction, but dissertations, unlike books, can structurally contain an apparent inconsistency and still be a contribution to scholarship.

6. Linda Nochlin, "Why Have There Been No Great Women Artists?" in *Art and Sexual Politics,* ed. E. Baker and T. Hess (New York: Macmillan, 1973); reprinted in *Women, Art, and Power and Other Essays* (New York: Harper & Row, 1988), 145–78.

7. Anne Sutherland Harris and Linda Nochlin, *Women Artists 1550–1950* (Los Angeles: Los Angeles County Museum of Art, 1976).

8. Lawrence Alloway, "Art," *Nation,* April 2, 1973, 446. Alloway states that the *Codex Artaud* presents "a remarkable compound of two kinds of signs in which verbal and visual image interpenetrate."

9. Laura Cottingham, "Notes on 'Lesbian,'" *Art Journal* 55, no. 4 (Winter 1996): 72–77; see esp. 76.

10. Reprinted in Hans-Ulrich Obrist, ed., *Leon Golub: Do Paintings Bite? Selected Texts 1948–1996* (Ostfildern, Germany: Cantz, 1997), 74.

11. Jonathan Katz, "The Art of Code: Jasper Johns and Robert Rauschenberg," in *Significant Others: Creativity and Intimate Partnership,* ed. Whitney Chadwick and Isabelle de Courtivron (New York: Thames and Hudson, 1993), 189–206.

12. Trinh T. Minh-ha, *Woman Native Other: Writing Postcoloniality and Feminism* (Bloomington: Indiana University Press, 1989), 6.

AT LAST! A GREAT WOMAN ARTIST

WRITING ABOUT CAROLEE SCHNEEMANN'S EPISTOLARY PRACTICE

KRISTINE STILES

INTRODUCTION

I decided to write, since it's so much like a letter
I would make to myself were I someone else.
 Carolee Schneemann

Carolee Schneemann wrote this sentence in a letter to her friend Elsa. It is one of the earliest of millions of lines that make up the artist's epistolary practice. What Schneemann underscored in this provocative thought is that she had "decided to write" *about* herself *to* herself through the intermediary of her correspondents (Figure 22). Her letters represent the thoughts that she would like to have received *about herself* from someone else. These stories that she told herself about herself are the records of her passage through the world. They are not only multiple narratives of her worldview but memories of her life. No wonder she made carbon copies of her own letters and saved those of her correspondents for forty years. They were the instruments through which she organized and made sense of her life, "like a letter I would make to myself."

© Kristine Stiles. I would like to thank Bonnie Marranca for initiating what has become my book, *Correspondence Course,* and for her perceptive and critical questions on this essay. I thank Edward Shanken for his partnership in my intellectual process. Thanks, too, to the editors of this volume for their belief and support. Most of all, thanks to Carolee Schneemann for the gift of her friendship and the beauty and courage of her work.

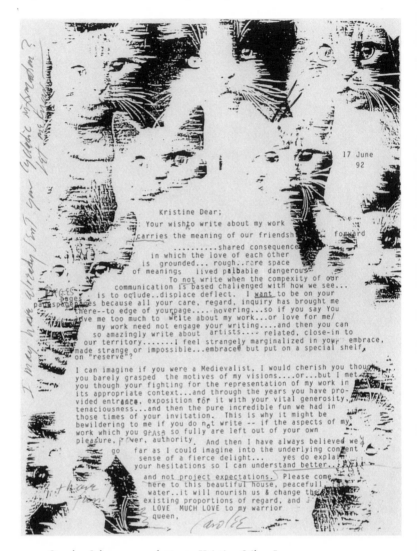

22. Carolee Schneemann, letter to Kristine Stiles, June 17, 1992

In June 1994, when I first sat down in Carolee Schneemann's eighteenth-century stone home to read her letters, I realized that her epistolary practice constituted what could be theorized as an autobiography that coupled her textual to her artistic practice. Another statement by the artist in a letter reinforced my observation: "For me," she wrote in 1956, "to write is to see it." This line signifies one

of the many correspondences between her letters and her art. It is the sign of the agreement between her hand and her eye, the very interstice that Schneemann visualized seven years later in her body-action *Eye Body* (1963). *Eye Body* is a visual enactment of the connection between Schneemann's inner and outer worlds through the organ of sight, a contiguity whose history (or autobiographical "I story") the artist reinvented when she adapted the term *istory*. (*Istory* is the genderless word she used to rewrite the masculine possessive *his* of history.) The corporeal "eye" and the textual "I" are vividly fluid in the letters, a visuality that is indexed in the ways that she augments her letters with drawings, colorful stamps, and longhand corrections of typing errors with colored pens. Something more than a document, each letter becomes a work of art, displaying her reviewing hand on the page, a hand that intercedes in the impersonal technology of the typewriter to leave a mark of her presence.[1] The more one is immersed in her letters, the more intricate, deep, and enduring becomes the agreement between writing, drawing, painting, object making, and actions.

Once I began to notice these textual and visual correspondences, the shape of a book formed in my mind. I decided to compile a selection of letters by Schneemann and her correspondents, editing them for their aesthetic and cultural content. The book's first title was *It Only Happens Once*, the term Schneemann used to describe her writing process. That phrase also characterized the ephemeral conditions of her performances and, as such, articulated the dual and interconnected themes of her visual and textual practices, the theme I had identified as the subject of my introductory essay for her selected letters. Two years into the project, however, Schneemann reminded me of a series of photographic self-portraits she had made in 1980 called *Correspondence Course*.[2] I responded immediately by changing the title of the book to *Correspondence Course: Selected Letters of Carolee Schneemann, an Epistolary History of Art and Culture*. That title captures the act of communication—which is at the foundation of all of Schneemann's work—and symbolically suggests that those who read the book will also partake in a process of education, a course of learning about Schneemann and her times.

Correspondence Course encompasses forty years of Carolee Schneemann's exchange of letters with visual artists, filmmakers, dancers, poets, and the international avant-garde involved in happen-

ings and performance art. It also includes letters to and from critics, art historians, students, admirers, friends, enemies, and a host of other individuals involved in her life and in the arts. The letters offer a literary discourse that captures the ethos of the international avantgarde related to performance art and the general culture of experimental art in the second half of the twentieth century. They enable readers to share in the unfolding of Schneemann's art and character. An intimate portrait of generosity, coupled with selfishness and fierce ambition, appears. Her continual effort for professional recognition, her battle for financial stability, her development as a feminist, and the significance of her personal and intimate relationships are all intertwined with similar experiences told to her by her correspondents. The letters reveal personal aspects of her marriages, erotic attractions, and involvements and the tension between her need for a monogamous partner and, at the same time, her vehement insistence on personal autonomy. One is drawn to witness the balance she tried to maintain between her public life and her very private life. All this takes place within the context of Schneemann's search for self-definition, her unusually intense love of cats, her deep experiences of and responses to nature, and her pervasive sense of humor.

The three sections of this essay outline the circuitous route that led me to work on *Correspondence Course*. The first section tells how I came to read Schneemann's correspondence, how this process required an unusual balance of friendship and our professional roles as artist and art historian, and how that juggling act evolved. In this section, I use the familiar "Carolee" when I recount our interpersonal experiences. My aim in narrating this anecdotal story is to contribute to the demystification of the art historical process of writing about a living artist, making explicit the implicit role that such relationships play in shaping the production of art history, a factor that is often taken for granted.[3] In the second and third sections, as in this introduction, I return to the professional "Schneemann," when I write about her work. In the second section, I shift from the conversational, storytelling mode to introduce my methodological approach to theorizing Schneemann's epistolary practice. The third section considers Schneemann's art historical contribution. The purpose of such a close look at the process of producing art history is to reveal how the discipline creates itself and its canon. When the subject of art history is a woman, the history of women is at stake.

I

In 1979, while still a graduate student at the University of California at Berkeley, I served as a research assistant to Professor Peter Selz, then in the process of writing *Art in Our Times: A Pictorial History, 1890–1980.*[4] Selz kindly entrusted me to make some of the selections for the book since my dissertation research focused on happenings, Fluxus, and body art. One of my choices was Carolee Schneemann, an artist whose work I knew only through texts and illustrations. When Selz initially objected to including Schneemann in his book, I threatened to resign. He graciously acceded and authorized me to write to the artist, requesting an illustration. She responded enthusiastically and later made a point of stating that she realized that as a woman I had been instrumental in her inclusion in the book.

One might imagine, then, that a shared feminism had something to do with my selecting Schneemann for Selz's book. But it did not. At that time, I did not identify with feminism, having been disappointed by the elitism of a clique of art-world feminists in California at that time. I chose Schneemann simply because her work was *visually* powerful and indispensable for understanding the medium of live, presentational art. Her undeniable originality was clear even if one saw only photographic documents of her happening *Meat Joy* (1964) or her performance *Interior Scroll* (1975).[5] As visual images alone, these two works have the power to challenge concepts of the nature of visual art, art history, the institutions of art, art practice, and, certainly, how one might live one's life as a woman. In addition, Schneemann's book *More Than Meat Joy* had appeared in 1979, providing more access to her performances and to her aesthetic theories.[6]

Schneemann and I quickly became friends after meeting in 1980. I soon realized that to foster that friendship I had to maintain my distance professionally. And I did, waiting to write about her for over a decade. Why? It was more important to become her friend than to advance my career through my close relationship to her. I also recognized that I needed to mature as an art historian in order to grapple with the complexity of her art and its art historical and cultural contexts. Since I was a student when we met, and she an internationally recognized artist, the transition into friendship, although swift, was not fluid. Friendship required that we treat each other as equals, a process made all the more onerous by my being the art historian and her being the

artist. Professionally, I was the one expected to attend to her. So I demanded the same attention to my life as I paid to hers. She always returned it, generously. Nevertheless, this period of waiting to fulfill our professional relationship strained our friendship at times, especially as I increasingly wrote about her peers. Eventually, our friendship created the trust that enabled the privilege and enormous responsibility of editing *Correspondence Course,* even though, paradoxically, my access to the intimate material of Schneemann's life emerged from what I shall describe as a betrayal.

In the spring of 1994, Bonnie Marranca, coeditor of *Performing Arts Journal,* commissioned me to edit a book on Carolee Schneemann for the new "Art + Performance" series she and her husband, Gautam Dasgupta, had launched as part of their PAJ Books, published by Johns Hopkins University Press. The series would contain volumes on Rachel Rosenthal, Meredith Monk, and other important figures in performance art.[7] All the books in the series were to be composed of interviews with the artist, selected writings on the artist by critics, selected writings by the artist, illustrations of selected works, a bibliography, and a six-thousand-word introduction by the editor. Marranca's invitation could not have come at a more opportune moment, for I was up for tenure at Duke University. Moreover, both Carolee and I had been eager to undertake a project together, and I thought the book would be fun and easy to finish quickly. Carolee gave the project her blessings. I signed the contract, put the forthcoming book on my curriculum vitae, and immediately spent the small advance I received. A couple of weeks later, Carolee informed Marranca and me that another author had just received a contract from MIT University Press for another edited book of her writings. Although I was upset and felt that my project had been undermined and used for leverage to get the MIT contract, Carolee assured us that the two books were very different.

So that summer I traveled, at my own expense, to visit Carolee and begin work on the book. Carolee picked me up at the airport. We drove amicably to her home through the two-lane rural roads, admiring the flowering countryside until we spotted a huge white rabbit dead in the middle of the road. Carolee stopped the car and pulled the corpse off the road. Given the inauspicious beginning of the project, the beautiful dead animal seemed a very negative portent to me. And it was. Once settled in her home, I asked to see the prospectus for the MIT book, which clearly overlapped with my project in a way that rendered

one or the other redundant. I accused Carolee of betraying and manipulating me into a situation of writing about her. In tears, I explained that I now found myself in an impossible situation from which I could not easily extricate myself, one that was potentially dangerous given my upcoming tenure decision. I was angry and frightened and persisted in confronting Carolee with what I perceived to be her contrivance and duplicity. Initially she feigned misunderstanding and then the "inability to think just now." She wanted to "take a nap." I refused to let her go, haranguing her about my situation. Finally, she admitted that she had not been forthright. Then with a smile and a wave of her hand she said, "But there's enough to go around; look around, you'll find something to write about!"

What did I do? I looked around. I found boxes lined up of her voluminous correspondence in preparation for its possible purchase by the Getty Research Institute. When I first sat down to read the letters, I had not conceived of editing a book of her correspondence or of even writing about her writing. I was trying to pull myself together, get some ideas from the letters, and step back from the unnerving confrontation. I had spent money I did not have to come to visit her. I was not scheduled to fly home for another five days. I had to *do* something. I had to *find* something to write about. I envisioned my tenure slipping through Carolee's fingers. Then I read that line to Elsa: "I decided to write, since it's so much like a letter / I would make to myself were I someone else." I began poring through the boxes of her letters. I read every letter in five bleary days, working ten or twelve hours a day. I never even stopped to count them. After the first day, I told Carolee that I wanted to edit the letters for their aesthetic content and extraordinary documentation of the period. Carolee agreed. But when she agreed, I do not believe that she grasped the import of her decision. Nor did she fully comprehend the implications of selling her correspondence to the Getty. At lunch each day, we would regularly put a blanket on the grass and chat about her life. As I asked questions, aided by the content of the letters, I began to consider the immense intelligence and creativity of my friend in a manner that had eluded me before. At one point I exclaimed to her that the letters helped me to understand how immense and significant her oeuvre was. "You're just like your own big home with many windows," I observed. "But you keep the curtains pulled as a veil, opening only one at a time, so that no one can ever see the whole picture." She responded immediately:

"Baloney! The curtains aren't closed! No one has bothered to look."
She was right.

But the more letters I marked to photocopy for editing, the more uncomfortable Carolee became. As the days wore on and I continued to read and make notes, she began circling like one of her cats, looking at me, reading over my shoulder, fidgeting. On the last day, after I had finished, she suggested we go to dinner to celebrate. Then in the parking lot of the restaurant before we got out of the car, she lowered the boom: "You know," she looked at me with determination, "you can't have all the letters; you can't publish everything." I was completely exhausted and exploded. "It is too late, Carolee," I reminded her. "I have already read them all, and I know." I also warned her that if she thought she was vulnerable now—with me, her trusted friend—then she must think very carefully about putting her letters in a public archive. She would remain in control, she retorted, because she would retain the copyright. But I advised her that she could not anticipate what scholars might extrapolate and infer from the letters, and she could not control how they might interpret and use the information discovered in them—even if the letters were never quoted verbatim. This argument was useless, quite simply because she needed to sell the letters to pay her bills, to continue to make art, and to live. It was now Carolee's turn to cry. And she did. "I am still alive!" she shouted. "I have a life to live!" Again, she was right.

The dilemma Carolee and I have confronted revolves around the potential "exploitation of biography for political [and personal] ends," a process that Catherine Epstein recently formulated as "the politics of biography." Epstein quotes Philip Guedalla, an English historian writing in 1920: "Biography, like big game hunting, is one of the recognized forms of sport; and it is as unfair as only sport can be."[8] Carolee's fear, of course, was the possibility that I, an art historian, would treat her as big game, a trophy stuffed and hung on a wall exposed. At the end of the process of reading her letters, she knew that I knew too much about her. She had opened herself and her home to a friend, only to find that an art historian had gotten in. Ours was a double bind: If I behaved as a "professional" art historian, I would record what I knew; if she had not tricked her friend into signing a contract for a book about her, an art historian would not be writing about her. We had each other over a barrel. My knowledge as an art historian made her feel vulnerable, not only *to me* but *in the world*. We now realize

just how unprotected, perhaps even defenseless, this sharing of intimate information had made her and how it had confronted me with an ethical dilemma. Should I protect my friend or write about the whole of my knowledge of this important artist and the history of her work? Schneemann's words—"I am still alive!"—resolved the question for me. As a friend *and* art historian, I would not contribute to the erasure of the boundary between private and public. I would protect her secrets, maintaining her privacy even if that meant suppressing information from the historical record at the expense of an art historical understanding of her work. In her lifetime, I would tell nothing about Carolee Schneemann's art or life that she did not authorize. This does not mean that I coyly would hold back a "big secret" that might be gleaned by someone else who read her body of correspondence. Rather, I made a personal decision to be sensitive to and respectful of the moral implications entailed by my privileged access to the whole of Schneemann's life—her massive archive, her enormous body of work, her personal emotions and experiences, and so forth. In a period that witnesses the simultaneous development and exploitation of psychobiography and, at the same time, the deconstruction of the very notion of biography itself, scrutiny of one's practices is paramount.

While working on the book, I gave her my working manuscripts. She was astonished and thrilled. It was startling to find her own and others' aesthetic ideas culled from the correspondence and presented in a succinct, lucid, developmental chronology. She began to appreciate her own epistolary history, her aesthetic concepts, and the sheer beauty of her written style in a new way. But she also confronted reliving both the joy and the pain of her past, something she had not asked to do. Even though she could now systematically remember how she had once formulated her ideas about her art, and the ways in which her work and interpersonal relationships were interpolated with current events, she also found her life apparently wrapped up in a manuscript. However reaffirming, it was a double-edged sword. For the art historical process that distilled her words threatened her sense of *living in the present, for the future,* and, she feared, relegated her life to the past.

I have now been working on *Correspondence Course* for eight years. It is a very different book from the one for which I originally contracted. In addition, Carolee and I agreed that the contract needed to be renegotiated to include her, since the volume is composed of her

letters. Meanwhile, Carolee has my working manuscript, from which she inevitably began to draw ideas as she developed her MIT book, *Imaging Her Erotics: Essays, Interviews, Projects* (2002), for which I wrote the introduction. Meanwhile, my book no longer fit into the Johns Hopkins series "Art + Performance"; the University of Chicago Press decided not to publish it because of competition from the MIT book.

<center>II</center>

In my introductory essay to *Correspondence Course*—entitled "At Last! A Great Woman Artist: Carolee Schneemann's Epistolary and Aesthetic Practices"—I argue that the letters are the literary genre through which Schneemann wrote her autobiography and, in part, constructed her identity. This process is the inverse of the one described by the Canadian poet and writer Margaret Laurence in a letter to her friend Adele Wiseman: "Your letters make me feel I actually exist."[9] Instead of having someone else remind Schneemann of her vitality, the artist uses her own writing practice as a confirmation of her intellectual and emotional experiences and existence, which she extends to others. But Schneemann's method of letter writing is saved from narcissism by her action of writing *to* someone else, creating interpersonal communication, while at the same time writing *to* and through herself. In other words, she sets up a situation in which she requires herself constantly to negotiate her self-reflective mediations *in relation to* her epistolary interlocutors. Her rich correspondences with poet Clayton Eshleman and filmmaker Stan Brakhage are evidence of remarkable, mutual artistic influence, admiration, and support, as well as struggle over aesthetic and personal principles. Particularly in their discussions of gender, over which they battled vehemently, Eshleman and Brakhage's views appeared to pose a real threat to the identity that Schneemann wished to project as a woman and as a woman artist.[10]

In this regard, the question of the nature of self (in both its discursive and performative forms) is pertinent. My approach to this question draws on Paul John Eakin's brilliant study *Fictions in Autobiography*. In one particularly compelling section, Eakin juxtaposes concepts of autobiography theorized by Paul De Man and James Olney. Eakin notes that De Man holds autobiography to be prosopoeiac (a figure of speech

in which an absent person is represented as speaking, or a dead person is presented as alive and present). Hence autobiography is, according to De Man, "a discourse of self-restoration...by which one's name...is made as intelligible and memorable as a face."[11] De Man argues that "to the extent that language is figure (or metaphor, or prosopoeia) it is not the thing itself but the representation, the picture of the thing and, as such, it is silent, mute as pictures are mute." Furthermore, since in writing both readers and writers are "dependent on this language," De Man concludes: "[W]e all are...deaf and mute—not silent, which implies the possible manifestation of sound at our own will, but silent as a picture, that is to say eternally deprived of voice and condemned to muteness."[12] Olney takes a more positive approach, positing language to be a "theater of possibility, not privation, through which both the writer and the reader of autobiography move toward a knowledge—albeit mediated—of the self."[13] But Olney seems to agree with De Man regarding the mediated quality of autobiography in that "the self expresses itself by the metaphors it creates and projects, and we know it by those metaphors; but it did not exist as it now does and as it now is before creating its metaphors. We do not see or touch the self, but we do see and touch its metaphors: and thus we 'know' the self, activity or agent, represented in the metaphor and the metaphorizing."[14]

I theorize that Schneemann's epistolary practice resides at the interface between De Man's and Olney's concepts of autobiography. As she traces out the themes and the conceptual contours of her aesthetic ideas in the letters, these ideas are materialized in drawings. Drawings become the basis for paintings. Paintings transform into assemblages and environments, temporal and spatial operations that become bodily actions in happenings, body art, performances, films, and videos. She discusses all this work in the letters, creating an existential-aesthetic loop that joins her many modes of expression to her life *as a process*. My interest in the autobiographical character of Schneemann's correspondence is specifically the relationship between the metaphorical and metonymical processes that characterize the contiguity between her writing and her performances.[15] On the one hand, Schneemann's corpus of letters constitutes a textual and therefore a metaphorical and representational process. On the other hand, her corporeal acts (as a performance artist) constitute both a metaphorical and, more important, a metonymical form of presentational connection, communication, and extension of the self into the world. I argue that the continu-

ity between her discursive epistolary practice and her performative en-actments forms a synthesis of the De Man/Olney dialectic. While she may write in the prosopoeiac mode (as De Man would have it), she ac-tualizes that writing in real time, where her body is anything but ab-sent, deaf, and mute. Moreover, in writing her letters, Schneemann only temporarily suspends her body *as if* absent in the autobiographi-cal act (De Man's metaphorical de-facement). For she restores that body in the presentation of herself as a living subject before viewing subjects (Olney's "theatre of possibility"), a realization that material-izes the contingency of human interaction, the phenomenology of which is expressed not as metaphor but as metonymy. Addressing Schneemann's art through her letters, I theorize, evinces not only how the mind unfolds in linguistic time but how the epistolary mind is ac-tualized in the ontology of the performative body.[16]

The experience of reading Schneemann's letters helps one to grasp the breadth of her art historical significance and cultural contributions. To say this is not to suggest that the letters are necessary for compre-hending the quality of her art. Ironically, as Schneemann's body made her work famous, it also masked more direct access to her visual art. But in the letters, her nakedness disappears in the phenomena of prosopoeia. In this disappearance, the letters enable comprehension of the problem that critics and art historians have had in looking beyond the physicality of her actual body (the medium of so much of her art) to the body of works (including performance) that she has produced. Her correspondence becomes a course in the totality of her oeuvre, throwing open all the curtains to the windows of her artistic house and exhibiting the diversity of her aesthetic achievement.

My intuition that Schneemann's letters constituted an autobiogra-phy was confirmed several years after I began the arduous task of read-ing, selecting, editing, and transcribing them. Research on the book disclosed a statement she wrote in a letter of March 5, 1974, to artists Miriam Schapiro and Sherry Brody on the occasion of her contribution to their exhibition "Anonymous Was a Woman: A Documentation of the Women's Art Festival, a Collection of Letters to Young Women Artists." Schneemann explained: "All my writing has been implicitly or—more recently—explicitly addressed to unknown 'young women artists,' which has been a persistent and desperate need on my part, to serve as possible precedent since my own [role models] were a private company of suicided [*sic*] or demeaned historical women."[17] In her let-

ter, Schneemann included sections of her book *Parts of a Body House Book* (1974), with instructions that Schapiro and Brody select something from it for their catalogue. They chose an entry dated October 1971, which included the following excerpt: "We are on-lookers, observers to our given definitions, our own integration."[18] But this statement represents only part of Schneemann's concept of female identity. For although she reflected Simone de Beauvoir's famous theorization of the self-analytic cultural position of women as "other," at the same time her letters prove that she had already "decided" to write herself into self-definition.[19] Namely, she had already begun the long and solitary process of *refusing to regard herself from the outside*. In writing *to* herself, *about* herself, and *for* herself, Schneemann made sure that her words were the ones through which she (and those women interested in and affected by her process) would orchestrate the processes of developing a female identity *from the inside*.

However autobiographical Schneemann's view of herself is in the letters, I do not introduce the letters using the normative biographical manner reserved for the collections of deceased artists. Rather, I rely upon a chronological (instead of thematic) organization to reinforce how Schneemann herself developed a discourse on her life, and in my introduction I theorize, as I noted above, about the relationship between her discursive and aesthetic practices. In this respect, addressing her biography through chronology is biographic without apology on my part. For no matter how self-critical art history becomes as a discipline, with ever more complex theories applied to the practices and institutions of art, some basic chronological groundwork is necessary as preparation for building a structure of criticism. This is especially true when one writes about an artist as central to the discourses of experimental art but as neglected as Schneemann.[20]

Schneemann responded to this neglect by writing her own history and theorizing her own art in *More Than Meat Joy*, and she continued the process in her MIT book. Critics and art historians systematically rely on both books for their information about the artist, never considering that they may contain erroneous data.[21] Critics also overlook that both books were compiled and edited retrospectively *after* Schneemann experienced substantive changes in her life, her art, and the culture at large relative to the historical material in these books.[22] Nevertheless, *More Than Meat Joy* both orchestrated and determined the early critical reception of her work, boosting especially attention to her

performance work at the expense of her more static production. In short, the effect of *More than Meat Joy* was to co-opt criticism and establish a blueprint for how her history would be written. In this regard, Schneemann is like her peers Allan Kaprow, Joseph Beuys, Hermann Nitsch, and many other artists whose writings have determined critical discourse on their art.[23] Such self-consciousness is fully aware of the intersection of art and its histories, positing the self "explicitly or implicitly behind each sentence or line in a work."[24] In this way, Schneemann, like her peers, temporarily becomes her own historian, inventing the discourse around her and striking a balance between the modernist notion of a unified self—in all its existential conflict—and the postmodern construction of ironic multiplicity.[25] Moreover, in *Imaging Her Erotics,* Schneemann dons the discourse of poststructuralist criticism, keeping pace with the competitive market for theory that developed in the 1980s and 1990s. Yet although she plays with modernist and postmodernist notions of theory and identity, Schneemann appears remarkably consistent in her communications to the wide variety of celebrated individuals with whom she corresponded in Europe and the United States. Because of these individuals' own centrality in the construction of culture since the 1950s, *Correspondence Course* also includes a selection of her correspondents' letters, which amplify the monographic approach with an intertextual representation of an era, creating an unusual hybrid form that operates between literary genres. *Correspondence Course* is, then, a collection of letters that retains its historical authenticity as a biographical autobiography, as a critical, art historical study of the relationship between Schneemann's aesthetic texts, images, and actions, and as a compendium of a historical period described in the letters of those who lived through and created its cultural discourses.

A primary goal of the book is to examine Schneemann's place in art history. One way this is accomplished is by comparing and contrasting her letters with the epistolary practices of other artists and writers. For example, Schneemann's self-conscious practice of copying her letters is not unlike that of other self-aware artists. Paul Ferris has written that the Welsh poet Dylan Thomas "planned his life [and] set up his biographers in advance...[in a] self-conscious approach to the business of being a poet."[26] Schneemann's letters merit more than just a casual comparison to those of Thomas, whose flamboyance caused "harm" to his repu-

tation because he flaunted himself by "doing it all *in public* [emphasis in original]."[27] So too, Schneemann has been accused of exhibitionism, of flaunting her ideal body. Both Schneemann and Thomas wrote about themselves in the context of other artists and poets. But while Schneemann's letters are a veritable treasure trove of her enthusiastic interest in and support of other artists, writers, poets, critics, and art historians, "contemporary poets receive little attention from Thomas."[28] Where Thomas was "malicious...about many of his friends and acquaintances,"[29] Schneemann is endlessly supportive not only of the famous but of the unknown, whether graduate students, friends, or even enemies. For Schneemann such behavior was part of her personal code and investment in what she often referred to as "my tribe."[30]

Schneemann's "tribe" receives gracious, encouraging epistles—until someone crosses her or perpetrates what she might consider an injustice against her. To be the recipient of one of these antagonistic letters means that one is either a close enough friend that she can safely unleash her anger or an enemy she can afford to offend. When she recoils, she is like an angry dog, teeth bared. In such letters, Schneemann begins a series of drafts that she works and reworks, sometimes writing notes in longhand, then typing and editing the letter, and finally retyping it in duplicate, saving the carbon for her archive.[31] She used this very careful, self-censoring method especially with friends, but she also made it a habit to write multiple drafts and copy her letters. So too, Dylan Thomas "was a careful, often laborious drafter of letters throughout his life, [and] original versions were polished up and written out again."[32] Schneemann and Thomas, in this regard, are very different from someone like Virginia Woolf, whose letters have been described as written in "haste."[33]

Such are the kinds of comparisons that I explore in my introduction to *Correspondence Course*. In this survey, I have briefly introduced the scope of that work. My aim is unabashed. I hope to intervene in and hasten the cultural process of determining Schneemann's place in history, especially by considering her correspondence in relation to artists and writers whose historical reputations are secure. In addition, I compare and contrast her epistolary practice not only to that of Dylan Thomas and Virginia Woolf but also to that of Mary Cassatt, Emily Dickinson, Federico Garcia Lorca, Georgia O'Keeffe, Marcel Proust, and many other artists and writers, quite simply because they must be considered her historical antecedents and therefore her artistic peers.

III

Is Carolee Schneemann one of the great women artists that Linda Nochlin forgot in 1971 when she published her highly influential essay "Why Have There Been No Great Women Artists?"?[34] Nochlin's own account of what constitutes great art begins to answer this question:

> The problem lies...with [a] misconception...of what art is: with the naïve idea that art is the direct, personal expression of individual emotional experience, a translation of personal life into visual terms. Art is almost never that, great art never is. The making of art involves a self-consistent language of form, more or less dependent upon, or free from, given temporally defined conventions, schemata, or systems of notation, which have to be learned or worked out, either through teaching, apprenticeship, or a long period of individual experimentation. The language of art is, more materially, embodied in paint and line on canvas or paper, in stone or clay or plastic or metal—it is neither a sob story nor a confidential whisper.[35]

One look at Schneemann's art is enough to confirm that it is neither a "sob story nor a confidential whisper," the terms Nochlin used to criticize certain directions in feminist practice of the late 1960s and early 1970s. By contrast, Schneemann's work has been erotically scorching, irreverent, and intractably headstrong. She has pressed against the boundaries and definitions of what art might be by violating culturally proscribed behaviors for women (both in and outside the institutions of art). She refused to fall in line with minimalist, structuralist, and conceptualist aesthetics that dominated the late 1960s and early 1970s. At the same time, her work is always aware and expressive of the changes in cultural forms and is equally informed art historically. Schneemann's conceptualization of the possibility of form after Cézanne reflects her theory of how the eye may continue Cézanne's proto-cubist, fractured picture space off and away from the picture plane into the real time and action of the body extended in actual space. Her letters show how she develops different aspects of her art, recycling aesthetic ideas and responding to changing aspects of experimental art; new media, intermedia, and multimedia; film and video; and cultural theories such as feminism and poststructuralism. In other words, her work participates in and continues the discourse of modernism as much as it contributes to determining the narratives of postmodernism.

Nochlin, in her argument about the art historical construction of great art, cautioned that "no serious contemporary art historian" believes "the fairy tales" told about "great artists," such as "struggles against the most determined parental and social opposition, suffering the slings and arrows of social opprobrium like any Christian martyr, and ultimately succeed[ing] against all odds...because from deep within himself radiates that mysterious, holy effulgence: Genius."[36] Although the sobriety and self-conscious earnestness of a postmodern, deconstructive culture mitigates against such myths, it institutionalizes a double standard by merely replacing the old canon with a new one. For "great artists" continue to be identified all the time, just as "genius" awards are given annually. So when Nochlin asked the provocative question—"If Giotto, the obscure shepherd boy, and van Gogh with his fits could make it, why not women?"[37]—she ironically poked fun at the hyperbolic "hardships" attributed to male "genius" and was simultaneously attentive to the social obstacles that confront women's ability to achieve greatness. But what if such hardships are, indeed, not "fairy tales" but real? Then Nochlin's question—"Why not a woman?"—becomes a rhetorical one.

Carolee Schneemann *did* fight against the most determined parental and social opposition, one that included having her father call her a "monster of nature" because she refused to have children in order to pursue her art in her way.[38] Nochlin also points out that the majority of women artists came from families where a close male relative was an artist. Not Schneemann. Moreover, what if one actually *did* suffer the slings and arrows of social disrepute? In this respect, Schneemann's display of her nude body in the early 1960s was seen as vulgar, pornographic, and inappropriate and was dismissed as a device for gaining attention.[39] A decade after the movement of body art (which she pioneered in her unprecedented action *Eye Body*) had become an acceptable genre of visual art, the very same body she had used throughout the preceding two decades was no longer a viable medium. Suddenly she had become too old to perform nude, if one considers the view of Fluxus artist Dick Higgins, who wrote to Schneemann in 1981 to suggest that she find a "younger" surrogate:

> I think your strategy is wrong at the moment. You aren't recognizing that you are a master now (in the sense of master-artist, not of a male), that what you have been doing you have tried to do entirely yourself with your body as your instrument. But that instrument itself has changed. You're a beautiful woman, of course, but the very

nature of desire and potential for desire changes as one matures. You're less a Hollywood desire-object fetish as a physical entity than you once were.... What you need is, I think, to take a special kind of apprentice, to teach what you know on a one-to-one basis, and to find yourself a beautiful young woman to work with, not necessarily as a lesbian lover, but as a surrogate for yourself in certain performance situations so that you can maintain your masterly objectivity.[40]

The paradoxical, ironical, and maddening aspects of Higgins's suggestions are too obvious to require comment. Schneemann's entire career, like the life of women in general, has been caught in this contradiction, an age-old social problem that Schneemann's work not only depicts but represents. Moreover, many younger artists, including numerous imitators around the world, have received more critical attention, museum and gallery exhibitions and financial support, grants and other kinds of funding, teaching positions, new studios, and so on than she has. The perfect example of this neglect is the response I received in 1995 when I proposed a retrospective of Schneemann's work to a well-known museum in the United States. The chief curator, a man, turned down my proposal with the explanation that his audience would be "better served by an apple than the stem."[41]

Given such odds, why does Carolee Schneemann still radiate?[42] The answer cannot be that she is simply a genius. It is that, like any person accorded such accolades, she possesses "something special" that is not mysterious at all: dogged persistence. In this regard, it is far more compelling to observe how hard Schneemann has persevered to achieve her goals. Her indefatigable energy, her steadfast involvement in international culture, her insistence on creating work that expresses her experience of truth, and her refusal to accept inherited conventions for the behavior of women or women artists are all aspects of a rare will, determination, mastery of many fields of creative expression—and talent. Cultivated by education and personal rigor, she has studied the world and transformed her understanding of it into a visual and textual language that simultaneously constitutes and represents the culture of her time.

While the title of this essay about *Correspondence Course* celebrates Nochlin's groundbreaking essay, it also suggests an ironical gasp of "at last!" This irony calls for the paradoxical recognition that unless one is understood as "great" in her own time, she will not receive the support she needs and deserves. By all the criteria that Nochlin herself pro-

vided, Schneemann is a great artist. While it is beyond my purpose here to quarrel with Nochlin's definition of great art, it must be asked how the art historian's criteria prevented her from identifying "a great woman artist" in her midst. How, for example, would a "self-consistent" language of form, independent of social and cultural conventions, be identified? How could that form exist apart from culture and simultaneously be identified as aesthetic? How could artistic production ever exempt "personal expression" and "individual experience" from its results?[43] Most important, Nochlin's criteria for the tools of great art are too conservative and were even when she wrote the essay. Such criteria made it impossible for Nochlin to recognize how Schneemann—an artist whose body figured prominently as the medium of art—extended the medium of painting and sculpture into real time and space and insisted that it was a woman's right to do so.

It should be clear that my aim is to validate Carolee Schneemann's work. As a scholar, I will not contribute to the normative art historical paradigm that demands that she die in order to garner serious art historical attention and respect. I further refuse to be cowed by the dogmas of new art historical methodologies and theory that naively suppose a scholar is somehow lacking in critical acumen if she resorts to biography, much less celebrates an artist. I *want* to celebrate Schneemann's life's work *in her lifetime.* Why? Because Carolee Schneemann is, as she shouts, *alive!* I have staked my professional reputation, and I continue to stake it, on my scholarly conviction that Schneemann's art warrants more critical attention. Reading her letters makes the need for this acclaim manifest. For in them one finds the ways in which Schneemann consistently extended contemporary discourses into a visual and textual vocabulary of forms and ideas convergent with and expressive of the central themes of her time: the authority and fragility of the human body in the late twentieth century; the significance of gender in rethinking and reconstituting the social conditions of Western epistemology; the tenuous connections between disease, death, loss, and friendship; love and its fury; the intersection and intertextuality of contemporary media in the move from a unified modern identity to a multiple postmodern multiplicity; the growing interdependence of humans, animals, and nature in the postbiological age; and, perhaps the most daunting challenge of all, the representation and study of sexuality—that immense, mysterious territory that structures individual experience and interpersonal relations and invisibly shapes culture at large. At last, a great woman artist!

NOTES

1. A number of artists write such visual letters. See, for example, Joseph Cornell, *Joseph Cornell's Theater of the Mind: Selected Diaries, Letters, and Files* (New York: Thames and Hudson, 1993); *Briefe von Jean Tinguely an Paul Sacher und gemeinsame Freunde* (Letters from Jean Tinguely to Paul Sacher and common friends), ed. Margrit Hahnloser (Basel: Museum Jean Tinguely and Benteli, 1996); and *Letters from H. C. Westermann,* ed. Bill Barrette (New York: Timken, 1988).

2. Schneemann's performance *Correspondence Course* was initiated by an invitation from Paul McCarthy and Allan Kaprow to participate in a special issue of *The Dumb Ox* that they were coediting on the relationship between text and image. They instructed their guests to "provide both text and illustrative material to relate to your work in performance or action art." Schneemann answered with ribald, wildly self-satirizing, and irreverent photographic actions. The photographic actions were paired with letters that she either received or wrote, letters that vividly exhibit the absurd and/or disrespectful treatment of artists. For example, in response to the correspondence from the "Feminist Art Research Center, Canada," Schneemann photographed herself reflected in a mirror, wearing "studious" clear-plastic framed glasses. But she is topless with her shorts pulled down just above her pudendum, and she is sticking her tongue out at the camera while holding her hands up by her ears, wagging them at viewers. Another photograph shows her mirror reflection, this time from behind. Again she is topless with her pants down, a feather duster stuck between her buttocks! This photograph accompanies her letter to the German editor of a book on feminist art history in which she points out that her slides for illustrating the book have not been returned in a year and that she has not received the promised honorarium, a paltry $50. Here is a sampling of such letters she received as they appear in the original, grammatical errors intact!

From Student—Massachusetts

DEAR ARTIST IN SCHOOL I HAD TO WRITE ABOUT A FAMOUS PERSON I ROTE ABOUT YOU I THINK YOU ARE A KIND PERSON AN A GREAT ARTIST WHEN I GROW UP I WANT TO BE A GREAT ARTIST LIKE YOU I WISH YOU AN YOUR FAMILY GOOD HEALTH

From Filmmaker NYC

THIS IS THE BOZO AT ROBERT'S PARTY WHO THOUGHT YOU SAID YOUR NAME WAS HARRIET. WHEN YOU VISIT THE CITY, YOU MIGHT ENJOY MEETING ME FOR LUNCH OR DINNER. REGARDS.

From Feminist Art, Research Centre, Canada

We are a non-profit organization with no funding; we cannot pay for your contribution but will give your work a lot of exposure In order for us to make a wonderful festival and library, we need your material yesterday!

3. This is particularly true if one considers more intimate relationships such as those between couples like Rosalind E. Krauss and Robert Morris; Lucy R. Lippard and Robert Ryman, or Lippard and Charles Simonds; Clement Greenberg and Helen Frankenthaler; Barbara Rose and Frank Stella; and many others. My interest in the personal relationships that shape art and its histories dates from my essay "Unbosoming Lennon: The Politics of Yoko Ono's Experience," *Art Criticism* 7, no. 2 (1992): 21–54. I gave the first version of this paper in 1990 at "Feminism, Performance, and Postmodernism," a symposium organized by Kathy O'Dell and David Jocelet at the Boston Institute of Contemporary Art, in which Carrie May Weems, Anne Wagner, and others participated. At that time, Wagner expressed admiration for my paper and explained her intention to draw upon it, so I sent her a copy. Six years later, Wagner published *Three Artists (Three Women): Modernism and the Art of Hesse, Krasner, and O'Keeffe* (Berkeley: University of California Press, 1996), a study that, in part, explores these artists' relationship to their male partners and that certainly reflects another dimension of the interaction between art professionals in terms of her own marriage to the eminent art historian T. J. Clark.

4. Peter Selz, *Art in Our Times: A Pictorial History, 1890–1980* (New York: Harry N. Abrams, 1981).

5. I first encountered pictures of Schneemann's work in Udo Kultermann's *Life and Art* (New York: Praeger, 1971). It is symptomatic of the neglect of Schneemann that she was left out of the two most influential books on happenings published in the 1960s, even though one might make a case for *Meat Joy* as one of the most significant happenings of the period. These two books are Michael Kirby's *Happenings* (New York: Dutton, 1965) and Allan Kaprow's *Environments, Installations, and Happenings* (New York: Harry N. Abrams, 1966). The only author who included her in a study of happenings was Al Hansen. See his *A Primer of Happenings and Time/Space Art* (New York: Something Else Press, 1965). Inclusion in Hansen's book, however, may have been more of a curse than a blessing. For, as I have noted elsewhere, Hansen "posed a dilemma to himself and his colleagues.... [Even though it was] to his life-long credit, he remained unmanageable. [Moreover, he was] seldom seriously discussed." See Kristine Stiles, "Battle of the Yams: Contentless Forms and the Recovery of Meaning in Events and Happenings," in *Off Limits: Rutgers University and the Avant-Garde, 1957–1963*, ed. Joan Marter (Rutgers, N.J.: Rutgers University Press, 1999): 118–29.

6. Carolee Schneemann, *More Than Meat Joy: Complete Performance Works and Selected Writings*, ed. Bruce McPherson (New Paltz, N.Y.: Documentexte, 1979).

7. Since the spring of 1994 a number of these excellent monographs have appeared.

8. Philip Guedalla, *Supers and Supermen: Studies in Politics, History and Letters* (London: Fisher Unwin, 1920), 233, quoted in Catherine Epstein, "The Politics of Biography: The Case of East German Old Communists," *Daedalus* 128, no. 2 (1999): 1.

9. *Selected Letters of Margaret Laurence and Adele Wiseman*, eds. John Lennox and Ruth Panofsky (Toronto: University of Toronto Press, 1997), 3.

10. Eshleman was one of the first poets to recognize the unique character of Schneemann's writing, inviting her to publish in his poetry review *Caterpillar* 8–9 (1969). But Robert Kelly was the first poet to publish Schneemann. See her "Hormones Circling" in his mimeographed journal *Matter* (1963), unpaginated. Jerome Rothenberg and David Antin followed Kelly, publishing "Meat Joy Notes as Prologue," in *Some/Thing* 1, no. 2 (1965): 29–45. Her friendship with Brakhage dates from the 1950s. Their correspondence before the 1970s was stolen from her home in the late 1960s when she was living in England. I hope that it will resurface in the future.

11. Paul De Man, "Autobiography as De-facement," *Modern Language Notes* 94 (1979): 920–23, quoted in Paul John Eakin, *Fictions in Autobiography: Studies in the Art of Self-Invention* (Princeton, N.J.: Princeton University Press, 1985), 186.

12. Ibid.

13. Ibid., 188.

14. James Olney, *Metaphors of Self: The Meaning of Autobiography* (Princeton, N.J.: Princeton University Press, 1972), 30, 31, 34, quoted in Eakin, *Fictions in Autobiography*, 188.

15. For the theorization of the role of metonymy in augmenting the metaphorical capacities of visual art, see Kristine Stiles, "Synopsis of the Destruction in Art Symposium (DIAS) and Its Theoretical Significance," *Act* [New York] 1 (Spring 1987): 22–31; and Kristine Stiles, "Survival Ethos and Destruction Art," *Discourse: Journal for Theoretical Studies in Media and Culture* 14, no. 2 (1992): 74–102.

16. Recently, Richard Poirier has published a book that explores similar themes. See Poirier's *Trying It Out in America: Literary and Other Performances* (New York: Farrar, Straus and Giroux, 1999).

17. See Miriam Schapiro, ed., *Anonymous Was a Woman: A Documentation of the Women's Art Festival, a Collection of Letters to Young Women Artists* (Valencia: Feminist Art Program, California Institute of the Arts, 1974), 116. In her letters, Schneemann writes about having read the journal of the Russian artist Marie Bashkirtseff; as a romantic young woman, she must have felt as if it was written for her. It is typical of Schneemann that she would then want to write for other younger women artists. See *Marie Bashkirtseff: The Journal of a Young Artist, 1860–1884*, trans. Mary J. Serrano (New York: E.P. Dutton, 1919). In this regard, one of the most rewarding aspects of working on *Correspondence Course* was to observe how my female research assistants, Erica James, Elizabeth Kyle, and Alexandra Tuttle, all responded to the manuscript, personally identifying with Schneemann's developmental process and entering imaginatively into her times.

18. Schapiro, *Anonymous Was a Woman*, 116.

19. *The Second Sex* was published in English in 1952, and Schneemann read it in the 1950s. See Simone de Beauvoir, *The Second Sex* (New York: Al-

fred A. Knopf, 1952); originally published as *Le deuxième sexe* (Paris: Librairie Gallimard, 1949).

20. It may come as a surprise to hear Schneemann described as "neglected" when so many books, articles, and dissertations mention her work or interpret one or another of her performances or films. Yet she has only two works in museum collections, and she has had only one major museum exhibition—at the New Museum in New York, in 1996—unfortunately billed as a "retrospective." In this exhibition, the museum squashed a tiny, poorly installed sampling of her work into the front of the museum's already small space (cramped at that time because of renovations). It reserved the back of the museum for three installations by younger artists whose work had nothing to do with Carolee Schneemann's. A screening space for documentary videos of her work and her own films was set up in the middle of the exhibition in broad daylight. Light interfered with the clarity of the images, and noise from the videos and the gallery disrupted viewing of both her static and filmic works. The catalogue was skimpy, inexpensively produced, lacking in an extensive biographical and aesthetic survey of her work, and printed primarily in black and white. The entire affair was shocking, disrespectful, and painful to witness, especially since other institutions might imagine from it that she had already had a retrospective and that her work was overrated, even though such a judgment would reflect the unworthy exhibition rather than her art.

21. For example, the subtitle of the book is *Complete Performance Works and Selected Writings*. But the book is not a complete compendium of her performances: missing, among other very interesting performances, is *Aggression for Couples* (1972), a private action she did in London in 1972 with filmmaker Anthony McCall. Photographs from this action are included in *Correspondence Course*.

22. Feminism had entered the mainstream. The sexual revolution had gone sour. Drug experimentation had hardened into cocaine and heroin addiction. Hippie love had turned to the rancor of punk. The arms race had escalated. The United States had been humiliated as morally corrupt and had lost the Vietnam War. Schneemann herself had been divorced and remarried, and, she—like her times—had changed.

23. Part of the explanation for why so many artists associated with performance and other aspects of live art have resorted to writing is that criticism and art history have been so slow to acknowledge, understand, and theorize this genre of visual art.

24. See Ron Silliman's superb essay "Who Speaks: Ventriloquism and the Self in the Poetry Reading," in *Close Listening: Poetry and the Performed Word,* ed. Charles Bernstein (New York: Oxford University Press, 1998), 369.

25. She pointed out, in a telephone conversation with me on August 1, 1999, that she always tries "to obliterate a self" in her work.

26. Paul Ferris, introduction to *Dylan Thomas: The Collected Letters* (New York: Macmillan, 1985), ix.

27. Ibid.

28. Ibid., xv.

29. Ibid.

30. This is the name that she—and several other artists of her generation, most notably the French poet and pioneer of happenings, Jean-Jacques Lebel—give to the small group of visual artists, composers, and dancers who, in the late 1950s and early 1960s, forged the medium now called performance art.

31. I have not included such letters in this collection because of the length of the book. But in them one has the opportunity to observe the process of her self-restraint. I leave these letters for future scholars, in the hopes that a careful examination of her editorial process will be undertaken in relation to the equally careful polish of her art, which sometimes has been erroneously dismissed as messy and undisciplined.

32. Ferris, introduction to *Dylan Thomas*, xi.

33. Nigel Nicolson and Joanne Trautmann, eds., *The Letters of Virginia Woolf,* vol. 6, *1936–1941* (New York: Harcourt Brace Jovanovich, 1980), xii.

34. Linda Nochlin, "Why Have There Been No Great Women Artists?" in E. Baker and T. Hess, *Art and Sexual Politics* (New York: Macmillan, 1973), reprinted in *Women, Art, and Power and Other Essays* (New York: Harper & Row, 1988), 145–78.

35. Ibid., 149.

36. Ibid., 155.

37. Ibid., 154–55.

38. Among artists who immediately come to mind who have written about their decision not to bear children in order to practice art are Mary Cassatt, Eva Hesse, Harriet Hosmer, and Georgia O'Keeffe. In this regard, it is also interesting to note that in Schneemann's correspondence, there are few love letters (though perhaps she has not made all her correspondence public, even to me). The few letters between the artist and her first husband, the experimental composer James Tenney, are especially poignant and full of mutual interdependence and longing to be together whenever apart. These letters also chronicle both the torturous role that abortions and her refusal to bear children played in their lives before *Roe v. Wade,* as well as the grievous end of their intimate relationship (even while the couple remained close friends).

39. I discuss the issue of Schneemann's breaches of socially prescribed decorum in "Schlaget Auf: The Problem with Carolee Schneemann's Paintings," in *Carolee Schneemann: Up to and Including Her Limits,* exhib. cat. (New York: New Museum, 1996), 15–25. A good example of the kind of exaggerated description of Schneemann's work is a description of *Meat Joy* as an "orgy like dance program," to which "Carolee Schneemann was drawing sellout crowds." See Jerry Hopkins, *Yoko Ono* (New York: Macmillan, 1986), 47.

40. Dick Higgins to Carolee Schneemann, March 10, 1981.

41. I discussed the "apple/stem" problem in "Debate: The Empty Slogan of Self-Representation," *Siksi* [Helsinki] 12, no. 1 (1997): 87–90, and in "Never Enough Is Something Else: Feminist Performance Art, Probity, and the Avant-Garde," forthcoming in *Avant-Garde Performance, Textuality and the*

Limits of Literary History, ed. James M. Harding (Madison: University of Wisconsin Press, 2000), 239–89.

42. As Nochlin so brilliantly pointed out in "Why Have There Been No Great Women Artists?" the conditions for the production and reception of "great art" have made it nearly impossible for women to achieve. Schneemann certainly has made art in a period when it was relatively easy to study such things as the nude figure. I say "relatively" because a fascinating letter included in *Correspondence Course* describes how Tenney did not want Schneemann to model nude for her painting class, even though she insisted that all her fellow students take turns doing so.

43. The work of such artists as John Cage and Andy Warhol had already shown in the 1960s that such a goal was elusive, if not impossible, as silence and appropriation came to signify their individual styles.

EPILOGUE

MARK MAKING, WRITING, AND ERASURE

SARAH E. WEBB

In the thirty years since Linda Nochlin asked why there have been no great women artists, feminists have successfully sought to reverse traditional modes of art historical thinking. The work of women artists is now documented in monographs and institutionally collected and displayed. The contributions of feminist scholarship have created a space for a collection of readings like *Singular Women*. Yet, as Griselda Pollock posited, although there are *famous* women artists, "a careful analysis of their status will find that they are not canonical—providing a benchmark for greatness. They are rather notorious, sensational, commodifiable or token, and will be as virulently attacked as they are lovingly adored."[1] What is the implicit difference between canonical exaltation and exploitation, and does either interpretation permit an artist's work to be seen objectively? This book offers, not another exercise in retrieving the artist who is also a woman, but a rethinking of the site of her inscription—the monograph. How are her notations, her works, recorded, valued, made visible, qualified, or erased? Whose memory will be preserved and bear witness?

What follows, from my position as a (younger) artist, is a meditation on writing and erasure. It is intended to renew the dialogue between artist and scholar and thus to promote a continued exploration of the work made by the woman artist. In this epilogue I celebrate both

the artists and scholars whose voices compose this book and who make themselves visible, in both writings and artworks, through their words, their gestures, and their approaches to mark making. By extension, I urge collaboration between authors and artists, interpreting the authors as writers/right-ers of the artists. With their different voices and theoretical concerns, the contributors to *Singular Women* have taken up Toril Moi's question, "Must women reading women's texts take up the old, respectfully subordinate stance in relation to the author?"[2] Fortunately, their collective answer is no. This book acknowledges different approaches to mark making and creates a space for the convergence of authors' and artists' voices. Two works of art created by artists not included in this volume, Louise Bourgeois and Francesca Woodman, provide a tangible reminder that this text only begins to consider scholarly writing on the artwork of women. Bourgeois's sculpture *Destruction of the Father* (1974) and a photograph from Woodman's series *Space*2 (1975–76) may be viewed as visual tropes for interpreting a woman's work, and particularly the ways it can be simultaneously seen and silenced.

FATHER TIME: (M)OTHER TIME

Louise Bourgeois (b. 1911) describes her sculpture *The Destruction of the Father* (Figure 23) as follows:

> It is basically a table, the awful, terrifying family dinner table headed by the father who sits and gloats. And the others, the wife, the children, what can they do? They sit there, in silence. The mother of course tries to satisfy the tyrant, her husband. The children are full of exasperation. We were three children: my brother, my sister and myself. My father would get nervous looking at us, and he would explain to all of us what a great man he was. So, in exasperation, we grabbed the man, threw him on the table, dismembered him, and proceeded to devour him.[3]

Childhood memories and experiences often inspire Bourgeois's work. In this case, the subject is her father, a man who invited his mistress to live in the family home under the guise of children's tutor, an authoritative figure who enjoyed the act of entertaining, often at the expense of his family—in particular, his children. *The Destruction of the Father* revisits childhood trauma, but this time Bourgeois is in control as she rewrites the

23. Louise Bourgeois, *The Destruction of the Father*, 1974,
latex and stone

outcome of the meal. The artist (and daughter) makes the previously silent bodies at the table speak. While as sculpture the work is abstract, the viewer cannot escape the essential, uncomfortable reference of the forms as teeth in the art of a violent consumption. Bourgeois implicates her own father in her work. However, by extension can this "father" be read as traditional patriarchy and her sculpture thus be interpreted as a direct attack against a patriarchal version of (art) history? Kristen Frederickson's introduction prompts us to recall a version of art history taught by one father, H. W. Janson, and its silencing of women artists.

I find myself returning to Carol Mavor and her discussion of women's time, as defined by Julia Kristeva, and yearn for its gestational, repetitive cycles as a unique approach to seeing/recording beyond the monumental, linear moments encoded by the father.[4] Collectively, as readers, we have been deprived of the works of women artists by numerous acts of silencing. Their works are excluded from the canon, deaccessioned from institutional collections (or destroyed) or denied admission at all, their autobiographies unpublished, their journal entries ravaged. What we know of their stories, most of them unrecorded, suggests that while each woman's life is singular, they shared

the trauma of work encoded, but also erased, generation to generation, artist to author, mother to daughter. Although as editors of this book Kristen Frederickson and I have taken a traditional chronological approach to the artists included, our focus is to expose specific moments, or junctures, that have illuminated the complexity of vision necessary to the interpretation of the woman artist's story.

In her essay on the work of Clementina Hawarden and Sally Mann, Carol Mavor notes that mothers, as makers of children, are always in a state of almost being missed. By extension, so too are women as makers of art. Their work seems to be in a state of precarious, subterranean, existence—not entirely visible to the father, and capable of being missed either intentionally or accidentally. What threat does its inclusion pose to the father? Mary Sheriff writes that perhaps in the artwork of women "the father's paternity is doubly usurped, as the mother—both in her womb and her (art)work—creates her child, her daughter, her simulacr[um], through her imaginative power."[5] Deliciously, I imagine the facial expression of Louise Bourgeois's nervous father as he heads to the table for the last time.

Catherine Soussloff has challenged the myth (and its construction) of the artist-genius. She quotes Thomas Heffernan's assertion in his work on the sacred biographies of saints that such "texts have their beginnings not in the act of composition but in a complex series of anticipations."[6] Assuming what is to be discovered, art historians shape their search accordingly. Linear chronologies are constructed, pinnacles distinguished. Time is noted through the (patriarchal) eyes of the father. But what if because of complications related to gender, institutional biases, or an artist's material approaches, her life cannot be measured in such terms? Will that artist's singular accomplishments still be recorded, or will they be excised from the historical record?

Does the monograph as an art historical genre perpetuate the myth of the artist as genius and thus historically exclude the work of the "woman artist," as she is always called?[7] Is the monograph even a meaningful format for presenting the work and lives of women? Must it be destroyed, as the ultimate marker of Father Time? Or can we return to the table and rethink the monograph, developing its potential as an alternative curatorial space?

The photographic series *Space²* (Figure 24) by Francesca Woodman (1958–81) highlights the potential complications of encoding the work of women artists in the monograph. Woodman made most of her pho-

24. Francesca Woodman, from *Space²*, 1975–76, silver print

tographs while she was a student at the Rhode Island School of Design. Many began as class assignments inherent in the traditional institutional training of the artist. Rosalind Krauss hypothesizes that in *Space²* Woodman intended to "define a particular space by emphasizing its character, its geometries."[8] Woodman's solution, characteristic of all of her work, was to make a type of self-portrait; she climbed in and physically encased herself in a museum vitrine. As viewers, we encounter and scrutinize her body as an object of display. We see Woodman's left breast and thigh pressed against the glass as she squats. The viewers look down from a position that effectively intensifies the sense

of claustrophobia but also distance. Her head, moreover, appears cut from her torso as she stoops to avert our gaze.

The ambiguous gestures of Woodman's body, further accentuated by the intentional camera blur, are reminiscent of Charcot's images of hysterical women. The viewer is forced to ask, Is she trying to escape, to speak, only to be silenced by the cold, solid structure? Is Francesca Woodman like the hysteric, a spectacle, or does she represent herself discursively as a "speaking body,"[9] defying the grammar of patriarchy? Speaking of his own work, and not that of Woodman, the conceptual artist Christian Boltanski remarked that every time you put an object into a case you preserve it but effectively kill it as well.[10] The artwork, and by extension the artist, is interpreted through the glass box. Is the monographic format, as a single-subject study, also guilty of such treatment, and does it do an injustice to the woman artist?

I cannot deny that my initial awareness of Francesca Woodman's art was filtered through the details of her life. That is, her work was first presented to me when I was an M.F.A. candidate as that of a "romantic artist," one whose potential was tragically curtailed by untimely suicide.[11] Why do these sumptuous, mythic details of her life tantalize so many art historians and lead them to her work? The work of Francesca Woodman is fused to that of Frida Kahlo and Ana Mendieta; their bodies of work have been defined by their own physicality and use of self as medium, interpreted largely through the tropes of autobiography. Why does the body, specifically the female body, overwhelm the body of work?[12] I want to see Woodman's work, like Kahlo's and Mendieta's, as distinguishable from the circumstances of her death. For it is the primacy of her work that fascinates me as a visible trace of her existence, rather than an insistence upon her death and her absence.

Was Francesca Woodman trying to escape her glass box, or was she trying to maintain her balance within the structure? While her right hand exerts pressure against the vitrine, her left seems to caress the form or, by extension, her body imprisoned within. Perhaps the art historian writing the woman artist has a similarly ambivalent attitude toward the monograph, simultaneously wishing to escape the structure but also desiring to remain inside it. For better or worse, its familiar life-and-letters approach has given us a way to encode and recognize an artist's singularity. *Space*² reads as a visual paradigm of both the woman artist and the art historian—one that acknowledges (with self-

awareness) the implications of placing oneself in a predefined structure, whether display case, monograph, or canon. But how to proceed? As we have read, Barbara Bloemink and Kristine Stiles have reached similar conclusions on the need to investigate the artist in her original historical context. Kristine Stiles writes that "no matter how self-critical art history becomes as a discipline, with ever more complex theories applied to the practices and institutions of art, some basic chronological groundwork is necessary as preparation for building a structure of criticism." If the function of the monograph is to refocus our gaze on an artist's body of work, to understand it within its social-historical context, then the form is still valid. As the monograph has developed, however, it is organized, not around the artist's works, but around his or her life. For the female artist, it is a life disproportionately represented in relationship to men—either validating, or proposing, a male "genius" as the recognizer of her talent, or stressing her achievements despite her "lack" of masculinity. And what happens when women are added to the canon as "equivalents" to men, like ingredients in a recipe substituting one for the other, butter for margarine—the female Frans Hals, Caravaggio, or David? The yield is not necessarily the same.

As the authors collected in this book have argued, women artists need to help (re)make the monograph as a site for their work: to make visible what institutions fail to collect and display. We remember both Jo Nivison Hopper's generous bequest of her own and her husband's work to the Whitney Museum and the fact that the institution retained only three of her paintings for their permanent collection—a few minor pieces that managed to pass as Edward Hopper's. Of course, none of these have been published, exhibited, or even accessioned as her work. Similarly, although Florine Stettheimer steadfastly refused to sell her work during her lifetime and thus retained control over her output, when she died her relatives indiscriminately scattered her work to collections throughout the country. Like Gail Levin, Bloemink describes her painful discovery of these works in various states of disrepair and neglect.

The performative nature of Carolee Schneemann's oeuvre, and thus the difficulty of procuring objects, still the mainstay of museums, further complicates the material collecting of her work. Despite her profound influence on the field of body and performance art, Schneemann has only two pieces in museum collections and has been given only one solo museum exhibition to date. But does increased (institutional) vis-

ibility lead to increased power?[13] Arguably, performance art is often in-tended to question and to erode the patriarchal privilege of museum collecting. Yet because her work remains "uncollectable," Schneemann has been compelled to make salable objects to support herself and her (uncollectable) performance pieces.

Schneemann's situation is further complicated by her insistence upon using her own body, and bodily fluids, as medium. Her perfor-mance pieces are not only uncollectable but often interpreted as un-clean, messy. As the anthropologist Mary Douglas cautions, "Where there is dirt there is a system. Dirt is the by-product of a systematic or-dering and classification of matter, in so far as ordering involves re-jecting inappropriate elements."[14] Although the rejection of Schnee-mann has been extreme, Douglas's observation also has relevance to the (in)visibility of women artists—past, present, future. Where there is dirt there is a system, and traditional art history (as a system) has re-jected the woman artist as the inappropriate element.

Museum practice and the exhibition (as a site of display) privilege a commodifiable, seamless version of art history—the canon that we have been taught. Susan Stewart remarked that "within the develop-ment of culture under an exchange economy, the search for authentic experience and, correlatively, the search for the authentic object be-comes critical."[15] Museums have established themselves as repositories of cultural artifacts—objects collected, preserved, and by implication revered. As the museum has developed, institutional hierarchies have emerged so that one culture, one style, indeed one gender, has been val-ued over another.

Analyzing the work museums have excluded can be as telling as studying the works they included. Who defines the authenticity of a work of art, the legitimacy of its claims on historical remembrance? It appears that an individual artist's sustained visibility depends in part on the ease with which that artist can be inserted into the discursive history of art. Women artists whose work fits surreptitiously into one of the pedagogically useful "isms" are more likely to be accepted into the canon. Conversely, artists whose work disrupts those "isms," crosses boundaries to fit several "isms," or resists such categorization altogether are less likely to be absorbed by even the expanding canon.

Where can we create a space to exhibit the many works that do not adhere to the tenets privileged through patriarchy? Just over ten years ago, in the first edition of *Women, Art, and Society,* Whitney Chadwick

wrote that "feminism cannot be integrated into the existing structures of art history because [it] leaves intact the categories which have excluded women from cultural significance."[16] Therefore much will continue to be lost by trying to place women artists within a male-defined mold. However, can we recast that mold? The only possible inscription for many of the artists in this book would be a text, simply because the work—whether as object or performance—has ceased to exist. In truth, it would be difficult to find traditional publishers to champion such writing.[17] We need only turn to Amy Schlegel's essay, in which she addresses the methodologies for framing the work of Nancy Spero while conceding their potential drawbacks. Rethinking such a structural approach to cataloguing and exhibiting an artist's oeuvre is not only long past due but essential if (feminist) art historians are not to be forever relegated to the act of excavating the past.

Rethinking the monograph might also expose how the art historian chooses what (and how) objects are made visible. Such a dynamic happens in this book in the essays of Carol Mavor and Anne Higonnet and their respective discussions of Lady Clementina Hawarden and Mary Cassatt. Both return to the question: If images must be inscribed by the father, what images will be missed? For Mavor and Higonnet, the historically visible images of these artists are those containing elements of the maternal: Hawarden's photographs of her daughters, Cassatt's ceaseless repertoire of Modern Madonnas. While both authors have previously published their extensive research on maternal representation, in this book they refocus their discussion and with self-awareness reveal what guided their approach to each artist's specific visions. Mavor reveals why she intentionally "missed" Hawarden's landscapes in her book *Becoming: The Photographs of Clementina, Viscountess Hawarden.* Higonnet exposes the inherent contradictions of reading Mary Cassatt and her images within both an "art" and a "historical" context. Relying on the methodologies of both art history and visual culture, Mavor and Higonnet open doors for future scholars who might rethink not only Hawarden and Cassatt but also many artists whose work has been inscribed through a gendered approach to subject matter.

But now, a confession. As much as I have been advocating the monograph as a site for exhibiting (indeed curating) an artist's work, I admit that I still yearn for the details of an artist's life. My desire stems from a longing, not to filter work through autobiography, but to dis-

cover means to make my own work more visible. I search for mentors, for models. Perhaps it is because the discipline of neither art history nor studio production explicitly binds or defines my approach to making work that I continue to look somewhere between the two disciplines. But that leaves me without a clear identity, or at least with an inability to name myself. Am I an artist, a writer? Repeatedly I have been told that I cannot be both.

I find myself questioning the validity of such a statement, however, for is an artist not a cultural critic, a thoughtful scholar, a provocative performer? Why insist on reading an individual's merits according to labels and positions? In academia, one can see the physical separation of departments labeled art and art history, which are sometimes not even housed in the same buildings, as if they mutually excluded rather than informed each other. Why must the roles of artist and scholar be construed as separate entities? To be inscribed as an artist, must an individual erase all other markers? It is clear to me that my identities inform each other, indeed could not exist independent of each other. Through text, image, and object, my work makes visible what is ordinarily not seen—presenting an erased presence, exposing absence. I create in order to question the inherent historical encoding of what has been defined as the woman's place. These concerns are reflected not only in the physicality of my studio production but also in my writings on how the work of women artists is seen at all. I wonder what trace will remain of my work as an artist, a writer, a woman?

Being an artist involves a certain self-conscious (romantic) conditioning and internalizing of Western cultural values, which have been defined by patriarchal terms that give precedence to the notion of solitary genius. Whether it is possible, if one were even to want to mold oneself according to those values, is a different question altogether. Yet the question is one that bonds the women artists discussed in this book. I think back to Irene Rice Pereira's "Eastward Journey," the artist's authoritative statement about her life and work that she hoped would ensure her historical place. But as her biographer, Karen Bearor, cautions, Pereira knew that she herself was constructing a "Pereira" in accordance with her own needs. How must the woman artist see herself before she is made visible to others?

The contributors to *Singular Women* suggest new approaches to making the work of both artist and author visible by expanding our concept of the monograph. Paramount to such a revision in feminist

historiography is the development of the relationship between artist as maker of objects and art historian as scribe. Such a "relationship" is not limited to those who are contemporaries; it can also develop intergenerationally as the art historian revisits the original site of an artist's studio production. As I have argued, it is imperative that we not view these two professions as mutually exclusive, for both artists and art historians create and perform, working in tandem to make visible the contributions of women both as text and as image.

Only by writing in collaboration can the artist and the art historian right the woman artist so that her marks are not erased. I am drawn back to this passage from Carolee Schneemann in Kristine Stiles's essay: "All my writing has been implicitly or—more recently—explicitly addressed to unknown 'young women artists,' which has been a persistent and desperate need on my part, to serve as possible precedent since my own [role models] were a private company of suicided or demeaned historical women." Schneemann's letters are as important to future art historians as to practicing artists whose work has yet to be seen and recorded. Visual marks are made and letters written to be interpreted as much through the act of reading/readings as through the original act of artistic creation itself. It is a story of mutual dependence between text and image knitting these "singular women" and those beyond the pages of this book.

NOTES

1. See Griselda Pollock, *Differencing the Canon: Feminist Desire and the Writing of Art's Histories* (New York: Routledge, 1999), 9, for a more complete discussion of the (art historical) canon and feminist inscription.

2. Toril Moi, *Sexual/Textual Politics: Feminist Literary Theory* (New York: Routledge, 1985), 31.

3. Jean Frémon, *Louise Bourgeois: Retrospective 1947–1984*, exhib. cat. (Paris: Galerie Maeght Lelong, 1984), quoted in Mignon Nixon, "Bad Enough Mothers," *October* 71 (Winter 1995): 74.

4. Julia Kristeva, "Women's Time," in *Feminist Theory: A Critique of Ideology*, ed. Nannerl O. Keohane, Michelle Z. Rosaldo, and Barbara C. Gelpi (Chicago: University of Chicago Press, 1996), 31–53.

5. Mary D. Sheriff, *An Exceptional Woman: Elisabeth Vigée-Lebrun and the Cultural Politics of Art* (Chicago: University of Chicago Press, 1996), 50.

6. Thomas J. Heffernan, *Sacred Biography: Saints and Their Biographers in the Middle Ages* (New York: Oxford University Press, 1988), 18, quoted in Catherine Soussloff, *The Absolute Artist* (Minneapolis: University of Min-

nesota Press, 1997), 13. Kristen and I are grateful to Catherine for her early support of this writing project

7. Soussloff, *The Absolute Artist*, 4. For a valuable (early) discussion on this topic, refer to Christine Battersby, *Gender and Genius: Towards a Feminist Aesthetics* (Bloomington: Indiana University Press, 1989).

8. Rosalind Krauss, *Bachelors* (Cambridge, Mass.: MIT Press, 1999), 162.

9. See Stephen Heath's remarks in "Difference," *Screen* 19 (Autumn 1978): 51–112.

10. Lynn Gumpert, *Christian Boltanski* (Paris: Flammarion, 1994). See section ii, "The Early Work," for a complete discussion of Boltanski's working method and approach to materials.

11. Francesca Woodman committed suicide just before her twenty-third birthday.

12. Carolee Schneemann asked this very question of the audience when she was presented with a life achievement award for her work at College Art Association 2000 Conference by the Committee for Women in the Arts.

13. For a more complete discussion, refer to Peggy Phelan, *Unmarked: The Politics of Performance* (New York: Routledge, 1993).

14. Mary Douglas, *Purity and Danger: An Analysis of the Concepts of Pollution and Taboo* (New York: Routledge, 1966), 36.

15. Susan Stewart, *On Longing: Narratives of the Miniature, the Gigantic, the Souvenir, the Collection* (Baltimore: Johns Hopkins University Press, 1984), 133.

16. Whitney Chadwick, *Women, Art, and Society* (New York: Thames and Hudson, 1990), 12. *Women, Art, and Society* continues to be updated and is now in its third edition.

17. Perhaps electronic publishing and the World Wide Web will be the site for such an endeavor. For a provocative discussion of Martha Wilson's experience of turning Franklin's Furnace into a virtual exhibition space, see her article "Going Virtual," *Art Journal* 59, no. 2 (Summer 2000): 102–10.

BIBLIOGRAPHY

Adams, Timothy Dow. *Telling Lies in Modern American Autobiography.* Chapel Hill: University of North Carolina Press, 1990.

Agrest, Diana, Patricia Conway, and Leslie Kanes Weisman, eds. *The Sex of Architecture.* New York: Harry N. Abrams, 1996.

Ashley, Kathleen, Leigh Gilmore, and Gerald Peters, eds. *Autobiography and Postmodernism.* Amherst: University of Massachusetts Press, 1994.

Barthes, Roland. "The Death of the Author." In *Image, Music, Text,* translated by Stephen Heath, 142–48. New York: Hill and Wang, 1977.

Bashkirtseff, Marie. *The Journal of Marie Bashkirtseff.* With a new introduction by Rozsika Parker and Griselda Pollock. London: Virago, 1985.

Battersby, Christine. *Gender and Genius: Towards a Feminist Aesthetics.* Bloomington: Indiana University Press, 1989.

Baur, John I. H. *Revolution and Tradition in American Art.* Cambridge, Mass.: Harvard University Press, 1951.

Bearor, Karen A. *Irene Rice Pereira: Her Paintings and Philosophy.* Austin: University of Texas Press, 1993.

———. *Irene Rice Pereira's Early Work: Embarking on an Eastward Journey.* Coral Gables, Fla.: Lowe Art Museum, University of Miami, 1994.

Beauvoir, Simone de. *The Second Sex.* Translated and edited by H. M. Parshley. New York: Vintage Books, 1989.

Bernadac, Marie-Laure, and Hans-Ulrich Obrist. *Louise Bourgeois: Destruction of the Father, Reconstruction of the Father: Writings and Interviews 1923–1997.* Cambridge, Mass.: MIT Press, 1998.

Betteron, Rosemary. *Looking On: Images of Femininity in the Visual Arts and Media.* New York: Pandora, 1987.

Bird, Jon, Jo Anna Isaak, and Sylvère Lotringer. *Nancy Spero*. London: Phaidon, 1996.

Blocker, Jane. *Where Is Ana Mendieta? Identity, Performativity and Exile*. Durham, N.C.: Duke University Press, 1999.

Bloemink, Barbara J. *Friends and Family: Portraiture in the World of Florine Stettheimer*. Katonah, N.Y.: Katonah Museum of Art, 1993.

——— *The Life and Art of Florine Stettheimer*. New Haven, Conn.: Yale University Press, 1995.

Bloemink, Barbara J., and Elizabeth Sussman. *Florine Stettheimer, Manhattan Fantastica*. New York: Whitney Museum of American Art, 1995.

Boutelle, Sara Holmes. *Julia Morgan, Architect*. New York: Abbeville Press, 1988.

Brenson, Michael. "Elizabeth Catlett's Sculptural Aesthetics," in *Elizabeth Catlett Sculpture: A Fifty Year Retrospective*, exhibition catalogue. Purchase: Neuberger Museum of Art, Purchase College, State University of New York, 1998.

Broude, Norma, and Mary D. Garrard, eds. *The Expanding Discourse: Feminism and Art History*. New York: IconEditions, 1992.

———, eds. *Feminism and Art History: Questioning the Litany*. New York: Harper & Row, 1982.

———, eds. *The Power of Feminist Art: The American Movement of the 1970s, History and Impact*. New York: Harry N. Abrams, 1994.

Butler, Judith. *Bodies That Matter: On the Discursive Limits of "Sex."* New York: Routledge, 1993.

———. *Gender Trouble: Feminism and the Subversion of Identity*. New York: Routledge, 1990.

Carolee Schneemann: Up to and Including Her Limits. Exhibition catalogue. New York: New Museum, 1977.

Catlett, Elizabeth. *A Courtyard Apart: The Art of Elizabeth Catlett and Francisco Mora*. Biloxi, Miss.: Mississippi Museum of Art, 1990.

Chadwick, Whitney. *Women, Art, and Society*. Rev. ed. New York: Thames and Hudson, 1997.

Chadwick, Whitney, and Isabelle de Courtivron, eds. *Significant Others: Creativity and Intimate Partnership*. New York: Thames and Hudson, 1993.

Champagne, Leonora, ed. *Out from Under: Texts by Women Performance Artists*. New York: Theatre Communications Group, 1990.

Chandès, Hervé, ed. *Francesca Woodman*. Translated by Rana Dasgupta. New York: Fondation Cartier pour l'art contemporain, 1998.

Cherry, Deborah. *Painting Women: Victorian Women Artists*. New York: Routledge, 1993.

Chesler, Phyllis. *Women and Madness*. New York: Doubleday, 1972.

Chicago, Judy. *Beyond the Flower: The Autobiography of a Feminist Artist*. New York: Penguin, 1996.

Christie, J. R. R., and Fred Orton. "Writing on a Text of the Life." *Art History* 11 (December 1988): 558–60.

Cole, Doris. *Eleanor Raymond, Architect.* Philadelphia: Art Alliance Press, 1981.

Coleman, Debra, Elizabeth Danze, and Carol Henderson. *Architecture and Feminism.* New York: Princeton Architectural Press, 1996.

Collins, Patricia Hill. *Black Feminist Thought: Knowledge, Consciousness, and the Politics of Empowerment.* New York: Routledge, 1991.

———. "The Social Construction of Black Feminist Thought." *Signs: Journal of Women in Culture and Society* 14 (1989): 745–73.

Colomina, Beatrix, ed. *Sexuality and Space.* New York: Princeton Architectural Press, 1992.

Crimp, Douglas. *On the Museum's Ruins.* Cambridge, Mass.: MIT Press, 1993.

Culley, Margo, ed. *American Women's Autobiography: Fea(s)ts of Memory.* Madison: University of Wisconsin Press, 1992.

Dorsey, Peter A. *Sacred Estrangement: The Rhetoric of Conversion in Modern American Autobiography.* University Park: Pennsylvania State University Press, 1993.

Duncan, Carol. "Domination and Virility in Vanguard Painting." In *Feminism and Art History: Questioning the Litany,* edited by Norma Broude and Mary D. Garrard, 293–314. New York: Harper & Row, 1982.

Dunford, Penny. *A Biographical Dictionary of Women Artists in Europe and America since 1850.* Philadelphia: University of Pennsylvania Press, 1989.

Elizabeth Catlett Sculpture: A Fifty-Year Retrospective. Exhibition catalogue. Purchase: Museum of Art, Purchase College, State University of New York, 1998.

Elton, Fax. *Seventeen Black Artists.* New York: Dodd, Mead, 1971.

Fallaize, Elizabeth. *Simone de Beauvoir: A Critical Reader.* New York: Routledge, 1998.

Faludi, Susan. *Backlash: The Undeclared War against American Women.* New York: Crown, 1991.

Felman, Shoshona. *What Does a Woman Want? Reading and Sexual Difference.* Baltimore: Johns Hopkins University Press, 1993.

Ferrero, Pat, Elaine Hedges, and Julie Silber. *Hearts and Hands: The Influence of Women and Quilts on American Society.* San Francisco: Quilt Digest Press, 1987.

Finch, Lucine. "A Sermon in Patchwork." *Outlook Magazine,* October 28, 1914, 493–95.

Fine, Elsa Honig. *The Afro-American Artist: A Search for Identity.* New York: Holt, Rinehart and Winston, 1973.

Fraisse, Genevieve. *La raison des femmes.* Paris: Plon, 1992.

Frederickson, Kristen. "Anna Semyonovna Golubkina: Sculptor of Russian Modernism." *Woman's Art Journal* 18, no. 1 (1997).

Friedman, Alice. *Women and the Making of the Modern House: A Social and Architectural History.* New York: Harry N. Abrams, 1998.

Fry, Gladys-Marie. "Harriet Powers, Portrait of an African-American Quilter." In *Missing Pieces: Georgia Folk Art, 1770–1976.* Atlanta: Georgia Council for the Arts, 1976.

———. *Stitched from the Soul: Slave Quilts from the Ante-Bellum South.* New York: Dutton Studio Books and the Museum of American Folk Art, 1990.

Garrard, Mary. *Artemisia Gentileschi: The Image of the Female Hero in Italian Baroque Art.* Princeton, N.J.: Princeton University Press, 1989.

———. *Artemisia Gentileschi around 1622: The Shaping and Reshaping of an Artistic Identity.* Berkeley: University of California Press, 2001.

———. "Artemisia Gentileschi's *Self Portrait as the Allegory of Painting.*" *Art Bulletin* 62 (March 1980): 97–112.

Gornick, Vivian, and Barbara K. Moran, eds. *Woman in Sexist Society: Studies in Power and Powerlessness.* New York: New American Library, 1981.

Greenacre, Phyllis. "Woman as Artist." *Psychoanalytic Quarterly* 29 (1960): 208–27.

Grossman, Elizabeth G., and Lisa B. Reitzes. "Caught in the Crossfire: Women and Architectural Education, 1880–1910." In *Architecture: A Place for Women,* ed. Ellen Perry Berkeley, 27–39. Washington, D.C.: Smithsonian Institution Press, 1989.

Harris, Anne Sutherland, and Linda Nochlin. *Women Artists 1550–1950.* Los Angeles, Los Angeles County Museum of Art, 1976.

Heilbrun, Carolyn. *Writing a Woman's Life.* New York: Ballantine Books, 1988.

Helm, W. H. *Vigée-Lebrun, 1755–1842: Her Life, Work, and Friendships.* Boston: Small Maynard, 1915.

Herzog, Melanie. *Elizabeth Catlett: An American Artist in Mexico.* Seattle: University of Washington Press, 2000.

Higonnet, Anne. *Berthe Morisot.* New York: Harper and Row, 1990.

———. *Berthe Morisot's Images of Women.* Cambridge, Mass.: Harvard University Press, 1992.

———. *Picture of Innocence: The History and Crisis of Ideal Childhood.* New York: Thames and Hudson, 1998.

Hofrichter, Frima Fox. "The Eclipse of a Leading Star." In *Judith Leyster: A Dutch Master and Her World,* exhibition catalogue, 115–22. Worcester, England: Worcester Art Museum, 1993.

———. "Games People Play: Judith Leyster's *A Game of Tric-Trac,*" *Worcester Art Museum Journal* 7 (1983–84): 19–27.

———. *Judith Leyster: A Woman Painter in Holland's Golden Age.* Doornspijk, the Netherlands: Davaco, 1989.

———. "Judith Leyster's *Proposition:* Between Virtue and Vice." *Feminist Art Journal* 4 (1975): 22–26. Reprinted in *Feminism and Art History,* edited by Norma Broude and Mary Garrard, 173–81. New York: Harper & Row, 1982.

———. "Judith Leyster's *Self-Portrait: Ut Pictura Poesis.*" In *Essays in Northern European Art Presented to Egbert Haverkamp Begemann on His Sixtieth Birthday,* 106–9. Doornspijk, the Netherlands: Davaco, 1983.

Hole, Judith, and Ellen Levine. *Rebirth of Feminism*. New York: Quadrangle Books, 1971.

hooks, bell. *Art on My Mind: Visual Politics*. New York: New Press, 1995.

Hunt, Lynn, ed. *Eroticism and the Body Politic*. Baltimore: Johns Hopkins University Press, 1991.

Irigarary, Luce. *Speculum of the Other Woman*. Ithaca, N.Y.: Cornell University Press, 1985.

Janson, H. W. *The History of Art: A Survey of the Major Visual Arts from the Dawn of History to the Present Day*. Englewood Cliffs, N.J.: Prentice-Hall, 1962.

Kerby, Anthony Paul. *Narrative and the Self*. Bloomington: Indiana University Press, 1991.

Krauss, Rosalind. *Bachelors*. Cambridge, Mass.: MIT Press, 1999.

Kristeva, Julia. "Women's Time" in *Feminist Theory: A Critique of Ideology*, edited by Nannerl O. Keohane, Michelle Z. Rosaldo, and Barbara Gelpi, 31–53. Chicago: University of Chicago Press, 1996.

Lang, Gladys Engel, and Kurt Lang. *Etched in Memory: The Building and Survival of Artistic Reputation*. Chapel Hill: University of North Carolina Press, 1990.

Lejeune, Philippe. *On Autobiography*. Translated by Katherine Leary. Minneapolis: University of Minnesota Press, 1989.

Leon, Eli, ed. *Who'd a Thought It: Improvisation in African-American Quiltmaking*. San Francisco: San Francisco Craft & Folk Art Museum, 1987.

Levin, Gail. *Edward Hopper: An Intimate Biography*. New York: Alfred A. Knopf, 1995.

Lewis, Samella. *The Art of Elizabeth Catlett*. Claremont, Calif.: Hancraft Studios, 1984.

Lippard, Lucy R. *Eva Hesse*. New York: New York University Press, 1976; New York: Da Capo Press, 1992.

———. *From the Center: Feminist Essays on Women's Art*. New York: Dutton, 1976.

———. *Mixed Blessings: New Art in a Multicultural America*. New York: Pantheon, 1990; New York: New Press, 2001.

———. *The Pink Glass Swan: Selected Essays on Feminist Art*. New York: New Press, 1995.

Lodge, David, ed. *Modern Criticism and Theory*. Rev. ed. London: Longman, 1999.

Mann, Sally. *Immediate Family*. New York: Aperture, 1992.

Mathews, Nancy Mowll. *Mary Cassatt*. New York: Harry N. Abrams and National Museum of American Art, Smithsonian Institution, 1987.

———. *Mary Cassatt: A Life*. New York: Villard Books, 1994.

———. "Mary Cassatt and the 'Modern Madonna' of the Nineteenth Century." Unpublished Ph.D. dissertation, New York University, 1980.

Mavor, Carol. *Becoming: The Photographs of Clementina, Viscountess Hawarden*. Durham, N.C.: Duke University Press, 1999.

————. *Pleasures Taken: Performances of Sexuality and Loss in Victorian Photographs.* Durham, N.C.: Duke University Press, 1995.

Minh-ha, Trinh T. *Woman Native Other: Writing Postcoloniality and Feminism.* Bloomington: Indiana University Press, 1989.

Mitchell, Claudine. "Intellectuality and Sexuality: Camille Claudel, the Fin de Siècle Sculptress." *Art History* 12 (December 1989): 419–47.

Moi, Toril, ed. *The Kristeva Reader.* New York: Columbia University Press, 1986.

————. *Sexual/Textual Politics: Feminist Literary Theory.* New York: Methuen, 1985.

————. *Simone de Beauvoir: The Making of an Intellectual Woman.* Cambridge, Mass.: Blackwell, 1994.

Nochlin, Linda. "Florine Stettheimer: Rococo Subversive." *Art in America* 68 (September 1980): 64–83. Reprinted in *Women, Art, and Power, and Other Essays,* 109–35. New York: Harper and Row, 1988.

————. *The Politics of Vision: Essays on Nineteenth-Century Art and Society.* New York: Harper & Row, 1989.

————. *Representing Women.* New York: Thames and Hudson, 1999.

————. *Women, Art, and Power and Other Essays.* New York: Harper and Row, 1988.

Olney, James. *Metaphors of Self: The Meaning of Autobiography.* Princeton, N.J.: Princeton University Press, 1992.

Orton, Fred, and Griselda Pollock. *Avant-Gardes and Partisans Reviewed.* New York: Manchester University Press, 1996.

Parker, Rozsika. *The Subversive Stitch: Embroidery and the Making of the Feminine.* London: Women's Press, 1984.

Parker, Rozsika, and Griselda Pollock. *Old Mistresses: Women, Art and Ideology.* New York: Pantheon, 1981.

Peterson, Linda H. "Gender and Autobiographical Form: The Case of the Spiritual Autobiography." In *Studies in Autobiography,* edited by James Olney, 211–22. New York: Oxford University Press, 1988.

————. *Victorian Autobiography: The Tradition of Self-Interpretation.* New Haven, Conn.: Yale University Press, 1986.

Phelan, Peggy. *Unmarked: The Politics of Performance.* New York: Routledge, 1993.

Pollock, Griselda. "Artists, Mythologies and Media Genius, Madness and Art History." *Screen* 21, no. 3 (1980): 58–59, 95.

————. *Differencing the Canon: Feminist Desire and the Writing of Art's Histories.* New York: Routledge, 1999.

————. *Mary Cassatt: Painter of Modern Women.* New York: Thames and Hudson, 1998.

————. *Vision and Difference: Feminism, Femininity and the Histories of Art.* New York: Routledge, 1988.

————, ed. *Generations and Geographies in the Visual Arts: Feminist Readings.* New York: Routledge, 1996.

Prignitz, Helga. *El Taller de Gráfica Popular en México 1937–1977*. Translated by Elizabeth Siefer. Mexico City: Instituto Nacional de Bellas Artes, 1992.

Reckitt, Helena, and Peggy Phelan, eds. *Art and Feminism*. London: Phaidon, 2001.

Robinson, Hilary. *Feminism—Art—Theory: An Anthology 1968–2000*. London: Blackwell, 2001.

Robinson, Sally. *Engendering the Subject: Gender and Self-Representation in Contemporary Women's Fiction*. Albany: State University of New York Press, 1991.

Rosen, Randy. *Making Their Mark: Women Artists Move into the Mainstream 1970–1985*. New York: Abbeville Press, 1989.

Schapiro, Miriam, ed. *Anonymous Was a Woman: A Documentation of the Women's Art Festival, a Collection of Letters to Young Women Artists*. Valencia: Feminist Art Program, California Institute of the Arts, 1974.

Schneemann, Carolee. *More Than Meat Joy: Complete Performance Works and Selected Writings*, edited by Bruce McPherson. New Paltz, N.Y.: Documentexte, 1979.

Sheriff, Mary D. *The Exceptional Woman: Elisabeth Vigée-Lebrun and the Cultural Politics of Art*. Chicago: University of Chicago Press, 1996.

Smith, Sidonie, and Julia Watson, eds. *Women, Autobiography, Theory: A Reader*. Madison: University of Wisconsin Press, 1998.

Solomon, Nanette. "The Art Historical Canon: Sins of Omission." In *EnGendering Knowledge: Feminists in Academe*, edited by Joan E. Hartman and Ellen Messer-Davidow, 222–36. Knoxville: University of Tennessee Press, 1991.

Soussloff, Catherine. *The Absolute Artist*. Minneapolis: University of Minnesota Press, 1997.

Stettheimer, Florine. *Florine Stettheimer: An Exhibition of Paintings, Watercolors, Drawings*. New York: Columbia University Press, 1973.

Stiles, Kristine. *Correspondence Course: Selected Letters of Carolee Schneemann*. Unpublished manuscript.

———. "Unbosoming Lennon: The Politics of Yoko Ono's Experience." *Art Criticism* 7, no. 2 (1992): 21–54.

Tesfagiorgis, Freida High. "Afrofemcentrism and Its Fruition in the Art of Elizabeth Catlett and Faith Ringgold." In *The Expanding Discourse: Feminism and Art History*, edited by Norma Broude and Mary D. Garrard, 475–85. New York: IconEditions, 1992.

Tickner, Lisa. "Feminism, Art History, and Sexual Difference." *Genders* no. 3 (Fall 1988): 92–117.

Tufts, Eleanor. *Our Hidden Heritage: Five Centuries of Women Artists*. New York: Paddington Press, 1974.

University Museums Presents: Elizabeth Catlett: Sculpture and Graphics. Exhibition catalogue. Jackson, Miss.: University of Mississippi Press, 1984.

Van Slyck, Abigail A. "Women in Architecture and the Problems of Biography." *Design Book Review* 25 (Summer 1992): 19.

Vigée-Lebrun, Louise-Elisabeth. *The Memoirs of Elisabeth Vigée-Lebrun.* Translated by Sian Evans. Bloomington: Indiana University Press, 1989.

Wagner, Anne Middleton. *Three Artists (Three Women): Modernism and the Art of Hesse, Krasner, and O'Keeffe.* Berkeley: University of California Press, 1997.

Wallace, Michele, ed. *Faith Ringgold: Twenty Years of Painting, Sculpture and Performance (1963–1983).* New York: Studio Museum in Harlem, 1984.

West, Cornell. *Race Matters.* Boston: Beacon, 1993.

Witzling, Mara R., ed. *Voicing Our Visions: Writings by Women Artists.* New York: Universe Books, 1991.

Woolf, Virginia. *A Room of One's Own.* 1929. New York: Harcourt Brace Jovanovich, 1957.

Zegher, Catherine de, ed. *Inside the Visible: In, of and from the Feminine.* Cambridge: MIT Press, 1996.

Zeidler, Jeanne, ed. *Elizabeth Catlett: Works on Paper, 1944–1992.* Hampton, Va.: Hampton University Museum, 1993.

Zemel, Carol M. *The Formation of a Legend: Van Gogh Criticism, 1890–1920.* Ann Arbor, Mich.: UMI Research Press, 1980.

ABOUT THE CONTRIBUTORS

KAREN A. BEAROR, Associate Professor of Art History, Florida State University, specializes in twentieth-century U.S. art. She is the Chair of the Committee for Women in the Arts of the College Art Association, was the former arts representative on the International Fellowships Awards Panel of the American Association of University Women Educational Foundation, and is currently the Treasurer of the Association of Historians of American Art. She is the author of, among other publications, *Irene Rice Pereira: Her Paintings and Philosophy* (University of Texas Press, 1993) and *Irene Rice Pereira's Early Work: Embarking on an Eastward Journey* (Lowe Art Museum, University of Miami, 1994), the latter associated with an exhibition she curated at the Lowe Art Museum, University of Miami. She is now completing a book entitled *The Design Laboratory: Modernism and Progressive Education on the WPA Federal Art Project.*

BARBARA J. BLOEMINK is the Curatorial Director of the Smithsonian Institution's Cooper-Hewitt, National Design Museum. Formerly, she was Managing Director of the Guggenheim Hermitage and Guggenheim Las Vegas Museums and Chief Curator and Director of the Kemper Museum of Contemporary Art, the Contemporary Art Center of Virginia, and the Hudson River Museum. She has organized over eighty museum exhibitions of modern and contemporary art (including co-curating the Florine Stettheimer retrospective at the Whitney Museum of American Art); has published books on several artists, including Stettheimer, Georgia O'Keeffe, Michael Lucero, James Croak, and Kurt Seligman; and has contributed a chapter on Stettheimer and Marcel Duchamp to the recent anthology *Women in Dada,* edited by Naomi Sawelson-Gorse (MIT Press). She received her doctorate from Yale University.

KRISTEN FREDERICKSON received her Ph.D. from Bryn Mawr College and is owner and director of Kristen Frederickson Contemporary Art in New York

259

City. She has taught art history at Bryn Mawr College, Hunter College, Seton Hall University, the New York Academy of Art, and Christie's Education. She is the author of articles on modern sculptors Camille Claudel and Anna Golubkina, as well as numerous reviews of contemporary art in New York City, and was for three years Chair of the Committee on Women in the Arts of the College Art Association.

GLADYS-MARIE FRY is Professor Emerita of Folklore and English at the University of Maryland. Her books include *Night Riders in Black Folk History* and *Stitched from the Soul: Slave Quilts from the Ante-Bellum South* (New York: Button Studio Books, in association with the Museum of American Folk Art, 1990; reissued by the University of North Carolina Press, fall 2002). Dr. Fry has curated a dozen museum exhibitions at institutions such as the American Folk Art Museum, New York City; Huntsville Museum of Art, Huntsville, Alabama; and both the Renwick Gallery and Anacostia Museum, Smithsonian Institution, Washington, D.C. Her exhibition catalogues include *Man Made: African-American Men and Quilting Traditions; Broken Star: Freedom Quilts Made by Blacks in the Post Civil War South; Black Folk Art in Cleveland;* and *Yes Sir, That's My Baby: African American Artists' Dolls.* She has received major fellowships and grants from, among others, the Guggenheim Foundation, the National Humanities Center, Research Triangle Park in North Carolina, the National Endowment for the Humanities, the National Endowment for the Arts, the Rockefeller Foundation, and Radcliffe's Bunting Institute. Currently, she is a Senior History Consultant for the Smithsonian Institution, Washington, D.C.

MARY D. GARRARD is Professor of Art History at American University, Washington, D.C. She is the author of *Artemisia Gentileschi: The Image of the Female Hero in Italian Baroque Art* (Princeton University Press, 1989) and *Artemisia Gentileschi around 1622: The Shaping and Reshaping of an Artistic Identity* (University of California Press, 2001). With colleague Norma Broude, Garrard edited and contributed to *Feminism and Art History: Questioning the Litany* (Harper and Row, 1982), *The Expanding Discourse: Feminism and Art History* (HarperCollins, IconEditions, 1992), and *The Power of Feminist Art: The American Movement of the 1970s, History and Impact* (Harry N. Abrams, 1994), books that have become basic texts in many art history and women's studies courses in American universities. Garrard is presently completing a book on gender, art, and nature in Renaissance Italy.

NANCY GRUSKIN received her Ph.D. in art history from Boston University. She has taught architectural history at Connecticut College, Tufts University, and the University of Massachusetts–Boston. She is currently writing about streamlining and its relationship to feminine beauty ideals.

MELANIE ANNE HERZOG received her M.F.A. and Ph.D. from the University of Wisconsin–Madison and is Associate Professor of Art History at Edgewood College in Madison, Wisconsin. She has written several exhibition catalogue

essays and articles and is the author of *Elizabeth Catlett: An American Artist in Mexico* (University of Washington Press, 2000).

ANNE HIGONNET is Professor of Art History, Barnard College/Columbia University. She is the author most recently of *Pictures of Innocence: The History and Crisis of Ideal Childhood* (Thames and Hudson, 1998).

FRIMA FOX HOFRICHTER, chair of the History of Art Department at Pratt Institute, New York, received her Ph.D. from Rutgers University with her dissertation on Judith Leyster. She subsequently wrote a monograph on the artist, *Judith Leyster, A Woman Painter in Holland's Golden Age* (Davaco, 1989), and curated the related exhibition, "Haarlem: The Seventeenth Century," at the Zimmerli Art Museum at Rutgers. She also curated "Leonaert Bramer, 1596–1674: A Painter of the Night," Marquette University, and was a major contributor to the Philadelphia Museum of Art's "Ars Medica: Art, Medicine and the Human Condition." She is coauthor (with John Beldon Scott) of *Baroque Visual Culture: A Social History of Art* (forthcoming).

GAIL LEVIN is Professor of Fine and Performing Arts, American Studies, and Art History at Baruch College and the Graduate Center of the City University of New York. She is author of many exhibition catalogues, articles, and books on twentieth-century art, including *Edward Hopper: An Intimate Biography* (Alfred A. Knopf, 1995) and *Edward Hopper: A Catalogue Raisonné* (Norton, 1995). Her most recent book is *Aaron Copland's America: A Cultural Perspective* (Watson-Guptill, 2000).

CAROL MAVOR is Professor of Art at the University of North Carolina at Chapel Hill. She is the author of *Pleasures Taken: Sexuality and Loss in Victorian Photographs* (Duke University Press, 1995) and *Becoming: The Photographs of Clementina, Viscountess Hawarden* (Duke University Press, 1999) and has just completed two new books, *Boyish Labor: J. M. Barrie, Roland Barthes, Jacques Henri Lartigue and Marcel Proust* and *Full* (a novel).

AMY INGRID SCHLEGEL is an art historian and curator of contemporary art based in Philadelphia. She wrote her dissertation on the work of Nancy Spero and has also written on Ilya Kabakov, Komar and Melamid, Barbara Zucker, Sylvia Sleigh, and numerous other artists, some of whom she has invited to exhibit in Philadelphia. Schlegel has also taught art history at the University of Vermont and at Columbia University, where she received her doctorate.

MARY D. SHERIFF is Daniel W. Patterson Distinguished Professor in the Art Department at the University of North Carolina at Chapel Hill. She is the author of *Fragonard: Art and Eroticism* (University of Chicago Press, 1990), *The Exceptional Woman: Elisabeth Vigée-Lebrun and the Cultural Politics of Art* (University of Chicago Press, 1996), and *Moved by Love: Inspired Artists and Deviant Women in Eighteenth-Century France* (forthcoming from the University of Chicago Press). She is also editor of *The Cambridge Companion to Watteau*, forthcoming from Cambridge University Press.

KRISTINE STILES is an artist and Associate Professor of Art and Art History at Duke University. She is internationally recognized for her research and writing on performance and experimental art, and destruction, violence, and trauma in art. She coedited with Peter Selz *Theories and Documents of Contemporary Art* (University of California Press, 1996). Her forthcoming books include *Correspondence Course: Selected Letters of Carolee Schneemann, Uncorrupted Joy: Art Actions, History, and Social Value* (University of California Press), and *Concerning Consequences: Trauma, Survival, and Action in Art.* She received a John Simon Guggenheim Fellowship in 2000 to work on her manuscript "Remembering Invisibility: Documentary Photography of the Nuclear Age." Stiles is the recipient of numerous other grants, including the J. William Fulbright, Foreign Scholar, and she received the Richard K. Lublin Distinguished Award for Teaching Excellence at Duke University in 1994.

SARAH E. WEBB is an artist and Visiting Assistant Professor in the Department of Art and Art History at the University of Rochester in New York. She received her M.F.A. from Visual Studies Workshop, Rochester, New York. Her performance and installation work is exhibited nationally. Webb has curated two national exhibitions on the work of women: "Stories from Her" and "The Female Gaze: Women Look at Men." She has taught critical theory in the Fine Art Photography Program at Rochester Institute of Technology.

INDEX

Adam, Peter, 161
Adams, Timothy Dow, 185–86
Afrofemcentrism, 167
androgyne, 189
architecture: feminist scholarship on, 148. *See also* Raymond, Eleanor Agnes
Artaud, Antonin, 206
art historians: relationship with their subjects, 16, 17, 36–37, 39, 169, 248
art history: black artists in, 164–65; canon of, 2; male and female artists treated differently in, 13–15; rejection of women by, 245. *See also* monographs
art history, feminist: conflict with poststructuralism of, 4–5; dilemmas of, 210–12; first-wave, 204; goals of, 3; origin of, 1–2; second-wave, 205; third-wave, 209
artist-hero, 187, 188
artists: in monograph vs. thematic case study, 201; poststructuralism and, 5; "singular," 203. *See also* women artists
autobiography: Carolee Schneemann's letters as, 213, 214, 222, 223, 224, 225; De Man vs. Olney on, 222–24; Machann vs. Adams on, 185–86; Victorian, 182. *See also under* Pereira, Irene Rice

Barrie, J. M., 67
Barthes, Roland, 5, 72, 74–75, 201
Baur, John I. H., 132–33
Beauvoir, Simone de, 51
Begemann, Egbert Haverkamp, 40
Bellows, George, 130
Benjamin, Walter, 72
Bildungsroman, 186–87, 196n9
biography, 179–80; in architectural history, 159n5; feminist, 149; need for critically informed, 193; politics of, 220
Blocker, Jane, 72–73
boredom, 72
Bourgeois, Louise: *The Destruction of the Father*, 239–40
Brakhage, Stan, 222
Brenson, Michael, 173
Bronzino, Il: *Venus, Cupid, Folly, and Time*, 74
Broude, Norma, 5
Butler, Judith, 56

Cabanis, Pierre-Jean-George, 64n7
Cambridge School of Architecture and Landscape Architecture for Women, 151, 160n16
Caravaggio, 10
Carlyle, Thomas, 195n9
Carroll, Lewis, 66–67, 78n1
Cassatt, Mary: *The Bath*, 104; linking of maternity and pleasure by, 108–9;

Designer:	Jessica Grunwald
Compositor:	Impressions Book and Journal Services, Inc.
Text:	Sabon
Display:	Sackers Heavy Gothic
Printer and Binder:	Edwards Brothers